EDDIE
ADAMS
VIETNAM

For August Adams

EDDIE ADAMS VIETNAM

BY ALYSSA ADAMS
NARRATIVE BY HAL BUELL

UMBRAGE EDITIONS

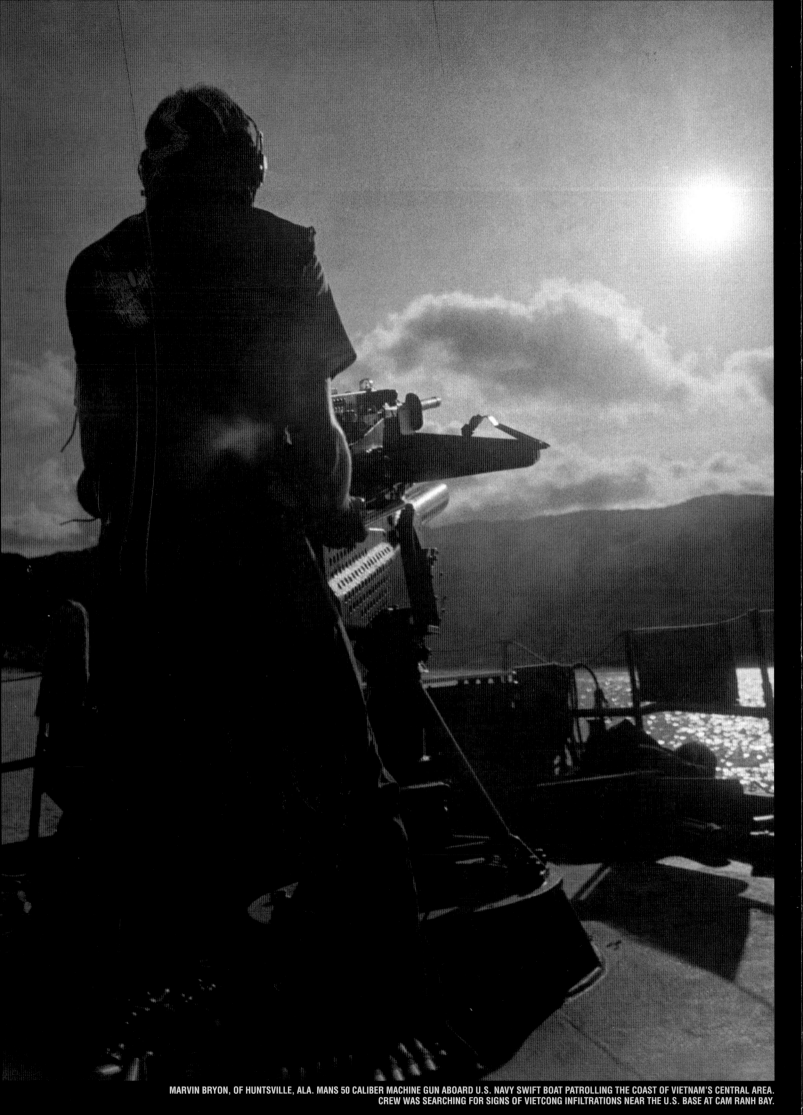

MARVIN BRYON, OF HUNTSVILLE, ALA. MANS 50 CALIBER MACHINE GUN ABOARD U.S. NAVY SWIFT BOAT PATROLLING THE COAST OF VIETNAM'S CENTRAL AREA.
CREW WAS SEARCHING FOR SIGNS OF VIETCONG INFILTRATIONS NEAR THE U.S. BASE AT CAM RANH BAY.

CONTENT

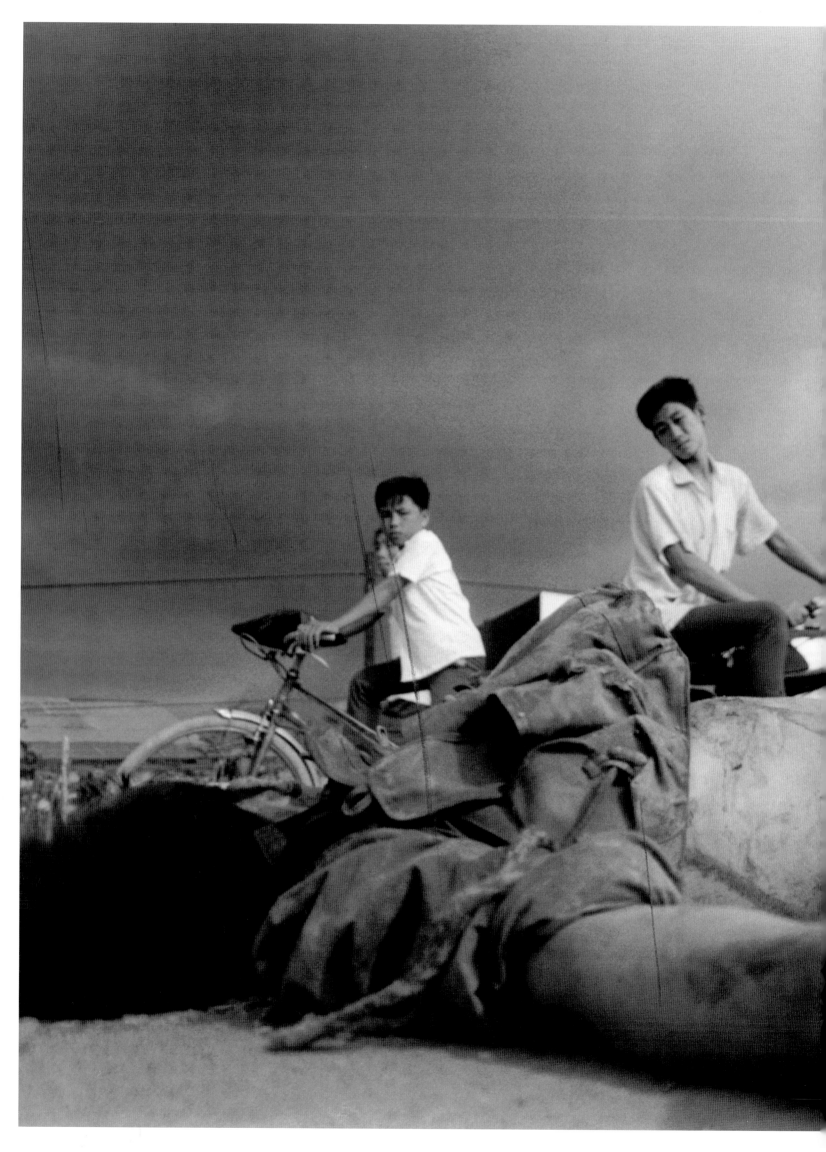

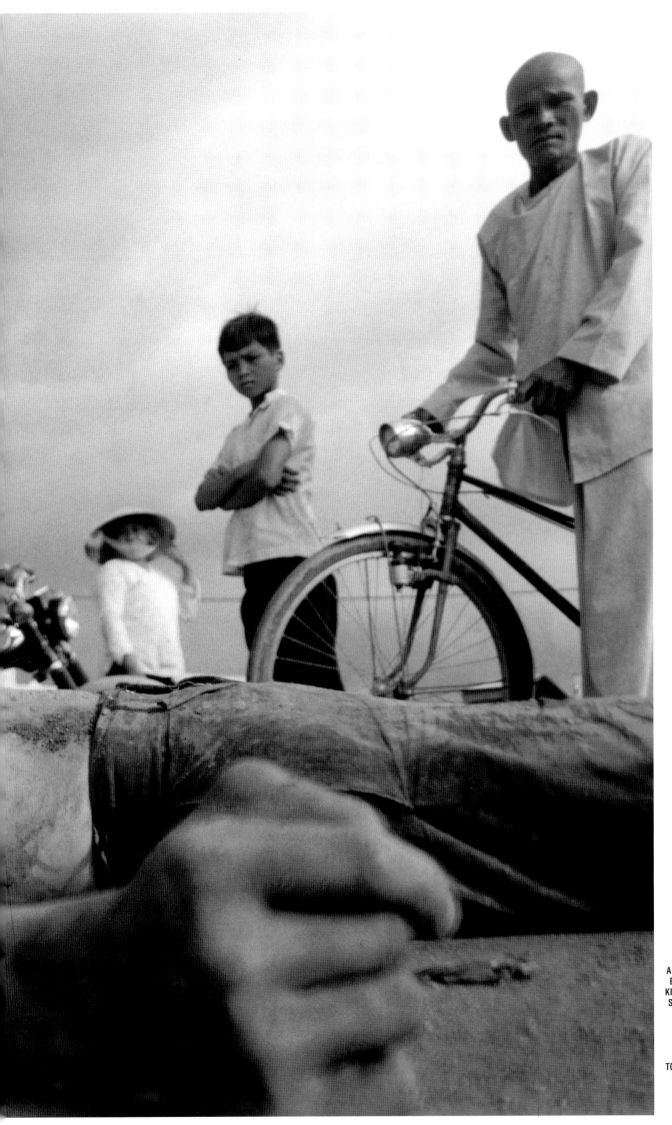

A YOUNG VIETNAMESE ON A MOTOR-BIKE STOPS TO LOOK AT A VIETCONG KILLED IN THE WESTERN SECTION OF SAIGON, CHOLON, DURING DAYLONG FIGHTING. A GROUP OF VIETCONG MOVED INTO THE AREA FOLLOW-ING AN EARLY MORNING MORTAR BARRAGE ON DIFFERENT PARTS OF THE CITY. THE FIGHTING WHICH TOOK PLACE IN CHOLON WAS NEAR A HEAVILY-HIT AREA DURING THE TET OFFENSIVE. MAY 5, 1968.

A LIFE IN PICTURES AND WORDS

How ironic that Eddie's most famous photo was also his cruelest. How strange that a man whose extraordinary body of work celebrates the richness and complexity of the human family is best remembered for an image he captured detailing the ultimate act of inhumanity.

Eddie Adams was very good at what he did. He was an absolute professional. What he did on that one day was not the product of happenstance. He was smart and brave, and he had that magnificent sense of anticipation that all brilliant action photographers have, the ability to sense what is going to happen before it actually happens.

The great combat photographers are tested all the time, caught between the most violent of impulses and the most generous ones, and able always to distinguish the difference between the two. They have to do all that and retain their own humanity

One of the great photos I have framed and hanging in my office was taken by Eddie. It depicts four or five Vietnamese all on bikes, pausing momentarily to look at a body lying along the road. The title I have given it, in my own mind, is "Sideshow." In some way the entire war—what it does to the living and the dead—is in that photo. If you look at Adams's remarkable body of work, so quietly elegant, it has one great connecting link: the singular humanity that runs through his photos. And at first that humanity seems to be solely that of the subjects, and then you see more and more of the photos, and you realize that in so many of the portraits it is as if the photographer was magically able to peer into the very soul of the subject, and the humanity is as much Eddie's as it is that of the subjects themselves.

Our generation of journalists and photographers formed (in some way that I suspect we have not entirely understood) a special bond with each other, perhaps because of the Vietnam War's shared and constant dangers. That generation is now passing, and Eddie's death is a reminder of that, and a reminder even more that in that difficult and dangerous assignment, we did what we were supposed to do, and then, on occasion, we reached out and did even more… and that in the powerful and luminescent work of someone like Eddie Adams, there is a certain nobility to what we do.

—DAVID HALBERSTAM

I was in the Saigon bureau of the AP in the 1960s and even then Eddie was well known as a man of action. I remember a story about Eddie. He wanted a close-up for an assignment and he was arrested at the UN for getting too close to a Cuban diplomat. That made the paper. AP chief of bureau Malcolm Browne said, this guy of action, "we need him here." That was in the early '60s. Eddie came to Vietnam because his beloved U.S. Marine Corps had. Up until 1965 the war had been of only peripheral interest to the U.S. Lyndon Johnson sent a combat force of Marines to Vietnam in '65 and when the Marines landed in Danang, Eddie was there to meet them. He did a yearlong tour of duty and then he returned in 1968. I worked closely with him, and that's basically when I got to know the guy.

He was very independent and a loner. The AP bureau at the time was very busy. There were fifteen to twenty people there—correspondents, other photographers—and Eddie, who came in and wanted to follow his own muse. Now, the Associated Press is a very organized wire service, where everyone was meant to take a degree of direction, you know, and deliver pictures on a regular basis. But Eddie wanted to be independent, so he very soon moved from the Saigon bureau to Danang where the Marines were based, which had a very small press contingent. He worked out of Danang most of the time he was there and when he returned he stayed at Danang. There he could pick the operations he wanted to go on and not answer to anybody—and he preferred it that way. The AP came to accept his attitude and consequently he delivered many great pictures, but let's be clear, he was not a team player in the traditional sense.

The Vietnam War was the last great war for the American press. It was rightly called "the press war." And actually it was the wire services' last great war, because for most of Vietnam, certainly in the initial years, the television crews had to ship their tapes back to the States to be processed, and in the later years, to Bangkok or Tokyo. So they were always a day or two behind the action. There was no live coverage during the Vietnam War for TV.

The main news competitors were the AP and UPI, the two great wire services. We sent twenty to thirty stories a day and a handful of pictures a day, all sent by radiophoto, which was really by telephone. American media were truly dependent on the wire service through most of American history up to and during the Vietnam War. The telex could send print news very quickly, and with the radiophotos you could send radio pictures quickly, especially when compared to the television handling of visual material.

American evening and morning newspapers got the news basically as it was happening. The wire services were powerful influences on news in the 1960s, much more than television. Consequently the AP had big bureaus with five Pulitzer Prizes from Vietnam. UPI got two or three Pulitzer Prizes. Those Pulitzers we got in Vietnam were indicators of the level of reporting we were doing.

The media/military relationship in Vietnam was very different than its relationship with the military in Iraq today. The military in Iraq is very uptight, and the Pentagon has severe rules of conduct for journalists and photographers. You have to get pre-approved to go on opera-

tions. You are not allowed near the front. You rarely see an American wounded or the dead body of an American in a photograph. In Vietnam the world was open to any of us. We could get on a medevac helicopter and go into the center of action where the wounded were being picked up. We could go out on point patrol or with a Marine patrol into an ambush where we saw a lot of action. And in doing so we made close connections with the soldiers in the field. So it was not unusual for a soldier, or a captain, or even a general, to come by the bureau and crash in one of our hotel rooms or just hang around the bureau and talk about what was going on in confidence. And these could be really close relationships.

Eddie had a close relationship with the Marines because he has been in Korea as Marine photographer. I remember him telling me when he arrived in Vietnam, well, he had been in Korea late in the war, but he had missed the action and now that he was in a real war with the Marines again, he wanted to see the action. And he used his contacts and his camaraderie with the Marines to go anywhere he wanted and that included flying around the war front with General Louis Watt (who was a commander). Anytime he wanted to go out with the GIs on their many patrols and actions he did; his pictures show his ability to be in the thick of it. I made a listing recently of the major operations Eddie had been on in the first year he was there, and I think there were twenty-three major military or Marine operations Eddie had accompanied. In Vietnam we had a system where reporters took pictures and photographers wrote stories or provided information for stories. Eddie therefore wrote a dozen stories in Vietnam under his byline, all very dramatic incidents. He not only took the pictures, he took notes, and picked up the comments from GIs and very effectively functioned as a reporter. But, as I want to emphasize, we had very good relations with the military, which does not exist today, unfortunately.

Most American soldiers who fought in Vietnam were draftees. They had to go there whether they liked it or not. But all of the journalists, including Eddie Adams, were volunteers. They could go, but didn't have to stay for that long. And essentially they covered stories in depth when they thought it was possible to do it safely. What happened during the course of the war was that lots of photographers and journalists got deeply involved, were sucked into the action, as Eddie was. Now some journalists were sucked right into death because there were helicopters that were shot down or they were hit. It was a question of how far and how deep into the action did you really want to go. Casualties mounted in Vietnam. Four AP photographers were killed during the war.

Being a journalist gives you an adrenaline rush that helps you press on to find the action. If there is a burglary in your hometown, if there is a school shooting, if there is a flood, if there is anything, you are one of the first to know about it, and being a journalist with a press card generally gets you close to the action. This applies to war as well as any other arena. Vietnam was exciting because not only did you get the adrenaline rush but you had total proximity to the action. You got close-ups of soldiers who were shooting, who were being wounded, officers giving orders to attack or to retreat. Photographers made dramatic action pictures. I don't think there is any doubt that the photo coverage of the Vietnam War is unique in modern American history, and I don't think it will be replaced because the military

has closed access to the frontline photographers that in Vietnam was wide open. The body of work from Vietnam, Eddie's work and that of the other great photographers who were there, many who were killed there, serves as an incredible example of what photojournalism at its apex can be.

Here's what I remember about Eddie's defining moment (not to him but as the world sees it). We were assembling outside our office, and there was an NBC correspondent and there was Vo Suu, a great Vietnamese television cameraman. We were waiting to see what the day would bring.

Eddie went with NBC to the outskirts of the city and came back with an amazing set of pictures and said, "I think I've got something here, I think I've got something." He took his film into the developing room and the technician developed the film and there it was, he had something all right, he had General Loan's picture.

Eddie had always said since that picture—the one that gave him the Pulitzer Prize and became the iconic image of the Vietnam War—was something he was sorry for. He hated the negative impact that he thought it had and in fact, years later, he went to personally apologize

to General Loan (who had come to the States as a refugee after the war) for the negative impact on Loan's life.

Eddie was very a patriotic young man. He really believed in his Marines, he believed in the military, he believed in American foreign policies—unlike many other journalists. Eddie often argued that he felt that picture was misunderstood, that Loan had had every right to shoot the guy, since the VC had been killing South Vietnamese people. I would always tell him—and we had many discussions about this—that the picture was valuable because the instant execution style of killing in Vietnam was quite common, though usually outside the range of cameras. On the battlefield, South Vietnamese soldiers often tortured and killed prisoners. We all knew that, it was matter of record, but it was rarely photographed. I told Eddie that what he captured was a moment of truth about the war. The picture was a tangible reality that came to characterize the whole conflict. His picture was as real as any that were taken. But Eddie, Mister Patriot, just would not accept that. He enjoyed winning the Pulitzer Prize as well as the fame that came with it, but in his heart he felt that he had let the country down.

—PETER ARNETT

Photographers are constantly looking through a lens, to see, to minutely observe, and that lens, the viewfinder, has such definition that even when you take the camera away, they still view the world with great clarity and definition. They see it for what it is. They see the important parts and they edit out lesser details because they're so conditioned to concentrate. That's why I've always valued my friendships with photographers: the best among them are great journalists as well as great artists.

Eddie was one of the best of them. He was one of those people who (if you were in journalism) you just felt you'd known forever. With Eddie formal introductions were not required. If you were in this business he felt he knew you, and you felt you knew him. I don't even remember the first time I met him. (It was not in Vietnam; but he was certainly one of the most famous photographers to come out of Vietnam.) But I do know that when I came to New York, he was suddenly a large presence in my life, with his Halloween parties at the studio, and his large-format camera.

Eddie was everywhere. He was around in his black hat and his black jacket talking about Mom, the war, and taking your picture, and for all of his celebrity as a photojournalist (and he certainly had it) he wore it about as lightly as anybody I've ever known.

I remember one party at his house, a Halloween party. All the photo dogs were there. I brought with me a senator, who shall go nameless for purposes of this story, who was a pretty famous Vietnam veteran, and the senator came to the Halloween party dressed as Don King. It could not have been more politically incorrect. He had a huge wig on, he was in blackface, and he was a United States Senator. Eddie and all the other photo dogs came over and said, "Look man, we're going to do you a favor, we're not going to take your picture and we're not going to tell anybody that you're dressed like this."

I thought that was about as honorable a thing as you can possibly imagine. Believe me, it wouldn't happen today!

Eddie had great friendships. He was a friend of David Kennerly. And of Dirck Halstead, another photographer, a good one, who had also been in Vietnam. Those guys were a posse. They were always around. And I was always spending time with them. I was partial to photographers. I like to take pictures myself, sure, but I also always loved their spirit. They were always in the thick of it. They were, almost all of them, very good journalists; I'd often go to them to get their insight about what was going on. This particular group was very much at ease with themselves. There were no prima donnas, because they wouldn't allow a member of their group to become a prima donna. They came in flavors. There were the enfants terrible like David and then there were the grand old men like Eddie. Eddie was like the guy that you would always remember as your coach. He talked out the side of his mouth and made pithy observations about things. Yet with Eddie, the humanity of the man is what always came through. He was quite… remarkable.

The real question I have is whether we'll ever see the likes of Eddie Adams again. His was a unique generation. Now we have digital cameras, and we have brave people out there doing the same kind of work—some very good work, no question about it—but it's just not the same somehow, because guys like Eddie had done it all. They'd gone everywhere, done everything, and played history out in black-and-white (which I still think is the greatest medium for photography). I was just in Saigon at the War Remnants Museum, and there is a whole wing there now devoted to photography. It reminded me what an important part of the Vietnam War that photography was.

Eddie Adams will be remembered forever for his influential art, but I will also remember his great character.

—TOM BROKAW

Having grown up in a blue-collar Pennsylvania neighborhood, I recognized Eddie's style: Punch first. There'd be plenty of time later to sort out the facts. And he did make the time for the sorting whether or not he extended a hand to pick you up off the floor. Eddie bore the traits of these neighborhoods: a steely loyalty built on stubbornness; a definition of community built on commitment; an expectation to win built on determination; a realization that physical pain was part of life but life was built on overcoming emotional pain. The Eddie we celebrate had to be the biggest and best photographer on the biggest and best story going—on any day, on any continent. Eddie engaged the world with passion, and he demanded we do the same.

The Associated Press—with its mission to pursue truth, its demands for speed and stamina, and the need for its photojournalists to be of the highest caliber—became for Eddie the harbor for much of his professional life, his professional soul. Eddie was on the AP payroll for almost fifteen years and considered himself an AP man all of his life. He was, quite simply, one of us—one of our most gifted, our most combative, our most unorthodox, our toughest and our most sensitive. One year, when he wanted another man's desk and didn't get it, he threatened to saw it in half. If he disagreed with an editor, he didn't just burn his bridges—he blew them up. His sense of betrayal was as deep and wide as his affections. And he rarely forgot either sentiment.

If there were one meaningful picture on page one, Eddie insisted of himself that it be his. This made him a ruthless competitor in daily news coverage—untiring, stubborn, difficult and brilliant. In feature pictures, he was a strategist—waiting hours sometimes for light or shadows to change so that he could see through his viewfinder the picture he had in his head. Photo editors often said he shot like an artist—every image framed as if it had been perfectly cropped. If he had an idea for a picture he allowed nothing and no one to stand in his way. Every picture was, for Eddie, a story. Sweet, sorrowful, tender, gripping, sexual, deadly—but always a penetrating reality. "I wasn't out to save the world," he said after one celebrated series of photographs. "I was out to get a story."

Eddie Adams was a tough competitor but a gentle soul, who not only had a passion for the camera but was dedicated to his friends. He never forgot them, even in their death. He inspired all of us and enriched our lives with his enthusiasm, drive, dedication and love of photography. I worked closely with Eddie during the Vietnam War, and he was always a big help to me, getting me access to major operations that he learned of in advance through his network of impeccable U.S. Marine sources.

He was often ahead of the rest of us, even the military itself, in getting the big stories. Even though he was best known for his powerful images, he was equally adept at reporting, and he bylined stories from Vietnam. I accompanied the Marines on several amphibious landings they made. Eddie was already on the beachhead awaiting us with a big smile. The military was at a loss to figure out how he got there before they did on these secret operations. I still don't know myself but my guess is that an advance Marine team dropped him off in a helicopter. Eddie had scores of sources in Vietnam and access to the highest ranking Marine officers. Our competitors feared Eddie would get a beat on them so some tried to follow him everywhere he went.

But when the smoke of the battle faded, Eddie hung out even with his competitors. One memorable photo is a celebration marking his thirty-fourth birthday

Eddie took one of the world's best-known photograph: the Pulitzer Prize-winning shot of an execution on a Saigon street during the Vietnam War. As many here know, he never considered it his best—or even a favorite—but in keeping with the journalist that he was, he knew it was historically significant. The fierce competitor in him would have been enraged if an editor had held it, the guy next to him had taken it instead—or gotten a picture on the wire faster.

In a one-size-fits-all world, Eddie was unique and unfiltered—a symbol for the committed journalist who finds within himself deep reserves of energy, imagination, and emotion to pursue the most challenging and dangerous stories to define and report truth regardless of the personal sacrifice. Eddie understood the power of a free press and embodied the responsibility that comes with it. For every celebrity he photographed, there were a thousand portraits of people in life's mainstream, many of whose lives were saved or improved because of his work. For all his brashness—the fame, the thirteen wars, the 500 awards, the friendships—Eddie found a justness in giving back to his community, the people and profession that provided for him.

The boy who started in photography with the *New Kensington Daily Dispatch* in Pennsylvania wanted to offer young photojournalists what he didn't have starting out: that mix of guidance, inspiration and support that only comes from rubbing shoulders with the best. And, so in 1988, with the help of friends and family, he created Barnstorm. Many of the photographs seen today in newspapers and magazines are taken by photographers who took part in the Barnstorm workshop. That, and his photographs, are now his legacy.

This story of his life is therefore told with the knowledge that if we don't meet Eddie's tough expectations, we deserve the punch first and the facts later. The emotional honesty that defined his pictures, the charisma and the larger-than-life character that Eddie became can't fool us. At heart, Eddie was our friend with a black porkpie hat and a ponytail who embraced life, pursued the truth and dared us to tell the story that would make someone's life better.

—TOM CURLEY

June 12, 1968; with Dang Van Phuoc, one of his favorite Vietnamese photographers on the AP staff who lost an eye covering a battle; Eddie; Henri Huet, of AP; and Kent Potter and Kyoichi Sawada, both competitors from UPI. These were Eddie's best friends, and he never forgot them, even decades later.

On the job, Eddie was serious, but outside of work he was fun to be with, witty and always playing jokes on his friends. I was at every workshop since Eddie founded it in 1988 except one I missed because of health issues. Eddie insisted that part of the workshop be a memorial service to his best friends killed in Vietnam, including some of those in the photo—Henri Huet, Kent Potter and Kyoichi Sawada. There are always tears in his eyes during the ceremony.

After I retired from the AP in 2000, I returned to my alma mater, West Virginia University, to teach journalism, and Eddie, despite a hectic schedule, accepted my invitation to speak there. The students loved him because of his wit and flamboyant style that included his signature black wardrobe and wide-brimmed porkpie hat. His wonderful photos live on in books and archives, and in colleges and universities, including the halls of West Virginia University's School of Journalism.

—GEORGE ESPER

Fresh from college, an aspiring photographer, I took my first job editing pictures at the New York headquarters of international picture agency Gamma Liaison. I hoped I'd learn enough about the business, and what makes a good picture, that I would be well equipped when I went into the field. The first day, my new boss, Jennifer Coley, took me by the arm into a large closet with a single overhead bulb and a small laminate desk (the kind we had in grade school, with metal legs and a hinged top) upon which rested a light table and a loop. All around me, stacked floor to ceiling, were thousands of identical tiny yellow boxes, each containing hundreds of slides. Jennifer explained that the famous photographer Eddie Adams had just joined Gamma: "Your assignment is to look through each of these boxes, and choose the slides you think we can sell. Put all the good slides to the right of the desk, and the 'outs' to the left."

She slammed the door and I got right to work, eager to succeed in my first endeavor. A week or so later, Jennifer returned. Expecting highest praise for my diligence, I proudly announced that I had edited nearly a quarter of the slides. I showed her the mountain of "ins," ready and waiting to be sold. Gamma would make millions. Then, she asked for the "outs." "Oh," I replied in all earnestness, "there are none. Eddie Adams doesn't take any bad pictures." Jennifer congratulated me heartily—and transfered me to sales.

Over the years, I discovered that my first instincts about Eddie were more right than I understood at the time. Eddie's demand for perfection, which so often cripples the creative process in others, was more than matched by his imagination, so fluid and original it would not be repressed. His pictures are legendary, and each one reflects his vision, the vision of a genius whose compassion knew no bounds.

Everyone knows Eddie is one of the greatest photojournalists of all time. But that is a small part of his greatness. Eddie was a fabulous storyteller, who could make you laugh and cry from one moment to the next. He was a man of courage, courage defined as overcoming personal fear in service of the common good. Eddie's career as a war photographer placed him on the front lines, in more firefights then the most experienced generals. He went wherever the toughest battles were waged, and showed all the world what it meant to be in war—what it meant to the soldiers, to the villagers, to the mother fruitlessly trying to protect her children, to the child whose world exploded and collapsed in front of her eyes. President Bush, justifying the Pentagon policy of suppressing pictures of flag-draped coffins returning from Iraq—this generation's Vietnam—commented, "No one likes to see a bunch of dead bodies." But in all the wars Eddie covered, he refused to ever cap his lens, and so opened our nation's eyes: in Korea, Vietnam, Iran/Iraq, and conflicts the world over—the list goes on.

Eddie shared the world's infinite terror, pain, sorrow, dignity, beauty and bravery so that the rest of us would have a glimpse of the reality of war—and appreciate better the gift of peace.

—KERRY KENNEDY

Eddie Adams changed history. Unless you're the President of the United States, you can't normally do that.

When Eddie awoke in Saigon on that hot Thursday morning on the second day of the Tet Offensive, February 1, 1968, a solitary photograph he'd take later in the day would affect the course of the Vietnam War.

Even though Eddie twisted and turned trying to get away from that photo as his piéce de résistance, it defined who he was and how people looked at him. It was the photographic equivalent of Joseph Heller's "Catch 22," a one-off moment of brilliance that framed the rest of his career and life. Ironically, Joe Rosenthal who took the monumental Iwo Jima picture, also railed every now and then at being inexorably linked to his one iconic image, "as if that's the only shot I ever took," he said. Of course both men took plenty of other photos, but none ever came close to their masterpieces.

When I delivered a eulogy at the Marines memorial service in San Francisco for Joe, Nick Ut, who took the photo of the little napalmed Vietnamese girl running down the road, sat in the front row. I pointed him out as the lone survivor of "The Goddamndest Photos I've Ever Seen Club." Eddie and Joe were the only other two members. The three of them were also fast friends, brought together by a profession they shared, and the fateful photos that are seared into the psyches of anyone who ever glanced at them.

While Joe's bright and shining heroic picture reflected the glory of God, Country, and The American Way, Eddie's was the obverse. His depiction of a Vietcong's moment of death at the hands of Saigon police chief Nguyen Ngoc Loan who served as judge, jury, and executioner, showed the raw, dark, and real side of war. This, however, was not the war we were used to seeing at the time in John Wayne movies . . .

When I finally got my chance at Vietnam as a young UPI photographer in 1971, Eddie told me that I was too late, that "all the good pictures had been taken." Considering what he had done three years earlier, I was inclined to believe him, but knew I had to go. A year later, when it was announced that I'd won a Pulitzer for my Vietnam photos, my most prized cable (and the shortest one), was from Eddie Adams: "I was wrong. Congratulations. Eddie."

Despite that seemingly contrite moment, Eddie had a well-deserved reputation as cranky and irascible. There was a kinder and gentler side, generally hidden, and was the one I liked best. His real passion was to pass his knowledge and insight to new generations of photographers.

The Eddie Adams Workshop is of course his major legacy outside of "The Photo," but there was an occasion when he made a major impact on a large group of middle school students that I had assembled in New York City. He told the story about himself as a young photographer, assigned to cover a family tragedy. When he arrived on the scene and observed the grief, he knew he couldn't take a picture, and left without picking up his camera. His message to the children was clear: sometimes it's better not to intrude. Eddie was still emotional about that night even after all those years. The students were impressed; their vision of hard-bitten news photographers softened a touch.

But right up until the end it was still about that moment which only took 1/500th of a second out of Eddie Adams' existence. He still told anyone who would listen that he had he had ruined General Loan's life with that famous photo. That may be, but the real question is would he have done it over again knowing the consequences. My bet is yes. That was his job, and nobody was better at it than Eddie Adams.

—DAVID HUME KENNERLY

Vietnam was a place of total accessibility. You just went to the airport in Saigon and found someone going to a battle site, going to Danang, or going to Pleiku. It was like getting a cab without having to pay a fare (except for the obvious grim possibilities).

Openness in the U.S. military just does not exist like that anymore. There's no hopping on helicopters now. In Vietnam you could commandeer a ride; with our military command passes we had the priority of a ranking officer to get on a transport. In fact the brass as much as said, "Hey, we're having a war here, please come on in." You were invited by the military. That sure doesn't exist anymore—and never will again.

Certainly Eddie's view, that correspondents saw more war than many in the military, more than most generals, is absolutely true. The generals typically only saw half of what was happening—if they bothered to go out at all. The same was true for most colonels. From Lieutenant Colonel on down, the grunt saw a lot of action. But we went out looking for trouble all the time. I don't mean to compare our roles with any of the grunts who did see action—and often for extended periods—but we were looking for it every day, and believe me, the colonels and the generals were not.

In 1965 Eddie came into my office for something, I don't remember what it was, and we instantly became good friends. My friends were mostly print guys, journalists working for *The Times* and the newspapers. But I would run into Eddie on stories and Horst Faas on stories, into Peter Arnett on stories and the other AP guys.

Eddie was viewed (as many of us were) as a sort of wild man. Eddie was not your sedate, thoughtful, reflective photographer. He was a grunt and he went out and did his job but he also looked for trouble both on and off the job. He liked to party. All of us drank a certain amount of stuff, and inhaled a certain amount of stuff in those days. (I'm clean now I guarantee it!) But Eddie liked a good time and he had a good time, yet at the same time he was dedicated totally to his job, as virtually all of those guys were, particularly the still photographers. They were a remarkable bunch, they really were, Eddie, Larry Burrows, Horst Faas, and Philip Jones Griffiths.

Eddie's Pulitzer picture obviously had a profound effect. It was one of the most shocking moments in journalism in the last hundred years. It was taken at a point when the country was already pretty disillusioned about the war and the politicians were also becoming increasingly disillusioned. In a sense, it was another nail in the coffin of Vietnam.

I got the willies when I saw it. I was in London and it came over the wire and the instant I saw it I was bowled over by it. We all knew General Loan; he was at all the briefings. He was a bit of a character. When I saw the picture one part of me was utterly shocked and in another way I was not surprised at all. He had a reputation, General Loan, for being a very cruel man and a rough customer and that's about as much as I can say.

Eddie's picture instantly became the iconic image of that period and in a sense it embodies everything that was wrong with that war. The brutality of it, the pointlessness of it; who were the good guys and who were the bad guys of it. The reality it conveyed was that this war would go on forever, perhaps it even said that about all war, but certainly it indicted this war.

One cannot help but make comparisons to Iraq now. At every turn there seems to be some relevance to connect these two tragic moments in our country's history. Eddies picture did all that—it still does today.

—MORLEY SAFER

I was a reporter at the *Fort Worth Star-Telegram* and talked the editor into sending me to Vietnam to track down the kids from our area who were in the service and write stories about them. It was the first time the *Star-Telegram* had sent a correspondent overseas since World War II so this was a big deal for our paper. I knew nothing about the war except what I read in the papers to the point that when I left Fort Worth in December of 1965 it was cold, so I wore a wool suit. And this was in the days before suitcases had wheels, so I was towing an eighty-pound piece of luggage with me. I didn't know where the war was, so just said to the cabbie, "Take me to Saigon," and the driver said, "You in Saigon."

So here I am in the middle of Saigon with an eighty-pound bag, wearing a wool suit, sweating so badly that I had actually sweated through the tops of my shoes. I didn't know where to go. Somehow I found my way to the AP office where I had no room, nobody to meet me or anything. I got up to the AP office and a kindly man named Ed White, who was the bureau chief of the Associated Press in those days, took pity—or maybe he just thought I was stupid and he should be kind to people who aren't very smart. He said, "You can stay in one of our rooms." So that became my headquarters in the AP office and that's how I came to meet Eddie Adams.

Not many people outside of journalism knew about Eddie Adams up to that point, but I sure knew who Eddie was. I didn't know the other photographers and journalists who were in the bureau, even people now famous, like Peter Arnett, who was there also. It really was an all-star group of reporters who worked at AP in those days and they did a great job.

Getting to know Eddie was a challenge. He was a little gruff at first. Eddie didn't take fools lightly and he wasn't the most welcoming kind of guy (until you got to know him), and Eddie liked to travel alone. He didn't like to travel with the reporters from the bureau. So sometimes, rarely, I would get to go along with him. In the course of these outings, he basically taught me how to take pictures. I had been given a 35mm Nikon, which is what most of the photographers in Vietnam carried in those days, but I didn't know how to use it. And Eddie taught me well, to the point that I became a pretty good photographer.

When I came back from Vietnam I actually had two interviews from *Life* magazine to go to work for them as a reporter/photographer. (This was before the term photojournalist existed. Then they would give young reporters cameras and call them photo/journalists.) I got through two steps of the interview process and might well have gotten a job at *Life* magazine, but it turned out that the local television station at Fort Worth asked me one day to come out and talk about the war on a talk show and as a result of that they offered me a job, at twenty dollars a week more than I made at the newspaper, so I took it, and that's how I got into television.

Had it not been for that offer I might well have become a photographer because of the training and the teaching that Eddie gave me in Vietnam. He was a won-

derful teacher. For Eddie the camera was just part of him, like with musicians, where the guitar or the piano just becomes a part of them and their fingers just connect to it. It was that way with Eddie and his camera. He was never without it. He had the best reflexes of anybody that I have ever really known. The famous Pulitzer picture that he took? Eddie told me he was just walking down the street and he saw a flash of light and it was the light reflecting off the gun barrel of that colonel's pistol and Eddie just raised his camera up, instinctively—and those instincts are what makes a great combat photographer.

What I also knew about Eddie, aside from the fact that he was a famous photographer, was the rumor he would go places where others wouldn't go. Eddie was not like the others. He was moody, he'd say very little. He taught me a few survival tricks. He said, "Look, you always set the distance on your camera to about ten feet. And then you try to stay away about ten feet from whatever you are trying to take a picture of." And he said to always set your exposure about what you think it is and then, if you have a chance, shoot things one stop above that and one stop below it: always bracket. He also said the secret to being a good photographer is just to expose a lot of film; if you expose a lot of film, you'll eventually get a good picture. But Eddie didn't have to expose a lot of film because he had such great reflexes and such an ability to see the news. Because Eddie wasn't just a photographer, he was truly a journalist, a storyteller. He thoroughly understood the power of a picture and that's what made him so good.

You know we all hear about the great difficulties between the government and the press that we had in Vietnam and indeed it was very tough. It got very sticky. But there was virtually no censorship, and it is one of the only wars America has fought where there was no censorship. They could try to control where you went by controlling your ability to get from one place to another.

You couldn't just get in a car and drive to a battle, but in the early stages of this war the first American reporters did that. People like Dave Halberstam and Neil Sheehan. They could control that to an extent, but after you were in there a while, you would find out that if you just went out to the airport and talked to the flight operators, you could generally bum a ride wherever you wanted to go. We pretty much came and went as we chose.

The great lesson I learned as a young reporter, and Eddie was one of those who helped me to understand this, was that if you were willing to share the war with the military, they would also take care of you. They would let you go with them and they would come to trust and respect you in the same way you would trust and respect them. One of the good things about the embedded program during Iraq was that it gave the American military (which has been very suspicious of the press since Vietnam) a chance to know better what it is we do and it gave these young reporters a chance to understand and appreciate what the military does. In the long run that was a very good thing. During those days in Vietnam this was a very good thing too.

Grunts loved Eddie because he was one of the bravest men I have ever been around, and he never talked about it, never mentioned it, but he went where the danger was and he was always willing to go. He never turned down one of those assignments. Actually, he initiated those assignments most of the time. Because Eddie had been out on so many operations with so many of these enlisted men and officers, captains and lieutenants, they'd call Eddie to come with them because they trusted him. Eddie got a lot of tips on what was going to happen and they knew he would never do anything to put their lives in danger, knew he'd also go with them, knew they could trust him.

But though the rank-and-file were all just trying their best in hard circumstances, the problem was that the whole basis of the government program in Vietnam was a fiction: this ongoing search for good news. They could always find the statistics, they could always find the model villages that they would bring visiting reporters to and explain how well the war was going. In the end it's not that the statistics were dishonest; it's just they were irrelevant, they had nothing to do with what was happening on the ground.

—BOB SCHIEFFER

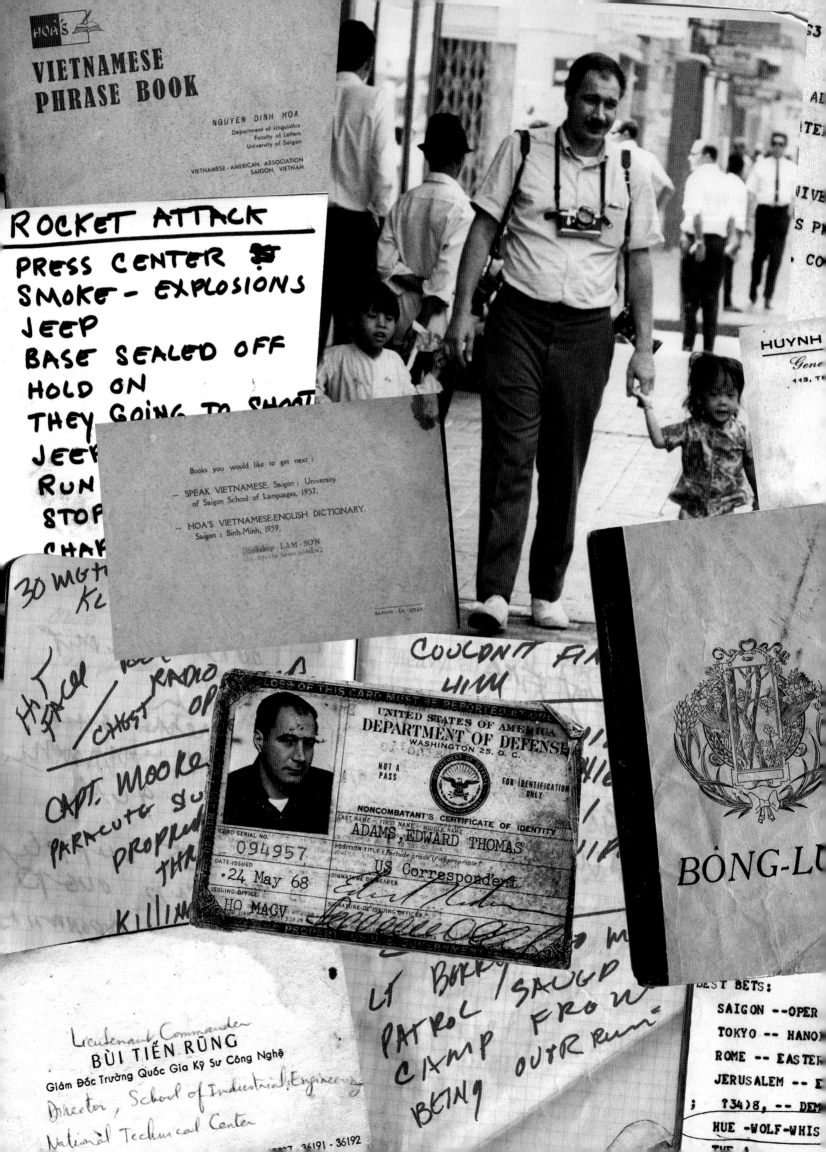

HOA'S
VIETNAMESE PHRASE BOOK

NGUYEN DINH HOA
Department of Linguistics
Faculty of Letters
University of Saigon

VIETNAMESE - AMERICAN ASSOCIATION
SAIGON, VIETNAM

ROCKET ATTACK
PRESS CENTER
SMOKE - EXPLOSIONS
JEEP
BASE SEALED OFF
HOLD ON
THEY GOING TO SHOOT
JEEP
RUN
STOP
CHAR

Books you would like to get next :

– SPEAK VIETNAMESE, Saigon : University
of Saigon School of Languages, 1957.

– HOA'S VIETNAMESE-ENGLISH DICTIONARY,
Saigon : Binh-Minh, 1959.

Bookshop LAM-SON
144, Độc-lập Street ĐÀNẴNG

SAIGON ÂN-QUÂN

HUYNH
Gene
113, TE

30 MG T
K2

CAPT MOORE
CHAT RADIO OP
PARACUTE S
PROPE
THR
KILLIN

COULDN'T FIN
LIM

LT BARRY
PATROL SAIGD
CAMP FROM
BEING OUTR RUN

UNITED STATES OF AMERICA
DEPARTMENT OF DEFENSE
WASHINGTON 25, D.C.

NOT A
PASS

FOR IDENTIFICATION
ONLY

NONCOMBATANT'S CERTIFICATE OF IDENTITY
LAST NAME - FIRST NAME - MIDDLE NAME
ADAMS, EDWARD THOMAS
POSITION TITLE (include grade if appropriate)
US Correspondent
SIGNATURE OF BEARER

CARD SERIAL NO.
094957
DATE ISSUED
24 May 68
ISSUING OFFICE
HQ MACV

SIGNATURE OF ISSUING OFFICER

LOSS OF THIS CARD MUST BE REPORTED

BÒNG-LU

Lieutenant Commander
BÙI TIẾN RỪNG
Giám Đốc Trường Quốc Gia Kỹ Sư Công Nghệ
Director, School of Industrial Engineering
National Technical Center

BEST BETS:
SAIGON --OPER
TOKYO -- HANO
ROME -- EASTER
JERUSALEM -- E
; 3408, -- DE
HUE -WOLF-WHIS

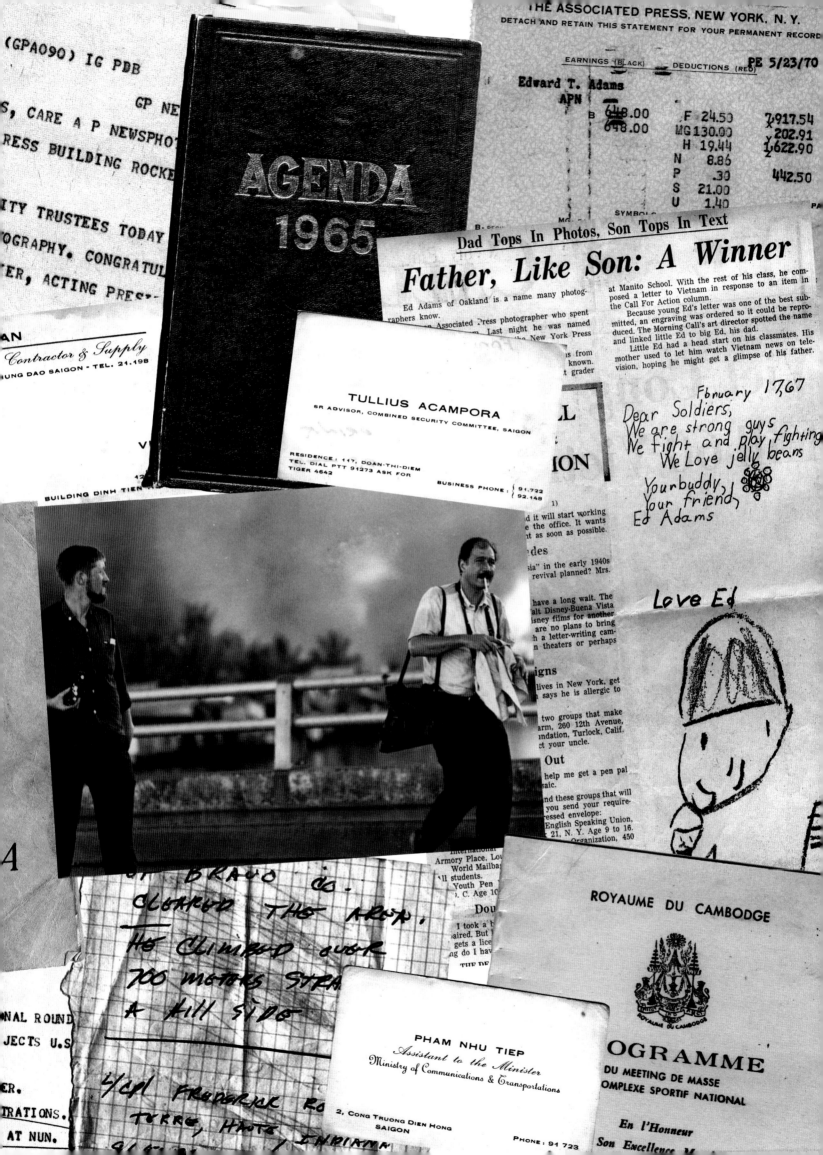

THE ASSOCIATED PRESS, NEW YORK, N.Y.
DETACH AND RETAIN THIS STATEMENT FOR YOUR PERMANENT RECORD

EARNINGS (BLACK)	DEDUCTIONS (RED)	PE 5/23/70

Edward T. Adams
APN

B	648.00	F	24.50	7,917.54
	648.00	MG	130.00	202.91
		H	19.44	1,622.90
		N	8.86	
		P	.30	442.50
		S	21.00	
		U	1.40	

SYMBOLS

AGENDA 1965

AN
Contractor & Supply
UNG DAO SAIGON - TEL. 21.198

V

BUILDING DINH TIEN

Dad Tops In Photos, Son Tops In Text

Father, Like Son: A Winner

Ed Adams of Oakland is a name many photog-
raphers know.

Associated Press photographer who spent
Last night he was named
the New York Press

s from
known.
t grader

at Manito School. With the rest of his class, he com-
posed a letter to Vietnam in response to an item in
the Call For Action column.

Because young Ed's letter was one of the best sub-
mitted, an engraving was ordered so it could be repro-
duced. The Morning Call's art director spotted the name
and linked little Ed to big Ed, his dad.

Little Ed had a head start on his classmates. His
mother used to let him watch Vietnam news on tele-
vision, hoping he might get a glimpse of his father.

TULLIUS ACAMPORA
SR ADVISOR, COMBINED SECURITY COMMITTEE, SAIGON

RESIDENCE: 117, DOAN-THI-DIEM
TEL. DIAL PTT 91273 ASK FOR
TIGER 4642

BUSINESS PHONE: { 91.722
{ 92.148

L
ION

February 17, 67
Dear Soldiers,
We are strong guys
We fight and play fighting
We Love jelly beans
Yourbuddy,
Your friend,
Ed Adams

d it will start working
e the office. It wants
t as soon as possible.

des
sia" in the early 1940s
revival planned? Mrs.

have a long wait. The
alt Disney-Buena Vista
isney films for another
are no plans to bring
h a letter-writing cam-
n theaters or perhaps

igns
lives in New York, get
h says he is allergic to

two groups that make
arm, 260 12th Avenue,
ndation, Turlock, Calif.
ct your uncle.

Out
help me get a pen pal
saic.

nd these groups that will
you send your require-
essed envelope:
English Speaking Union,
21, N. Y. Age 9 to 16.
Organization, 450

International
Armory Place, Lou
World Mailba
ll students.
Youth Pen
. C. Age 10

Dou
I took a b
aired. But I
gets a lice
ng do I hav
THE D

Love Ed

4

BRAVO is.
CLEARED THE AREA,
HE CLIMBED OVER
700 METERS STRA
A HILL SIDE

NAL ROUND
JECTS U.S

ER.

TRATIONS.

AT NUN.

L/CPL FREDERICK RO
TERRE HAUTE
INDIANA

PHAM NHU TIEP
Assistant to the Minister
Ministry of Communications & Transportations

2, CONG TRUONG DIEN HONG
SAIGON

PHONE: 91 723

ROYAUME DU CAMBODGE

OGRAMME
DU MEETING DE MASSE
OMPLEXE SPORTIF NATIONAL

En l'Honneur
Son Excellence M

BY HAL BUELL

EDDIE ADAMS PHOTOGRAPHER

Eddie Adams never considered himself a war photographer. He believed simply and directly that good photographers were good photographers no matter their subject, and that labels limited assignments. Though he covered thirteen wars in his half-century career, he photographed virtually every aspect of the human experience. This book, about the years he spent in Vietnam, is not meant to ignore the great variety of his other work, but to examine closely a period that profoundly influenced his life, as it influenced so many others of that era.

Two anecdotes from Vietnam capture the reach of Eddie Adams's persona. The first offers a glimpse of his humanity and the respect he showed for his subjects; the other reveals his gregarious, charismatic personality.

The first story occurred in 1968 when Adams returned to Vietnam. He learned that the gulf between the military and the press had widened considerably in eighteen months. Government/military credibility had plunged and the government/military believed that the media aided and abetted the enemy. The atmosphere distressed him and he took steps to improve matters. The AP's Peter Arnett, who covered Vietnam from start to finish and won a Pulitzer Prize for his reporting, told the story of the Adams effort in his book, *Live from the Battlefield:*

Eddie undertook to help break the ice, revealing another side of his personality that all his friends knew about. He was a social animal who reveled in organizing offbeat entertainment for his buddies.

Eddie tried his best to smooth the roiling waters at the Danang press center by including the Marines in a goofy club he formed called TWAPS: the Terrified Writers and Photographers. He collected five-dollar fees from scores of colleagues, wore a GI can opener around his neck engraved with the words, "Head TWAP," and demanded secret signs and catchphrases from members.

He decided to swear in as an honorary member the Marine Commander, Major General Lewis Walt, who was known as a good sport. Eddie organized a steak dinner on the banks of the Han River, with tables from the press center restaurant forming a large U shape and set with white linen cloth.

General Walt was late, and by the time he arrived with two lower-ranking officers, it was dark, most of the media were drunk and disorderly, and the

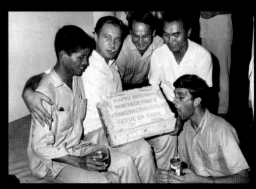

PHOTOGRAPHERS CELEBRATE A BIRTHDAY IN SAIGON JUNE 1968. L TO R: DANG VAN PHOUC/AP, EDDIE ADAMS/AP, HENRI HUET/AP, KYOCHI SAWADI/UPI, KENT POTTER/UPI. HUET, SAWADI AND POTTER WERE LATER KILLED IN VIETNAM.

sky over the Marble Mountain in the middle distance was ablaze with streaking white light as helicopter gunships fired on Vietcong guerrillas.

Eddie was wearing a red satin happi coat pinned with four dozen cheap medals purchased on the Danang black market. His helmet was pushed down over his ears. He asked General Walt to rise and repeat with him, "When under fire, I must shout bao chi" (Vietnamese for journalist), and the general obliged.

Eddie continued, "When I contract a social disease I must inform all other TWAPs the name of the carrier." The general laughed at this point but Eddie, with a straight face, declared, "This is serious," and the officer cleared his throat and repeated the line.

Eddie then presented him with a gold tie bar engraved with the TWAP emblem, which he promised to wear with pride. We all got to shake the general's hand that night, and even though there was no immediate improvement in our relations with the press center staff, we did all enjoy the free steak dinner.

Social activities were an important part of Adams's world. Before he went to Vietnam he invited scores of New York media people to an annual daylong New Year's Day party at his home in New Jersey. The feature attraction was a great roast pig complete with apple in mouth. When he moved to New York City he held riotous Halloween parties at

his downtown residence/studio. Each year as an AP staffer and for many years thereafter he took a Christmas walk through the AP facilities at 50 Rockefeller Plaza. He wore a bright red Santa suit, a flowing white beard, rang a bell and wished everyone in the building a merry Christmas, including the president in his office.

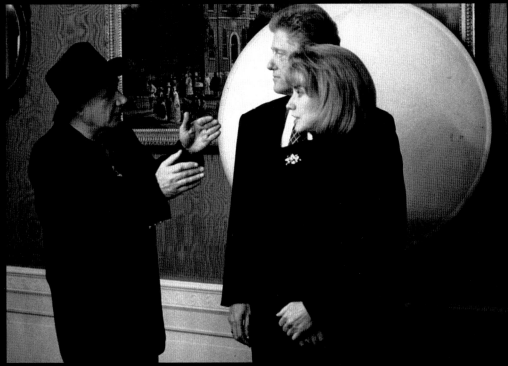

EDDIE ADAMS DIRECTS PRESIDENT CLINTON AND FIRST LADY HILLARY CLINTON FOR A 1995 *PARADE* MAGAZINE COVER.

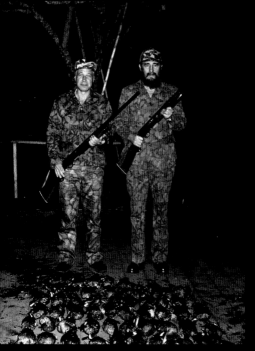

EDDIE ADAMS AND FIDEL CASTRO AFTER A DUCK HUNT. ADAMS WENT TO CUBA TO PHOTOGRAPH CASTRO FOR AN APRIL 1, 1984 *PARADE* MAGAZINE COVER.

The second, and more serious, anecdote is taken from an oral history interview conducted by historian David Culbert of Louisiana State University:

I was with a company of Marines and we were pinned down and being rocketed on a hill with nearly fifty percent casualties...It was the first time I actually saw Vietcong running with their guns all around us...and there are dead Marines dug into holes...and so I'm lying on the ground with my head sideways...you get closer to the ground this way...if your head is up this way you might catch some shrapnel...I'm lying there and

I noticed a Marine, blond hair, blue eyes, facing me...just about five feet away...my head was this way, he was looking right at me this way. In all the operations I'd been on in Vietnam I'd never seen fear on a person's face like I did on his face. I had a camera with a 35mm lens on my side and I slid it off in front of me...but I couldn't push the button...I put the camera down....I brought it back again and swung it up the second time because this kid, he was almost frozen with this expression. And I tried three times and I couldn't push the button.

And I remember exactly what was going through my mind at that time...I know that my face looked exactly like his...and I didn't want anybody taking a picture of me. This kid, he left...it was only a few minutes that we were pinned down. That was the only time I've ever seen him, but I could identify him walking on the street today. I could see that picture, page one, cover, you name it...I mean I could see it in print everywhere...the impact it would've had...but you know, I think there's a line that separates when you photograph and when you don't photograph.

Horst Faas, the two-time Pulitzer winner who headed up the AP's Vietnam photo operation for a decade, reflected on Adams's time in Vietnam for *The Digital Journalist:*

Eddie was after more than just good day-to-day newsphoto coverage of the war. He was after the

perfect, meaningful photograph, expressing the frustrations, the bravery, the suffering of the war— all expressed in one image. He had tried for years, on countless military operations—and would become very moody and depressed when it did not work out perfectly. New York headquarters was happy with his work—but Eddie wasn't.

A philosopher once said, "That which sustains us also consumes us." Adams lived to make the perfect picture; making perfect pictures, however, is an elusive, frustrating pursuit. Adams was not a violent man but he covered war. He was not politically motivated but he photographed world leaders on a regular basis. He was bemused rather than impressed by celebrities but made pictures of celebrity royalty. He was not an athlete but he covered sporting events. He was neither Republican nor Democrat but photographed presidents from each party. Adams's ambition took him to the far corners of the world but he never sought position as a wire service editor, magazine editor, or newspaper editor. He only made pictures.

His catalog of photographs made in Vietnam are all in black-and-white. He shot some color in Asia but his major client, the AP's, primary priority was for black and white photos. That was fine with Adams, who observed:

All war should be done in black and white. It's more primitive; color tends to make things look too nice. It makes the jungle in Vietnam look lush—which it was. But it wasn't nice.

Photographs speak with eloquence for the photographer and reveal his or her heart and soul. Too narrow a look at his images, however, may tell only a partial story. As Adams said, a single picture can lie, can distort. Adams did not cover Vietnam because it was war. He covered it because it was the big story of his time. He wanted to be where the news was breaking and where dynamic, compelling pictures were possible.

He saw himself a photographer, pure and simple. He detested the description "photojournalist." When asked his favorite kind of assignment, he replied that he had no favorite, that he enjoyed all his assignments. And he added that he believed

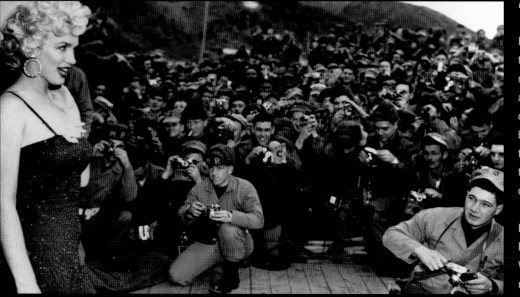

EDDIE ADAMS FAR RIGHT LOWER CORNER, IN KOREA AS A MARINE, SHOOTING MARILYN MONROE.

"photojournalist" was a poor description, that a good photographer can make good pictures of anything—a war, a ball game, a fashion photo, a crime scene. He shot pictures for *Penthouse* in its heyday. *Photojournalist is a label that limits assignments,* Adams would say, *and good photographers do not have limits.*

Adams was born in New Kensington, Pennsylvania, on June 12, 1933. By the time he was twelve he was making pictures, and by the time he finished high school he was a regular contributor to the local newspaper, the *New Kensington Dispatch*. They were mostly wedding pictures which he submitted in 8x10 inch print form. After high school he joined the newspaper staff but soon enlisted in the U.S. Marine Corps. He photographed Corps activity in Korea. He later worked on the *Battle Creek Enquirer* (Michigan) but graduated to *The Philadelphia Evening Bulletin* and finally joining the Associated Press in New York in 1962, just short of his thirtieth birthday.

I first met Adams in 1963 when I returned from a four-year assignment in Asia. Our lives intersected at crucial times in our separate careers. I was charged with bringing new kinds of photography to the wire service to match expanded news coverage; Adams had collected numerous awards and was recognized as a talented newcomer who was willing to photograph anything and try anything. We had mutually beneficial ambitions. We got to know each other well and created an unspoken partnership that lasted forty years.

Adams was well suited to the AP. He had no political or social agenda. He was dedicated to telling the story truthfully and straightforwardly. No picture was barred, there was no spin, no special selection to advocate any idea. He photographed multi-picture stories or a simple oddity that makes for a good image. It was always the image that counted above all else.

Adams was not an easy man; not in his early career, and not later. Some said he was difficult. I always believed his prickly personality was traceable to his determination that nothing should dilute his photographic narrative. He was toughest on himself, searching always for that "perfect picture," then resorting to harsh self-criticism and falling into moodiness when the photo fell short of his self-set standards. I started calling him Easy Ed, an irony that recognized his demands on himself and others, me included. It was a nickname born of affection and respect that lasted decades.

His frequent crankiness did not limit his circle of friends, however. His widow, Alyssa, expressed it best in a eulogy delivered at a memorial ceremony in St. John the Divine Cathedral in Manhattan:

People enjoyed being in his company. When you were with Eddie you felt close to the center of the universe. His gravitational force was strongest when he was excited about something. His excitement drew you in, you couldn't help but be excited with him or for him. He was just a kid sometimes— as if he had discovered something for the first time. He was eternally twenty-eight years old. There were times when people fell out of favor and then his sun did not shine on you. But you always knew where you stood with him. There was no gray area, just black and white and for that, you had to respect him.

EDDIE ADAMS ON ASSIGNMENT IN A MADRID CABARET FOR *A DAY IN THE LIFE OF SPAIN* MAY 7, 1987. PHOTO: KAI MUI.

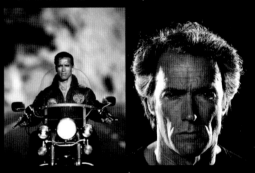

ARNOLD SCHWARZENEGGER AND CLINT EASTWOOD PHOTOGRAPHED BY ADAMS FOR *PARADE* MAGAZINE IN THE 1980S.

PHOTOJOURNALIST IS A LABEL THAT LIMITS ASSIGNMENTS, AND GOOD PHOTOGRAPHERS DO NOT HAVE LIMITS.

Eddie was hot and cold, yin and yang, pussycat and hellcat, half Italian and half German, plus a Gemini to boot. He was a study in contrasts, and often his own worst enemy, criticizing his work as never good enough. Being a friend of Eddie was both demanding and rewarding.

Adams was also a flamboyant character. After Vietnam and after the AP he adopted a wardrobe of all black: shirt, pants, jacket. He even designed a special long coat for formal wear. A black Trilby always covered his balding head, the crowning symbol of his public appearance. (I once asked him if his underwear was black, too.)

After the AP Adams worked as a staffer with *Time* magazine, then returned to the AP for a period, then left again and did considerable photography for *Parade* magazine, mostly covers, hundreds of them. He also did other journalistic assignments for other publications.

Adams often said that he was just a photographer making pictures of what he saw. At his memorial service Jack Jacobs, former Army captain and winner of the Medal of Honor in Vietnam, said:

Well, sorry Eddie, you changed the world—and us—forever.

1965
THE BEGINNING

When asked why he took his camera and darkroom to Civil War battlefields Mathew Brady responded: "Spirits in my feet said go, and I went." That has always been reason enough for photographers.

In the months before his assignment to Vietnam, Adams believed, along with many others,

from Vietnam the media sent hell home daily.

Why Vietnam was special will become clear in the story of Eddie Adams and his coverage of the war, but his reasons for wanting to go there and place himself in harm's way will probably remain elusive. He said openly and unabashedly that it was essential for him to cover the big story. If he was not assigned to the big story he could not sleep at night; he would watch the story on television, spotting the opportunities for good photos. It was rather more difficult for him to express his driving need to make perfect pictures, pictures that told stories in a single, perfectly composed frame, pictures with an unmistakable message.

I THINK I'M READY FOR GRADUATION FROM COVERING THE BILLIONTH PERSON TO VISIT A BOAT SHOW TO COVERING VIETNAM.

that no war was photographed like Vietnam and that no future war ever would be. Uncounted photographs brought the brutal horror of that especially brutal war to the world's front pages and television screens in a way and in a volume not previously encountered. There was no censorship and there was unfettered access to the firefights. The fighting was up close and personal. It is a cliché of documentaries on World War II that veterans who experienced those fierce battles did not want to talk about the hell of war. But

Another motivating factor was his Marine Corps experience. He knew photography when he enlisted in the Corps after high school but was disappointed with his assignment to air controller duty after boot camp. He immediately bugged his superiors for a photo berth until he got his way. It was a tactic he would use the rest of his life—determination coupled with talent were Adams's strong suits. His Marine Corps superiors eventually gave in, assigned him as a photographer and shipped him to Korea.

EDDIE ADAMS AS A HIGH SCHOOL PHOTOGRAPHER IN NEW KENSINGTON, PENNSYLVANIA.

Before Eddie and I started to work together in 1963, my experience with Vietnam (as AP Asia editor out of Tokyo from 1960) was limited. The war was smaller stuff then—a back-alley, brush-fire war. The big Asia stories were Nikita Khrushchev's visit to Indonesia, President Eisenhower's visit to India, the cancellation of Ike's visit to Japan because of street demonstrations, the overthrow of the Syngman Rhee post-WWII government in South Korea. At one point U.S. Marines landed in Bangkok and made their way to Laos over some back-country sniping but the level was low. Pictures flowed sporadically from Vietnam but many were after- the-fact pictures of battles between the Vietcong and government troops. John F. Kennedy assigned U.S. advisors and materiels to Vietnam to help the government stop the Communist pressures from the North, and from the Soviet Union and China. It was the Cold War played out in Eastern Europe and fought to some extent in Vietnam's countryside.

Then came Mal Browne's compelling picture of a Buddhist monk's protest of government policies by setting himself afire in a Saigon street in June 1963. The picture flashed to the world through the AP's picture networks and just as suddenly the world had a new awareness of Vietnam. Browne's picture was on Kennedy's desk as the President instructed Henry Cabot Lodge, newly appointed ambassador to Saigon, to find out what was going on over there. President Ngo Dinh Diem was assassinated months later, and a military group took over the government.

Later in 1963 I was back in New York and Adams was established on the New York staff. Horst Faas, newly assigned to Asia, covered a Vietnamese war that was heating up. American advisors (not considered combat troops) appeared more and more in the photographs that Faas and Vietnamese photographers shot for the AP. The pictures were graphic and compelling, with stories that matched. Faas's 1964 picture coverage of the escalating warfare won a Pulitzer Prize, the first of many awarded to Vietnam photographers before the war's conclusion.

The volume of pictures increased as the war escalated and Adams saw the story taking over the front pages. More and more I was working with photographs sent to New York from Saigon. *"It's a great story,"* Adams said over and over again and he started his campaign for a combat assignment.

Once a Marine, always a Marine. Like most clichés it is probably true; Marine training instills a love for the Corps that trumps most other loves. Adams played his Marine card when it was announced that Marines would be assigned to Vietnam in 1965 as the first U.S. combat troops. He knew many of the generals from his experiences in Korea, and insisted that he be allowed to cover the Marines in Vietnam. *I think I'm ready for graduation from covering the billionth person to visit a boat show to covering Vietnam,* he wrote in one of his many memos. It was classic Adams hyperbole, but he made the point.

He was assigned to Vietnam.

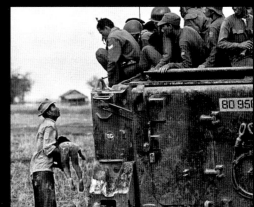

A FATHER HOLDS THE BODY OF HIS CHILD AS SOUTH VIETNAMESE ARMY RANGERS LOOK DOWN FROM THEIR ARMORED VEHICLE MARCH 19, 1964. THE CHILD WAS KILLED AS GOVERNMENT FORCES PURSUED GUERRILLAS INTO A VILLAGE NEAR THE CAMBODIAN BORDER. (AP PHOTO/HORST FAAS)

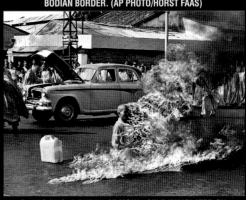

QUANG DUC, A BUDDHIST MONK, SELF-IMMOLATED ON A SAIGON STREET JUNE 11, 1963 TO PROTEST ALLEGED PERSECUTION OF BUDDHISTS BY THE SOUTH VIETNAMESE GOVERNMENT. (AP PHOTO/MALCOLM BROWNE)

EDDIE ADAMS'S VIETNAM COVERAGE

FEBRUARY 1965—Goes on first operation; encounters VC.

MARCH 1965—Covers arrival of first 8,000 Marine combat troops.

MARCH 1965—Spends three days in field with Marines at **Rung La**, which was wiped out by VC.

MARCH 1965—Covers first Marine combat action in Vietnam.

APRIL 1965—VC executed at **Danang** field, Adams photographs.

APRIL 1965—Accompanies Marines on first patrol outside perimeter; helps rescue wounded Marine. Awarded commendation.

APRIL 1965—Final Marine combat troops arrive.

MAY 1965—AP's **Saigon** office moves to new offices. Adams says staff says it looks like New York.

JUNE 1965—Spends twelve days in **Pleiku** Special Forces camp.

JULY 1965—Caught in highway ambush at **Cheo Reo**, heaviest combat of first stay in Vietnam. Fifty Vietnamese killed, four Americans, 130 Vietcong.

JULY 1965—Chopper carrying Adams hit as it lands in **Ban Gia**. No injury.

JULY 1965—Covers "Little Hawaii" at **An Hoa**.

AUGUST 1965—Visits American destroyer USS *Henderson*.

SEPTEMBER 1965—Richard Nixon visits **Danang**. Adams and Nixon recall his pictures from Nixon's birthday.

SEPTEMBER 1965—Goes on first night raid.

OCTOBER 1965—AP photographer Bernie Kolenberg killed in plane crash.

OCTOBER 1965—AP photographer Huynh Than My killed when VC overrun his position in the **Mekong Delta.**

OCTOBER 1965—Joins relief column to **Plemei** in Central Highlands. Ambushed but makes it to camp.

NOVEMBER 1965—Goes to New York on home leave.

JANUARY 1966—Returns to Vietnam from leave.

FEBRUARY 1966—Johnson and Ky confer in Hawaii.

FEBRUARY 1966—At **Hoai Chau** Adams caught in friendly fire, almost killed with U.S. troops.

FEBRUARY 1966—Covers a series of battles nearly every other day.

APRIL 1966—Adams, Horst Faas and Fort Worth writer Bob Schieffer beaten by demonstrators in **Saigon**.

JUNE 1966—Returns to New York.

JUNE AND JULY 1966—Covers race riots, campus demonstrations in the U.S. at Detroit, Cleveland, Newark.

NOVEMBER 1967—AP sends Adams back to Vietnam at his request.

JANUARY 1968—Arrives in Vietnam for the third time.

JANUARY 1968—Goes to **Nha Trang** on assignment.

FEBRUARY 1968—Leaves **Nha Trang,** goes to **Saigon**, makes his famous picture of a Vietcong executed on a **Saigon** street by General Nguyen Ngoc Loan.

JANUARY 1968—Newly returned from the U.S., he covers a VC camp inside Cambodia.

FEBRUARY 1968—Photographs war in the streets of **Saigon** and **Cholon**.

FEBRUARY TO APRIL 1968—Covers the Tet Offensive in **Saigon**, **Hue** and in the **Mekong Delta** plus several days covering General Nguyen Ngoc Loan.

MAY 1968—Covers **Dong Hoa** and **Dai Do** battles.

OCTOBER 1968—Is in **Laos** covering Pathet Lao activities.

NOVEMBER 1968—Leaves Vietnam; returns to New York.

MAY 1969—Is awarded the Puliter Prize for Spot News Photography for his picture of a Vietcong executed in a **Saigon** street.

NOVEMBER 1977—Goes to **Thailand,** photographs Vietnamese Boat People.

1993—Visits Nguyen Ngoc Loan in Virginia where he is a restaurant owner.

THE BIG STORY

ell, my dream has come true. I just finished shrimp cake on my flight to San Francisco en route to Saigon, Adams noted on the first page of a cryptic journal he kept during his first tour in Vietnam. And he added: *I feel normal. Said goodbye to buddy Hal at JFK and to my family....just have to score extremely well...many counting on me...like Hal said, I got to knock 'em dead.*

After a stopover in San Francisco, his flight to Honolulu passed uneventfully with time at the airport only to send a few postcards. Guam and Manila were next and then on February 15, 1965, Adams wrote: *Well, I'm now looking over Vietnam...looks like a series of snakelike rivers, like a maze.*

Unmistakable architecture, a legacy of France's generations of colonization, provided a backdrop to the ground level maze that Adams's car negotiated through Saigon's streets, abounding with pedicabs and scooters. Silent columns of Vietnamese rode bicycles, the predominant mode of transportation. To the newcomer the most notable cyclists were young girls in their flowing *ao dai*, the graceful, long garment that resembles a negligee as much as street wear. Sidewalk food stalls emitted mouth-watering smells, and sounds from shops mingled with the calls of vendors. Giant trees shaded many of the streets.

Here and there armed military, grim reminders that there was a war out there, stood guard and walked patrols in the warm tropic air. To a young man on his first foreign assignment the milieu spelled adventure, exotic and compelling. Adams's extensive experience did not reduce the newcomer's tingle.

Adams joined a remarkably versatile team of veteran AP journalists at the AP bureau in Saigon in 1965. 1963 Pulitzer Prize-winning writer Malcolm Browne; Peter Arnett, also a Pulitzer winner for his reporting in 1965, was similarly handy with a camera; Horst Faas, Pulitzer winner for his picture coverage during the 1964 days of escalating war, who also wrote his share of stories; George McArthur, Korea War correspondent. Ed White, pipe-smoking, unflappable Chief of Bureau and an Asia news veteran of many years, monitored the reporting. George Esper, a future Chief of Bureau, was an experienced correspondent. Arnett and Esper would be among those who remained in Saigon after the city fell to the North Vietnamese ten years later, staying on until the North Vietnamese told them that it was time to leave.

Just checked in at the Majestic Hotel [another colonial leftover from the French days]...doubled up with pal Ed White...was on the crapper when I heard a loud screechy sound...maybe an air raid...nope...then a sound like a mass of planes overhead. I ran to the window and looked out... then turned off the air conditioner.

A dams provided funds to a Vietnamese staffer at the AP bureau who would pick up uniforms, packs, boots, and other gear for the field. *Later I met an old Marine Corps friend at USIS [United States Information Service, America's public relations arm to the Vietnamese people] and then an old Air Force Master Sergeant from Tarentum, Pennsylvania [the country of Adams's youth]. I got my Vietnamese and USIS correspondent's cards today...and tomorrow I get a card for the PX [the military post and commodities exchange to which accredited correspondents were given access].*

A visit to the AP bureau was next. A few years later the AP would have more space and greater facilities but the bureau that welcomed Adams in 1965 was a cramped office crowded with desks and typewriters. A tiny bathroom functioned as its intended purpose as well as a tiny photo lab where film was processed and prints made. If nature called the callee would simply have to wait (or find other facilities) while photography completed its process uninterrupted. Word copy and captioned prints were taken by hand to the communications head elsewhere in Saigon and delivered to Vietnamese attendants

who transmitted the material to the outside world. Paper copies of incoming messages and news were picked up off the AP world wire and were hand- carried to the bureau for response and reference.

Adams slept until eleven a.m. the following day, a victim of jet lag.

Was oriented today by Faas...visited the radio station and checked messages that came in over the wire...made some pictures of the new government today...also visited MACV [Military Assistance Command Vietnam]...then went to dinner with Horst, his wife Ursula and Ed White at a restaurant in Cholon [a Saigon suburb inhabited mostly by the city's Chinese community]...the menu was shark fin soup, crabs, pigeon heads, steamed fish, lichee nuts....everything was extremely good...except for the pigeon heads.

The next day Adams went to a helicopter medical evacuation site near Saigon. Photographers frequently spent hours at these stations waiting to hitch a ride to battle locations on choppers summoned to evacuate the wounded.

Dressed up for combat today in all of my black market uniform...wore a pair of old, size thirteen boots, green pants, beatup army jacket, Horst Faas's German pack, Arnett's canteen and my

three cameras...looked just like a Vietcong... then spent the day at the U.S. helicopter medical evacuation airport...Guess what? It was the first day that they had no calls at all...so no pictures today...went up in a chopper in a training flight with a pilot who was new to Vietnam...at night I went to supper with Faas and White at a French restaurant.

In these first few days in Vietnam Eddie learned what older hands knew—war was unpredictable. Combat photographers traveled for days with patrols and nothing happened. Then one day or night all hell broke out just beyond a base camp's perimeter and a patrol found itself under fire. Or a Vietcong ambush would catch patrols several miles from the camp and remote from assistance. But on that first day there was nothing for Adams to photograph.

A second day with no picture opportunities convinced Adams to head for Danang, the central port city that was home to a large force of South Vietnamese military and the site of a major airbase. It was from this field that U.S. aircraft flew daily bombing runs over North Vietnam. Danang was also home to U.S. personnel who frequently traveled with South Vietnamese on combat missions, but as advisors, not combatants. The Marine force destined for Vietnam, the first American combat troops assigned to

the war, was to arrive at Danang in several weeks. Their mission, to provide protection for the base, would lead to contact between American and Vietcong forces.

Home for Adams in Danang was the press headquarters, a rickety complex situated along a river. Like many vintage Vietnamese structures, the rooms were high-ceilinged in the European manner and studded with Singapore fans that shifted but failed to properly cool the humid air. The AP maintained a room at the press center, as did other wire services and the television networks. Correspondents would come and go and take pot luck on getting a room for a few days stay. Military personnel were assigned to see to the press's needs.

Arrived in Danang today...looks real military... much more than Saigon...John Wheeler, our correspondent here from Malaysia...met me at the airport and started me immediately on a tour of introductions with the right people at the various American installations like Army, Air Force, MACV, etc...Seems the only way we can find out what is happening is to fraternize with the officers at the Officer's Club...still didn't make a picture...bought a camouflage uniform today... may be helpful...Just heard that a British soldier the VC picked up the other day was found...minus his head.

ON PATROL

The early days in Danang were frustrating for Adams, anxious as he was to make pictures of battle action. His journal reflected the tedious, daylong waiting for South Vietnamese Army patrols that did not happen or ventures into the countryside that failed to make contact with the enemy. Evenings were spent fraternizing with the military in search of possible stories and/or word about forthcoming operations.

Got about six miles from the base today... wanted to get closer [to possible Vietcong locations] but no way of getting there...unsafe to drive...and no copters will take me...still pretty damned boring...

Well...a coup d'etat today in Saigon...tanks crushed barricades...some generals placed under house arrest...seems as though my luck is normal...nothing.

Tomorrow maybe I will go on a patrol...or something...still haven't made a picture... damnit...spent most of the day trying to find a Vietnamese airborne outfit so I could get to a village where they were pulling out mines ...never did find it...got on to a good story on propaganda...will take an airplane on a leaflet drop next week...got orders from New York to get with the Seventh Fleet...won't get out of Danang until Monday so hope to spend tomorrow on a patrol...no patrol today.

Went to special sector today at 0800 dressed in tiger suit and ready to go on an operation and nothing happened....heard from good sources that a demonstration by Buddhists and students protesting the new government was to take place...went to the scene and sat and nothing... chased a couple of tanks around town...got a tip that Westmoreland was at G3...went there and got him to pose for pix by Hawk missiles... NY wants me to get aboard 7th fleet...but hear action supposed to take place next couple of days...spent many hours at Officers' Club to find out what's going on...

A few days later Adams wrote:

Nothing again today...except word from Mal Browne that Wheeler and I stick close to the air base for the next few days...this coincides with rumors around here...got all cameras cleaned up and ready for an operation at 0530...then at 1330 a Psychological Warfare mission set up at my request...

Am getting restless...

Toward the end of February Adams got his first taste of conflict Vietnam-style. He linked up with a U.S. Army advisor and accompanied a South Vietnamese patrol via helicopter to territory north of Danang.

Jungle patrols ran to form and consisted of Marine combat teams visiting villages to seek signs of Vietcong presence or to flush out Vietcong teams in hideouts or campsites. Some patrols were conducted on foot from a base camp and, usually acting on a tip, headed for a village where it was suspected that Vietcong restocked their food stores, conducted propaganda sessions, intimidated villagers to join their campaign against the government or just moved to new areas to avoid government patrols. Other patrols started with a helicopter ride to a landing spot, then the landed troops moved off into the countryside to seek out the Vietcong. Machetes were used by the forward soldiers to chop their way through bamboo. In areas of thick foliage great red ants and snakes harassed the sweaty troops. Punji stakes, sharpened bamboo spears driven into the ground, could puncture a boot, their poisoned tips creating serious wounds. Cold water rivers were crossed, providing momentary refreshment from the pervasive and debilitating heat. At higher elevations, however, river crossings in the late afternoon meant sleeping all night in wet clothes and suffering shivers. Most photographers owned several military outfits to match

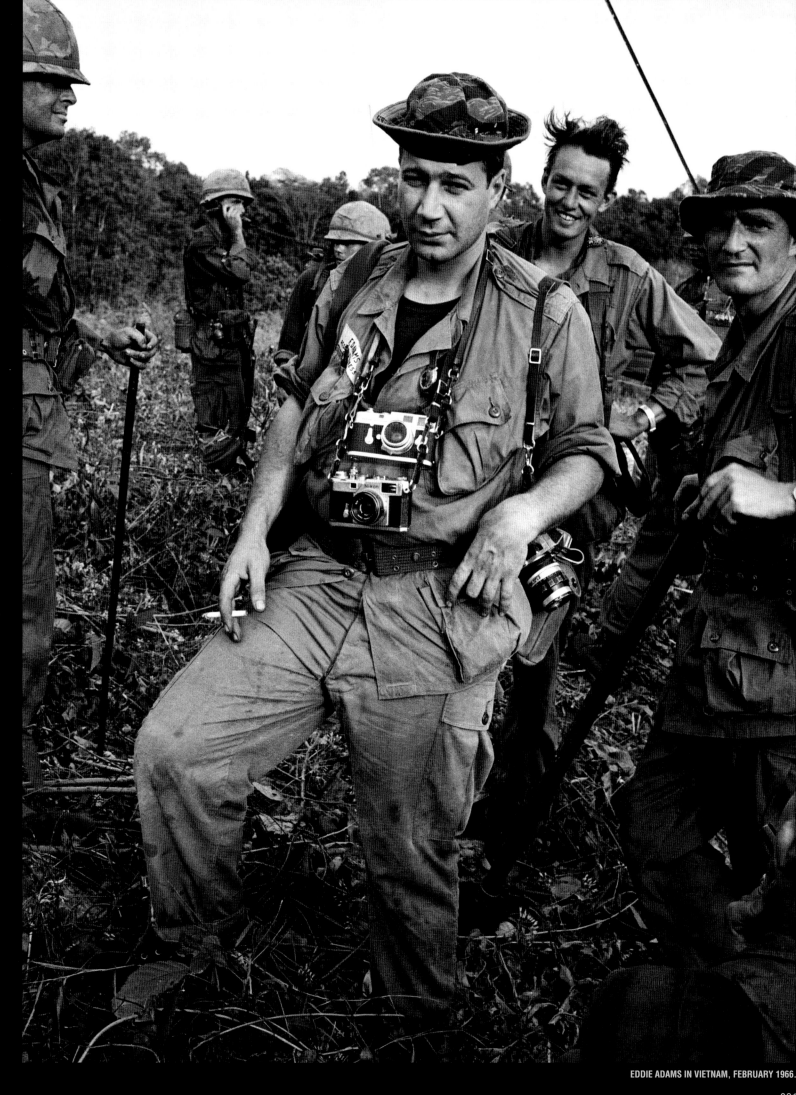

WELL...COUP D'ETAT TODAY IN SAIGON... TANKS CRUSHED BARRICADES...SEEMS AS THOUGH MY LUCK IS NORMAL...NOTHING...

whatever unit they accompanied. The idea was to look like everyone else when the shooting started; those who stood out were immediate targets, in the enemy belief that they were special or high-ranking. Some patrols lasted for just a few hours or a day; others were longer, requiring overnight stays in the field.

Adams carried three cameras, one with a wide angle 35mm lens, the other with a longer lens. The third acted as a backup in case of loss or damage. He used the 35mm most. Condoms were commonly used to keep film and cameras dry against rivers, swamps, and rain. In an drab olive medic's bag he carried film, two notebooks, pencils, penlight, lens-cleaning tissues, a chamois cloth, miniature screw driver, a small brush, ball of string, cigarettes, and three packages of hard root-beer candy. He said he could get along for quite a few days in the field.

Photographers ate what the troops ate, especially when they traveled with American units. The menu was usually C-rations. When traveling with Vietnamese, who sometimes carried live fowl with them for dinner, journalists could decide between fresh food cooked Vietnamese style or C-rations. Faas warned newcomers to note carefully how Vietnamese looked after their live food. If they took better care of their ducks than their weapons, find another unit.

Of his first foray, which started with a helicopter ride, Adams wrote: *I was really frightened today and said my prayers continuously minutes before I landed in the command helicopter with Lt. John Schwartz as advisor. It was my first*

operation and his last before heading home... The guns blasted away and rockets strafed the area before we hit the deck...guns blazing, we jumped out of the chopper...after the landing we rode personnel carriers and encountered fourteen barricades before arriving at Hue [Vietnam's ancient capital north of Danang]... met Sgt. Mike Rogers in the advisor's mess at Hue....I remember him, he tossed me out of Arlington Cemetery during the JFK funeral.

Another longer operation kept Adams in the field for several days in early March.

Covered two VC villages being evacuated today...the Vietnamese army pays the villagers to leave their homes and finds them a new area to live in...then wait for the VC to reoccupy the village...then it's bombed.

Watching these people cry and move their belongings to small junks almost had me crying with them...a girl and her mother were crying hysterically as they burned spiritual belongings...little cute children, no more than five years old, carried huge loads over their shoulders. Makes me think of Amy, Ed, and Susan [Adams's children]...what a sight!

That same day a strong force of Vietcong attacked, overpowered, and wiped out a regional defense force at a town called Rung La. A rescue force was sent to the town but the Vietcong vanished by the time the rescuers arrived. *Next day S/Sgt Curry, a U.S. Army photographer, and myself went to an area by chopper where the town of Rung La had been overrun by the*

VC...*Two South Vietnamese airborne battalions arrived through the jungle to the town...as usual the VC had slipped back into the jungle and there was no contact...We slept in a rubber plantation and had company—a snake... ate rice, wild pig, and I don't know just what else...After dawn we left the rubber plantation...on the way out saw relatives watching the torn up bodies of the dead soldiers who were killed in Rung La yesterday...moaning death cries wiped out any other sounds...the army transferred the truck loads of bodies into colorful coffins at a fork in the road...*

We went five miles through the jungle and what a bitch...never did this with the Marines in Korea...didn't make many pictures...just worried more about survival...ran out of water and started to drink muddy water...not too sanitary...came across much elephant dung and fresh VC emplacements...but made no contact. ..Got a ride out late in the day to Saigon with a fairly good story but no good pictures...

That night I went out with Faas, MacArthur and White...ate well...had a ball.

Instant changes from the dirt, mud and danger of patrols to the comfortable life in Saigon made for bizarre twists of daily life for correspondents and photographers. Photographers in World War II and Korea might spend several weeks or months in the war zone, sometimes at headquarters, sometimes in bunkers, sometimes on the move with active units, then take a respite in safer, comfortable surroundings.

Photographers in Vietnam, however, covered a firefight in a remote jungle village or on the slope of a dusty hill laid barren by artillery, then rode in a helicopter with wounded Vietnamese (and later wounded Americans) to Saigon or Danang. That evening it was dinner in a Vietnamese, Chinese, or French restaurant, or bar-hopping the hostess clubs that follow military activities anywhere in the world. During his initial weeks in Vietnam, Adams lived and operated in this confusing world. With the coming of the Marines, however, he opted for a semi-permanent move to Danang and awaited the arrival of the Marines.

...OVERED TWO [UC] VILLAGES BEING
...VACUATED TODAY — THE ARMY
...S THE VILLAGERS TO LEAVE THEI[R]
...OMES & FINDS THEM A NEW
...EA TO LIVE IN — THEN WE
...AIT FOR THE UC TO REOCUP[Y]
...E VILLAGE — THEN WE BOMB IT
...WAS WATCHING THESE people.
...Y AND MOVE THERE BELONGINGS
...SMALL JUNKS ALMOST HAD
...CRYING WITH THEM — A GIRL
...ITH HER MOTHER WERE CRYING
...ysterically AS THEY BURNED
...PIRITUAL BELONGINGS — LITTLE
...UTE CHILDREN — NO MORE THAN
...YEARS OLD CARRYING HUGE
...OADS OVER THERE SHOULDERS
...AKES ME THINK OF AMY, B[U]
& SUSAN — WHAT A SITE

TODAY S/SGT CURRY, USA PHOTOG &
MYSELF WENT TO AN AREA BY
CHOPPER WHERE THE TOWN OF RUNG LA
HAD BEEN OVERRUN BY THE UC —
TWO AIRBORNE BNS ARRIVED LATER IN
THE DAY FOR AN OPERATION THROUGH
THE JUNGLE TO THE TOWN — WE
SLEPT IN A RUBBER PLANTATION
& HAD COMPANY — A SNAKE — A
RICE WILD PIG & I DON'T KNOW
JUST WHAT ELSE —

WENT ABOUT 5 miles THROUGH
THE JUNGLE TODAY & WHAT A
BITCH — NEVER DONE THIS WITH
THE MARINES IN KOREA — DIDN'T
MAKE MANY PIX — JUST WORRIED
MORE ABOUT SURVIVAL — RAN OU[T]
OF WATER & STARTED TO DRINK
MUDDY WATER ETC — NOT TO[O]
SANITARY — CAME ACROSS MUC[H]
ELEPHANT SHIT & FRESH VC
EMPLACEMENTS — BUT MADE N[O]
CONTACT — GOT A RIDE OUT LATE[R]
IN THE DAY TO SAIGON —
WITH A FAIR STORY BUT X
GOOD PIX — WATCHED SOME
OF THE RELATIVES WATCHING
THE TORN UP BODIES OF THE DEA[D]
SOLDIERS — WHO WERE OVER-RUN [AT]
RUNG-LA YESTERDAY — MOANING
DEATH CRIES WERE PLENTY [BU]LL
THE ARMY TRANSFERED THE TRUCK[S]

...Y CHIEF OF STAFF JOHNSON
...IVED TODAY — A PIX
...NOT MUCH — SLOW DAY
...T OUT IN PM WITH
...S WHITE, & MCARTHUR —
...well — HAD A BALL

ARRIVAL OF THE MARINES

Between mid-March and late April some 8,000 Marines arrived in a series of landings. They settled in at base camps in Danang and Hue. During the weeks of their arrival there was little action, though at one point the Vietcong attempted interference.

Went on an operation today to secure a town for the last Marine landing tomorrow...We got pinned down for five minutes by sniper fire...I hit the deck and watched the bullets kick up the dust ahead of me...we had two of our company wounded...could have used a 500mm lens. The last shipment of Marines arrived today, making a total of 8,000 with some shipped to Hue... Next we expect the 25th U.S. Army Division.

The arrival of the Marines struck Adams as somewhat laughable. Incoming troops splashed ashore through surf à la World War II island invasions but were met by Vietnamese girls with flower necklaces and tempting smiles. Adams covered it but he knew the glitz would soon dis-

appear, replaced by the reality of jungle patrols in Vietcong territory.

Once on the scene in sufficient numbers the Marines initiated patrols up to thirty or more miles around the bases to seek out Vietcong units. Through it all Adams and Wheeler kept busy covering the search missions. UPI's staff, beefed up since the Marine arrivals, presented a steady competitive presence and both men had their hands full shooting pictures and calling stories back to Saigon for the AP wires. Shipping film to the Saigon office was likewise time consuming. Flights had to be located, packages logged in and shipped. Sometimes pigeons (passengers boarding aircraft who were willing to take a small parcel for pickup at the Saigon end) agreed to help with shipments. But that meant another excruciating phone call to the AP in Saigon to arrange pickup. Time flew by.

Wire service correspondents in Vietnam served dual purposes: photographers and writers each

wrote stores and took pictures. In April, Adams reported on the first substantive Marine encounter with the Vietcong (page 36).

Eluding military security was another skill set photographers needed. For example: On Easter Sunday, 1965, a bomb rolled off a towed cart on the Danang base and exploded near a napalm-mixing site. The initial blast ignited napalm that touched off other bombs and turned the napalm stockpile into a flaming inferno of jellied gasoline.

Crashed the gate, Adams noted in his journal, *with Al Chang* [also an AP photographer]*, a National Geographic photographer and another from Stars and Stripes... A Vietnamese guard threatened us with his rifle but we talked our way past him, and got near the napalm....made some pix...jeep broke down...hitched a ride to the USMC compound and asked General Karsh for his jeep, which he gave me...another photographer got an ambulance and an aid in*

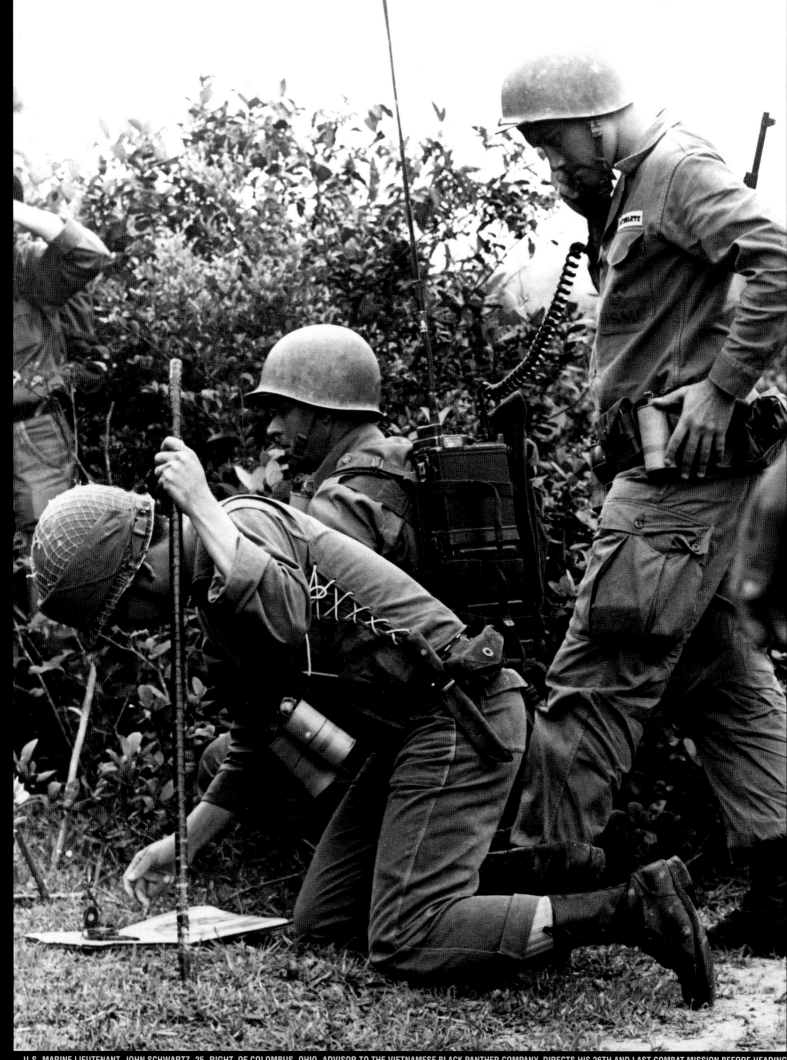

U.S. MARINE LIEUTENANT, JOHN SCHWARTZ, 25, RIGHT, OF COLOMBUS, OHIO, ADVISOR TO THE VIETNAMESE BLACK PANTHER COMPANY, DIRECTS HIS 26TH AND LAST COMBAT MISSION BEFORE HEADING HOME. HE PLANS A 30-DAY VACATION IN MIAMI WITH HIS PARENTS.

the ambulance got us out of the gate in time to make the Air Vietnam flight at 0950....and called in story by 1010am. Operation tomorrow, he wrote in his journal before he hit the sack.

Adams took great pride in the contacts he developed with the Marine brass and the access he had to Marine operations. He went on more than one hundred such missions—Vietnamese and American—during his first nine-month tour and developed his special way of working in the field. After his return from Vietnam he talked to Arthur Spiegelman of *The Bergen Record*:

One of the first things I learned is that the best way for me to cover this war is to stick with the lead platoon when I go on a mission. If any one is going to get hit, it's them....Making pictures in Vietnam is easy...Things are happening all around you and you just have to press a button and not get killed. You take pictures from whatever position you are in—including lying on your belly.

The morning operation after the Danang bomb blast turned out to be:

A big farce....Have been reporting more than taking pictures...was planning to go to Hue tomorrow...then was told that Marines will patrol outside their perimeter in the AM...figure on going with them...also heard that Marines will be going on the offensive...wait and see...Arnett coming in tomorrow afternoon.

Major Moyers, USMC, was surprised when I met him this AM on the "secret" first patrol that the Marines went on outside their perimeter... we didn't make any contact as candy and leaflets were passed out to the villagers...leaflets said, "The Marines are here to defend you, not to shoot you as the Vietcong say."

Got a real good beat on UPI who didn't know a thing about it...also heard that this is the beginning [of the Marine offensive].

Today it happened...I was the only newsman with the USMC recon company and reaction force when they made their first encounter with the VC...had a good little firefight...was a little frightened when a radioman who was standing a few feet from me (was hit) and I saw his hair fly in the air and the blood pouring out...I yelled, "He's hit."...helped carry him to a medevac chopper while the bullets were flying freely... had to leave the scene early with the only story and pictures...another AP exclusive.

Went out again with the Marines, a compansized patrol...we threw rockets, artillery and machine gun fire into VC territory...but no reply...guess they were afraid of us...chicken bastards...supposed to be about 300 of them where we were, only nine miles from the base...won't be long now before we hit them... Al Chang was along this trip.

Got lots of company today...everybody watching me now...Henri Huet, UPI Vietnam photog, and George Sweers, St. Pete Times, showed up and we got into a good fire fight and I thought for sure I wasn't going to make it when the bullets kicked up all around me...four wounded Marines.

Got a great picture today of a family under fire with Marines in background charging...but Henri got it, too...can't seem to lose him...am really tired today... going to rest tomorrow and maybe day after.

Slept until 1030am today...woke up with a sore leg...probably from walking too much...Maj. Wolf said that Capt. Collins put in for a letter of commendation for me for helping carry a wounded Marine...if that's true I really don't deserve it...Be only a short time before the Marines go on full press offensive.

Information received by Adams proved accurate. Marine patrol activity was stepped up as they aggressively pursued enemy positions in Vietcong territory. Increased activity also meant increased danger, a reality not lost on Adams on a Marine operation in the final days of April: *Bloody patrol today...one wounded about six feet from me...two stepped on two mines and*

FIRST ENCOUNTER

DONG RICH, Vietnam (AP) – Bravo Company moved past the ruins of an old French church when the Vietcong opened fire with automatic weapons.

The Marines hit the dirt and 1st. Lt. Brenden Cavanaugh of Rockleigh, NJ, deployed one squad of his second platoon to flush the enemy from a hill.

At about the same time mortar rounds began dropping near the 3rd platoon on the other side of the hill. The Marines countered with machine guns, 3.5-inch rockets and small arms. As suddenly as it had begun, the Vietcong fire stopped. The Leathernecks finally reached the Communist position only to find the Vietcong had fled unharmed.

The squad sent up the ridge line found a Vietcong tunnel through which the Communists had escaped into heavy undergrowth.

There were no casualties.

The two platoons settled down. They hoped they would get their chance the next day to tangle with the Vietcong.

During the night the faint sound of drums could be heard, possibly the Vietcong using a primitive communication system to warn of the approach of the American troops.

At first light the second day the platoon began climbing over boulders pressing up the slopes of a 1,000-foot hill where a Vietcong base camp was believed to be located.

The blazing tropical sun made metal parts of weapons almost to hot to touch. Clothes were quickly soaked through with sweat as the Marines fought their way through elephant grass that slashed their arms and faces. The Marines quickly began tapping their water supply—a one-quart canteen on each hip.

A scout sent out ahead of the main party returned from the upper reaches of the slope so exhausted he could scarcely catch is breath.

"I saw three of them I couldn't make one of them out too clearly, but one of them wore a khaki uniform and the other had on a black shirt and shorts. I could see their weapons as they were hightailing it out away from me. They moved so damned fast out of sight I couldn't get a shot off at them."

The faces of the young Marines around the scout were tense and each had written on his face the hope that finally there would be a meeting with their elusive foe.

Higher up the slope the Marines moved grim-faced toward the Vietcong camp, each moment expecting to be hit by a hail of gunfire. None came.

-EDDIE ADAMS

took wounds in the leg and head from shrapnel...and they were also just a few feet away...makes me worry a little more now...crossed rivers about five times today in water up to my chest...but produced a few good pix.

Patrol again today...but we were lifted in by chopper...those were the only decent pix...not much else at all except 40 cases of heat prostration...leg not feeling bad today...Lou Cioffi in bad shape...lost all his wind...but managed to survive the day...got airlifted out to base camp.

Lousy patrol today...one so-called VC killed...they wanted to cut his ears off and send them back but sent the body instead...Arnett was with me today...he stayed, I bugged out with the chopper...had a long talk with Maj. Wolf...said stick close by...will do.

A dams provided a story of a typical three-day patrol that described the pattern of war as it was fought by these first American troops committed to battling the Vietcong. It captured the tough test of endurance the Marines faced in blistering heat that consistently rose to more than a hundred degrees, a war in which lack of water was often a greater danger than a sniper's bullet.

Early in May, Adams noted: *Got a wonderful letter from Don Huth* [Southeast Asia boss] *to-*

day...said my pay has been raised...really surprised...Never expected it at all.

At the same time Adams went to Saigon to help move the AP bureau to new quarters which he described as, *Really nice...Browne says it looks too much like NY...he's right.*

Al Resch, world wide photo boss of the AP (the man I would succeed in 1968) and his wife visited the AP bureau in Saigon on an inspection trip.

Faas and Huth and Jackson [Tokyo staffer assigned to Vietnam] *and Ursula and me met them at the airport....got a real warm handshake from Resch.*

Adams took the opportunity to push the candidacy of Henri Huet as an AP staffer. Huet, a

photographer of superior talent, was universally liked by the Vietnam press corps. Faas likewise endorsed hiring Huet, which would take him away from UPI. The deed was done and Huet, half French and half Vietnamese, brought his long experience as a photographer to the AP's ranks. He would win many awards for his work but perished tragically in a helicopter crash over Laos in the waning days of the war.

Catching up on his mail, Adams noted: *Got a funny letter from Buell today...says some woman wants to have a chapel built in Vietnam in my name...Hah!!* At the same time Adams got a letter from the Marines, a *great letter of appreciation from Capt. Collins...something I will surely frame and hang up at home.* The letter commended Adams for his help with the wounded on a Marine operation.

DRUMS OF WAR

BINH THAI, Vietnam (AP) – The roll of drums echoed along the valley.

"The Vietcong know you are coming," said the Vietnamese officer. "The drums are the alarm."

Lt. Gary Krause of Nanuet, NY, grinned broadly.

"We'll show them we're here," he said.

Krause was with a forty-one man U.S. Marine Corps reconnaissance group that moved down one of the valleys leading to the Marine-occupied Hill 327 outside Danang.

The eight-hour patrol penetrated several miles into the countryside. They had contact twice with the Vietcong. The operation included the first helicopter assault landing of U.S. Marines in South Vietnam.

"I want to re-enlist for anther six months after this," one Marine shouted to his comrades after this village objective was taken.

This type of eagerness pervaded the whole operation, an action aimed at further securing the defenses of the Danang air base.

Two hours after starting off, at 820 am, bursts of auto-

matic weapons fire cold be heard in the distance, then came the beat of the drums.

At 835 am, a Marine scout ran back from a forward position and said four men were moving toward the Marines.

At 910 am a Vietnamese peasant said many Vietcong guerrillas were only 500 yards ahead, behind a mine field and had been there for several days, positioning themselves.

The Marines were told through interpreters that he Vietcong apparently were gathered all around them.

At 1015 am the first shooting began as one round of snip-

er fire came into the forward elements of the Marines. No one was hit.

Machine gun fire opened up from three directions and the Marines were virtually pinned down for thirty minutes. However, they inched forward slowly from one rice field dike to another toward the tree line of Binh Thai village, a Vietcong fortified hamlet.

The marines organized a frontal assault on the village. As they reached the ridge line, the Vietcong were fleeing. The Marines occupied the village at 1155 am.

-EDDIE ADAMS

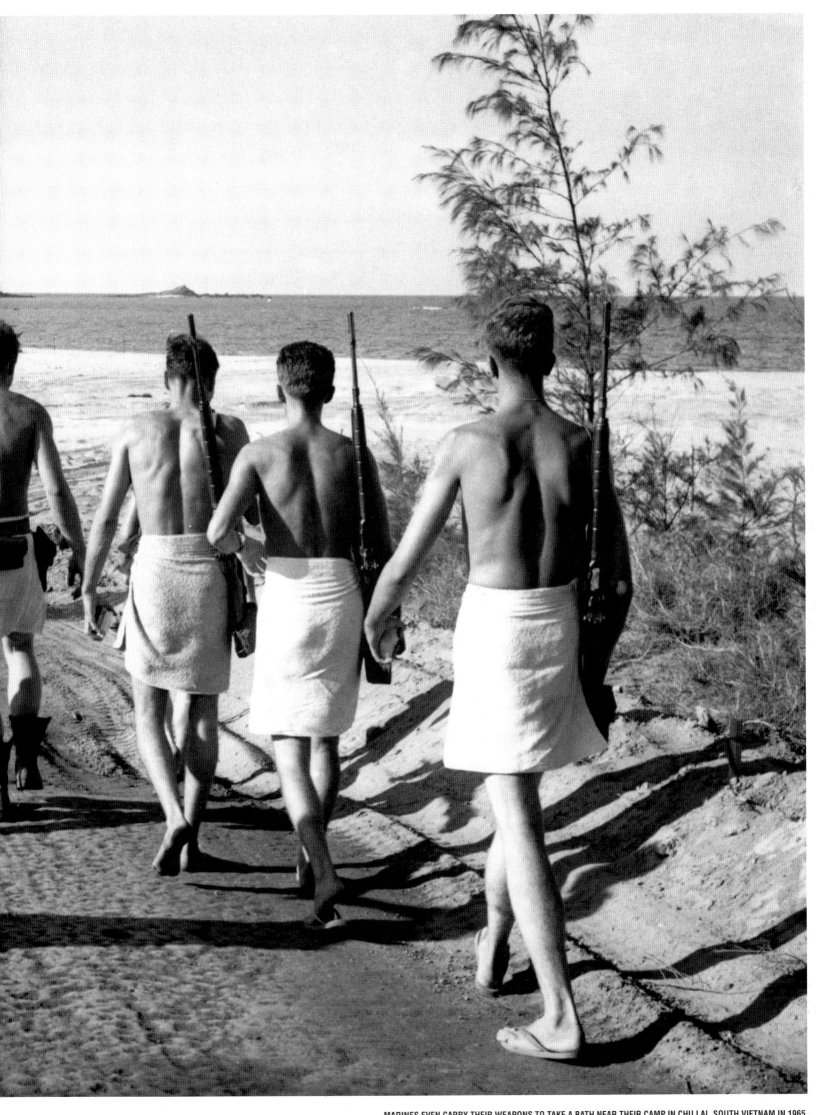

MARINES EVEN CARRY THEIR WEAPONS TO TAKE A BATH NEAR THEIR CAMP IN CHU LAI, SOUTH VIETNAM IN 1965.

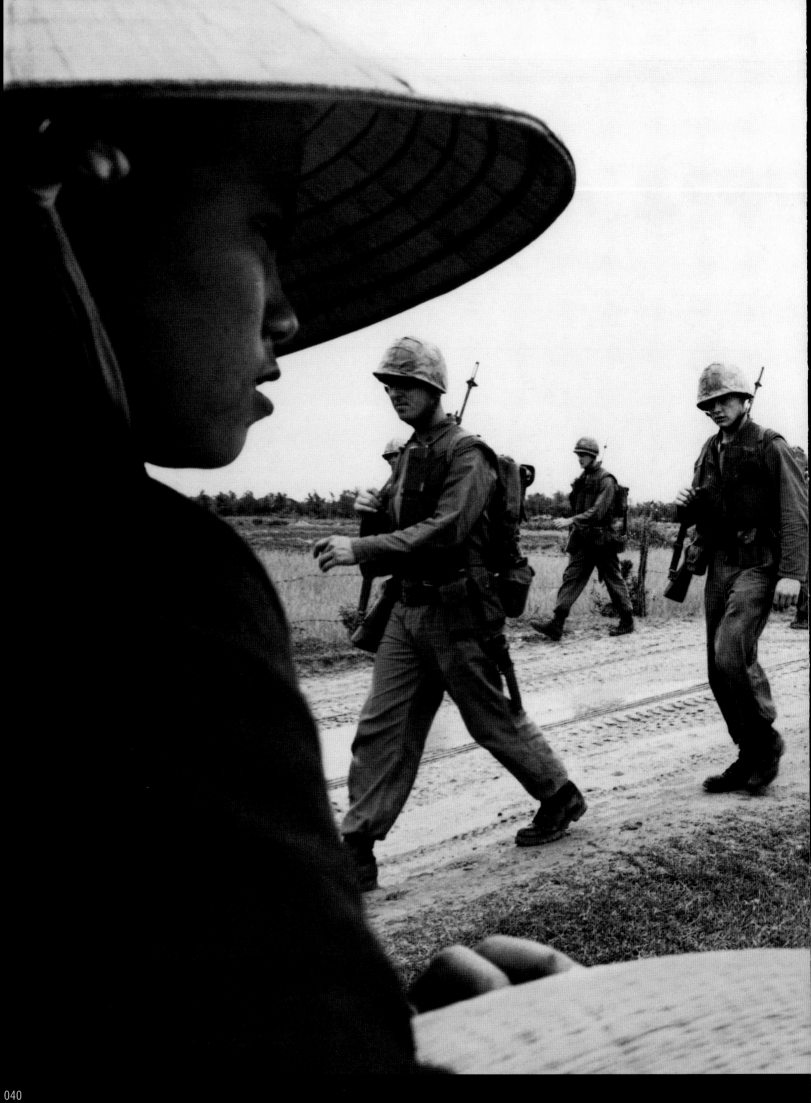

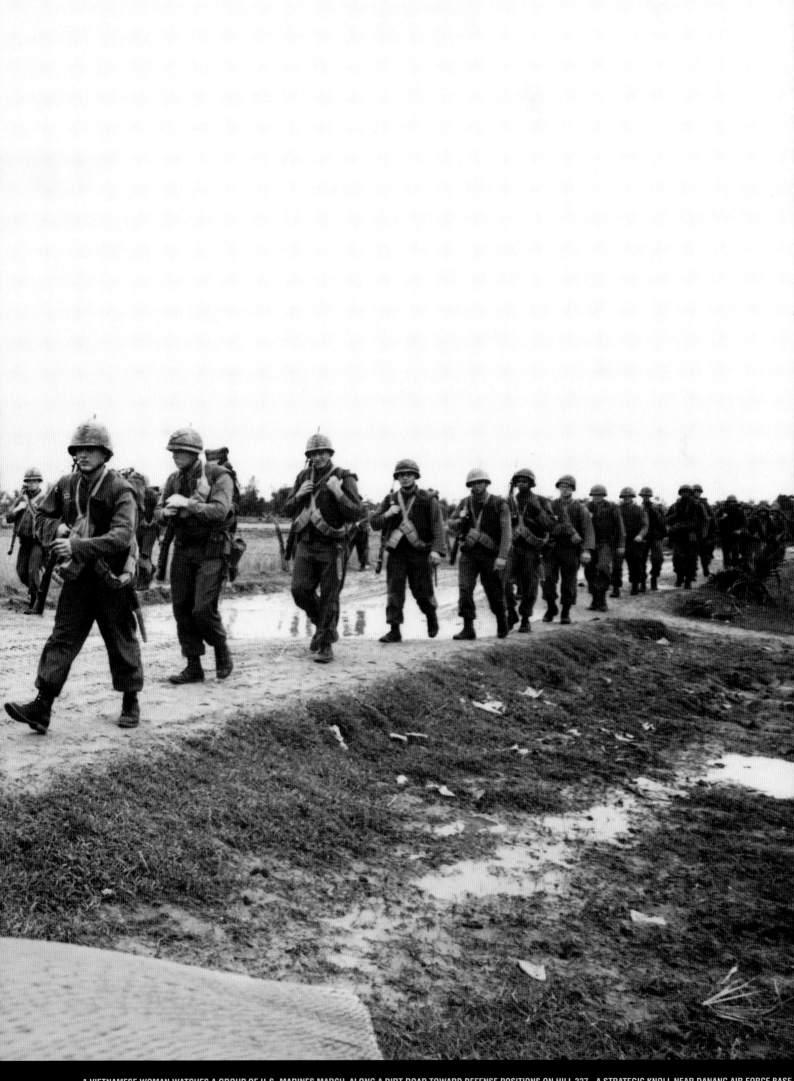

A VIETNAMESE WOMAN WATCHES A GROUP OF U.S. MARINES MARCH ALONG A DIRT ROAD TOWARD DEFENSE POSITIONS ON HILL 327, A STRATEGIC KNOLL NEAR DANANG AIR FORCE BASE.

I THINK
ALL WAR
SHOULD BE
SHOT IN
BLACK-AND-WHITE.
IT'S MORE
PRIMITIVE.
COLOR TENDS
TO MAKE THINGS
LOOK TOO NICE.
IT MAKES THE
JUNGLE IN
VIETNAM LOOK
LUSH—WHICH
IT WAS. BUT IT
WASN'T NICE.

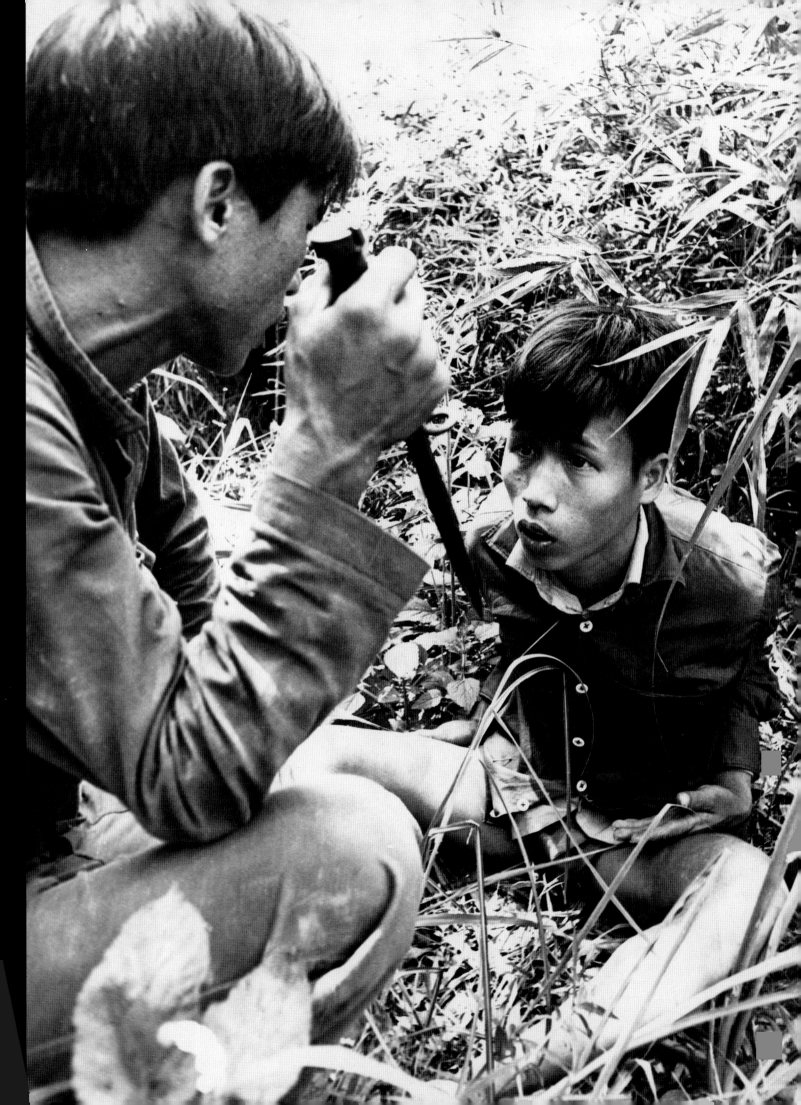

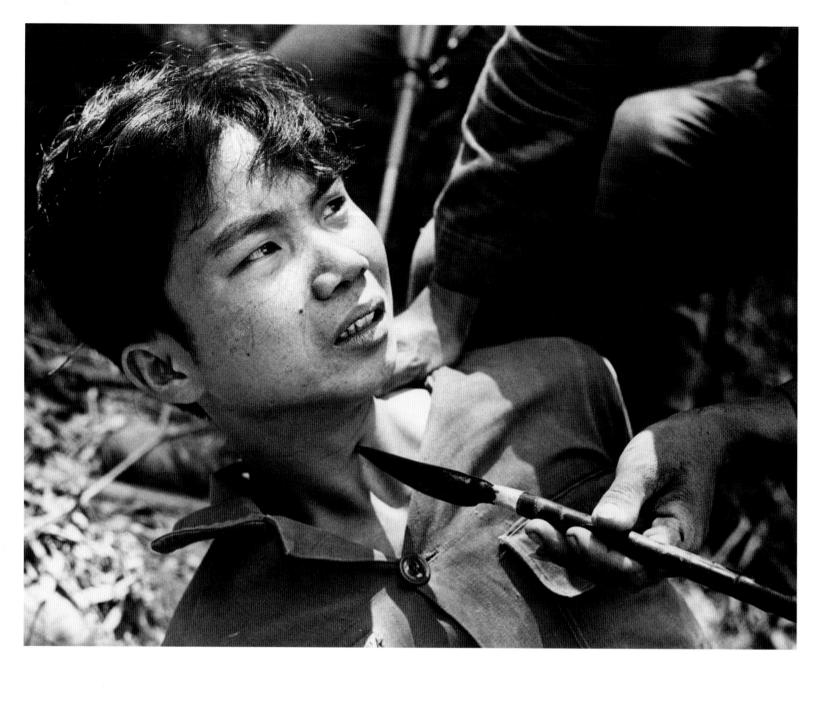

PREVIOUS PAGE: A VIETNAMESE SOLDIER HOLDS A DAGGER
THREATENINGLY OVER A VIETCONG GUERRILLA MARCH 28, 1965. HE LATER
REVEALED THE HIDING PLACE OF RED CHINESE-MADE GRENADES.

ABOVE: PRISONER QUESTIONING
WITH THE PERSUASION OF A VIETCONG-MADE SPEAR PRESSED AGAINST
HIS THROAT, THIS CAPTURED VIETCONG GUERILLA DECIDED TO TALK TO
INTERROGATORS. HE WAS CAPTURED WHEN TWO VIETNAMESE BATTALIONS
OVERRAN A VIETCONG CAMP SOUTHWEST OF DANANG AIR FORCE BASE.

OPPOSITE: A SUSPECTED
VIETCONG GUERRILLA REELS BACKWARD AFTER BEING STRUCK IN THE
FACE BY A SOUTH VIETNAMESE SODLIER DURING AN OPERATION IN QUANG
NAM PROVINCE, TEN MILES SOUTHWEST OF DANANG. TWO BATTALIONS
OF VIETNAMESE TROOPS TOOK THIRTY PRISONERS, INCLUDING THIRTEEN
DESCRIBED AS HARD-CORE VIETCONG, AND KILLED FIVE OTHERS.

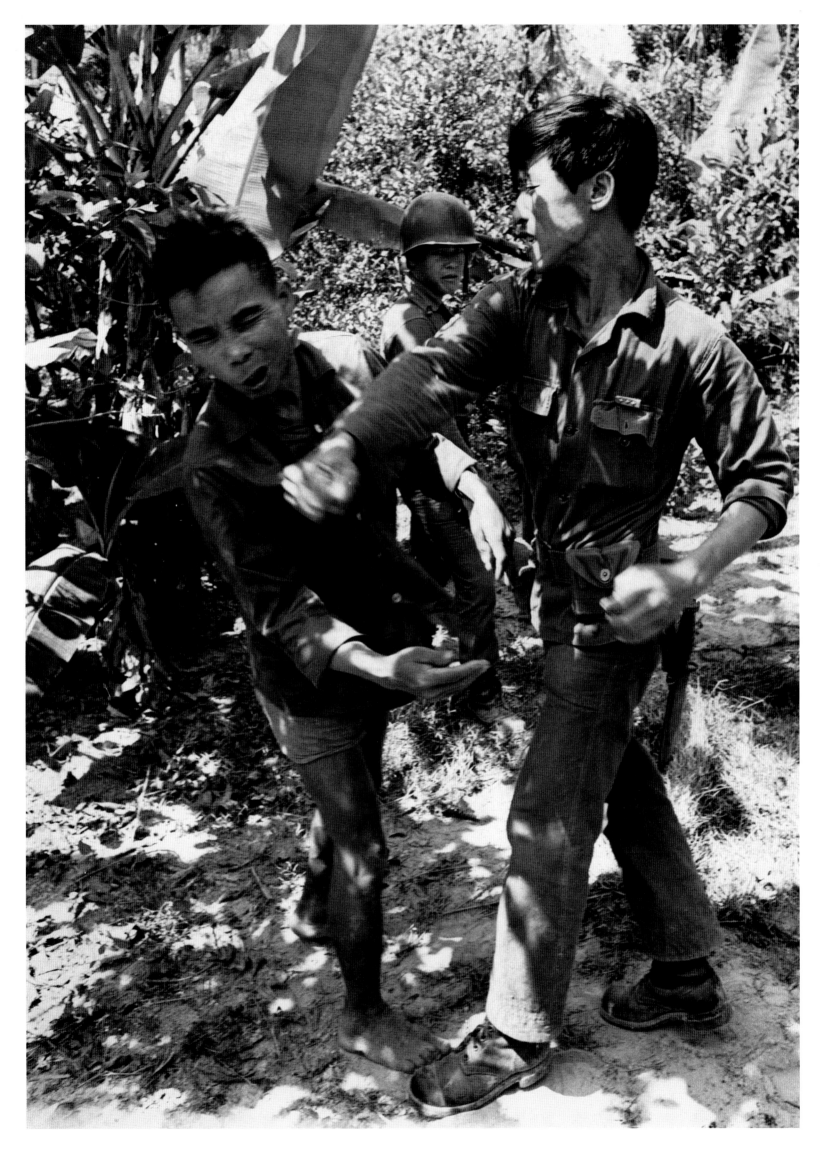

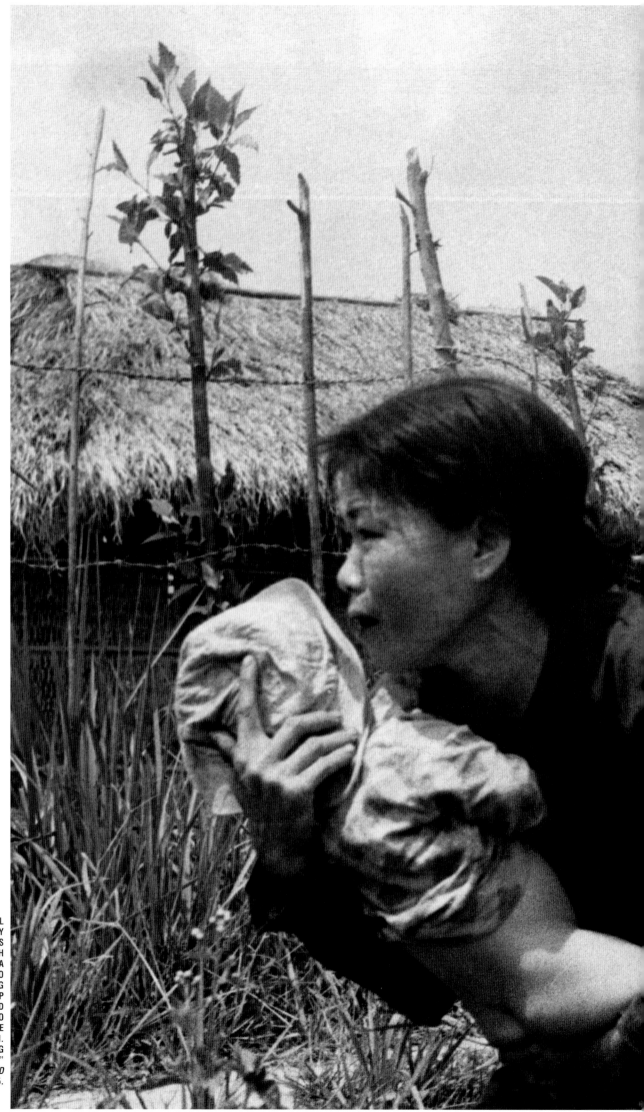

"THESE PICTURES WERE SHOT APRIL 25, 1965, WHILE I WAS LYING ON MY BELLY HIDING FROM SNIPER FIRE. I WAS WITH A MARINE PLATOON JUST SOUTH OF DANANG. WE WERE LOOKING FOR A COMPANY OF VIETCONG BELIEVED TO BE IN THE AREA. AFTER THE SHOOTING STOPPED, THE MARINES ROUNDED UP ALL THE VILLAGERS AND QUESTIONED THEM. THEY GOT FEW ANSWERS. NO ONE WOLD TELL WHERE THE MEN OF THE VILLAGE WERE—A TYPICAL REACTION. THE PICTURE OF THE WOMAN HOLDING THE CHILD HAS BECOME MY FAVORITE." EDDIE ADAMS IN *THE BERGEN RECORD* NOVEMBER 13, 1965.

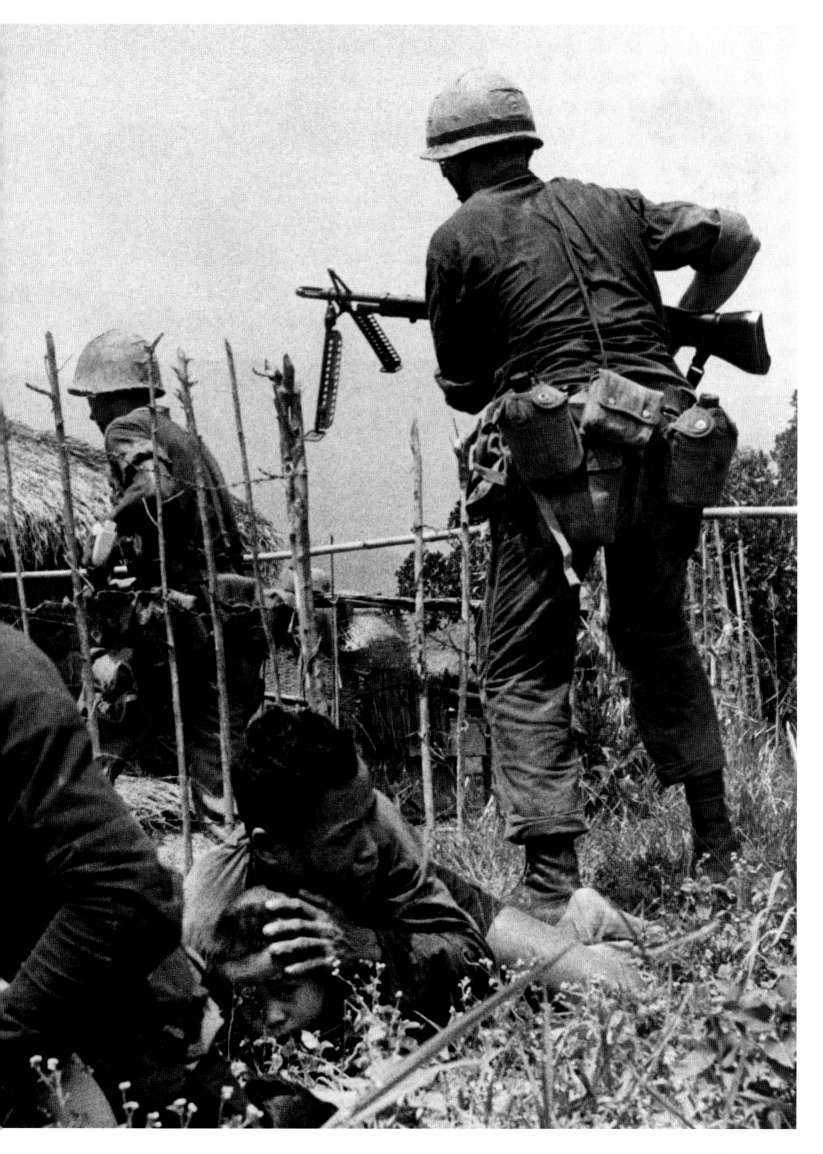

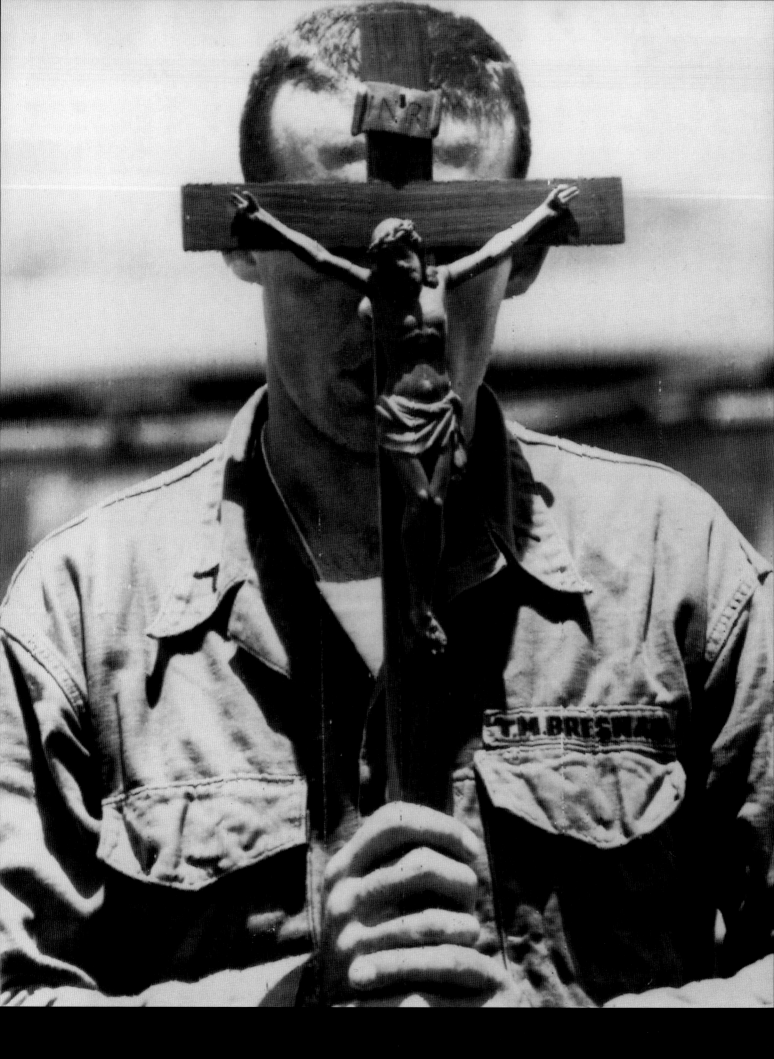

PRIVATE FIRST CLASS THOMAS M. BRESNAN, A MARINE CORPS MACHINE GUNNER FROM FLUSHING, NEW YORK, HOLDS A CRUCIFIX DURING A GOOD FRIDAY SERVICE AT THE MARINE CORPS COMPOUND AT DANANG AIR BASE IN VIETNAM APRIL 16, 1965.

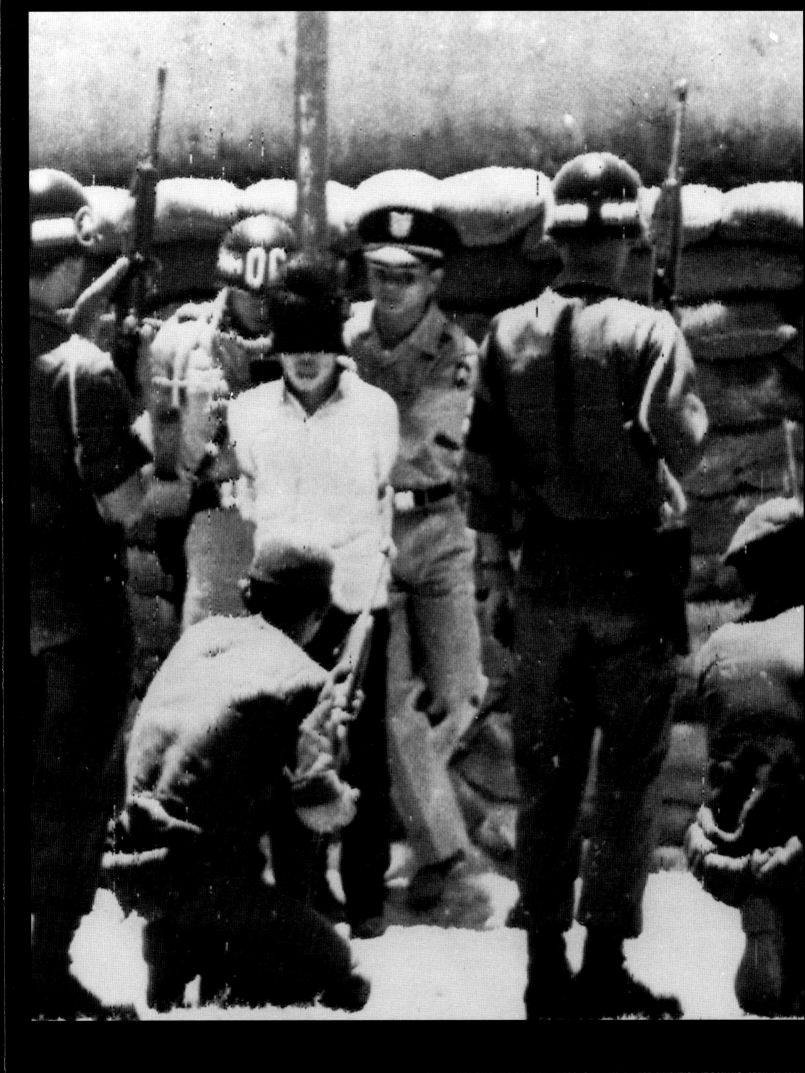

VIETNAMESE SOLDIERS PREPARE VIETCONG LE DAU, 24, FOR EXECUTION AT DANANG, APRIL 15 1965.
HE WAS EXECUTED AFTER BEING CONVICTED OF ATTEMPTING TO BLOW UP A HOTEL OCCUPIED BY AMERICANS IN DANANG ON APRIL 4.

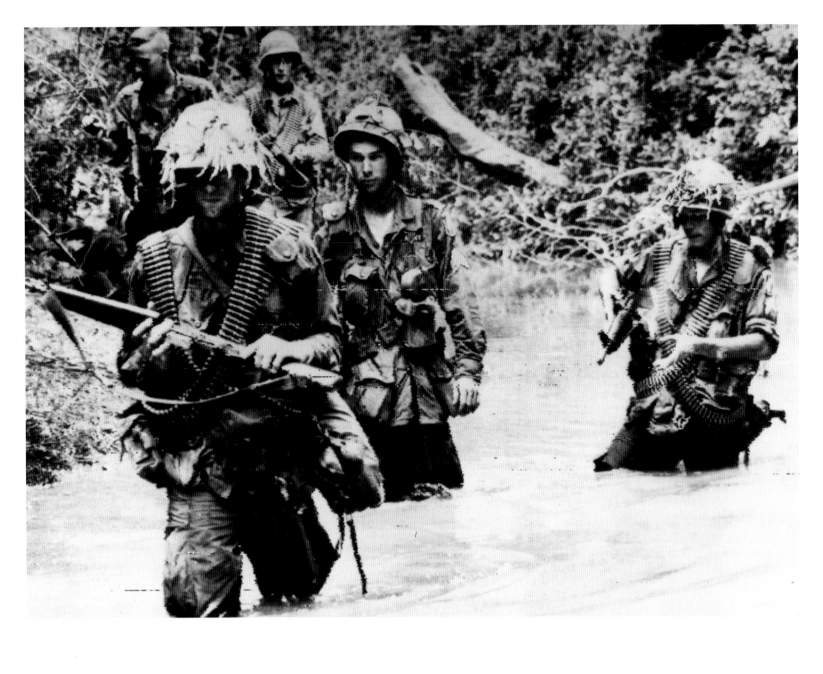

ABOVE: HEAVILY LADEN WITH BANDOLIERS OF AMMUNITION, A
U.S. AIRBORNE RECONNAISSANCE PLATOON WADES THROUGH A JUNGLE
STREAM JUNE 2, 1965, IN SEARCH OF VIETCONG GUERRILLAS. NEARLY
2,000 MEMBERS OF THE U.S. 173RD AIRBORNE BRIGADE ARE ENGAGED IN
A MASSIVE SEARCH-AND-DESTROY OPERATION OF GUERRILLA HIDEOUTS
IN JUNGLES ABOUT FORTY MILES NORTHEAST OF SAIGON. THIS PATROL IS
FROM THE 1ST BATTALION OF THE BRIGADE.

OPPOSITE: REFLECTIONS OF HEAVILY ARMED U.S. MARINES ARE CAST
UPON THE WATER AS THEY CROSS A STREAM ON A NARROW
FOOT BRIDGE ON THEIR WAY FROM DANANG AIR FORCE BASE IN VIETNAM
APRIL 29 1965. THE LEATHERNECKS ARE MEMBERS OF A PATROL UNIT THAT
MOVED DEEP INTO VIETCONG TERRITORY.

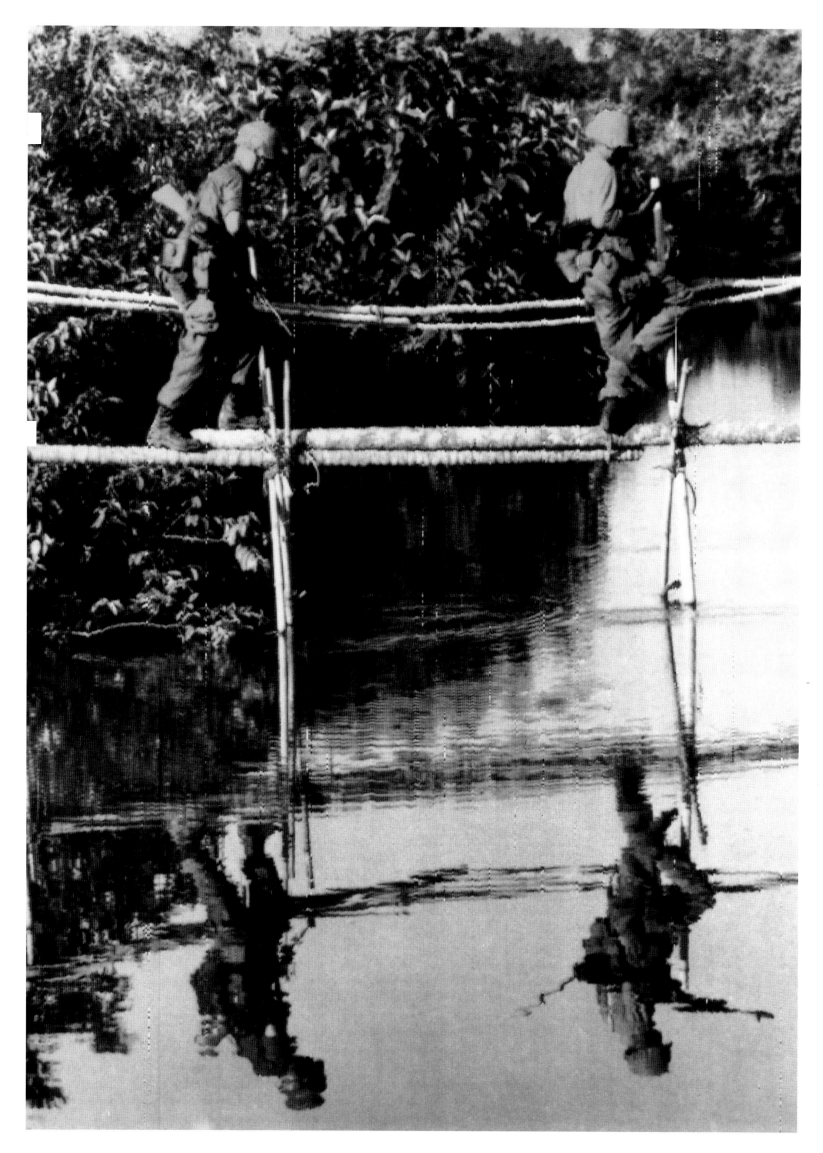

ABOVE: PLEIKU-BOUND ON ROUTE 19
SOUTH VIETNAMESE SUPPLY TRUCKS BYPASS A BRIDGE DESTROYED BY
THE VIETCONG AS THEY HEAD TOWARD PLEIKU ALONG ROUTE 19, JULY 18,
1965. THE ORIGINAL BRIDGE WAS BLASTED AND A TEMPORARY BRIDGE,
AT TOP, ALSO WAS KNOCKED OUT FOR A TIME. THE CENTRAL MOUNTAIN
ROUTE WAS OPENED BY A LARGE SOUTH VIETNAM TASK FORCE AND SUPPLY
TRUCKS PUSHED SUPPLIES TO PLEIKU.

OPPOSITE: CARRIES WOUNDED BUDDY
U.S. MARINE SGT. LYLE LEWIS OF TACOMA, WASHINGTON, CARRIES
WOUNDED LEATHERNECK TO STRETCHER AT BASE OF A HILL, APRIL 28,
1965. THE MARINE WAS INJURED WHILE SERVING ON A PATROL UNIT THAT
MOVED DEEP INTO VIETCONG TERRITORY FROM DANANG AIRBASE.

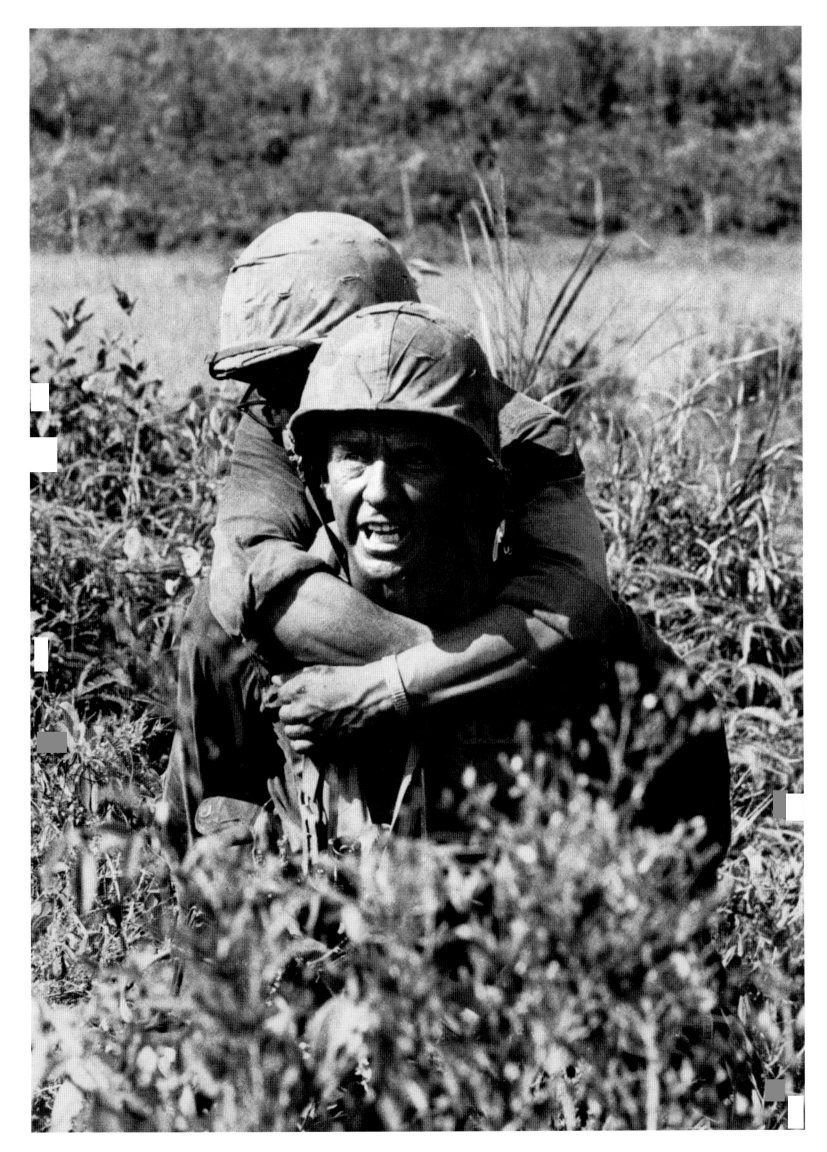

ONE OF THE FIRST THINGS I LEARNED IS THAT THE BEST WAY FOR ME TO COVER THIS WAR IS TO STICK WITH THE LEAD PLATOON WHEN I GO ON A MISSION. IF ANYONE IS GOING TO GET HIT—IT'S THEM.

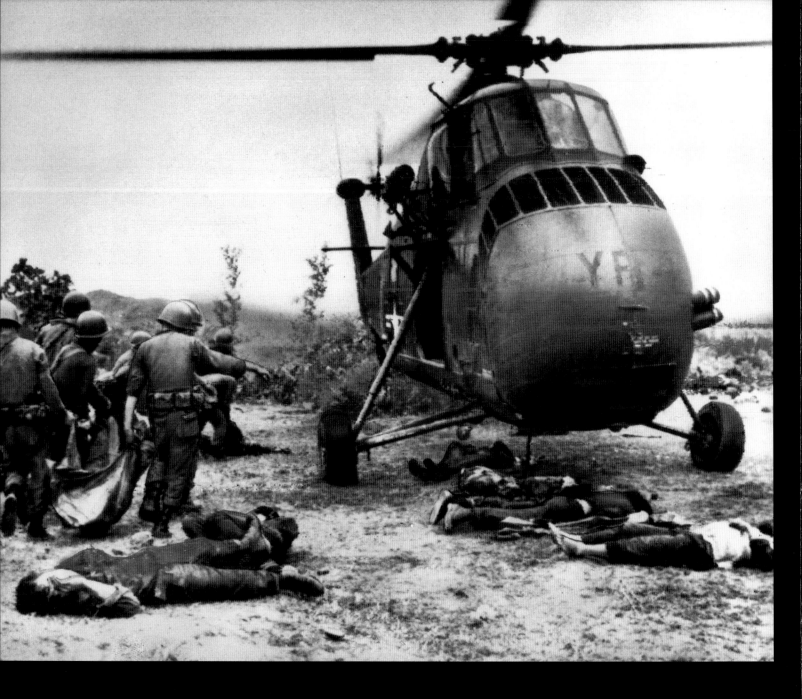

PREVIOUS PAGE: A LONG LINE OF TRUCKS OF SOUTH VIETNAM ARMY
ENGINEERS HALTS ON ROUTE 19 BETWEEN PLEIKU AND QUI NHON IN THE
CENTRAL MOUNTAINS JULY 18, 1965 AFTER THE ROAD HAD BEEN REOPENED
BY A NATIVE TASK FORCE ASSISTED BY U.S. B52 BOMBERS FROM GUAM.
LARGE VIETNAMESE MILITARY UNITS OVER THE PAST FEW DAYS HAVE BEEN
CONVOYING SUPPLIES TO THE PLEIKU AREA OVER ROUTE 19, ALONG WHICH
THE VIETCONG HAS CONDUCTED NUMEROUS AMBUSHES.

ABOVE: VIETNAMESE SOLDIERS CARRY THE BODIES OF THEIR COMRADES
FROM THE BATTLEFIELD IN QUANG NGAI PROVINCE TO THE WAITING U.S.
MARINE CORPS HELICOPTER MAY 31. BODIES OF AT LEAST SEVENTY-FIVE
VIETNAMESE MARINES AND TWO AMERICANS WERE FOUND ON THIS HILL
WHERE THEY WERE KILLED BY VIETCONG FORCES THAT OVERRAN THEIR
POSITION. QUALIFIED MILITARY SOURCES SAID THAT ABOUT 350 MEN IN
TWO VIETNAMESE BATTALIONS WERE KILLED IN THE BATTLE.

OPPOSITE: THE BODY OF A VIETNAMESE RANGER IS TAKEN ABOARD A U.S.
MARINE CORPS HELICOPTER MAY 31. HE WAS WOUNDED IN BATTLE ON
A HILL EIGHT MILES WEST OF QUANG NGAI, AND LATER KILLED BY A
VIETCONG WHO SLIT HIS STOMACH OPEN WHEN HIS POSITION WAS OVER-
RUN. EDITORS NOTE: ATTENTION IS CALLED TO THE POSSIBLY
OBJECTIONABLE NATURE OF THIS PICTURE.

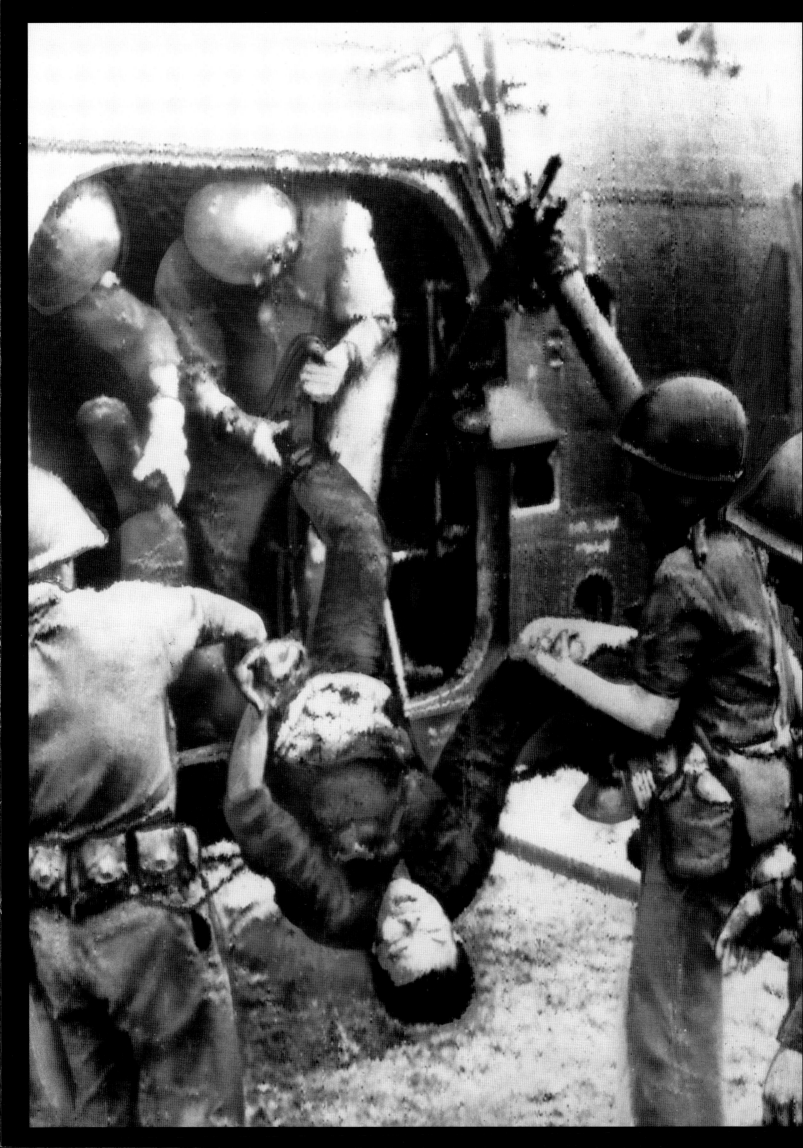

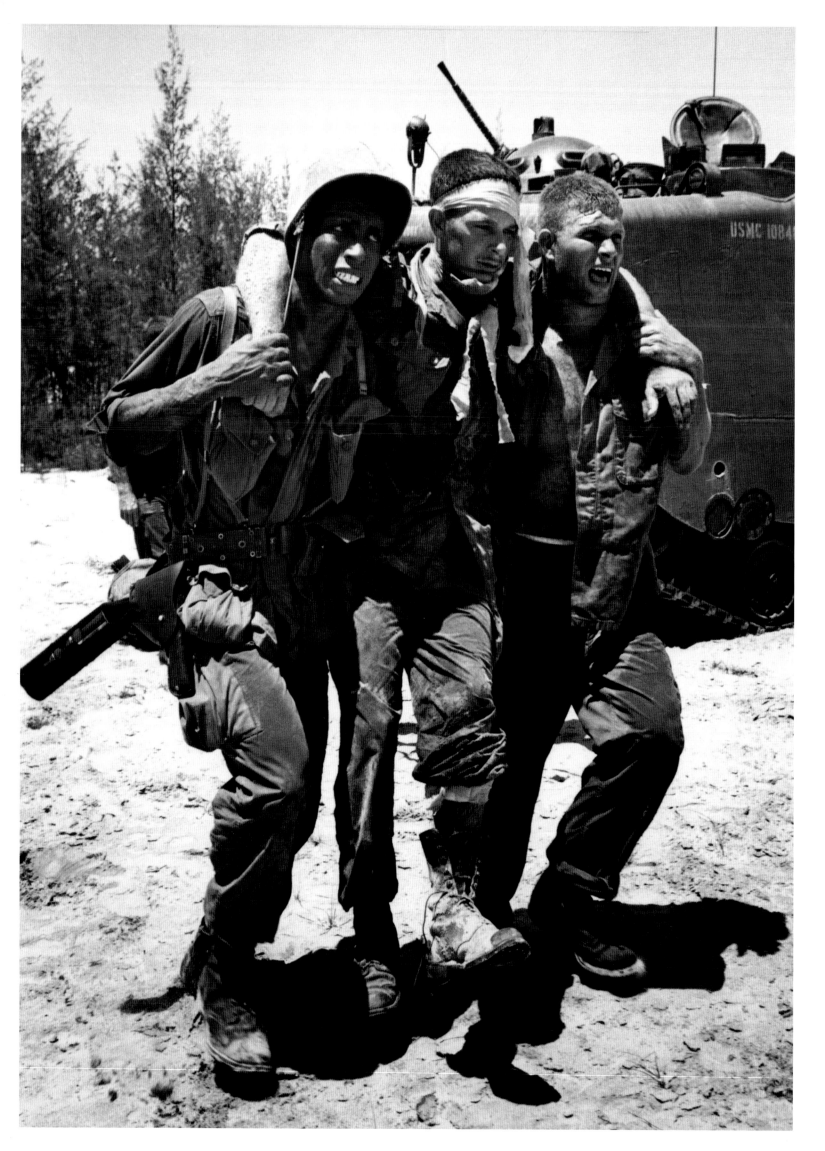

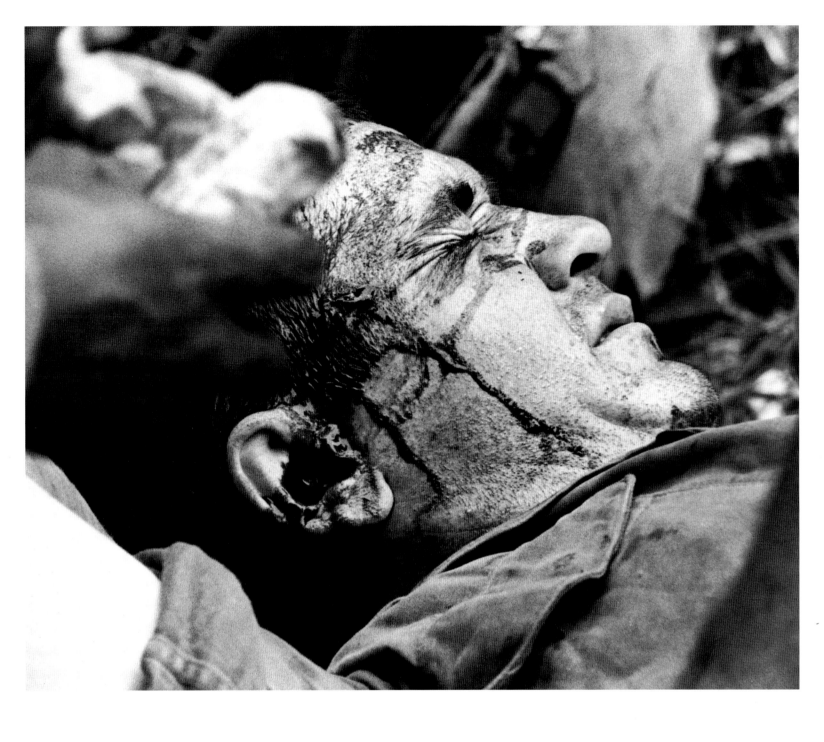

ABOVE: BLOOD STREAKS THE FACE OF MARINE PFC ROBERT
E. HERBISON OF MEDFORD, OREGON, AS HE GETS MEDICAL ATTENTION
AFTER BEING WOUNDED IN THE HEAD AND LEGS BY VIETCONG SNIPER
FIRE. HERBISON WAS HIT DURING A MARINE OFFENSIVE OPERATION
AGAINST VIETCONG VILLAGE COMPLEX OF LE MY, SOUTHWEST OF
DANANG, SOUTH VIETNAM, MAY 4,1965

OPPOSITE: WOUNDED U.S. MARINES, AN HOA, VIETNAM, JULY 1965.

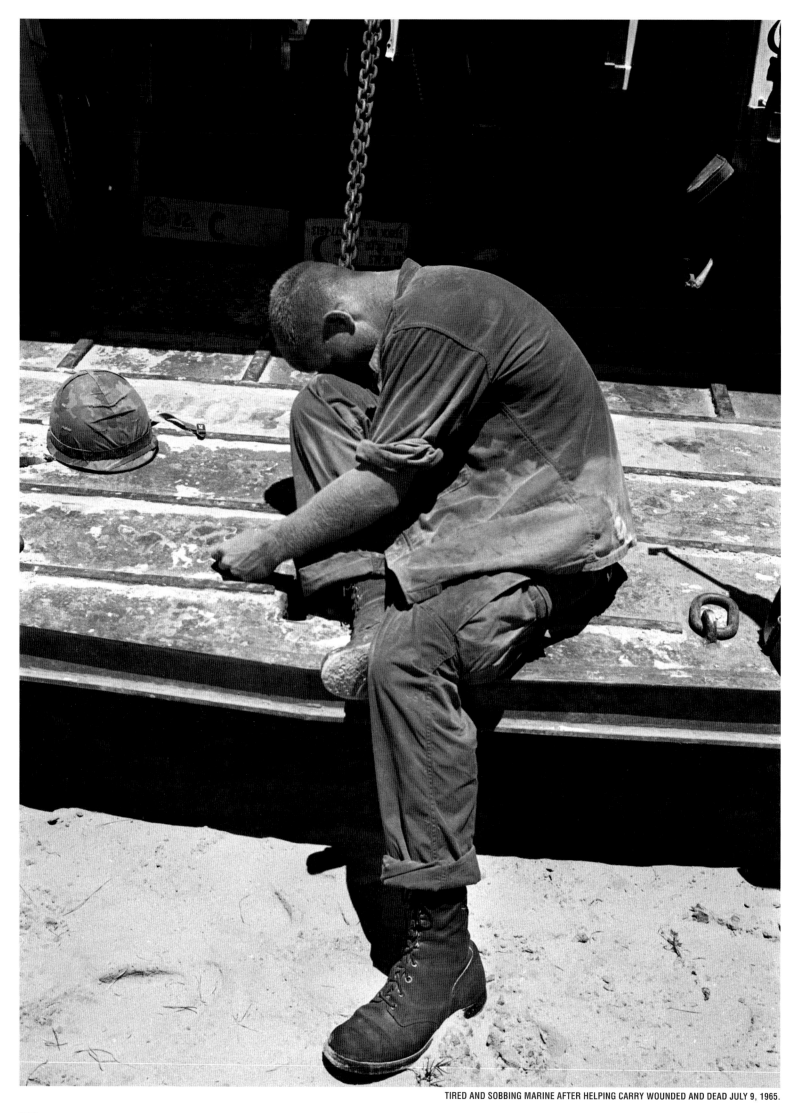

TIRED AND SOBBING MARINE AFTER HELPING CARRY WOUNDED AND DEAD JULY 9, 1965.

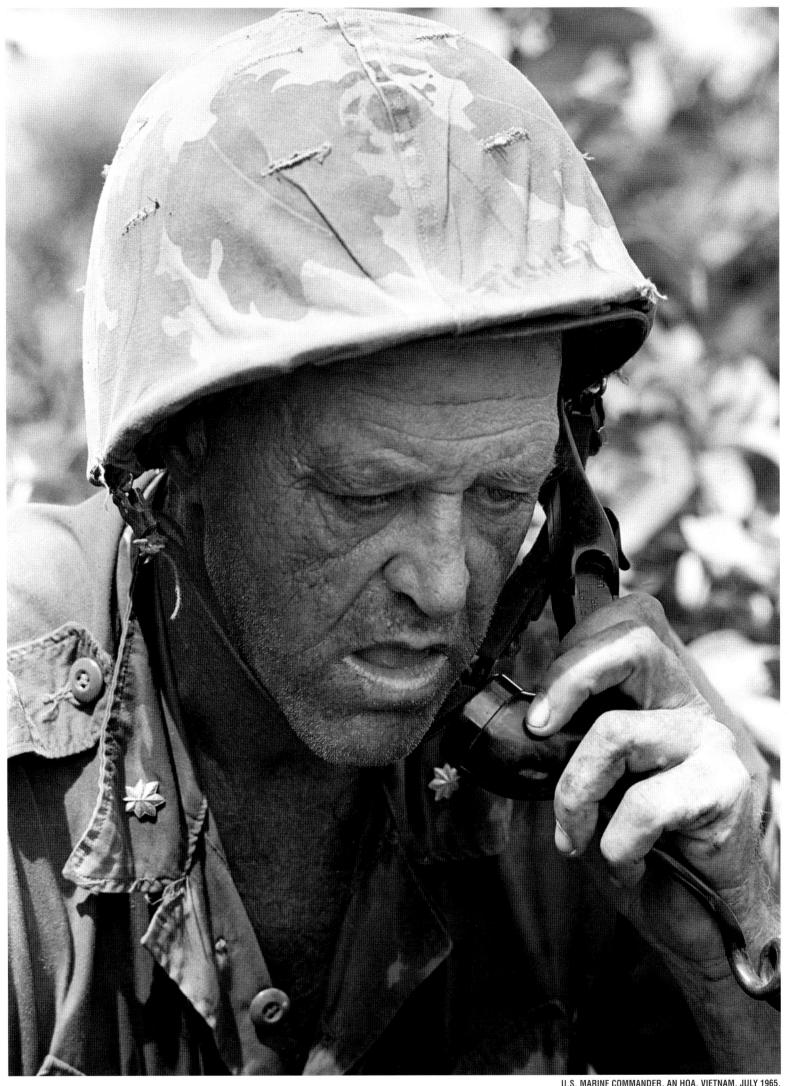

U.S. MARINE COMMANDER, AN HOA, VIETNAM, JULY 1965.

Despite new, aggressive patrolling by the Marines, Adams's downbeat reaction to his pictures was reflected in complaints he wrote to his journal. He believed...possibilities so far were limited. His drive to excel was dampened daily even though he shot many pictures that were widely printed. The work of Faas and the Vietnamese photographers, the photos produced by writers, and the Pulitzer Faas won in the spring of 1965 put Adams on a first-class photojournalistic team to which he made significant contributions. Whatever the team reputation might be, however, personal satisfaction eluded him. His journal entries documented increasing frustration:

Taking off from Danang today for Pleiku....getting scared here that I'm not doing much...Marines have been doing only small patrols ...making many friends with them but not getting much work done...hope to get the elephant story with the Montagnards while in the Pleiku area.

And days later, after returning from one mission to Pleiku:

I have been terribly upset here (Danang)... seems as though nothing is working out properly...spent twelve days in Pleiku, Qui Nhon, Nha Trang, Cam Ranh Bay...and went to the monsoon in Pleiku...unable to do a thing...I feel I am letting Buell and the AP down immensely. Saigon has been getting all the news breaks and Danang has been a real nothing, especially this past month...really have to get on the ball.

Went on an intended Marine Corps air strike that never came off...will try again tomorrow.

The fact that the source of his frustration was beyond his control offered little consolation. Adams's obsessive need to make the great picture made him unable to see or unable to understand the reality that war was unpredictable. Periods of quiet boredom were followed

by periods of exhausting action. Changing circumstances were orchestrated by troop movements, weather, reliable and unreliable tips, and other equally serendipitous motivations—and not by photographic ambitions.

When change came, it came suddenly—as it did for Adams in July. He was caught in a highway ambush that stretched into a daylong attack on a South Vietnamese Army convoy. It was one of the heaviest battles he would cover during his first tour of Vietnam.

The convoy was a relief mission assigned to evacuate some 2,000 people on the verge of starvation after a flood caused crop failures. Three South Vietnamese battalions, an artillery battery, and a handful of U.S. advisors made up the operation. Missions like these where the South Vietnamese and the U.S. forces tried to win "hearts and minds" by helping large groups of peasants and villagers —were prime targets

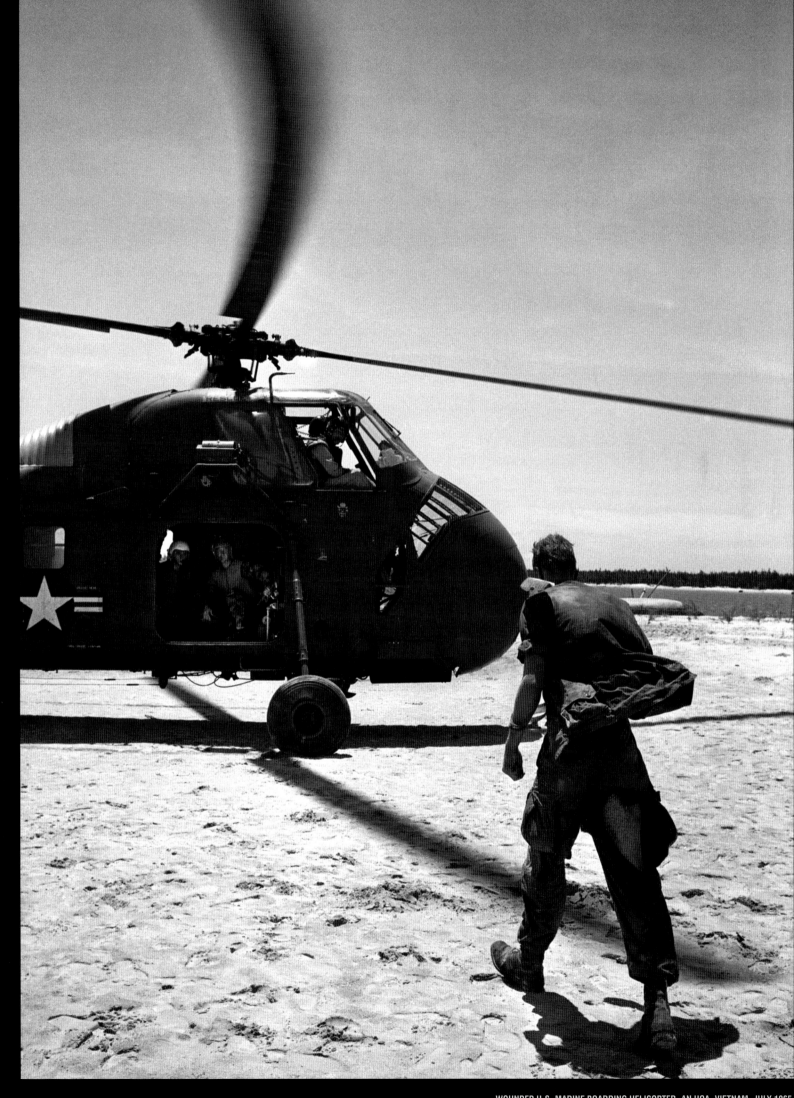

WOUNDED U.S. MARINE BOARDING HELICOPTER, AN HOA, VIETNAM, JULY 1965

of the Vietcong and were undertaken to disrupt aid to the countryside and discredit the South Vietnamese government.

The main section of the convoy, consisting of trucks carrying supplies and troops, moved along the highway ahead of Adams and his group of U.S. advisors and a South Vietnamese backup force. Adams rode with the advisors, senior American enlisted men and officers who trained South Vietnamese troops and advised on tactics in actual battlefield situations.

Vietcong in regiment strength attacked the main column near Cheo Reo in the Vietnamese highlands some 150 miles south of Danang. Daylong fighting left fifty Vietnamese soldiers dead, four Americans killed and two wounded. Vietcong killed were estimated at 130. Death and injury were constant companions to the photographers who covered the war. The AP would lose a number of photographers, some of them friends of Adams. At Cheo Reo death that came quickly to new found military friends had its impact, too. Adams wrote about just

such an incident. The story begins the day before the convoy moved out of Ea M'Kea to bring aid to the farmers who lost their crops.

A few days later Ba Gia, a small outpost some seventy miles south of Danang, was attacked and overrun by Vietcong. The VC rampaged for several hours through the dozen small houses in the village and killed anyone they sighted. Two 105mm Howitzers were captured and dragged away. Instead of disappearing into the jungle, the VC conducted a fierce mortar and artillery attack on the village and a nearby air strip near Quang Ngai. Adams flew into the air strip in a chopper during the attack while the outpost was still seriously threatened.

They fired at every helicopter that arrived at the landing strip, he wrote for the AP. *My chopper was hit two times by mortars before it landed.*

Ba Gia was pockmarked with mortar craters. The tangled wreckage of an armed helicopter flown by U.S. Army pilots was spreadeagled on an open piece of ground. One U.S. airman died

in the wreckage, two others were wounded. The communists, probably in three battalion strength, took Ba Gia in ninety minutes.

Adams spent two hours at the outpost before a Marine officer ordered him to depart on one of the final choppers taking out wounded before dusk. As the chopper prepared to lift off, Adams made a picture that stayed with him for years.

We had to get out fast, he wrote later. *I ran with other members of the party toward a clearing where a helicopter had landed to pick us up. Children were running through the grass in great confusion. Just as I climbed aboard I saw a woman kneeling nearby. On the ground next to her was a dying South Vietnamese soldier, possibly her husband. She lifted her arms toward me, asking for help, when there was no help I could give. I poked my camera out the open helicopter door to focus on the woman. My eyes were blurred with tears as I made her picture. I couldn't help her. All I could do was record her tragic plight on film.*

TIME TABLE TO A BATTLE

915am – First man wounded, hit by a bullet through his helmet.

1015am - We seem surrounded. Heavy fire, grenades exploding, mortar shells coming in from all directions.

1017am – The artillery outfit behind us has been hit.

1025am – One battalion of Vietcong is spotted over the hill, attacking the 2nd Battalion of the 40th Vietnamese Regiment. Armed helicopters are hitting them now.

1030am – Two guerrillas captured by 5th Battalion. They confirm a Vietcong regiment is in the area.

1032am – Two Vietnamese soldiers are killed.

1035am – A Vietnamese private runs toward us holding his bleeding head. The medic patches him up and he runs off, but returns shortly with a shell fragment in one leg.

1040am – A soldier takes two grenades off a dead man and lopes up the hill. He falls, hit in the stomach.

1052am – We are told four aircraft coming to help us. Guerrillas are spotted fifteen yards away on our flanks. Two are captured: one is eighteen years old, the other sixteen.

1105am – Our air support has arrived and is overhead. One American with the mobile control unit has been hit... It's too hot for the helicopters to come down.

1113am – Skyraider fighter-

bombers come in to strafe. But they are hitting an area of our own troops. Branches from the trees are falling over us as the bullets slice through them.

1130am – A Vietcong detachment moves in to pick up dead and wounded. Four are killed.

1150am – We are still surrounded, but contact has slowed.

1152am – A U.S. Air Force L-19 spotter plane has been shot down thirty feet from the southernmost of our companies. It crashed nose first on a rocky hillside and burst into flames. A U.S. advisor, Sgt. Ralph Conklin of Draper, NC, leads a charge to pull out the pilot and observer. But the party is driven back by Vietcong grenades.

1156am – Conklin tries again,

dodges a grenade and reaches the plane. Both men inside are dead.

1205pm – Ammunition starts to pop from the burning plane.

1225pm – Casualties in my vicinity—three Vietnamese killed, five wounded. Two Americans wounded, six missing.

1250pm – Heavy contact with Vietcong starts up again.

1253pm – Vietcong are sighted coming down the road toward us, we call in armed helicopters to disperse them.

125pm – A spotter plane drops white marking smoke on our position. This means he thinks we are the enemy. Conklin shouts over his radio: *"Do not strafe! I repeat, do not strafe!"*

The embattled outpost fought off Vietcong assaults for days until a rescue force was finally airlifted in. But Ba Gia remained the scene of fighting over and over again until the war's end.

Days later Adams rode an amphibious tank as it crossed a body of water that separated the main Marine base at Chu Lai from a Vietnamese naval installation at An Hoa island. Their mission: to take An Hoa back from the VC that overran the base just as they had at Ba Gia.

The fight lasted from mid-morning until 2 p.m., as Marines cut through barbed wire entanglements. Just before nightfall the Marines were ordered to burn An Hoa and a neighboring village to prevent Vietcong from reoccupying them. Adams's story concluded: *[An Hao] "Little Hawaii' was a hellish graveyard.*

Fighting ebbed and flowed through the summer months and into the autumn of 1965. Back in Danang, tedium set in once again. Adams accompanied Marines that moved on Cam Ne, visiting a village where they had clashed with VC some weeks earlier. A booby trap on a village gate caused casualties but there was otherwise no contact with the enemy. Bent bamboo poles with deadly spikes in the village were dismantled. Back in Danang Adams heard that a major battle broke out at nearby Chu Lai. His journal noted:

Tim Page and Paul Dean were the only newsmen there...and they stayed on...biggest U.S. story of the war and I wasn't there.

Followed by a single, self-mocking comment: *Hah!*

In early September, after pressuring the Marines for access that he believed he had been denied by General Walt, Adams spent more than a week to get exclusive coverage of a forthcoming major Marine attack. The so-called major attack, it turned out, was another disappointment. He detailed the incident in his journal. *I told the Marines I wanted to see Gen. Walt about poor help and info...LIFE was on an operation when I was told nothing was happening, no opera-*

tion at all...am furious. A meeting with Walt was arranged and, *Gen. Walt tells me he will make up favors owed by giving me huge operation all alone...we will see.*

The promise was made but later Adams notes, *Seems Saigon (AP bureau) knows all about the upcoming operation....*The implication was that if the AP Saigon bureau knew about a serious operation out of Danang others would know also. In all probability so would the Vietcong. His journal entry concluded with the sarcastic comment, *....Big Secret!*

As Adams negotiated with the Marines to be included in the forthcoming big assault, Richard Nixon arrived in Danang.

Nixon arrived in Danang today...had a short chat...remembered birthday portrait and cake...also talked to Gen. Karsh who hinted about upcoming operation...talked to LIFE this PM...seems they too are to have operation all alone... And then the often inscribed self-mockery in the journal: *Hah!*

137pm – Vietnamese infantry under fire to the south.

200pm – Vietcong are either withdrawing or reforming for a new attack. They call, "Come over here comrades and raise your hands if you want to live." The Vietnamese troops take no notice.

405pm – A U.S. Army radio operator, Private Gene Thomas of Ottumwa, Iowa, walks into task force headquarters with wounded Private Joseph Bell, who was hit in one hand and is in a state of shock. Thomas had been with an eighteen-vehicle group overrun by the Vietcong to our north."We were surrounded,"he said.

"When they opened up we all jumped and took cover in the elephant grass. We could hear the Vietcong talk, but could not understand them. Everything hap-

pened so fast. One buddy was shot all full of holes. He grabbed my leg and asked me to pull him to safety. But he lasted only a few minutes and died."

"The Vietcong were only twenty-five feet from us. Some had green uniforms, others black pajamas. I think I killed two of them."

500pm – Nearly dusk in these mountains. Captain Henry Hosman of Crystal Lake, Illinois, and Captain Gordon Pollard of El Paso, Texas, show up near the command post.

"All we did was run from one position to another dodging mortars," Hosman said. "The Vietcong had many weapons. One of them just stood there in the open and kept spraying the area. There were five of us Americans together. I don't know what happened to the rest."

540pm – Part of our forces reaches the site of the ambushed convoy. The Vietcong had taken the C-rations and scattered the psychological war leaflets around. They left the radios and other supplies behind.

550pm – Vietcong fire explodes artillery ammunition.

625pm – Machine guns open up on us and we call for helicopter medical evacuation. The helicopters didn't come.

645pm – Two more Americans show up—Lieutenant James Gleason of Boone, Iowa, with a bandage around his head, and Private Kenneth Ford of Vernon, Texas. They had hid from Vietcong in a ditch.

725pm – Planes are still dropping bombs.

750pm – Armed helicopters return, see us and fire into our ranks, wounding a Vietnamese paratrooper.

The troops curse the pilot.

755pm – Captain William R. Foster of Pocatello, Idaho, returns.

He said, "I lost radio contact with everyone about 2:30 p.m. When the firing started I took all the men I could find and hid in a creek bed."

800pm – Darkness sets in. The Vietcong are puling out, leaving the field to the government forces.

-EDDIE ADAMS

INHABITANTS OF BA GIA FIGHT TO GET ABOARD U.S. MARINE
HELICOPTER IN EFFORT TO ESCAPE FROM VIETCONG MORTAR
SHELLS JULY 5, 1965. THE AIRCRAFT WAS ONE OF TWO
HELICOPTERS ABLE TO LAND AT THE OUTPOST, SOME 330
MILES NORTH OF SAIGON, WHICH CAME UNDER COMMUNIST
ATTACK. CHILDREN RUN ABOUT IN CONFUSION IN RIGHT
FOREGROUND AS SMOKE RISES FROM THE VILLAGE.

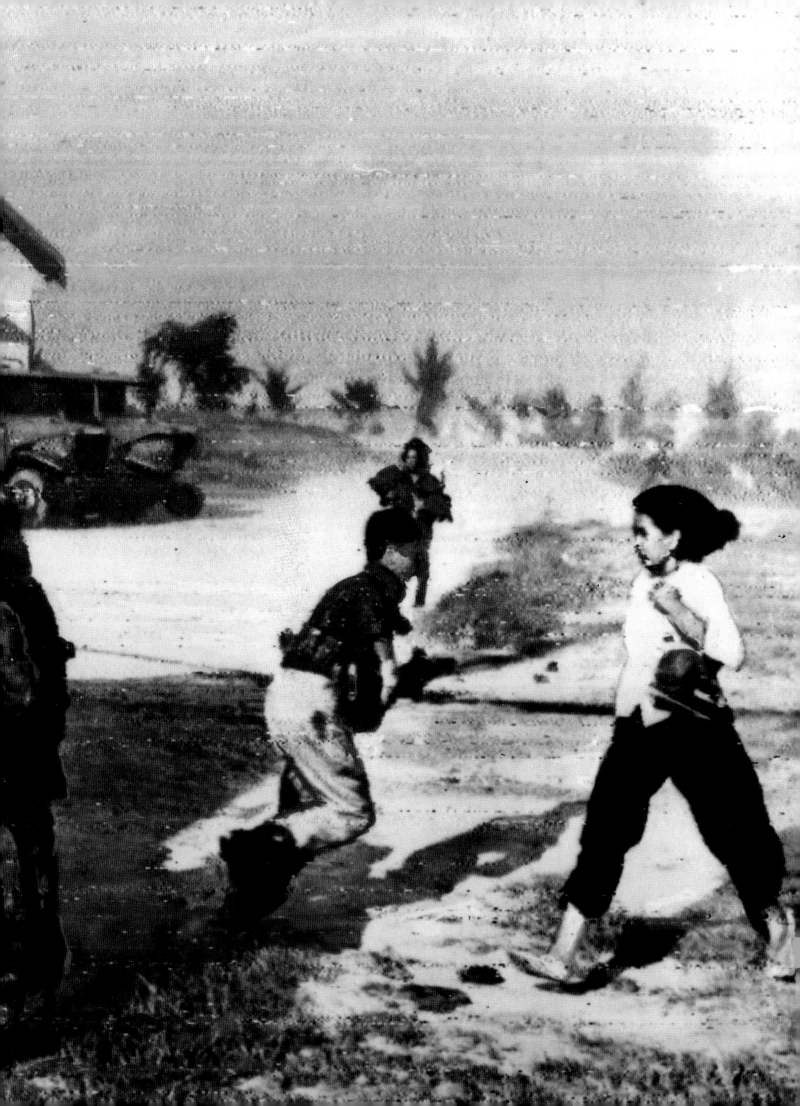

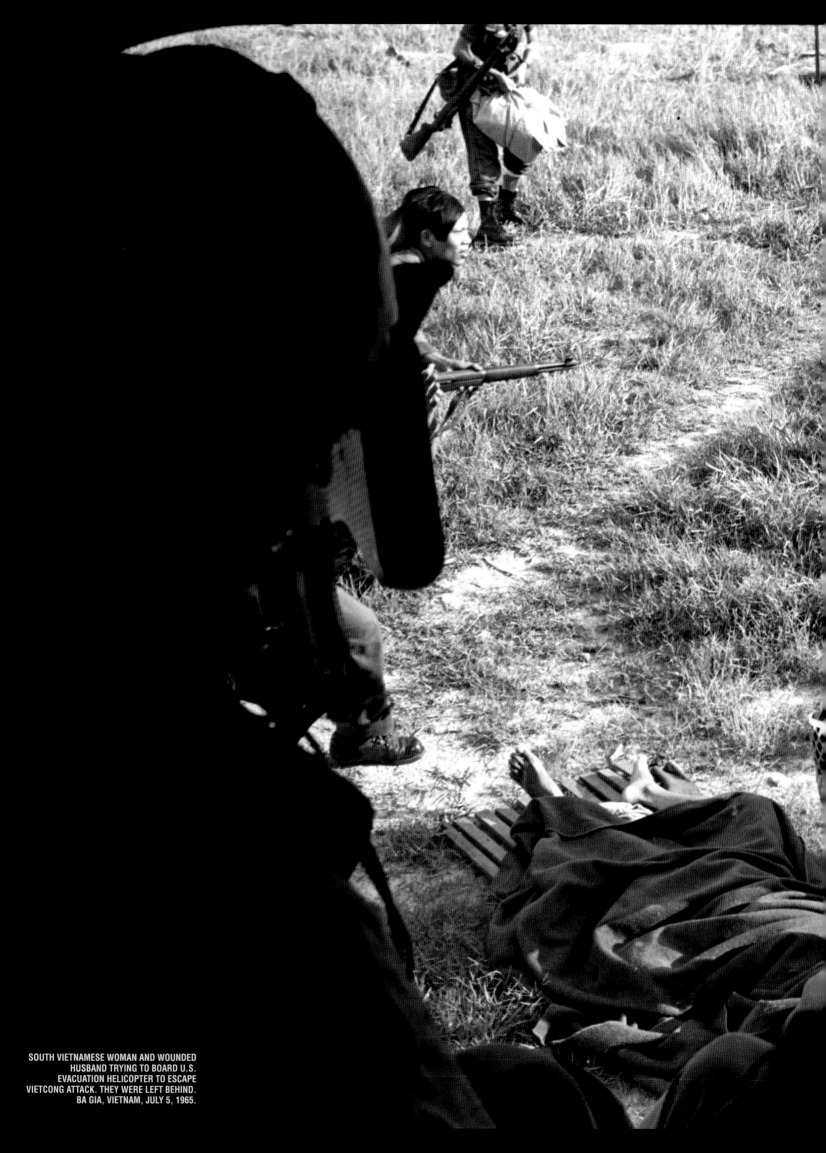

SOUTH VIETNAMESE WOMAN AND WOUNDED
HUSBAND TRYING TO BOARD U.S.
EVACUATION HELICOPTER TO ESCAPE
VIETCONG ATTACK. THEY WERE LEFT BEHIND.
BA GIA, VIETNAM, JULY 5, 1965.

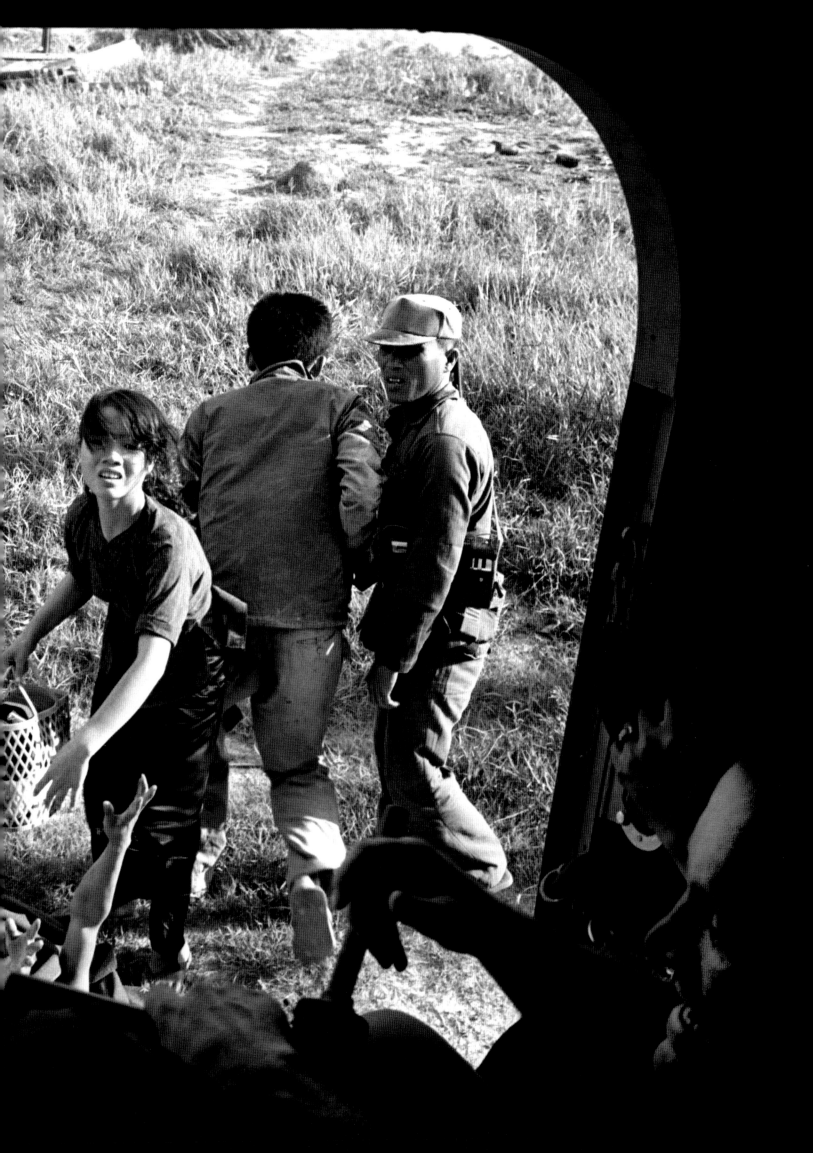

AM SUPPOSED TO BE THE ONLY CIVILIAN ON UPCOMING MARINE MAMMOTH OPERATION...THE BREAK I'VE BEEN WAITING FOR...

Am supposed to be only civilian on upcoming Marine mammoth operation...the break I've been waiting for....Being flown to Chu Lai tomorrow to go aboard ship for amphibious landing...beach heavily mined according to intelligence...we'll see...want to go on first wave.

Two days later: *Boarded ship and transferred to a landing craft...slept on deck with troops for the evening...movie at night...interrupting the movie was the voice of the chaplain wishing us victory on the assault. Before boarding the Amtrak for assault a chaplain in a white robe blessed us... made us all a little more frightened...Vo Win was with me...we and LIFE only ones in the assault. Stormed the beach today with first wave... was running and making pix at same time... no contact with VC...operation a big flop at this stage...seems VC tipped off about our coming...lousy pix and story...waste of time...got ride back to Danang with Gen. Walt.*

As Adams struggled with his coverage of the Marines his friend Henri Huet, now an AP staff photographer, covered the U.S. Airborne and their patrols against the Vietcong.

Henri pinned down by VC for 24 hours...good battle with Airborne at An Khe...20 U.S. killed, 50 wounded, VC casualties unknown. Sure wish I was there...Think I'll leave Marines in another week.

Talked to General Walt today...told him of my plans to leave Danang and Marine coverage... said he had nothing big planned for immediate future...said future operations would be last minute plans...also, next move up to VC.

Going out on a night raid this evening...should be good...also getting a little frightened at getting short now...seems many always get it when only a few days or weeks left in country.

His reference to *getting short now* was to a scheduled rest in the U.S. after nine months of full time war coverage. Adams spent little time in Saigon, preferring instead to stay close to the Marine contingent at Danang, joining their patrols and operations at every opportunity. A steady diet of dirt, dust, mud, mortar attacks, ambushes, beach landings, threatened convoys and dangerous auto passages on highways takes its toll on the most hardy

of those in the combat zone. Correspondents like Adams, who covered the war first-hand and up-close, saw more action than many military; seeking, as correspondents did, daily pictures and stories on the latest battles, newspeople hopped from place to place to report firefights, exposing themselves on a regular basis to the brutal conflict unique to Vietnam.

Peter Arnett wrote about the risks taken by correspondents, writers, and photographers in a November 1966 AP story citing the high casualty rate among newspeople.

For men whose daily job it is to capture and transmit the taste, the feel, the smell of battle, few wars have been as perilous as the nightmarish struggle in Vietnam.

This is because it is a war without any front lines, without clearly marked friendly or enemy territory or clear lines between combatants. It is a war of treacherous ambushes and of swift hit-and-run attacks by a wily foe who materializes suddenly from the jungle, strikes viciously and vanishes.

Reporters and photographers regularly venture to places where the action is, to record in words and on film the color, the flavor, the terror, the triumphs and the heartbreaks of a confused and confusing conflict.

Events of the final weeks of his first tour in Vietnam underscored for Adams the truth of Arnett's story; two AP photographers were killed in one eight-day period and Adams himself had a close call in a battle at Pleiku.

MARINES INVADE DANANG VILLAGE

EA M'KEA, VIETNAM (AP) –
A day before the good-natured Air Force captain had been swapping jokes with me in a dark and deserted schoolhouse waiting for the operation to begin.

Suddenly he was dead thirty feet behind me, a column of flame licking at his plane and his crumpled body.

The Vietcong had hit hard about two hours before, as a battalion of Vietnamese paratroopers was threading its way along the rocky slopes of a high mountain pass. Machinegun fire and mortar shells had cut deeply into our men.

The Vietnamese paratroopers and their American advisors were fighting a pitched and desperate battle there on the slopes. They were surrounded and they knew it.

The air was thick with bullets and fragments. Overhead a silver-colored two-seater spotting plane had been dodging around the slopes all morning, the genial pilot radio-

ing the latest word on the enemy up ahead.

We hadn't noticed the plane for several minutes. But then came a splintering crash just behind us, followed by a reverberating explosion. The plane had been hit and crashed through the trees and into the ground, thirty feet behind us.

I ran with an advisor and two Vietnamese paratroopers toward the crash. But already a huge column of flames had engulfed the wreck.

We could see the pilot's arm hanging limply from the burning mass of metal as we approached within ten feet. We could see no trace of the Army major who had been flying in the back seat as his observer.

That was as close as we could get. Vietcong fire drove us back to cover behind a huge rock as grenades boomed a huge shower of fragments around our position.

- EDDIE ADAMS

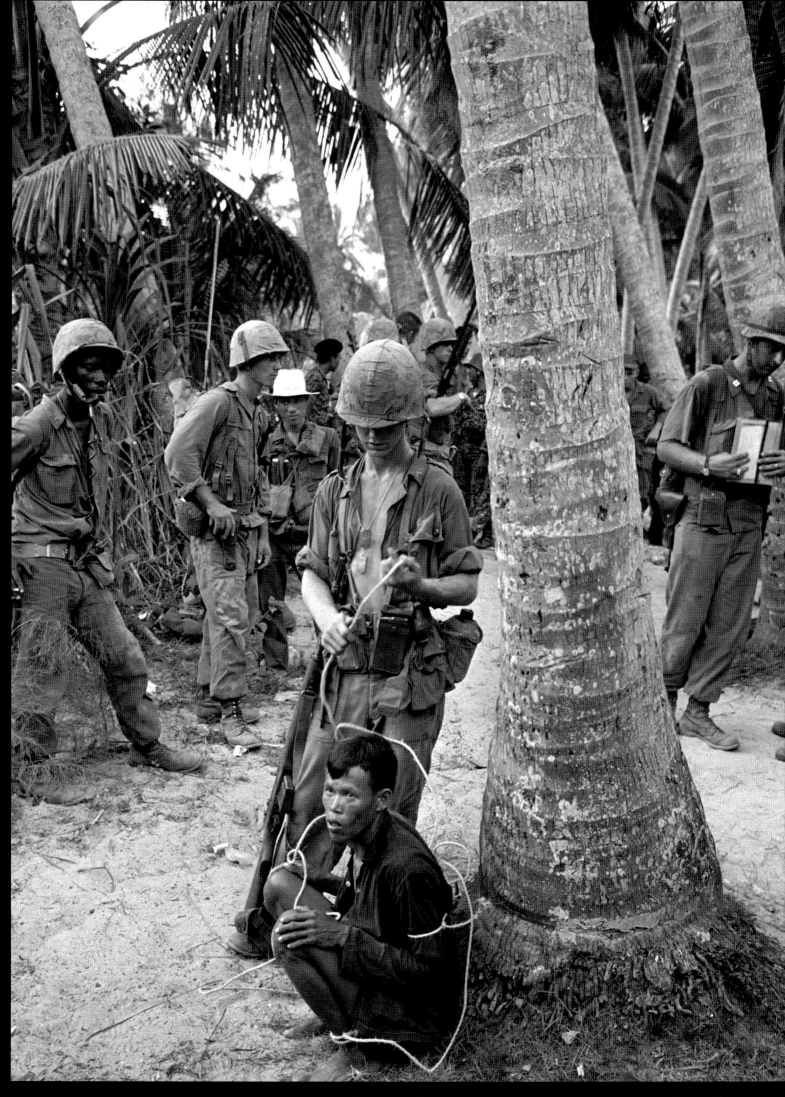

AN HOA, SOUTH VIETNAM. MARINE STANDS GUARD OVER VIETCONG SUSPECT TIED TO THE END OF A ROPE, JULY 9, 1965.

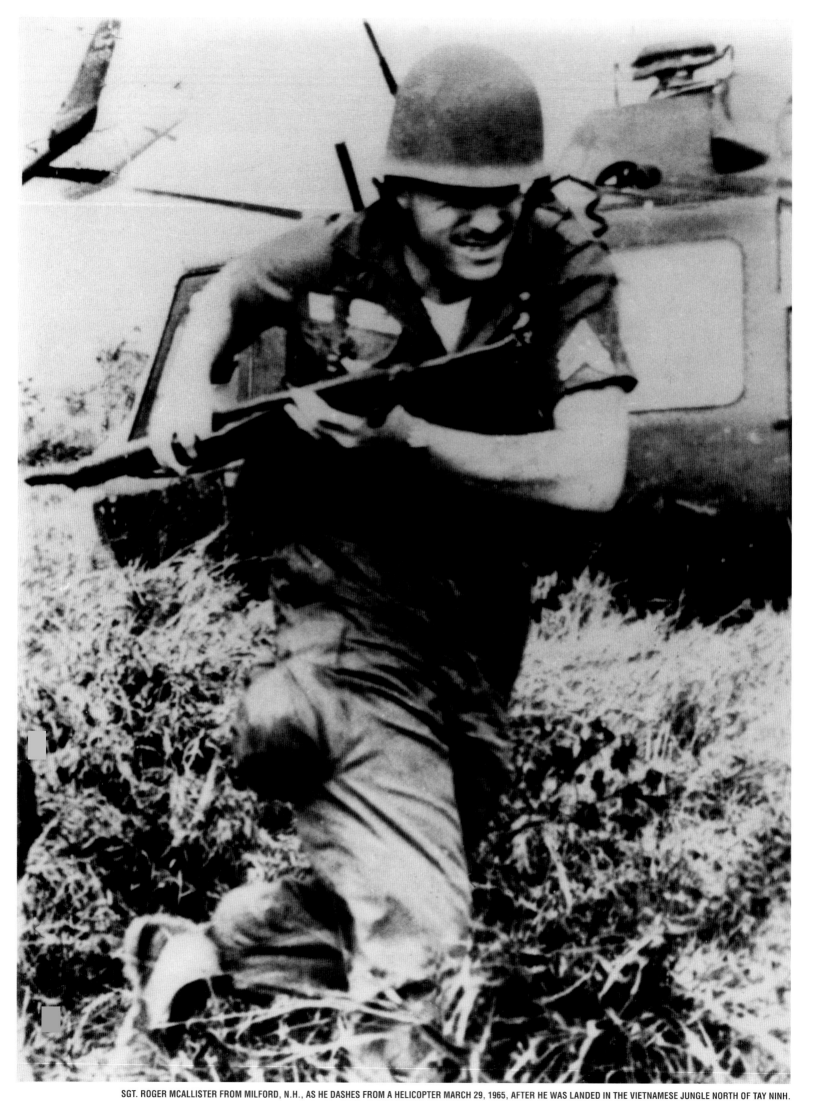

SGT. ROGER MCALLISTER FROM MILFORD, N.H., AS HE DASHES FROM A HELICOPTER MARCH 29, 1965, AFTER HE WAS LANDED IN THE VIETNAMESE JUNGLE NORTH OF TAY NINH.

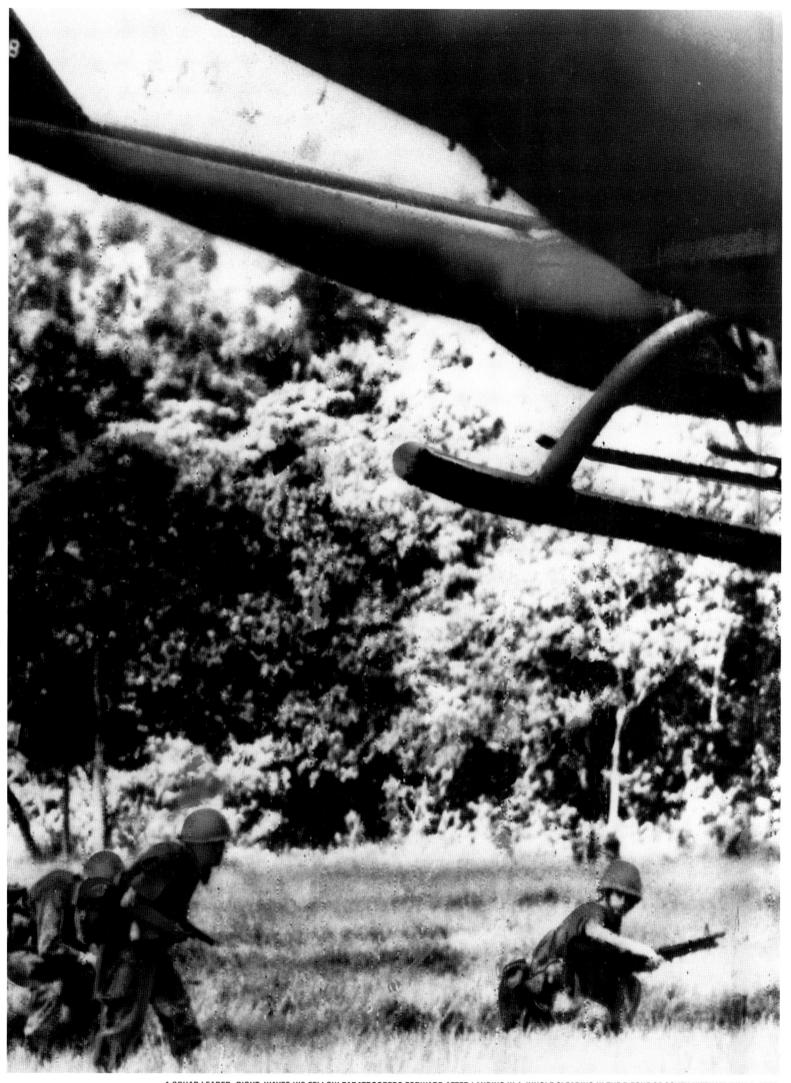

A SQUAD LEADER, RIGHT, WAVES HIS FELLOW PARATROOPERS FORWARD AFTER LANDING IN A JUNGLE CLEARING IN THE D ZONE OF SOUTH VIETNAM JULY 6, 1965.

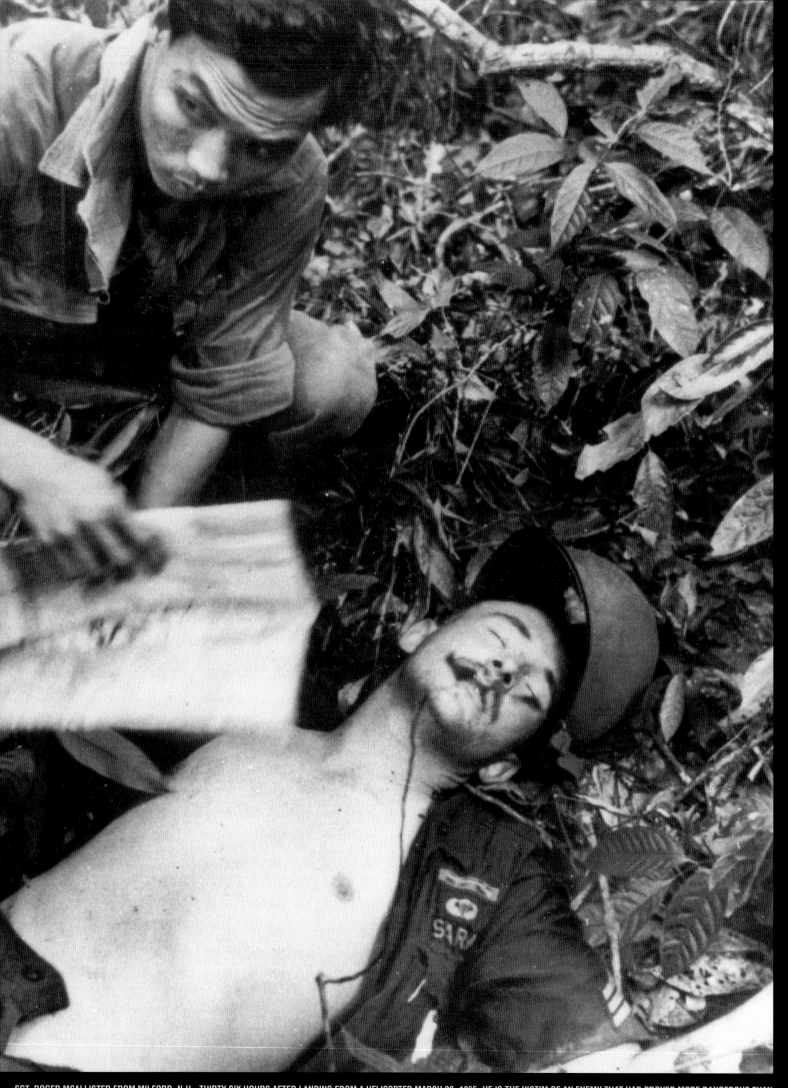

SGT. ROGER MCALLISTER FROM MILFORD, N.H., THIRTY-SIX HOURS AFTER LANDING FROM A HELICOPTER MARCH 29, 1965. HE IS THE VICTIM OF AN ENEMY THAT HAD PROVED MORE DANGEROUS THAN THE VIETCONG: HEAT PROSTRATION. MCALLISTER COLLAPSED AFTER CRAWLING THROUGH THE JUNGLE IN 100 DEGREE HEAT WITH A RADIO STRAPPED TO HIS BACK. HE WAS EVACUATED BY HELICOPTER.

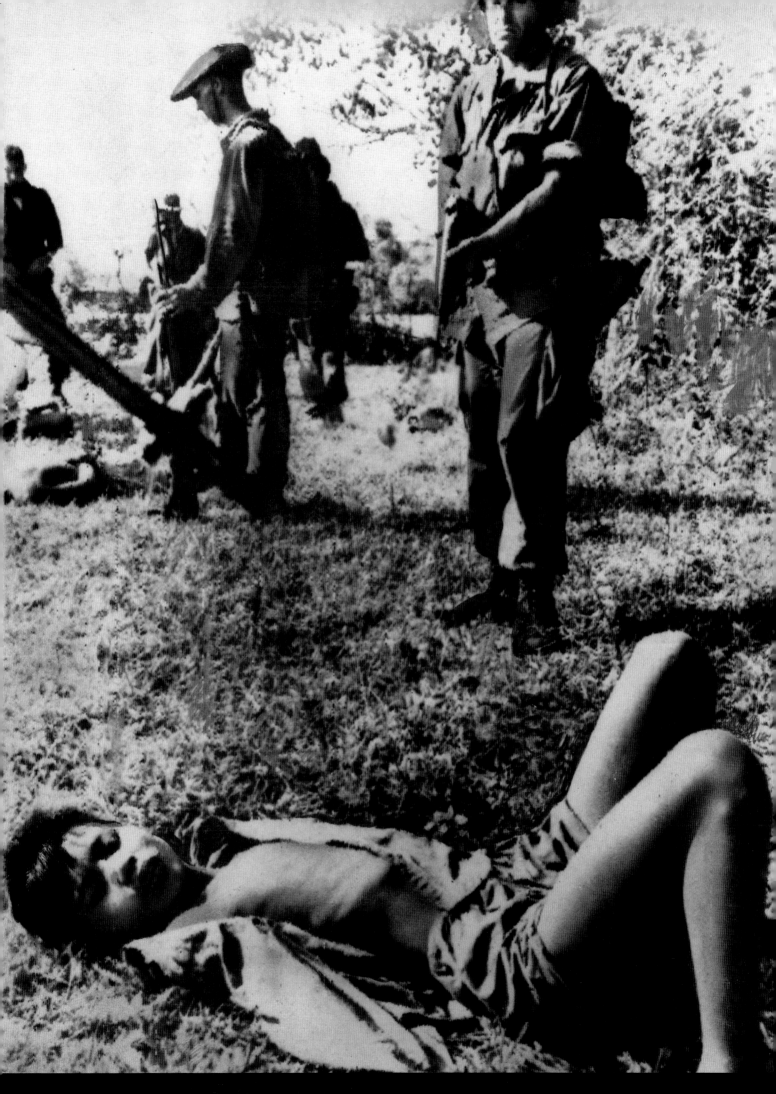

A U.S. MARINE KEEPS A CLOSE WATCH ON A YOUNG VIETNAMESE BOY SUSPECTED OF BEING A VIETCONG AGENT. HE WAS TRUSSED AND KEPT UNDER CLOSE WATCH, OCTOBER 1965.

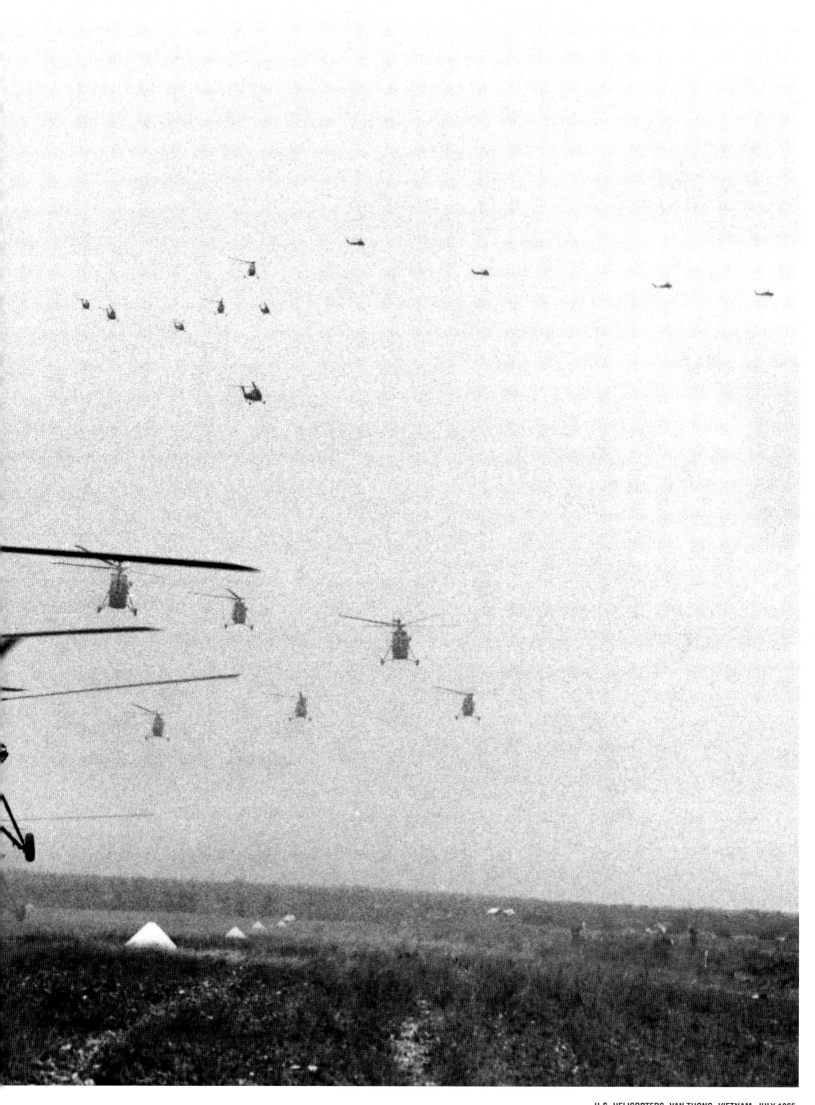

U.S. HELICOPTERS, VAN TUONG, VIETNAM, JULY 1965.

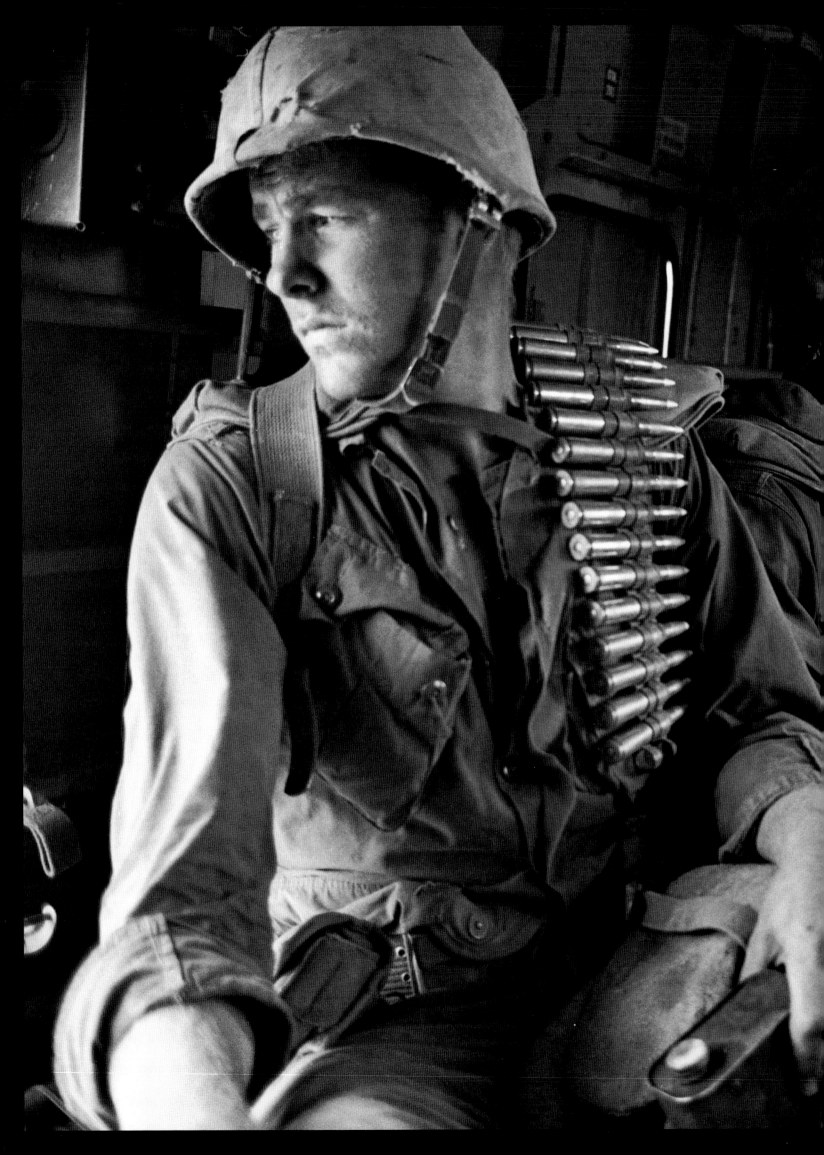

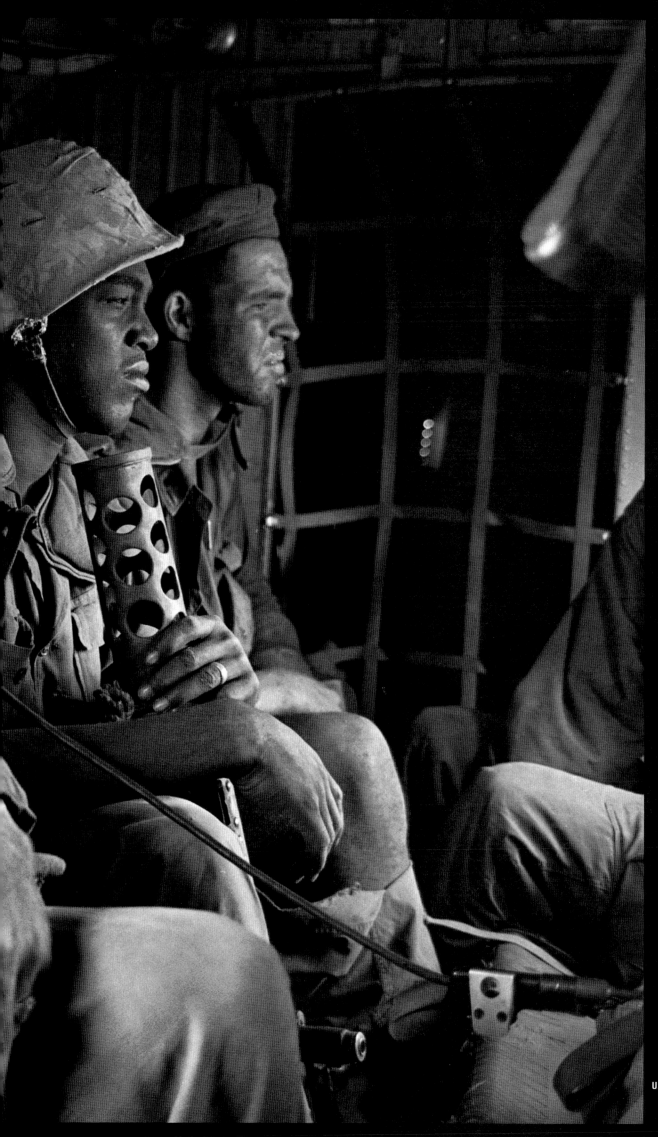

U.S. MARINES, VAN TUONG, VIETNAM, JULY 1965.

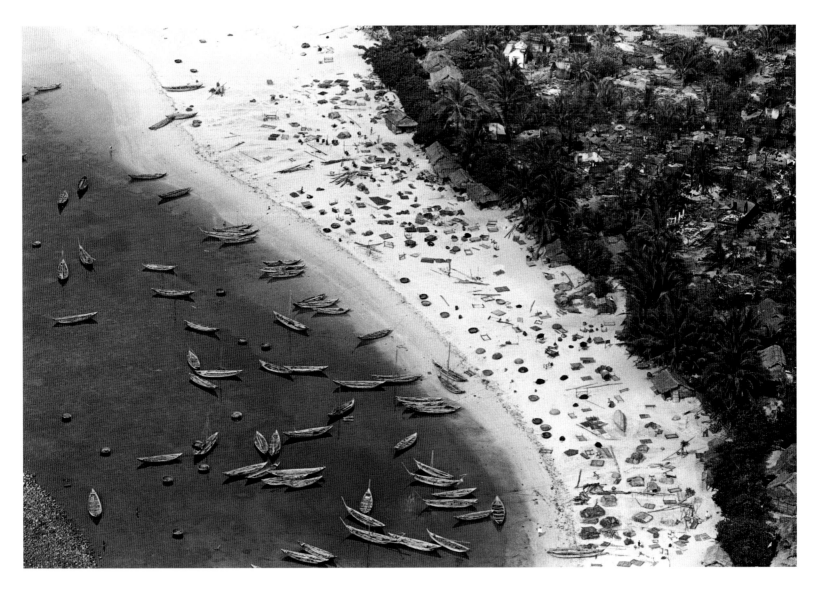

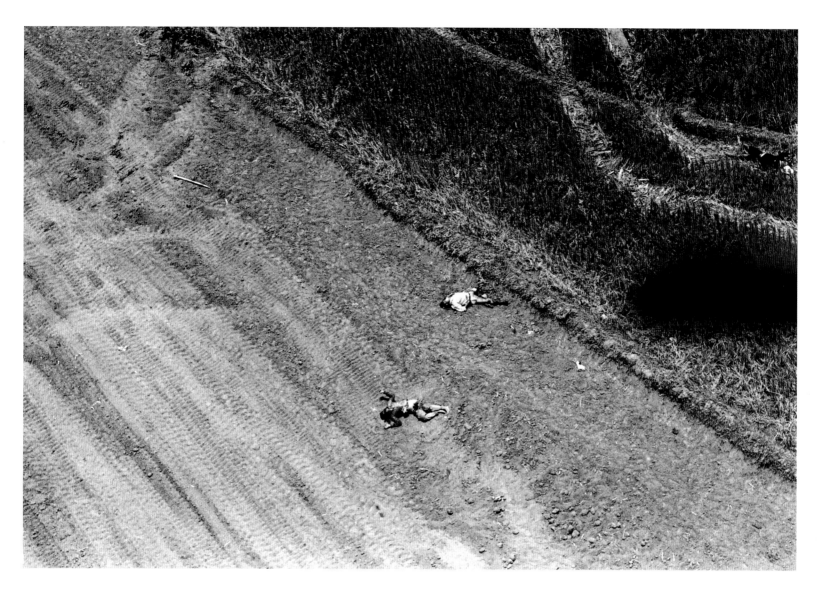

ABOVE AND OPPOSITE: AIR ATTACKS ON AN HOA, VIETNAM. BEFORE AND AFTER. JULY 1965.

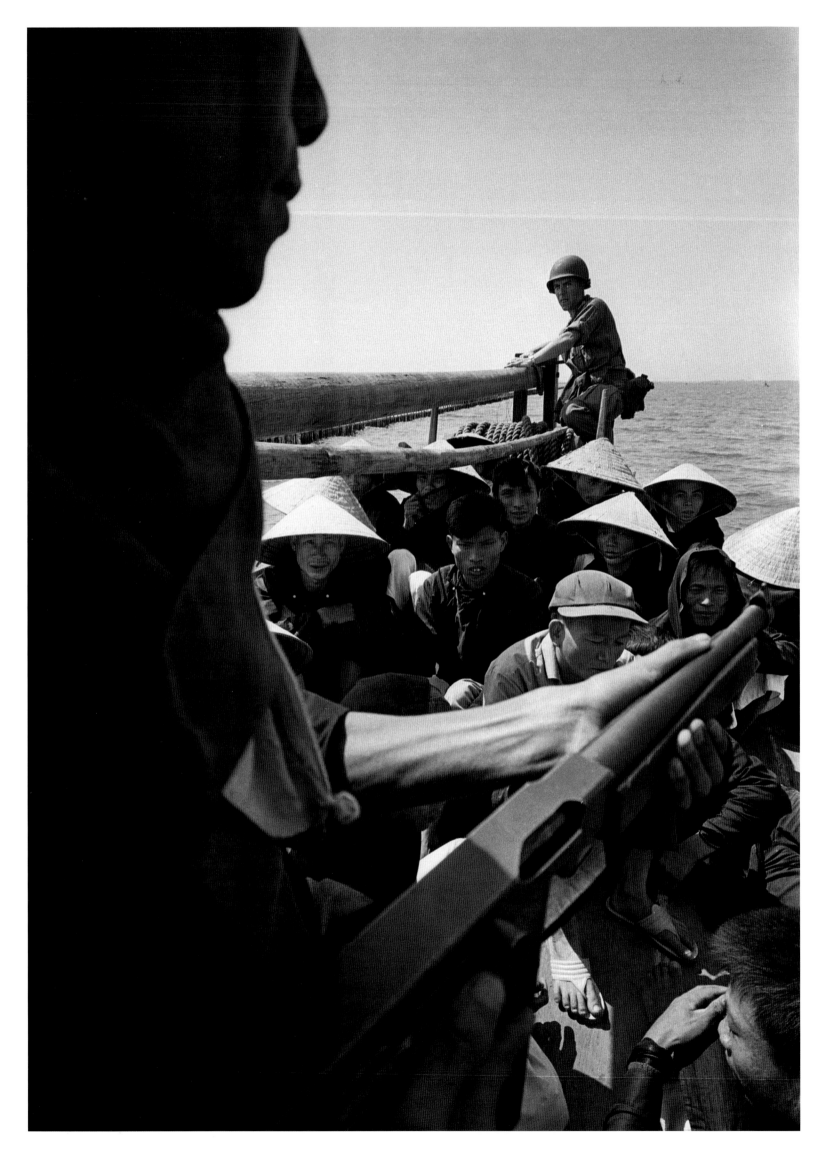

ABOVE: U.S. MARINE CORPORAL STANLEY BORNINKHOF OF SHELBY, MON-
TANA STANDS GUARD WITH MACHINE GUN AT CORNER OF A HOUSE IN BA
GIA. IN BACKGROUND IS WRECKAGE OF A U.S. ARMY HELICOPTER.
THE AIRCRAFT WAS SHOT DOWN BY VIETCONG FIRE JULY 5 AS IT TRIED TO
LAND AT THE OUTPOST, SOME 330 MILES NORTH OF SAIGON. ONE
CREWMAN WAS KILLED AND THE OTHER THREE WERE EVACUATED FROM
BA GIA, WHICH HAS BEEN RINGED BY VIETCONG POSITIONS.

OPPOSITE PAGE: VILLAGERS ARE EVACUATED FROM A VIETCONG
CONTROLLED AREA NEAR PLEI ME IN OCTOBER 1965.

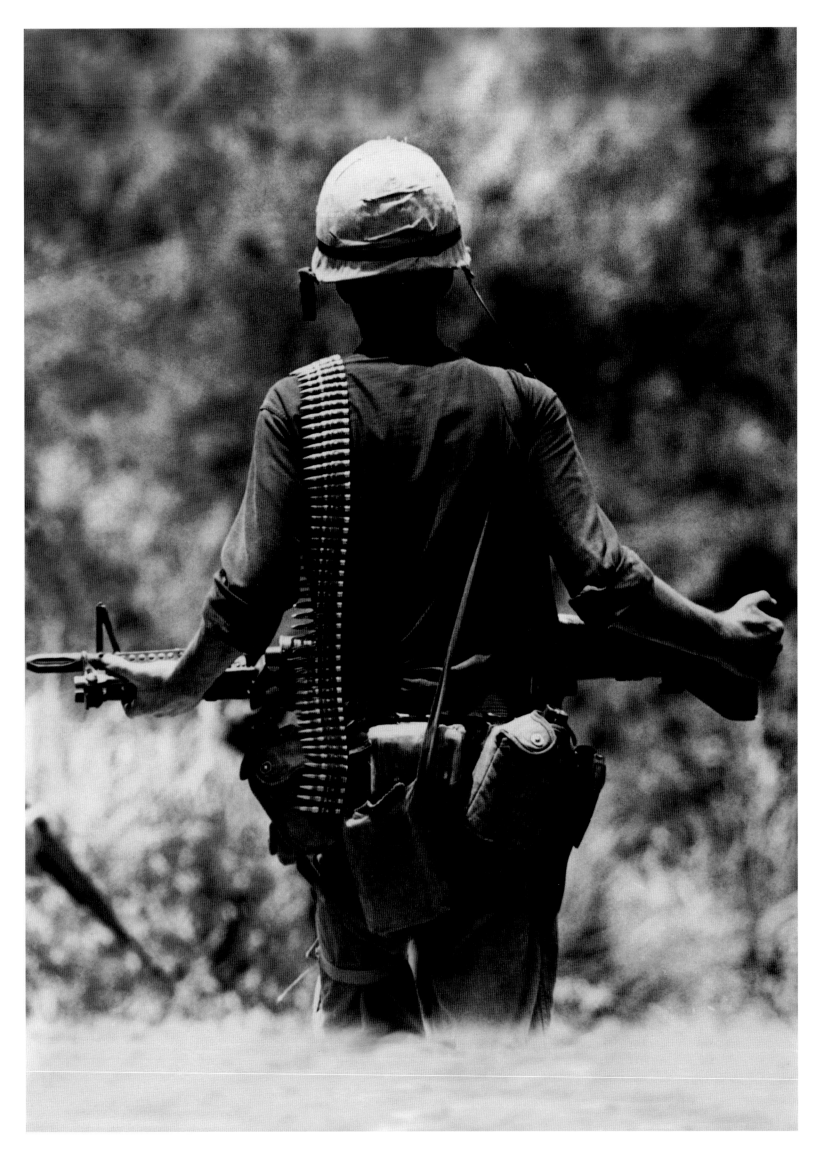

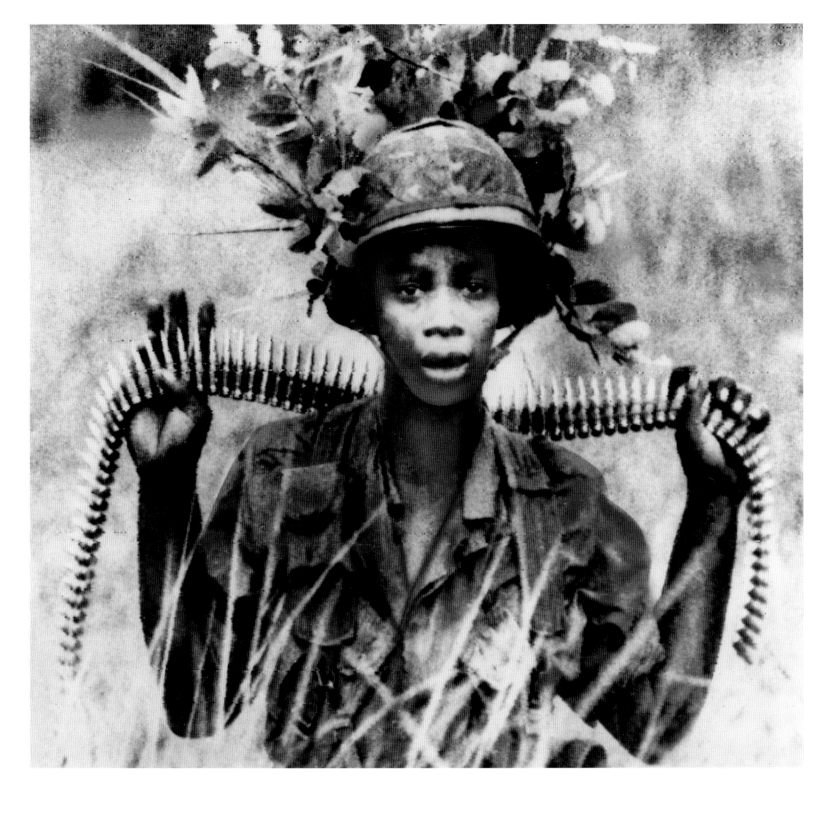

ABOVE: PARATROOPER DRAPES HIS FINERY OF WAR,
A BANDOLIER OF CARTRIDGES FOR HIS M-60 MACHINE GUN OVER HIS
SHOULDERS AND WEARS A HELMET ADORNED WITH BRANCHES AS
HE PREPARES TO MOVE OUT WITH HIS PLATOON IN SEARCH OF VIETCONG
GUERRILLAS IN SOUTH VIETNAM. HE IS A MEMBER OF THE 173RD
AIRBORNE BRIGADE WHICH IS CONDUCTING A SEARCH-AND-DESTROY
PATROL IN THE JUNGLE FORTY MILES NORTHEAST OF SAIGON.

OPPOSITE: IN PURSUIT OF RED GUERRILLAS
U.S. MARINE CARRIES MACHINE GUN AND AMMUNITION BELT INTO
THE SOUTH VIETNAMESE JUNGLE AS AMERICAN TROOPS GO
INTO ACTION NEAR DANANG AIRBASE.

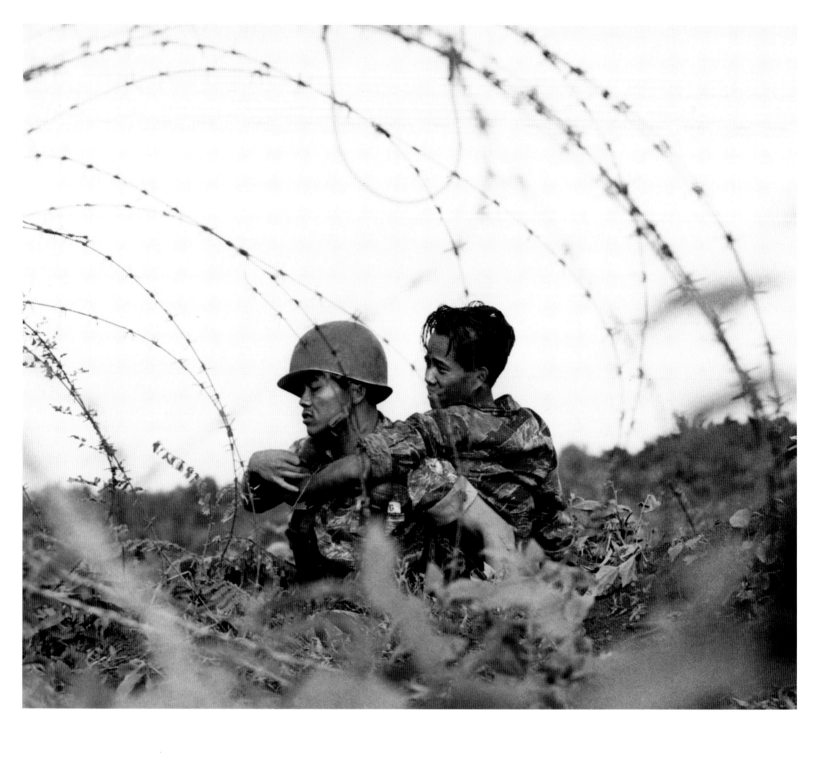

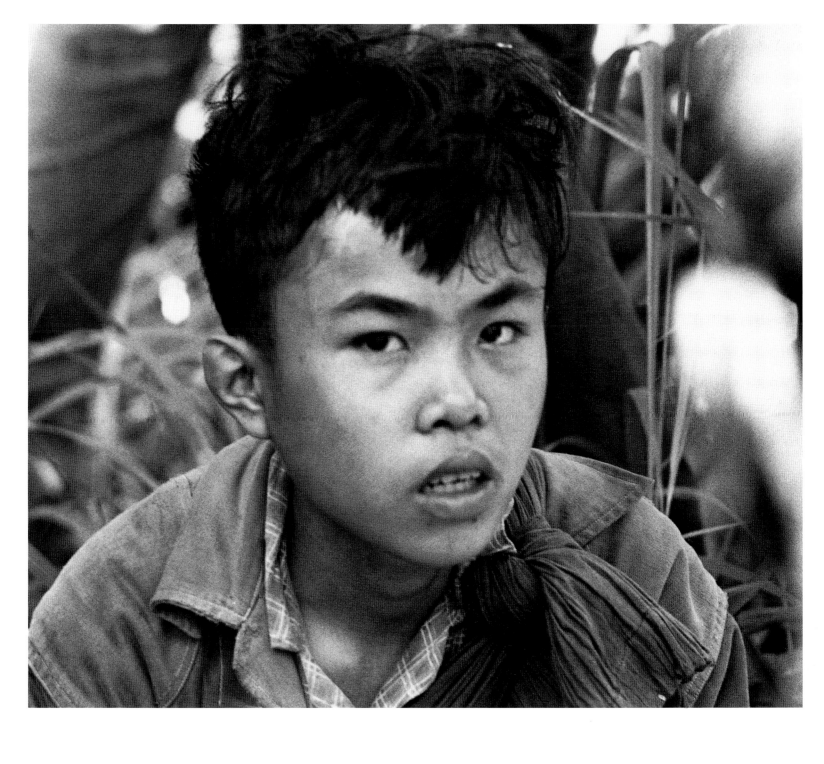

ABOVE: FACE OF THE ENEMY. A VIETCONG SOLDIER, CAPTURED JULY 1, 1965, DURING AN AMBUSH OF GOVERNMENT TROOPS NEAR CHEO REO, LOOKS APPREHENSIVELY AT HIS CAPTORS AS HE AWAITS INTERROGATION. THE EIGHTEEN-YEAR-OLD GUERRILLA WAS ONE OF TWO PRISONERS TAKEN BY GOVERNMENT TROOPS. HEAVY CASUALTIES WERE INFLICTED BY BOTH SIDES IN THE FIREFIGHT THAT FOLLOWED THE AMBUSH.

OPPOSITE: A WOUNDED VIETNAMESE RANGER IS CARRIED ON HIS FRIEND'S BACK THROUGH BARBED WIRE TO MEDICAL ATTENTION AT PLEI ME AID STATION. THE POST, UNDER ATTACK FOR SEVERAL DAYS, WAS REINFORCED BY RANGERS, BUT MANY WERE WOUNDED AS THEY ARRIVED.

THE FIRST FATALITIES

On October 2,1965, AP photographer Bernie Kolenberg, in Vietnam for one week, climbed aboard an A1E Skyraider on a Vietcong chasing mission 250 miles north of Saigon near Qui Nhon. He was an experienced photographer who had been in Vietnam months earlier on assignment for his newspaper, the Albany, New York, *Times-Union*. He was recalled by his editor on the grounds that Vietnam was becoming too dangerous. But like so many photographers he yearned to return to combat coverage. He contacted the Associated Press, which accepted him as a volunteer staff member.

The Skyraider in which he was riding collided with another plane as they chased down enemy troops. Both planes crashed. Kolenberg and the two pilots perished. Chief of Bureau Ed White recovered Kolenberg's body from a temporary morgue and arranged for shipment of his remains back to his home town.

The effect of Kolenberg's death was still heavy on the staff when Huynh Than My, a staff photographer since 1963, was killed just eight days later in the Mekong Delta. My was wounded in May by machine gun fire but returned to coverage as soon as he was released from the hospital. On his Delta assignment My was wounded once again in the chest and arm. While he awaited helicopter evacuation the enemy overran the South Vietnamese position and killed all the wounded. White went to the battle scene to escort My's remains to Saigon.

Adams heard the news of My's death as he covered 1st Cavalry Division operations near An Khe, not far from where Kolenberg was killed. Adams knew My well. The Vietnamese cameraman was popular among the correspondents, and he often dined with Adams in Vietnamese restaurants when Adams visited Saigon.

Of the 1st Cavalry operation his journal, once again, noted:

Operation a big flop. Intelligence says that the VC told to get out of the area one day before the start of the operation.

The next entry in his journal, in large scrawled letters, recorded the devastating news:

My killed by 2nd BN, VC in Delta today with 44th Vietnamese Rangers, the best unit in Vietnam. Heavy casualties...My was killed in the Delta where he was born and wounded last May. A Vietnamese companion and I told My's wife of his death and took her out to the airport for the arrival of the body. I, too, broke down with her...My was a friend and cameraman... shot in the arm and neck...My was the fourth correspondent to get killed here...worries us all a little more...Fifteen others were wounded in action...But we have to cover the war.

At the funeral ceremony a large contingent of newspeople, Adams and many from the AP staff among them, accompanied the coffin to the cemetery. In the cortege was Huynh Cong Ut, My's younger brother who would come to work for the AP as a darkroom attendant, grow into a combat photographer known as "Nick" Ut and win a Pulitzer Prize in 1972 for his dramatic photo of Kim Phuc, burned by napalm, running naked down a Vietnamese highway—now a classic.

The war coverage continued but in the AP bureau, amid the clatter of typewriters and the flow of photographs, the death of two of their number was not lost on the staff. For Adams the final battle of his first tour in Vietnam awaited his camera at Plemei in the Central Highlands, home to the feisty Montagnard mountain people trained by U.S. Special Forces.

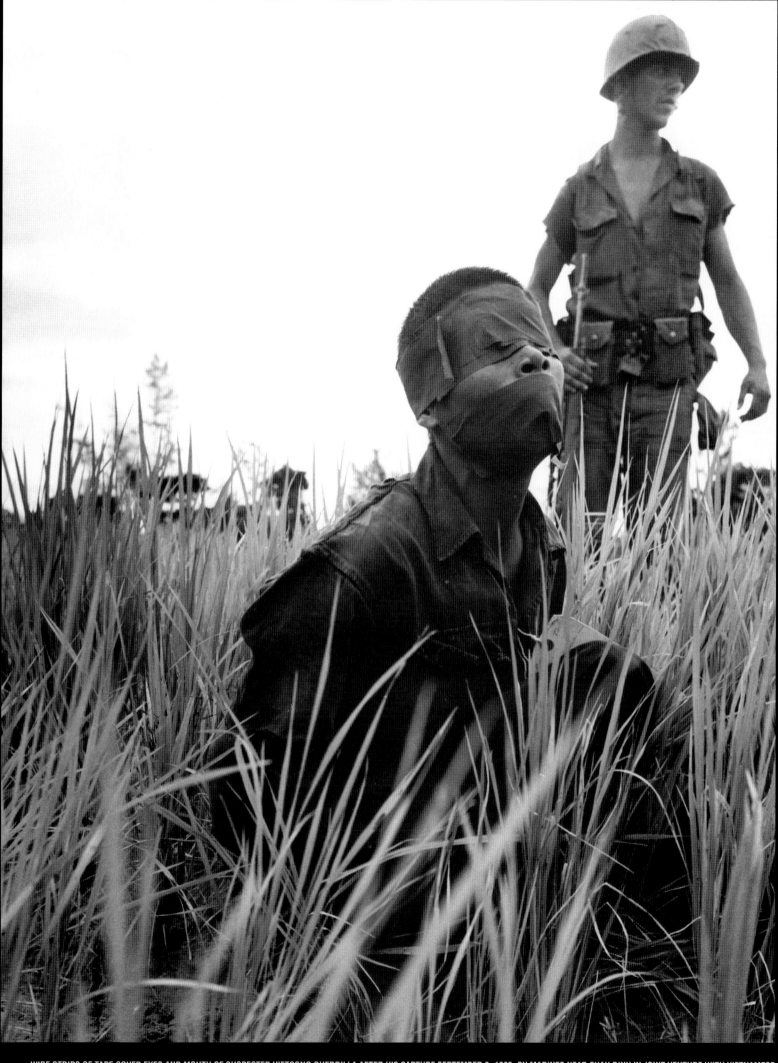

WIDE STRIPS OF TAPE COVER EYES AND MOUTH OF SUSPECTED VIETCONG GUERRILLA AFTER HIS CAPTURE SEPTEMBER 9, 1965, BY MARINES NEAR CHAU DINH IN JOINT VENTURE WITH VIETNAMESE TROOPS ON BATANGAN PENINSULA 20 MILES SOUTH OF CHU LAI. LEATHERNECKS AND GOVERNMENT FORCES MADE LANDING ON THE PENINSULA SEPTEMBER 7 AND CONTINUED OPERATION TO CLEAR AREA.

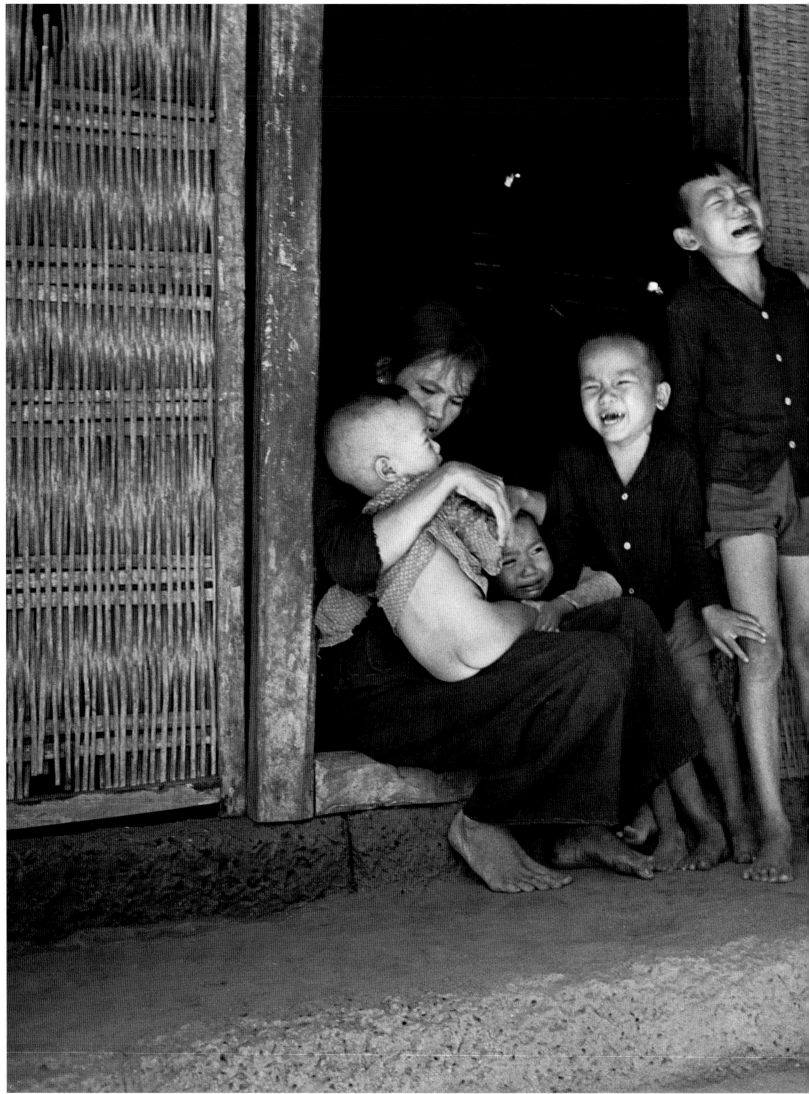

MARINES AT CHAU THUAN SEPTEMBER 9, 1965.

n the fall of 1965 U.S. military intelligence reported that North Vietnamese troops were moving into Laos and Cambodia to support the Vietcong fight against South Vietnamese troops and the growing number of U.S. combat forces. In July, Adams rode in the first convoy on Route 19, a highway that linked the Vietnamese coast with the mountain town of Pleiku. The highway was closed for some time and used as the primary infiltration route of Vietcong and North Vietnamese regulars into South Vietnam. It also provided a convenient escape route to Cambodia for Vietcong after battles with government troops. South Vietnamese troops with U.S. air support reopened the highway to block and disrupt the North Vietnamese presence as well as Vietcong activity.

Some twenty-five miles from Pleiku was Plemei, a small outpost along Highway 19. It was manned by Montagnard irregulars. The Montagnards, who lived a remote highland life with a strikingly different culture than most of Vietnam, were not necessarily loyal to the central government. But they were protective of their unique culture, which they believed was threatened by the VC and the Northerners. The Special Forces bonded with the Montagnards, armed them, and created a viable listening post and defense against the local Vietcong.

Despite his earlier unproductive visit to Pleiku, Adams decided to visit the area once again in October to learn more about the presence of North Vietnamese regulars.

Left Pleiku today, he wrote in his journal, after three days…got good pix and story on a twelve-year-old soldier…good bunch of troops…camp has never been attacked in its two years of existence.

He no sooner returned to Danang than change came again without warning. Vietcong forces, for the first time supported by North Vietnamese regulars, encircled the Plemei camp, dug in deeply in the surrounding terrain and opened a major assault against the outpost.

Plemei was attacked last night, Adams noted in his journal, and is still surrounded by VC…flew over this morning and made pix of air strikes around the camp…B57 was just shot down over the camp…also an armed Huey with all of its crew dead…got story and pix off to Saigon.

Pleimei was a triangular-shaped outpost, its inhabitants protected by intertwined strands of barbed wire, watch towers, and heavily sandbagged bunkers. It was spotted with mortar and machine gun emplacements.

The usual sequence of these battles began with a sudden attack, fierce fighting, and then an equally quick withdrawal of the Vietcong into the jungle. Not so at Plemei. The VC and their Northern Vietnamese support made a frontal assault on the small outpost manned by a dozen U.S. Special Forces and several hundred Montagnard irregulars. The defenders fought off the enemy some of the attackers

left dead on the barbed wire perimeter. The attacking force withdrew to heavily camouflaged positions, but instead of vanishing they poured artillery, mortar and machinegun fire on the besieged camp for several days. Air support had its effect but the enemy force dug in, waited out the bombing and then resumed their attack on the outpost. Helicopters eventually dropped in with two loads of South Vietnamese regulars but major support took the form of a reaction force of some 250 South Vietnamese Rangers and their American advisors. They headed for Pleimei overland.

Experienced combat photographers in Vietnam knew, or learned the hard way, that reaction forces were certain to be ambushed as they rushed to relieve small outposts and that it was therefore risky to join them. Horst Faas made that call and went with a relief column to Dak To—and was ambushed. You have to weigh the possibility of good pictures against the danger, he often said.

Adams knew the risk, too. And he made the judgment to join the Ranger relief column on their twenty-five mile trip from Pleiku to Plemei. Other photographers joined the column—Kyoichi Sawada of UPI, a Paris Match photographer and a film photographer, Charles Burnett of KLA-TV in Los Angeles. During the day there was only one minor contact with the Vietcong. It failed to slow the unit's progress.

Adams wrote in his journal:

By our first night out we were within a half mile of the camp. We sacked out in the jungle...with flares dropping all over us to guide air strikes which continued all night long...some of the bombing was dangerously close to us, but we didn't get hit...and fortunately the VC didn't hit us.

The next morning the relief force moved forward to join the camp's defenders.

We got to the edge of the jungle...could see the camp from a clearing and we ran up to the first line of barbed wire that surrounded the camp... saw two wounded soldiers lying in the open.... sniper fire opened up...I looked back about fifty yards to my rear...a machine gun opened up on us...a radio man and Burnett looked like they were dancing...they dropped...troops and a U.S. advisor moved up to Burnett right away... he was later evacuated. I cradled my camera in my arms and Sawada and I crawled on our bellies the next 100 yards into the camp...all sorts of fighting continued throughout the day...about fifty friendly casualties today.

The attack continued that night with heavy mortar bombardments a constant threat. *We were fortunate that we were not overrun,* Adams wrote. Adams photographed the battle, planes dropping supplies on the camp, the wounded brought into the camp on the backs of their buddies. He watched bombing and napalm attacks from U.S. aircraft that dropped explosives just barely outside the camp's perimeter.

The battle ended when the combined VC and North Vietnamese regulars withdrew, probably into the safety of nearby Cambodia.

Now came the trip home, relief from the war and its dangers, and holiday time with his family—whom he had not seen for nearly a year. He would return to his assignment in early 1966.

WITH FLAG FLYING

PLEI MEI, South Vietnam (AP) – The Special Forces camp at Plei Mei is a blasted wreck. It looked Saturday as if it had been tortured by an earthquake.

But blood of the Vietcong casualties from four days of fighting stained the ground outside and two flags still rippled defiantly above the camp.

One is the yellow and red flag of South Vietnam. It is of regulation size. The other is the U.S. flag. It is small, six by ten inches.

The American flag was raised by Sgt. First Class Joseph D. Bailey of Lebanon, Tennessee. Bailey raised the miniature Stars and Stripes on a staff next to the tin-roofed, bamboo-sided quarters of the U.S. advisors.

"If we've got to go down", he said, "we'll go down under our own colors."

Minutes later Bailey was dead. Small arms fire killed him on a rescue run to a crashed helicopter. A captain and a medic, himself wounded, carried the body back into the camp. The crew of the helicopter shot down by the VC were all killed in the crash.

"Let's keep that flag up there," the captain said.

The captain, his face darkened by the sun, greeted the Vietcong with enthusiasm. His carbine was never silent.

"Those Vietcong are just like ants, swarming all over the place," he said, slapping another clip in his weapon. "The first time they came at us they had large bushes tied to their backs. We let 'em have it. They were out in the open and it was just like shooting ducks."

"But they can fight; some got through our barbed wire. They overran an outpost right at the start and took a Montagnard lieutenant prisoner but he escaped later on."

Another U.S. soldier said some of the enemy machine gunners were chained to their guns to insure that they would stay put.

-EDDIE ADAMS

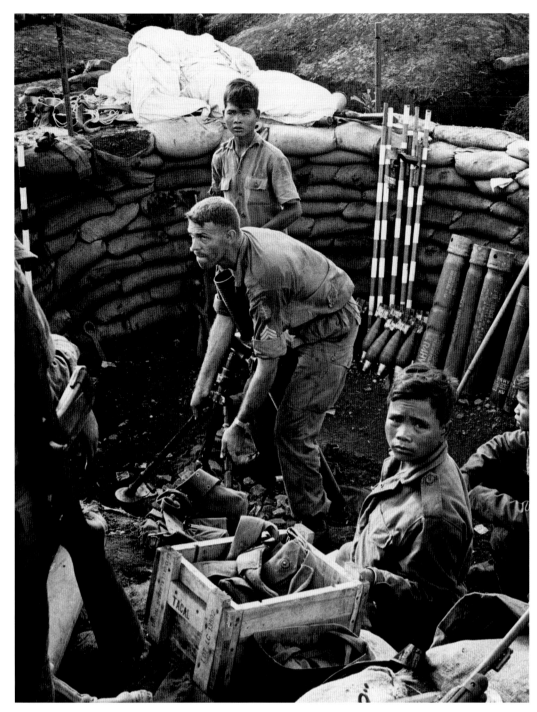

PREVIOUS PAGE: PARACHUTES BILLOW IN THE WIND SHORTLY
AFTER THEY HIT THE GROUND AT PLEI ME LAST WEEKEND DURING AN
ATTACK ON THE SPECIAL FORCES MONTAGNARD POST BY VIETCONG
GUERRILLAS. THE SUPPLIES ENABLED THE VIETNAMESE TROOPS AND THEIR
AMERICAN ADVISORS TO STAVE OFF GUERRILLA ATTACKS UNTIL REIN-
FORCEMENTS ARRIVED.

ABOVE: WARM-UP BEFORE AIR STRIKE
SOUTH VIETNAMESE AIRFORCE SKYRAIDERS WARM UP MOTORS AT
DANANG AIRBASE BEFORE TAKEOFF MARCH 21 FOR RAID ON VU CON, 15
MILES INSIDE COMMUNIST NORTH VIETNAM. THE SKYRAIDERS LATER
POURED FIFTY-TWO TONS OF BOMBS AND ROCKETS DURING THE TEN-
MINUTE RAID ON THE COMMUNIST MILITARY BASE. ABOUT FORTY U.S. AIR
FORCE JETS HAD REPORTEDLY BLASTED ANTI-AIRCRAFT POSITIONS BEFORE
THE ATTACK. IT WAS THE 8TH AIR STRIKE INTO THE RED NORTH SINCE A
SERIES OF U.S. AND SOUTH VIETNAMESE RAIDS BEGAN FEB.7.

OPPOSITE: U.S. AND VIETNAMESE TROOPS SET UP MORTAR
POSITION AT PLEIMEI.

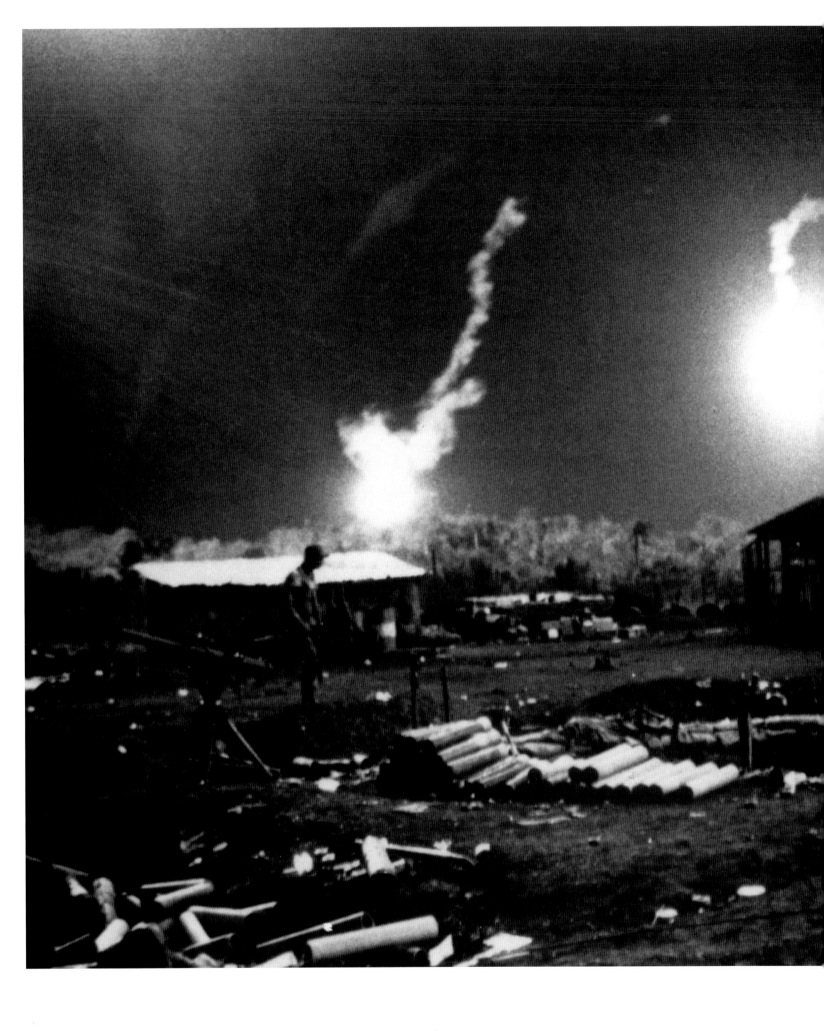

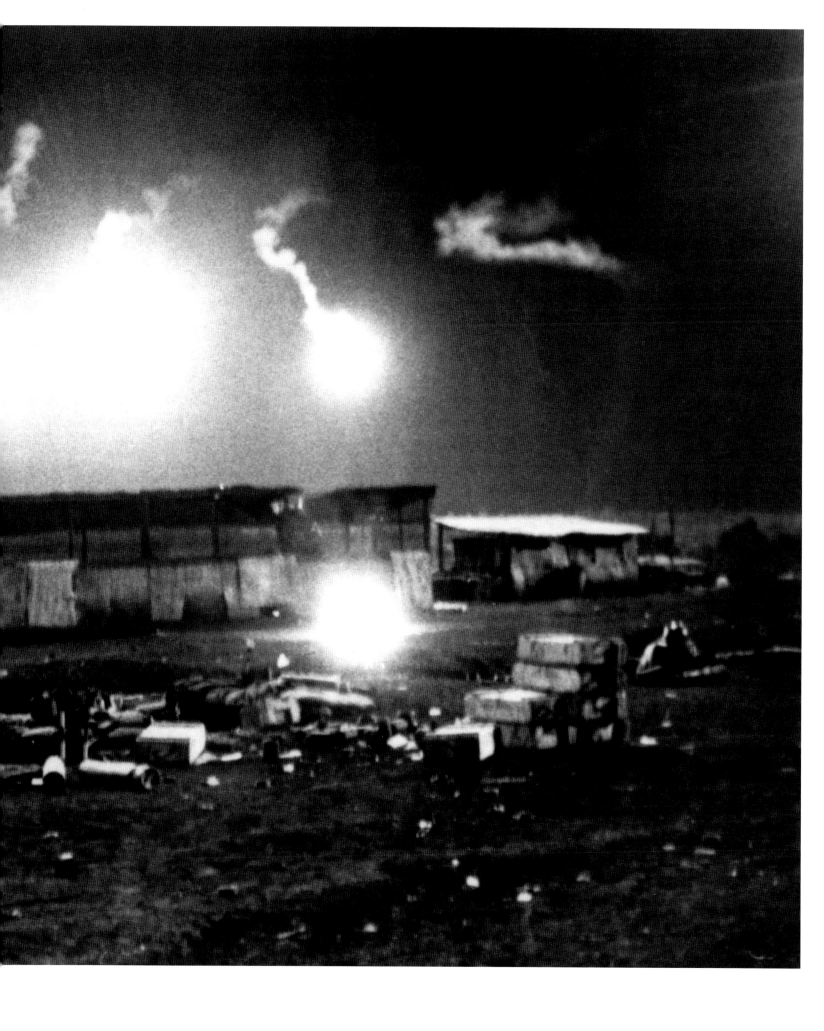

FLARES DROPPED BY U.S. AIR FORCE PLANES LEAVE WHITE TRAILS OF SMOKE AS THEY DROP INTO THE BELEAGUERED U.S. SPECIAL FORCES OUTPOST AT PLEI ME, SOUTH VIETNAM. BITTER FIGHTING CONTINUED THROUGHOUT THE NIGHT AS VIETCONG GUERRILLAS PRESSED THE ATTACK DESPITE POUNDING BY U.S. PLANES AND WITHERING FIRE FROM THE CAMP.

MONTAGNARD SOLDIERS PATROL PLEI ME, ABOUT 210 MILES NORTH OF SAIGON, DURING AN ATTACK BY A LARGE NUMBER OF VIETCONG GUERRILLAS. THE DEFENDERS WERE BESEIGED FOR SEVERAL DAYS BEFORE THEY BEAT OFF THE ATTACKERS.

THERE ARE SO MANY SEATS ON A HELICOPTER, WHOEVER GETS THE FIRST SEATS GETS ON. THE GUY FROM THE LITTLE CIRCULATION OF THREE HAD JUST AS MUCH WEIGHT AS YOU DID—EVEN THOUGH YOUR PICTURES WERE GOING WORLDWIDE.

AIRDROPPING SUPPLIES IN PLEI ME, VIETNAM, OCTOBER 1965.

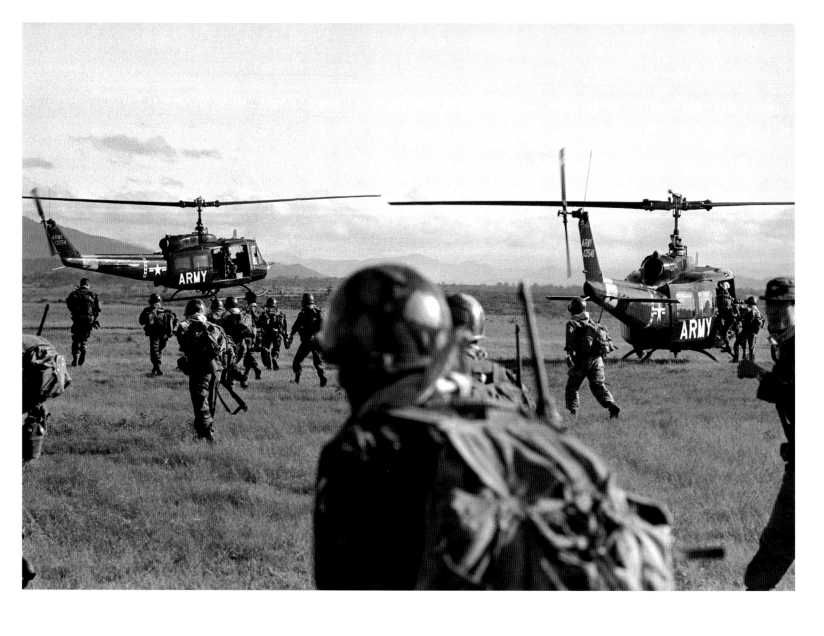

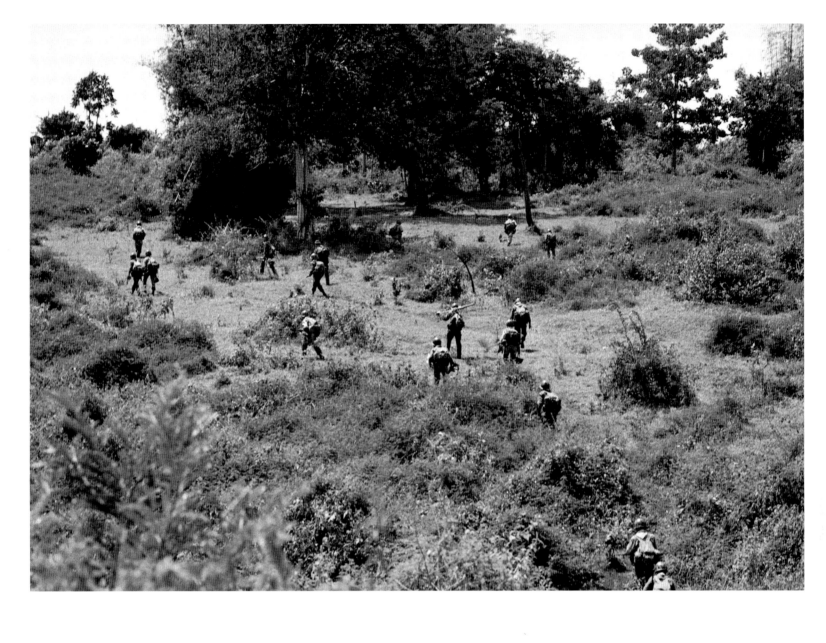

U.S. MARINES AND GOVERNMENT FORCES, PLEI ME, VIETNAM, OCTOBER 1965.

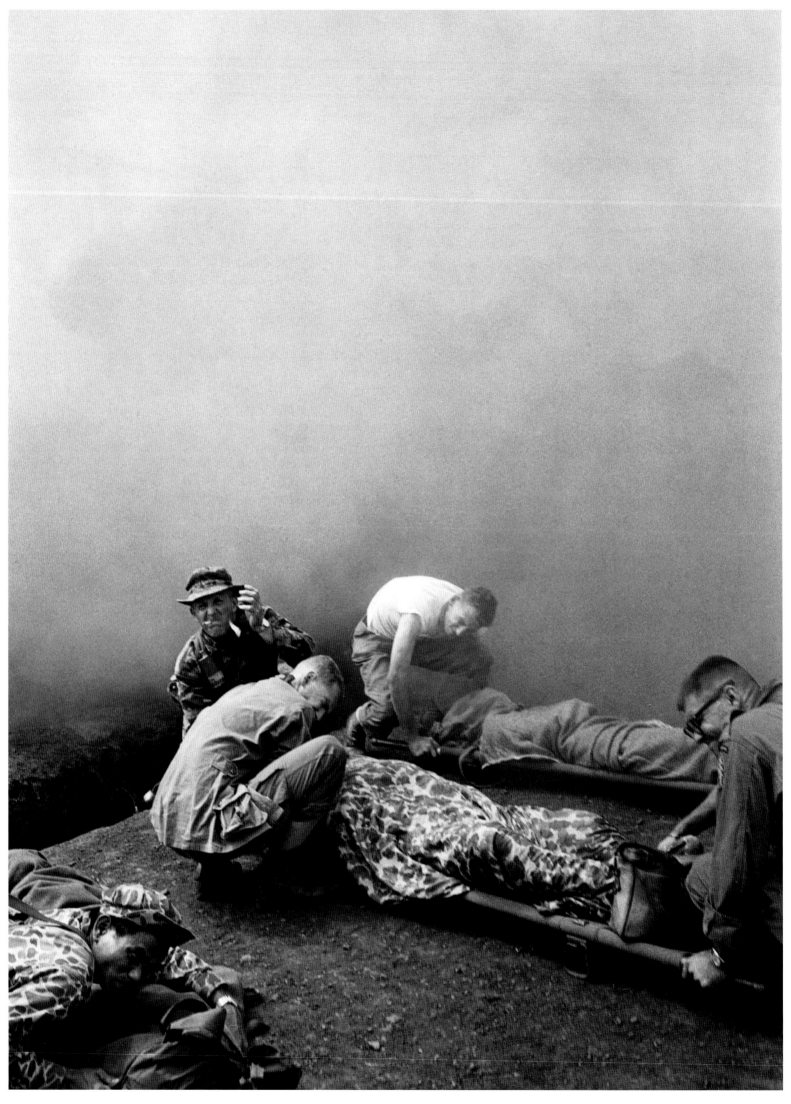

U.S. MARINES AND GOVERNMENT FORCES TEND TO THE WOUNDED AMIDST FIGHTING, PLEI ME, VIETNAM, OCTOBER 1965.

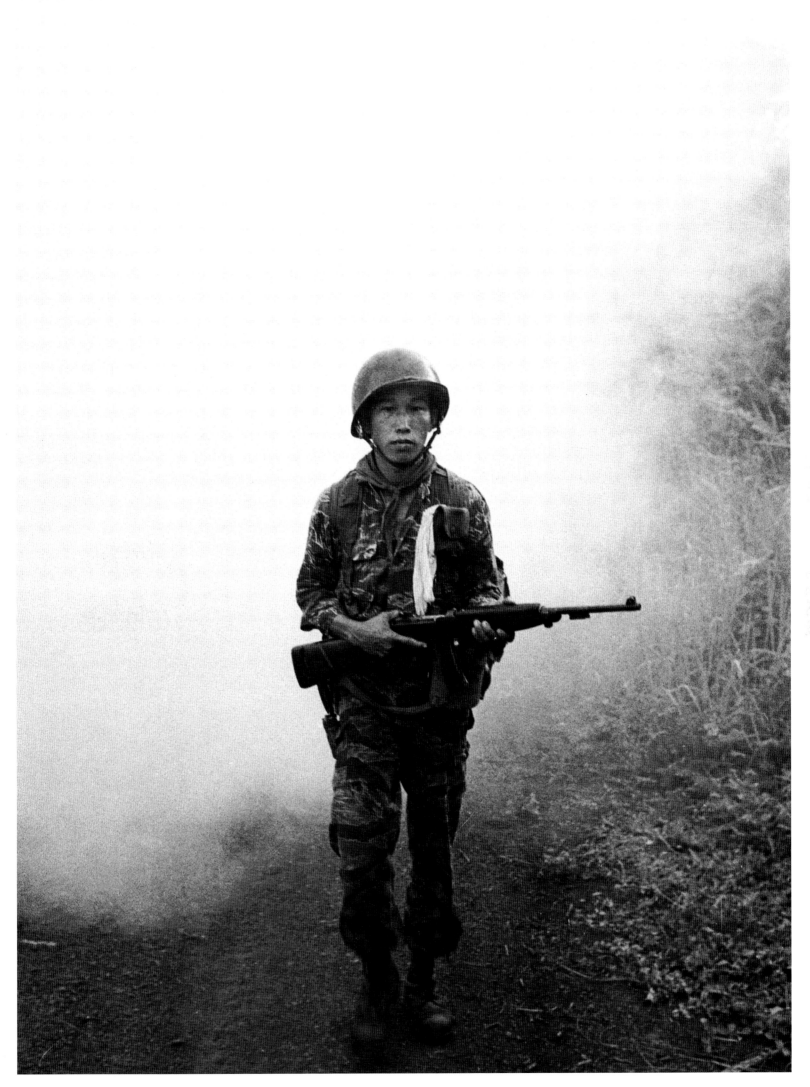

SOUTH VIETNAMESE SOLDIER, PLEI ME, VIETNAM, OCTOBER 1965.

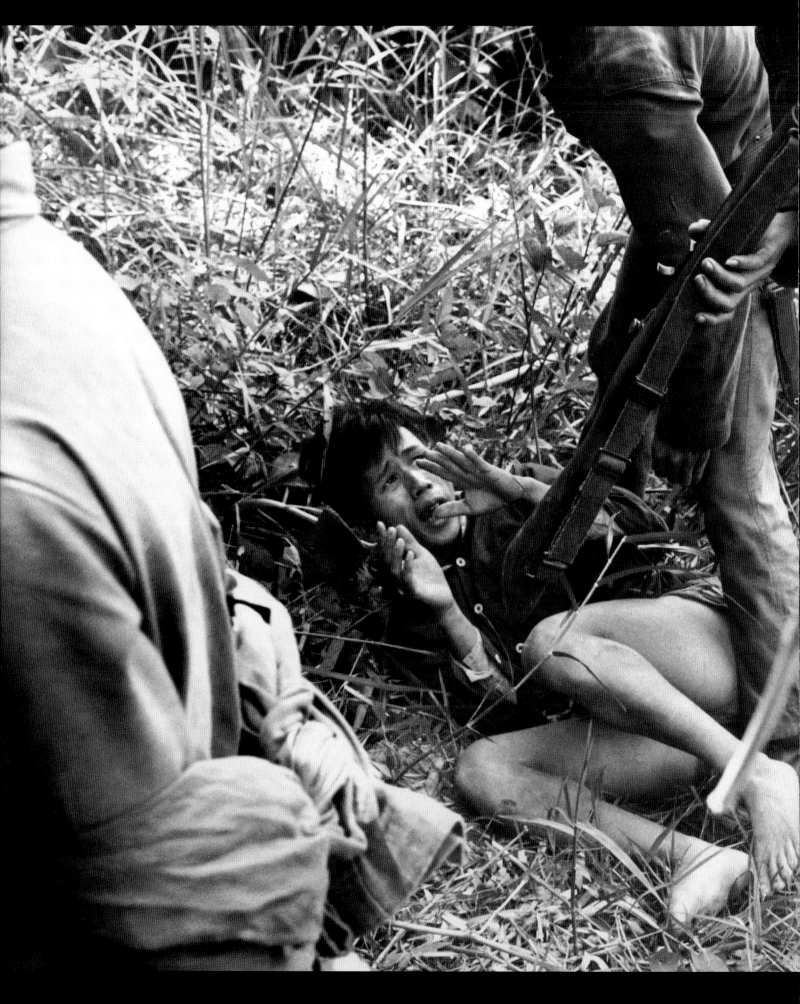

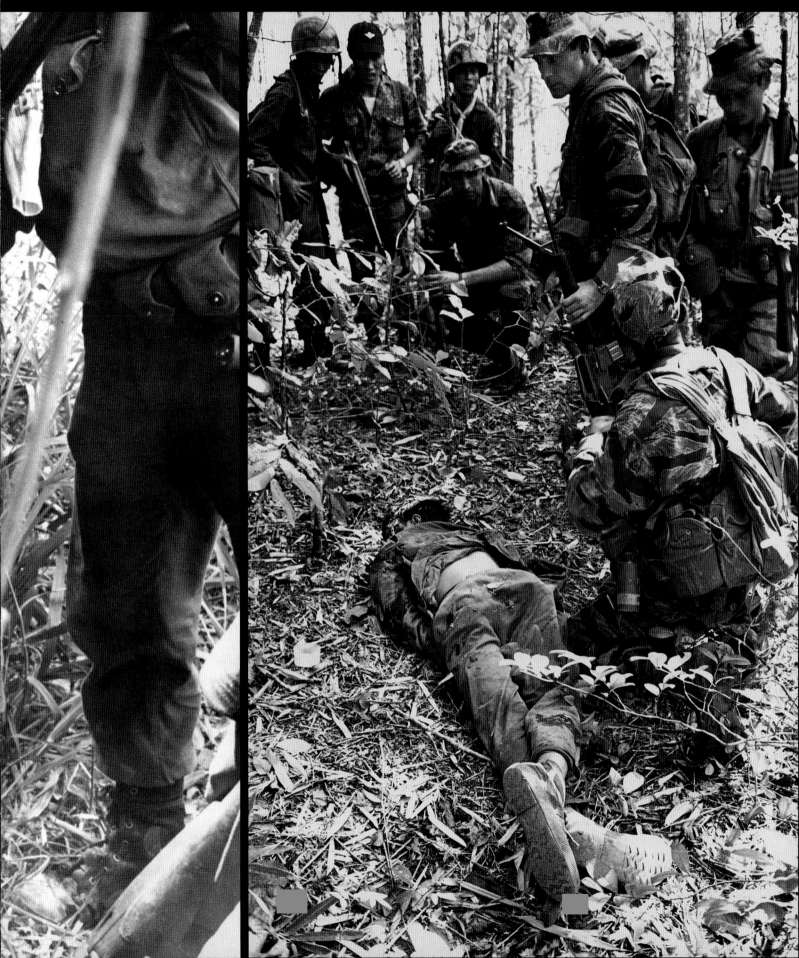

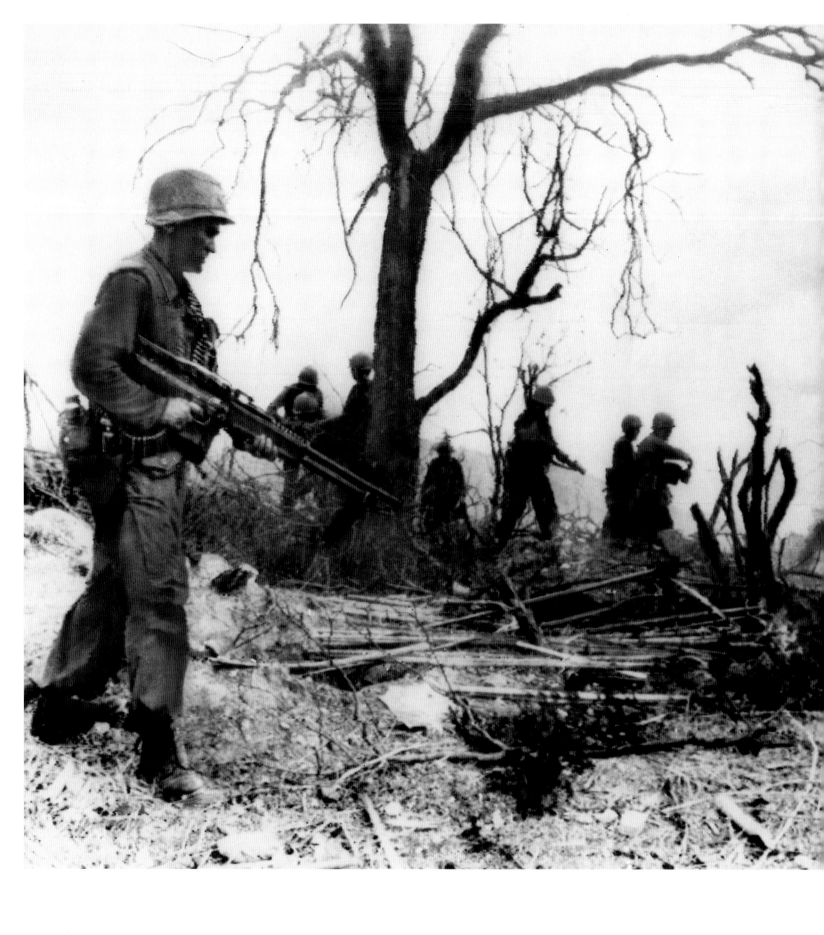

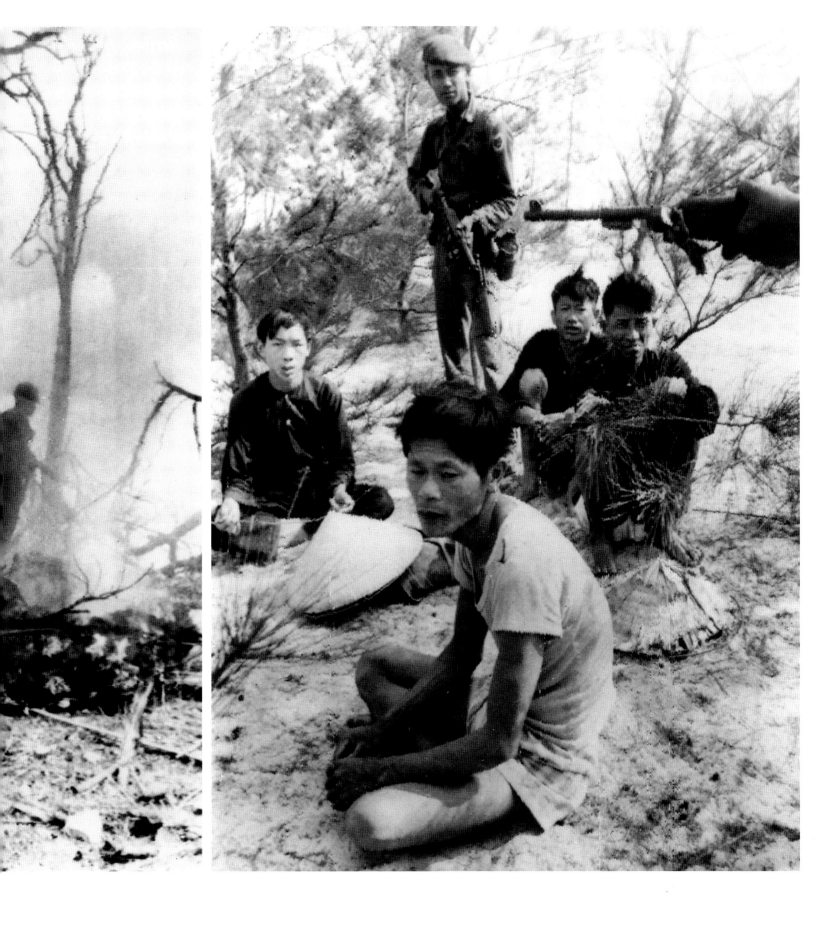

ABOVE: CAPTURED VIETCONG.

OPPOSITE: MEN OF THE U.S. FIRST CAVALRY DIVISION, FERRIED INTO
PLEI ME BY HELICOPTERS, MOVE CAUTIOUSLY OVER THE CREST OF A HILL
OCTOBER 26, 1965, SEARCHING FOR REAR-GUARD ELEMENTS OF THE VIET-
CONG FORCE THAT HAD KEPT THE OUTPOST UNDER SIEGE FOR A
WEEK. SOLDIER AT LEFT CARRIES A LIGHT MACHINE GUN AS HE
APPROACHES BURNING PILE OF UNDERBRUSH.

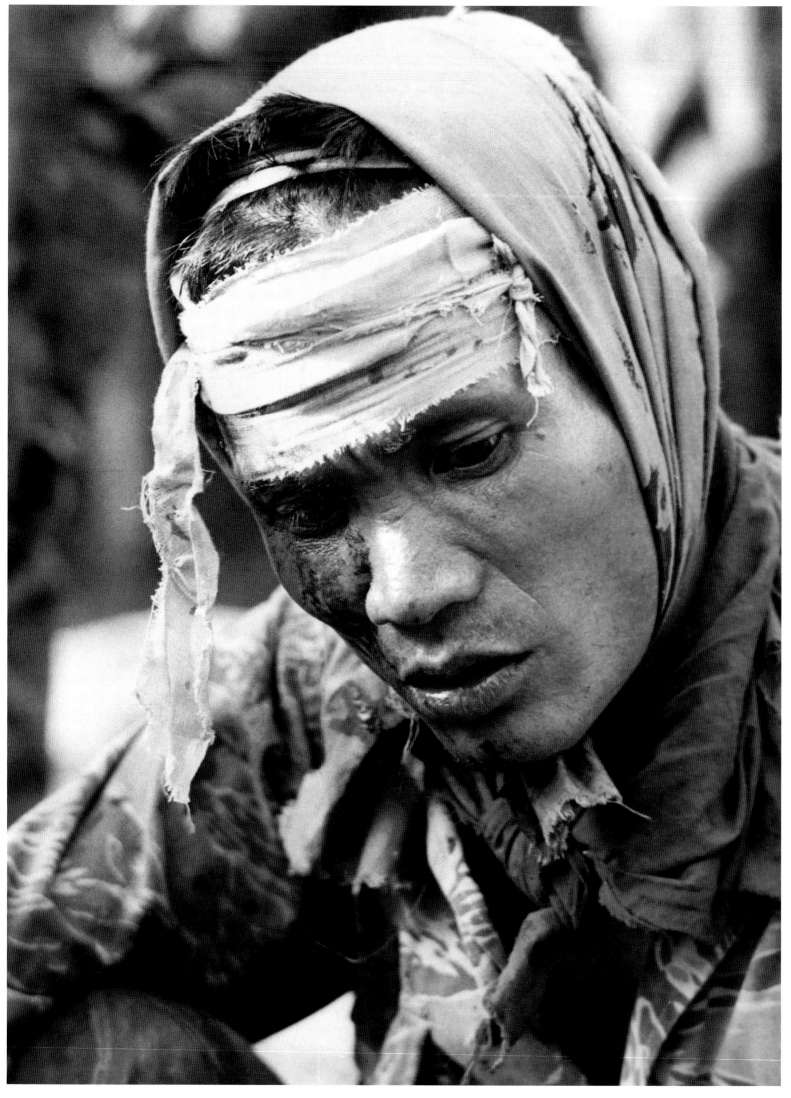

WOUNDED SOUTH VIETNAMESE SOLDIER, PLEI ME, VIETNAM, OCTOBER 1965.

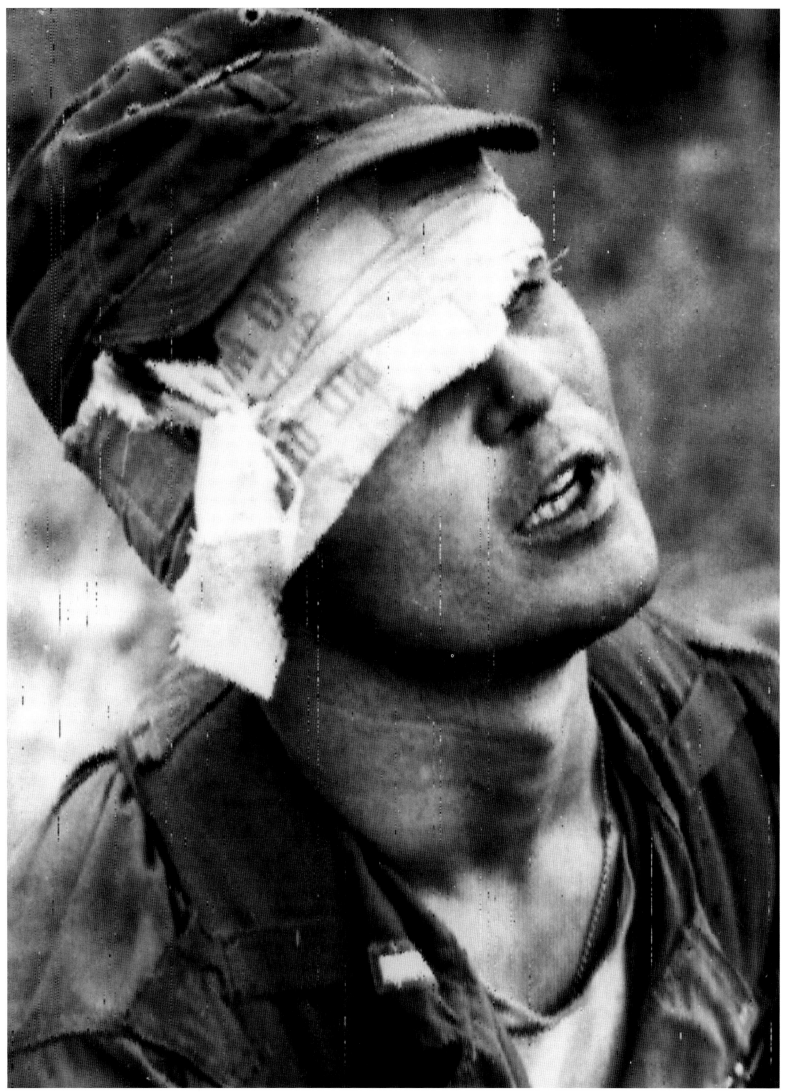

U.S. ARMY LT. JAMES GLEASON, A BANDAGE OVER A HEAD WOUND, TALKS TO FELLOW SOLDIERS AFTER SURVIVING A HEAVY VIETCONG AMBUSH JUNE 30 NEAR CHEO REO IN THE CENTRAL HIGHLANDS OF VIETNAM. GLEASON AND OTHER AMERICANS WERE ADVISING A VIETNAMESE FORCE WHICH WAS TO EVACUATE A SMALL TOWN NEAR CHEO REO WHEN THE GUERRILLAS ATTACKED THE MOTORIZED CONVOY.

1966 ESCALATION

Holidays end. Wars continue. Adams returned to his Vietnam assignment in January, right after the New Year. By January 10 he was on the wire with a story of a 1st Cavalry attack on a North Vietnamese campsite inside Vietnam but less than a football field's distance from the Cambodian border. It was the closest to Cambodia that American troops had ever operated; Washington ordered that no U.S. troops should enter Cambodia's territory.

The story Adams wrote had a humorous lead: *Along the Cambodian Frontier (AP) – U.S. troops have captured and burned four Vietcong camps 100 feet from Cambodia's border, striking so swiftly a Communist general left his toothbrush behind.*

American troops found the toothbrush and toothpaste in a blue and white checkered bag when they took the Communist hideout.

Pinned to the bag was the single silver star of a brigadier general. The camp was set afire.

But there was no contact with the North Vietnamese, or the Vietcong. The most anyone saw was a group of khaki-and black-clad troops flee across a river into Cambodia. Adams spent several days with the GIs, watched them locate other campsites and see other signs of Communist military activity. He caught a helicopter flight back to Danang.

Days later he climbed aboard a medevac to cover a battle thirty miles north of Saigon, where a U.S. unit had been attacked during the early morning hours. He reported a good story but was too late for pictures. He returned to Danang reminded—and discouraged by the recollection—that not every operation results in dramatic pictures.

Unpredictability, however, works both ways, sometimes pitching the combat photographer into benign situations, but other times into fearsome, hellish confrontations that are chaotic and complex, a mix ripe for error and death. On the first of February Adams's pursuit

of pictures took him into a near-fatal encounter in a Vietnamese graveyard. He rode a medical evacuation helicopter to the site near Hoai Chau where the VC had wounded a number of Americans. The chopper settled down on a soft, sandy rise in a cemetery surrounded by jungle. At the moment of touchdown the wounded ran an erratic path through the gravestones to board the helicopter, their faces twisted against the sting of sand whipped up by rotor blades. Snipers opened up. Adams photographed the bizarre scene. Those not wounded took cover in a ditch or behind gravestones.

He wrote that one of the men not hurt said, *I hope we get moved out of here. There isn't much left of the company.*

As the helicopters lifted off with the wounded, Vietcong sniper fire increased. Adams and three others, caught in the open, inched forward when a sudden blast of fire came in from a new direction on the right flank.

We slammed into the ground, Adams wrote, *and more fire opened up. A mortar shell kicked up a geyser of earth not too far away on our left rear.* Fire increased. Grenades, mortars and fifty and thirty-caliber machine gun bullets came racing and blasting around them. Tracer bullets screamed over their heads and picked at the earth between the four. Adams hugged his arms close to his hips and lay facedown in the sand. His chin began compulsively digging a hole. The onslaught continued for some fifteen minutes. At that moment an American soldier behind them stood to his feet and cried out, *We're Americans, we're Americans…don't shoot.* He threw a purple smoke grenade to the ground. As he stood there an incoming grenade plopped into the command group just fifty yards away. Five men were hit, including a television cameraman.

Lying there in the sand, Adams wrote, *I began to realize that this was not the enemy shooting at us. The firing slackened off and stopped. Lumbering into view were half a dozen armored troop-carrying vehicles. Clinging to them were Vietnamese paratroopers. It was they who had been lacing us with their fire power.*

I stood up and walked over to an American

LYING THERE IN THE SAND I BEGAN TO REALIZE THAT THIS WAS NOT THE ENEMY SHOOTING AT US.

advisor with the Vietnamese. *"How could this happen?"*

He replied, *Well, we got fire from this direction, and we returned it.*

American troop strength by the spring of 1966 had escalated to some 200,000, mostly combat troops. The war took on a decidedly American face.

More Americans in combat meant that there was little let-up in the action; Adams became a commuter on medical evacuation helicopters that hurried to battle sites to pick up wounded, leaving him behind to photograph the battle or cover the debris. He moved from battle site to site, sometimes making storytelling pictures,

sometimes producing little of worth. A weekend visit to Saigon to catch up on sleep, have a drink with friends and a good dinner ended in more coverage, this time of street demonstrations. A beating from rioters was thrown in for good measure.

Brief story summaries of only a few of the clashes Adams covered during this period capture the pace of an escalating war (page 118).

The need for coverage increased as the number of Americans involved in battle increased; coverage became frenetic. There were more dangerous patrols and more movement from battle to battle with the accompanying risky rides on helicopters. Operations were larger. The entry of North Vietnamese regulars

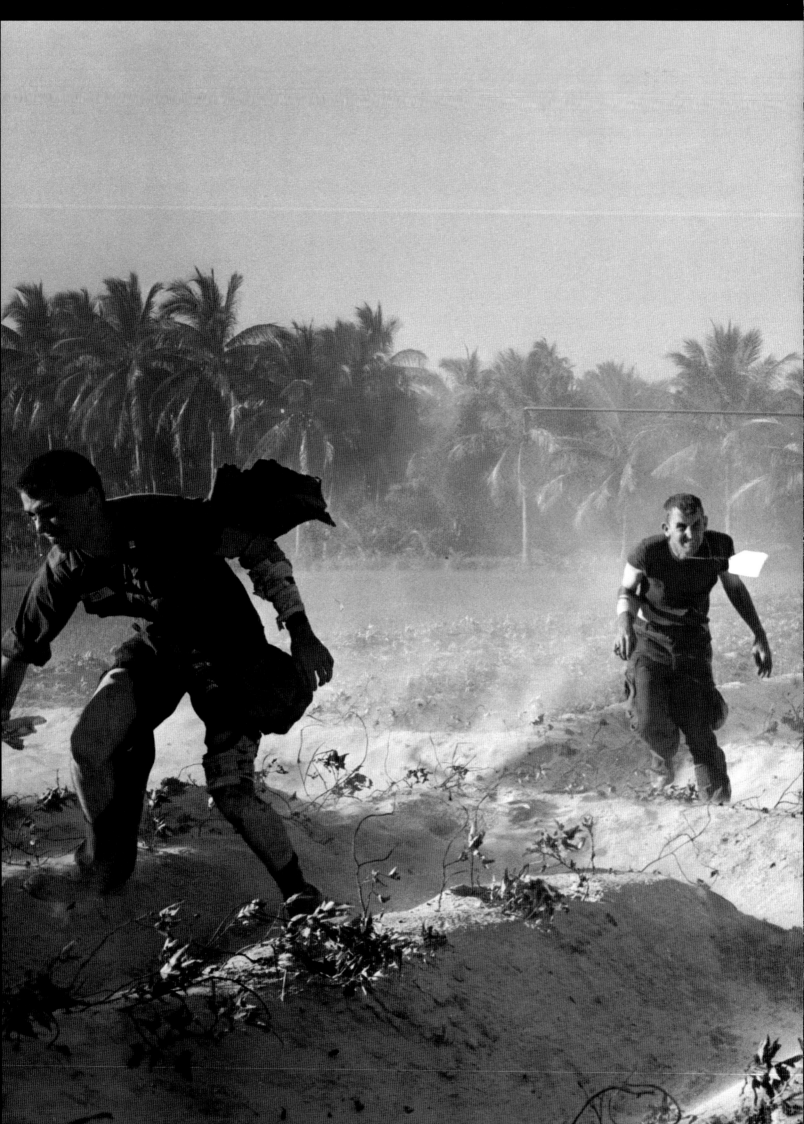

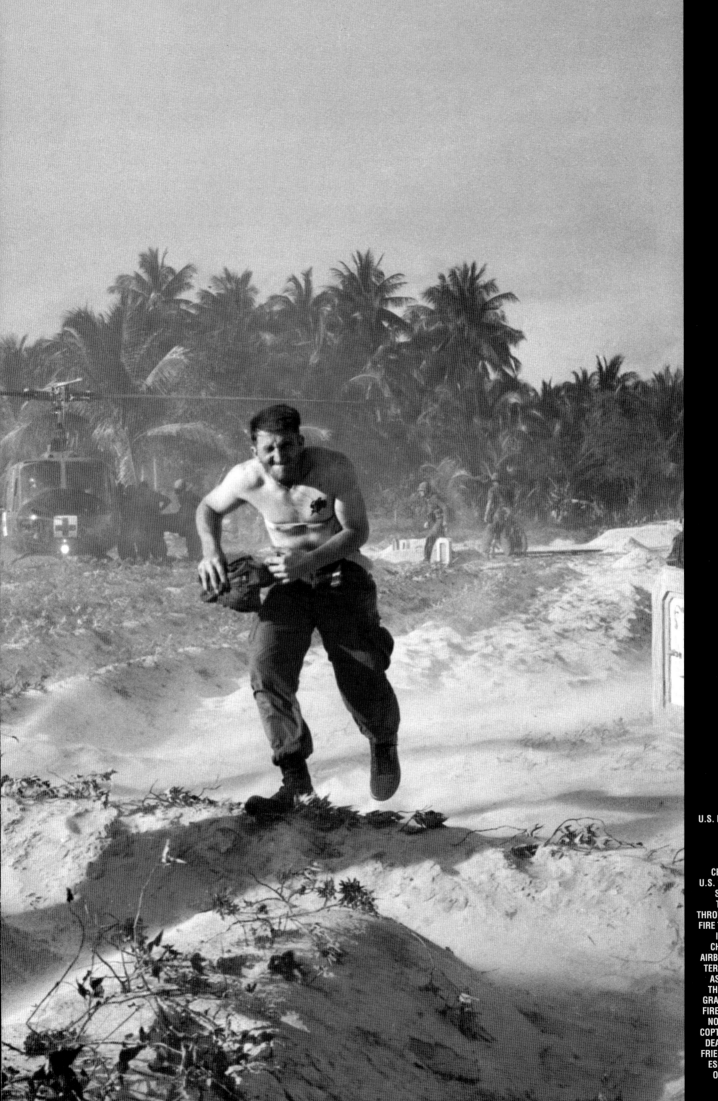

4 NEXT PAGES:
U.S. MARINE, 1ST CALVARY,
HOAI CHAU, VIETNAM,
JANUARY 31, 1966.

ESCAPE THROUGH
CEMETERY. A GROUP OF
U.S. 1ST CAVALRY DIVISION
SOLDIERS, SEVERAL OF
THEM WOUNDED, RACE
THROUGH VIETCONG SNIPER
FIRE TO REACH HELICOPTER
IN A CEMETERY IN HOAI
CHAU JAN.31. SAND AND
AIRBLASTS FROM HELICOP-
TER ROTOR WHIP AT THEM
AS THEY DASH THROUGH
THE CEMETERY, DODGING
GRAVESTONES AND ENEMY
FIRE. TROOPS OF THE UNIT
NOT EVACUATED ON HELI-
COPTER WERE CAUGHT IN A
DEADLY CROSSFIRE WHEN
FRIENDLY SOUTH VIETNAM-
ESE TROOPS MISTAKENLY
OPENED FIRE ON THEM

brought heavier and more prolonged attacks. Adams exposed himself regularly to danger. As was the case with other photographers, he probably saw more action than most military.

If there was a battle in the Delta we'd take off and get on a helicopter, and once you get down to the Delta we spent two or three days covering the war, get back on the helicopter and go out with the wounded, and go back to Saigon and have your film processed, get drunk and whatever for a day or two and then go up to Danang because the Marines were in some deep doo-doo...so we would hop, skip and jump from site to site...you'd be with the Army down here, with Marines over there, with the First Cav over here, with 173rd Airborne over there...we would go with all the battles instead of just locking onto one unit.

Operations came and went; film was dispatched to Saigon; radio circuits carried pictures to the world; print packages were dispatched almost daily from the productive Saigon office. Through it all, however, a single experience remained indelibly in Adams's memory—that day in the Hoa Chau cemetery.

He recalled later:

I was with Jack Lawrence from CBS and we were pinned down in a cemetery, right in the middle of the Vietcong and South Vietnamese troops... and it's about seven in the evening, and we watched the tracers just kick up around Lawrence and myself just outlining our bodies in the sand... When those shells started flying I dug my head into the dirt and kept trying to dig in deeper. There were shells dropping all around us... It was a miracle I wasn't killed... and that really got us spooked... you know, we were pretty well spooked... and it stayed with me until weeks later.... After that I called it... it was too close. I wrote a letter to the AP asking to return home... and I thought it was all over. I never wanted to see the place again.

Peter Arnett remembers the day Adams came to Saigon and took him aside and asked him to help write the letter to AP headquarters asking for reassignment to New York. Arnett told the story of their conversation in an article on the web site of *The Digital Journalist* in which he recalled how emotionally upset Adams was. He believed he would be seen as "chicken," and as abandoning his friends. But Adams would say in the same breath that he'd had it with Vietnam...he didn't want to be killed there. Arnett recalled his response to Adams— that he had been in action for almost a solid year, unlike many others who came in for short periods. He explained to Adams that he and Ed White and Horst Faas and George Esper and Henri Huet and the Vietnamese staff had families in Vietnam and were there for the duration. He assured Adams that everyone knew he had done more than his share and that he really didn't have to write an apologetic letter. Adams insisted, and Arnett helped him. Wes Gallagher, AP's General Manager, himself a veteran war correspondent from World War II, wrote back with approval for reassignment and thanking him profusely for his work.

Adams left Vietnam never to return...or so he thought.

KNEE DEEP IN WAR

Februray. 22
BOI LOI WOODS, Vietnam (AP) – The private walked over to the poncho-covered bodies. He uncovered the face of one, knelt and touched the crucifix hanging from his neck to the lips of the dead man.

Then he put the poncho back in place, got to his feet and kicked bitterly at the dirt as he walked away.

Only a few hours earlier the young officer whose body was beneath the poncho had been joking about going home, saying, "Just wait until I get back..."

Februray. 24
TAN BINH, Vietnam (AP) – A bulldozer tore into soft jungle ground to dig a mass grave for eigty-nine enemy dead.

The huge hole marked the battleground where, before dawn today, a brigade of the U.S. First Infantry Division withstood one of the fiercest Vietcong assaults of the war.

The Communists attacked at 230 a.m., lobbing mortar shells and firing recoilless rifles at the encampment. Then they swarmed toward the base, crossing a minefield in an attempt to take their objective. The fight lasted three and an half hours.

One Vietcong was dropped twenty yards from his goal, as he charged forward with a torpedo to blow a hole in the American barbed wire.

March 7
CHAU HAI, Vietnam (AP) – Slowly, silently a company of U.S. Marines went back for their dead on the hill with no name today.

Knee deep in the mud of the rice paddies they hardly deigned to reply to the Communist snipers who tried to halt their march.

They found the bodies where they had left them Friday afternoon on a small, barren hill of whitish clay where there had been no place to hide.

First, combat engineers groped around, searching for booby traps. Scavengers had stripped the bodies of weapons and equipment, but steel helmets lacerated by machine-gun bullets and discarded flak jackets were strewn about the field.

March 27
VINH LOC, Vietnam (AP) – A company of U.S. Marines fought a pitched, three-hour battle with North Vietnamese Army regulars Monday and estimated they killed 150 of the enemy.

April 3
SAIGON (AP) – Vietnamese riot police broke up an anti-government, anti-American demonstration by about 200 youths with clubs and tear gas early Sunday, using force for the first time in the current political crisis.

The 200 were a hard core of among thousands who demonstrated on Saturday roughing up several Westerners and shouting, "Down with America."

The crowd kicked and punched Western photographers and jumped on two U.S. military jeeps that attempted to get through. A motorcyclist who looked like an American soldier was stopped and pummeled, but managed to get away.

The photographers assaulted were Horst Faas and Eddie Adams of AP and Bob Schieffer of the *Fort Worth Star-Telegram.* None was hurt seriously.

-EDDIE ADAMS

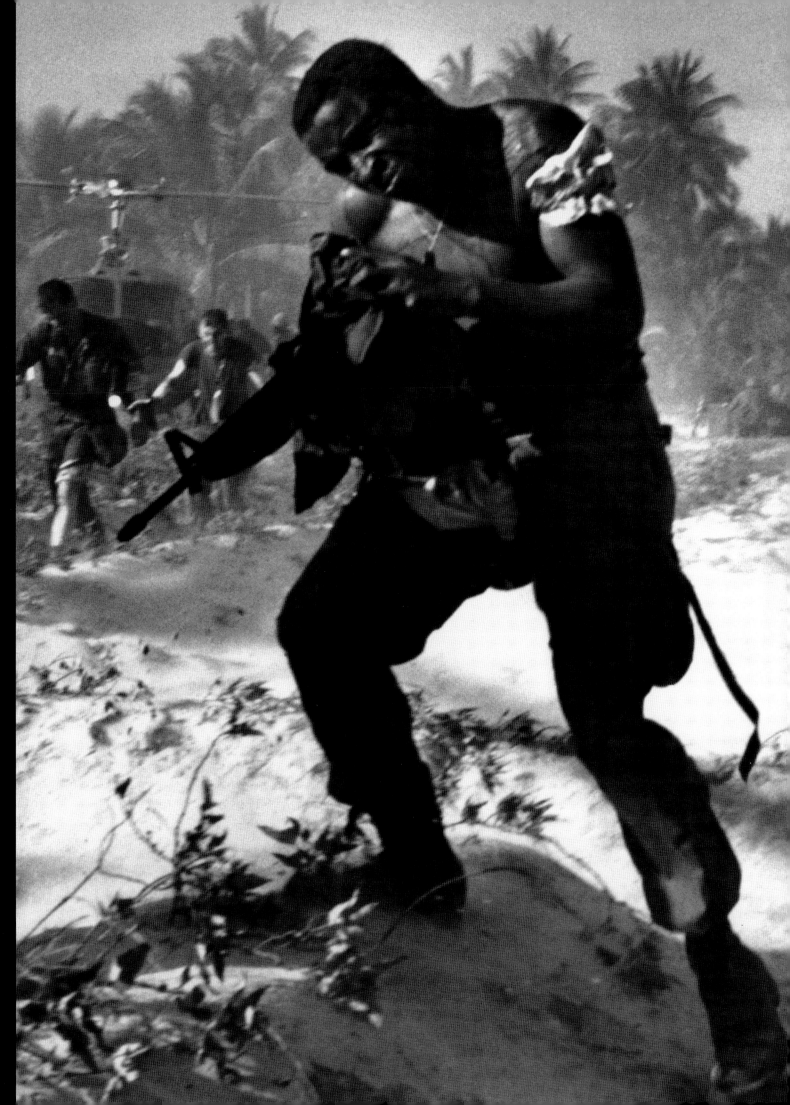

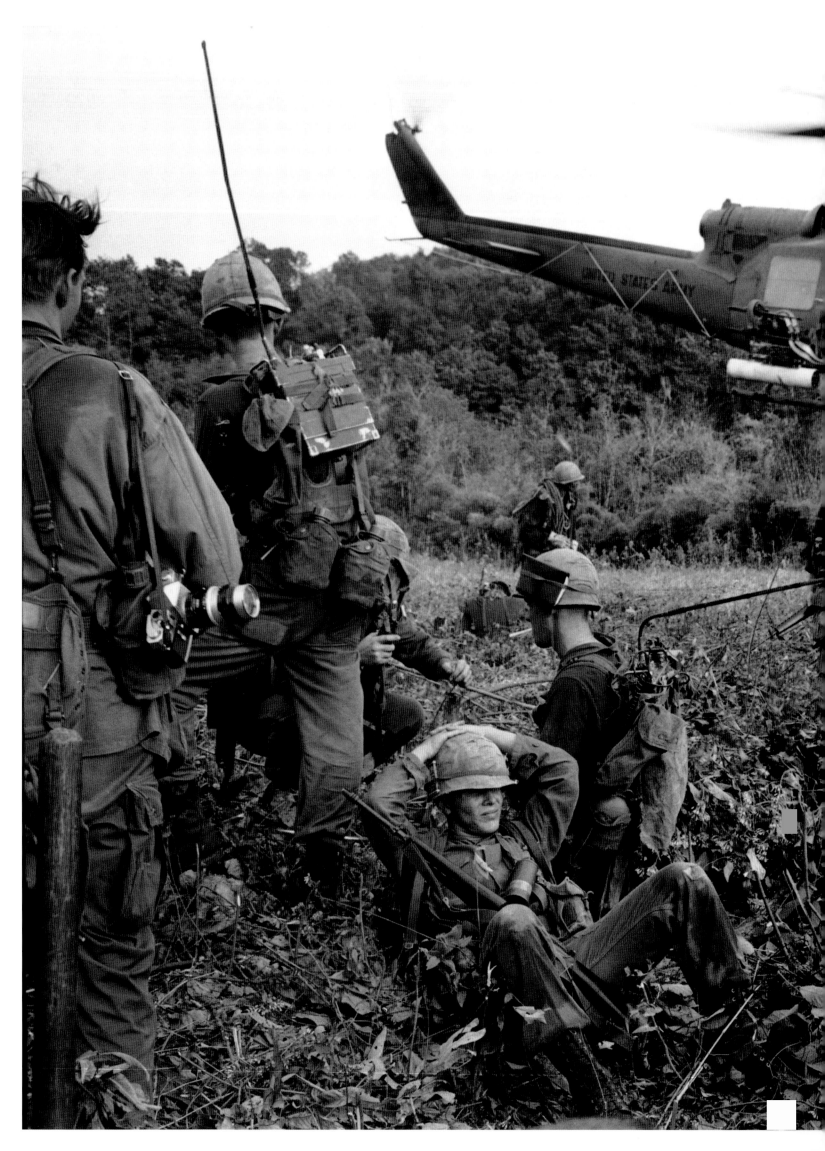

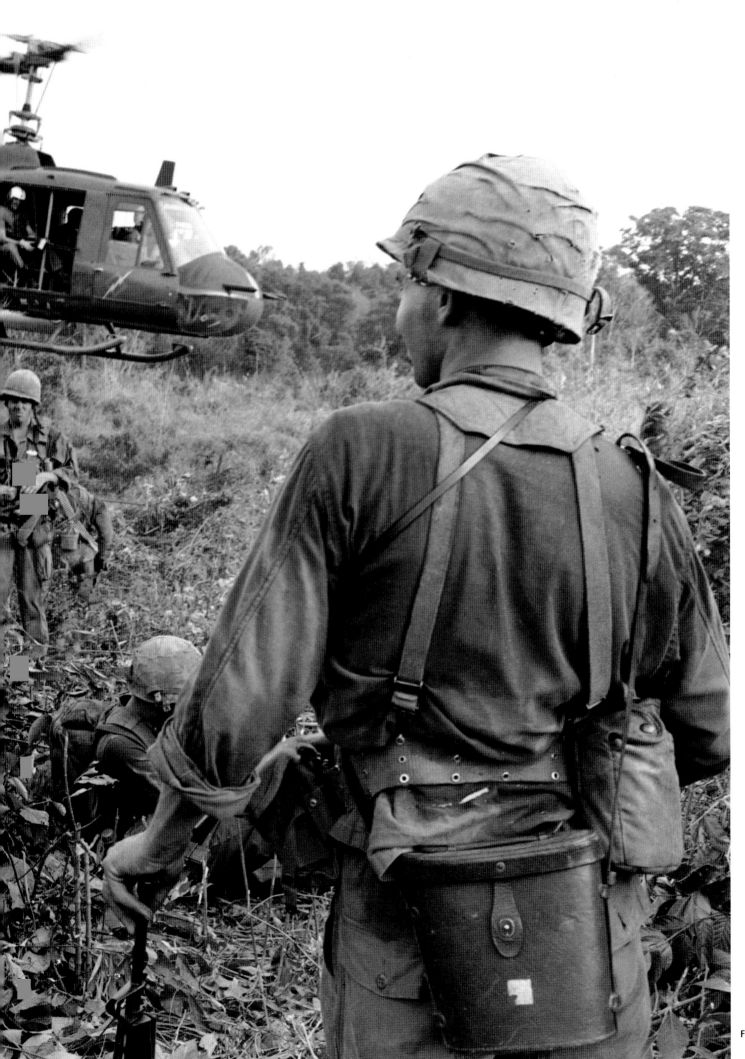

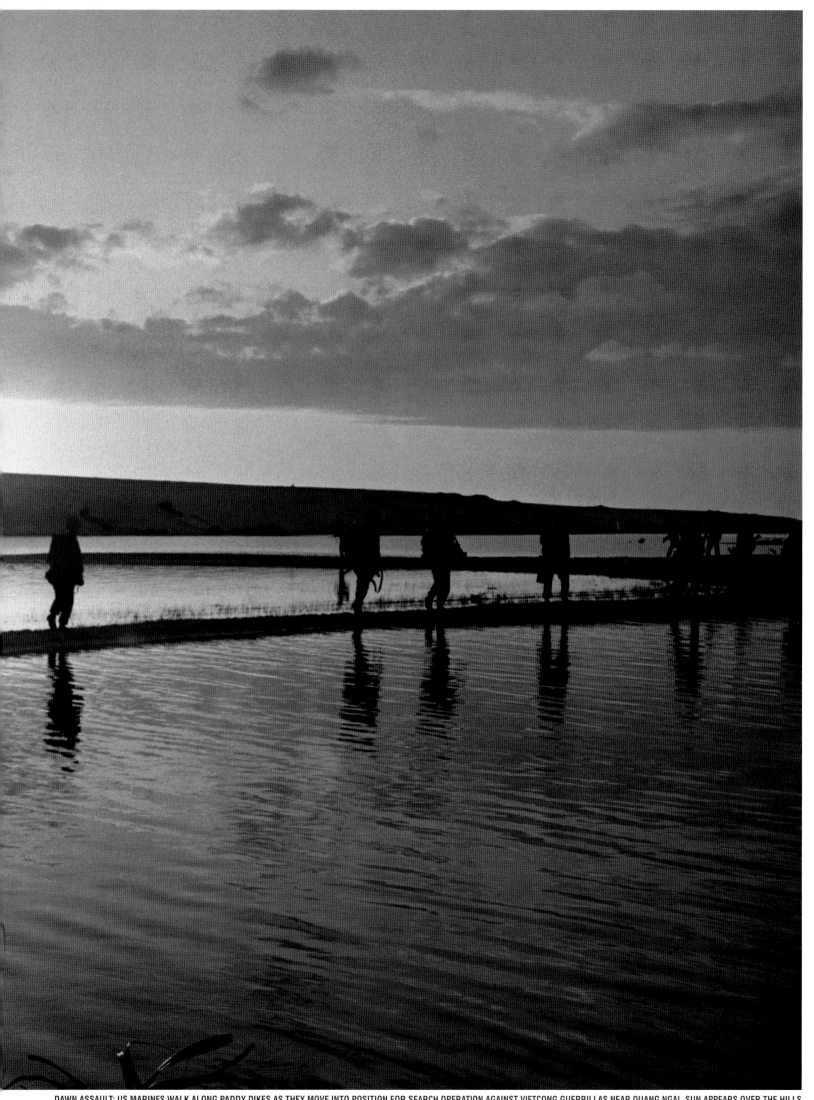

DAWN ASSAULT: US MARINES WALK ALONG PADDY DIKES AS THEY MOVE INTO POSITION FOR SEARCH OPERATION AGAINST VIETCONG GUERRILLAS NEAR QUANG NGAI. SUN APPEARS OVER THE HILLS AS THE LEATHERNECKS' COLUMN ADVANCES. JANUARY 29, 1966.

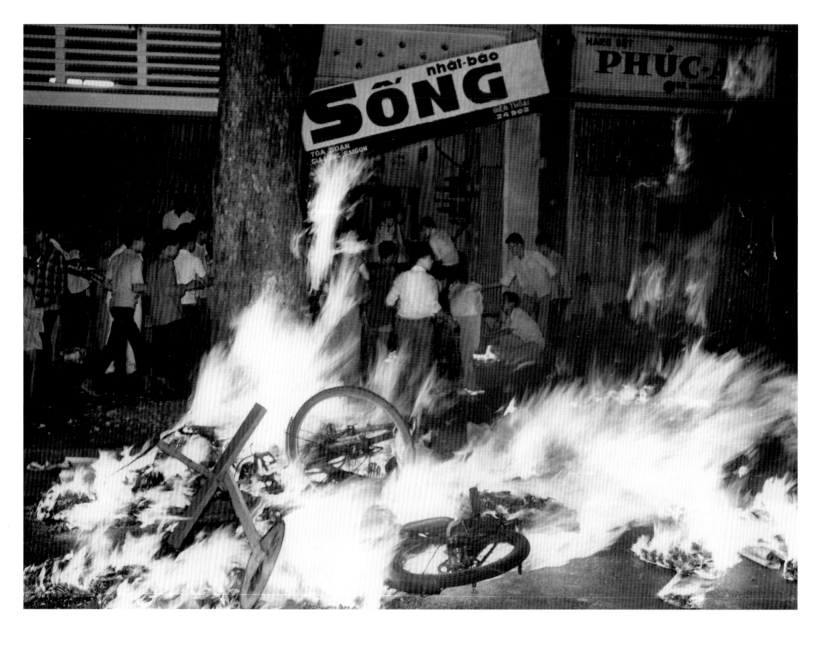

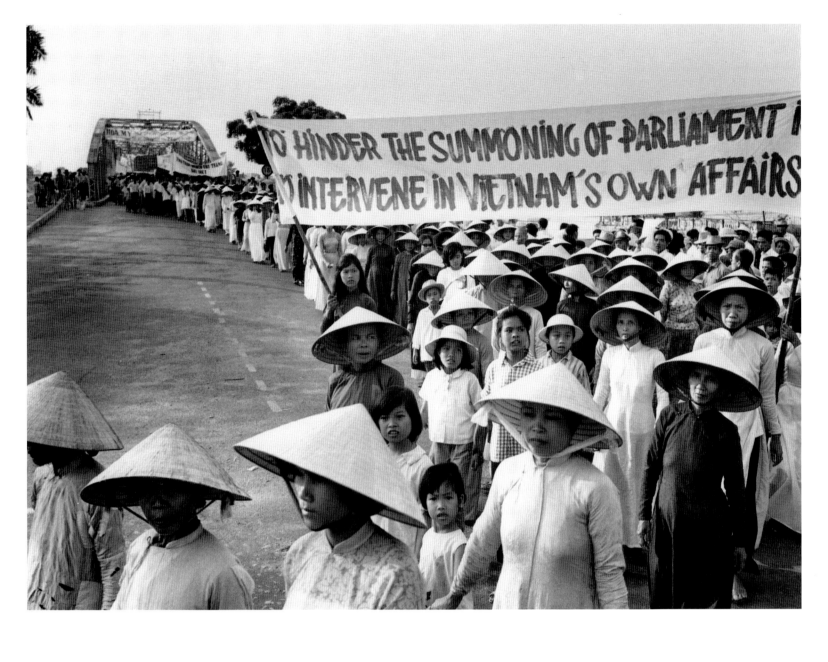

To hinder the summoning of parliament... to intervene in Vietnam's own affairs

ABOVE: OPPOSING SAIGON GOVERNMENT
SOME 10,000 SOUTH VIETNAMESE MARCHED ACROSS A BRIDGE IN HUE
MARCH 23, 1966 DURING A DEMONSTRATION AGAINST THE POLICIES OF
THE GOVERNMENT IN SAIGON AND PREMIER NGUYEN CAO KY. A SIMILAR
DEMONSTRATION WAS STAGED IN DANANG, NOT FAR AWAY. THE
DEMONSTRATIONS INTENSIFIED THE POLITICAL DISPUTE BETWEEN THE
MILITARY GOVERNMENT AND BUDDHIST LEADERS.

OPPOSITE: SAIGON NEWSPAPER SACKED
MOBS STAGING CONTINUOUS RIOTS IN SAIGON AGAINST THE SOUTH
VIETNAMESE GOVERNMENT SET FIRE TO MOTORBIKES APRIL 6, 1966 AFTER
RANSACKING THE NEWSPAPER OFFICES IN THE BACKGROUND. PREMIER
KY'S MILITARY GOVERNMENT, HOWEVER, APPEARED TO BE MAKING SOME
HEADWAY TOWARD ENDING THE COUNTRY'S POLITICAL CRISIS.

1967 BACK HOME

And so, Adams believed, the war for him was over. Back to life in these United States. There was plenty to cover: students were rioting on campuses, anti-war and pro-war demonstrations were commonplace, race riots left whole sections of metropolitan centers burned out, and American culture was changing at an alarming rate. He had barely shaken the dust off his combat boots; memories of a beating given him by a Saigon mob were still fresh. The AP assigned him to riots in Detroit. Scores were killed and millions of dollars in property were destroyed by fire.

Adams covered rioting in Newark also, just a short distance from his home in suburban New Jersey.

Coverage in these new surroundings was not what bugged him about being back in the U.S. Something else was missing. In many ways he was glad to be back; he had been separated from his family for far too long. There was ample coverage for his camera. But he was disappointed that he had not met his own goals in Vietnam. He groused. He complained.

There was more. He had really wanted out of Vietnam, but after returning he couldn't understand anyone. He described a scene he witnessed on a New York street:

It was a Marine, walking right across the street on Sixth Avenue and 50th street with crutches, and a cab almost hit him, and kept blasting his horn at him…and you know the kid could only walk so fast. And that bothered me…nobody really seemed to care about Vietnam at all…and that bothered me.

I walked into the AP office and I saw these guys just sitting there pounding away on their typewriters wearing their nice clothes…nobody cared. They didn't want to hear about Vietnam. And that really bothered me, you know, like, I think the only people who really were concerned about Vietnam were those with a son or a relative there…there was a war going on and nobody cared.

Months of frustration set in. He suffered from what many correspondents (and military) experienced: that they left their buddies behind, that there was no way an individual could understand or share the feelings of those who covered (or fought) the war. In New York many editors and photographers went home at night, pulled a big boulder in front of their doors and lived their private lives, as compared to Vietnam where social life, entertainment, work, and battle was one big ball of wax, and where the only subject was the war. And where, surreptitiously, Vietnam's exotic embrace seduced the most jaded American just as it had seduced generations of French colonialists.

It was true: The single dimension of life in Vietnam, the bonding that existed in that atmosphere and the sense of the story's importance was minimized on editors in the U.S. Vietnam, to them, was one of many stories they coped with daily. Adams in New York watched the pictures roll in from the battlefields of Asia, pictures that set his mind all the more to his belief that Vietnam was THE big story, a story few cared about as much as he did and, though he requested to be relieved of his Vietnam assignment in 1966, by late 1967 he asked to be returned to the war. His request was granted.

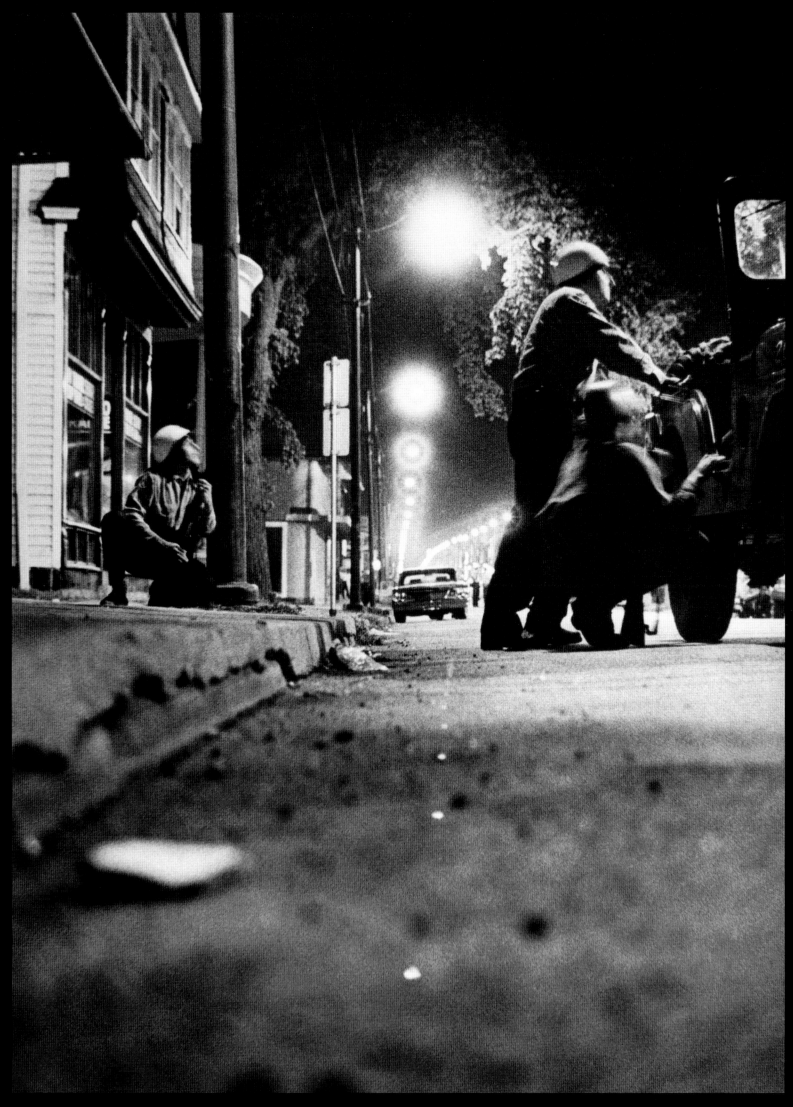

THE DETROIT RIOTS JULY 25-29, 1967.

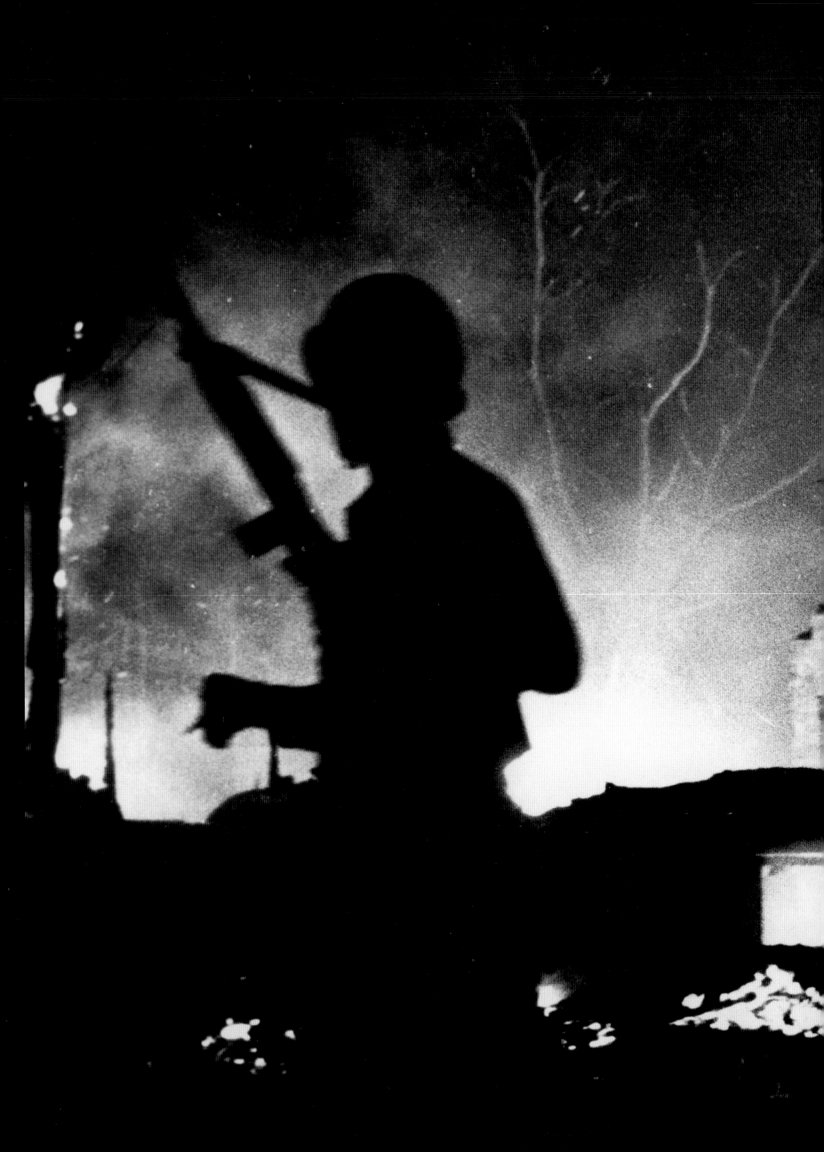

A SOLDIER IS SILHOUETTED IN THE FLAMES
OF A FIRE DURING RIOTS IN DETROIT,
JULY 25-29, 1967.

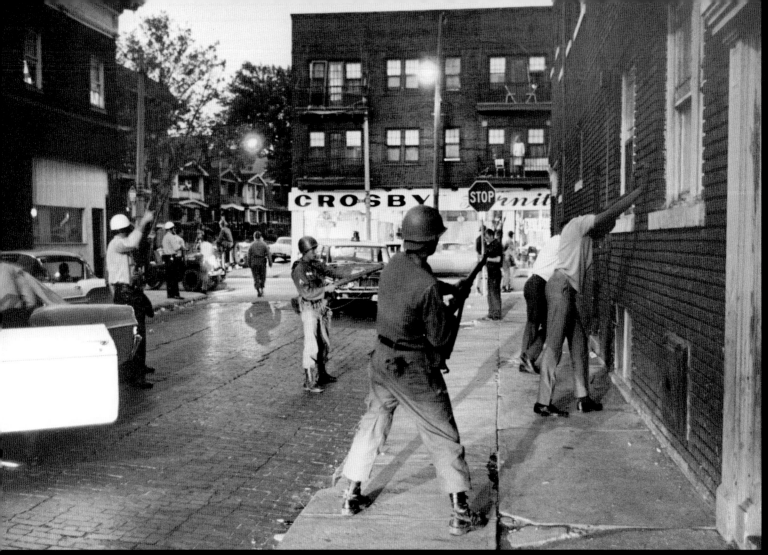

NATIONAL GUARDSMEN HOLD SUSPECTS ON A CLEVELAND STREET DURING SIXTH NIGHT OF RIOTING, JULY 1967.

THE LONG HOT SUMMER

DETROIT (AP) – The soft spoken airline captain announced over the plane's loudspeaker, "Ladies and Gentlemen, to our right you have one of the saddest sights in America."

Large, ugly clouds of dark gray smoke jutting up over a scattered area greeted the Detroit-bound passengers.

The sight was so similar to the aftermath of a bombing raid in South Vietnam, I felt as though we were the assault troops ready to move in for the kill.

It was only about an hour later when all hell broke loose on the east side of the city, the first riots in that area since violence started.

Hot pieces of steel from three directions pounded the pavement, pinning down state police and guardsmen for one and a half hours.

It wasn't too long when a voice shouted, "Hold your fire, hold your fire…we got a wounded." Moments later another guardsman was hit. Blurting over the police radio were reports of two more men shot.

Lying on the steaming pavement on my stomach brought back memories of an incident in a graveyard with the U.S. First Cav in Hoi Chau, South Vietnam.

Then, well over a year ago, I was lying face down in the hot sand compulsively digging a hole with my chin trying to bury myself…automatic weapons fire was coming from three directions.

A guardsman with dirt on his arms and a rifle cradled in his arms while crawling on his stomach reminded me of a friend, a Special Forces sergeant crawling into the embattled camp of Ple Mei. He was later killed in the camp's perimeter.

Around the corner many Negro residents were sitting on their porches this hot summer night taking a matter-of-fact attitude just like the South Vietnamese in Saigon.

Tactics that are being used by Detroit rioters could be compared with those of the Vietcong: guerrilla warfare…a series of small scattered actions…never knowing where they will hit next.

-EDDIE ADAMS

The previous week Adams was in Cleveland where rioting likewise broke out. Caught in a street shootout he photographed a war-like scene. Battle clad men drove jeeps mounted with thirty-caliber machine guns. Another hundred men took cover behind trees, weapons aimed at roofs.

"Red hot steel screams out of the darkness," he wrote. "Then comes another bullet and another. They search and search but never find the sniper," Adams reported.

"To anyone who has seen Vietnam the scene seems familiar. But this is not Saigon. This is Cleveland, Ohio, where Ohio National Guardsmen moved into an East Side Negro slum in the wake of rioting and fire bombing." *Ed. note.*

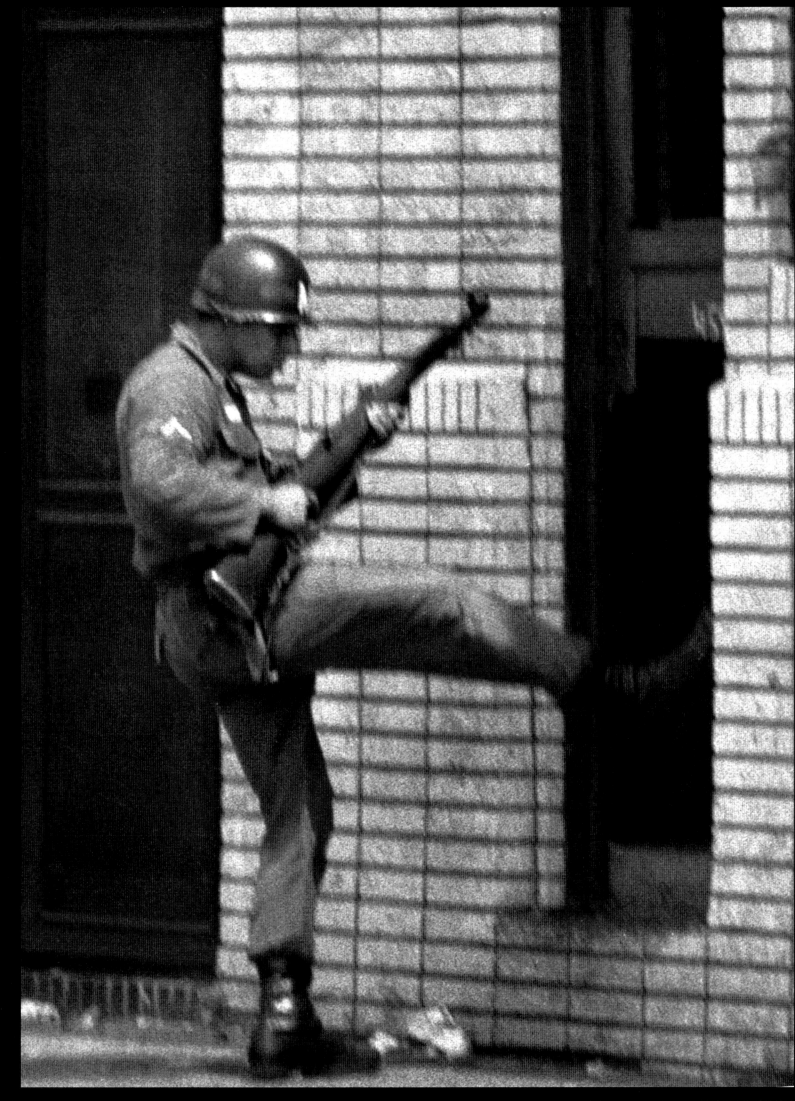

NATIONAL GUARDSMEN KICKS AWAY DEBRIS DURING SEARCH FOR WEAPONS, JULY 1967.

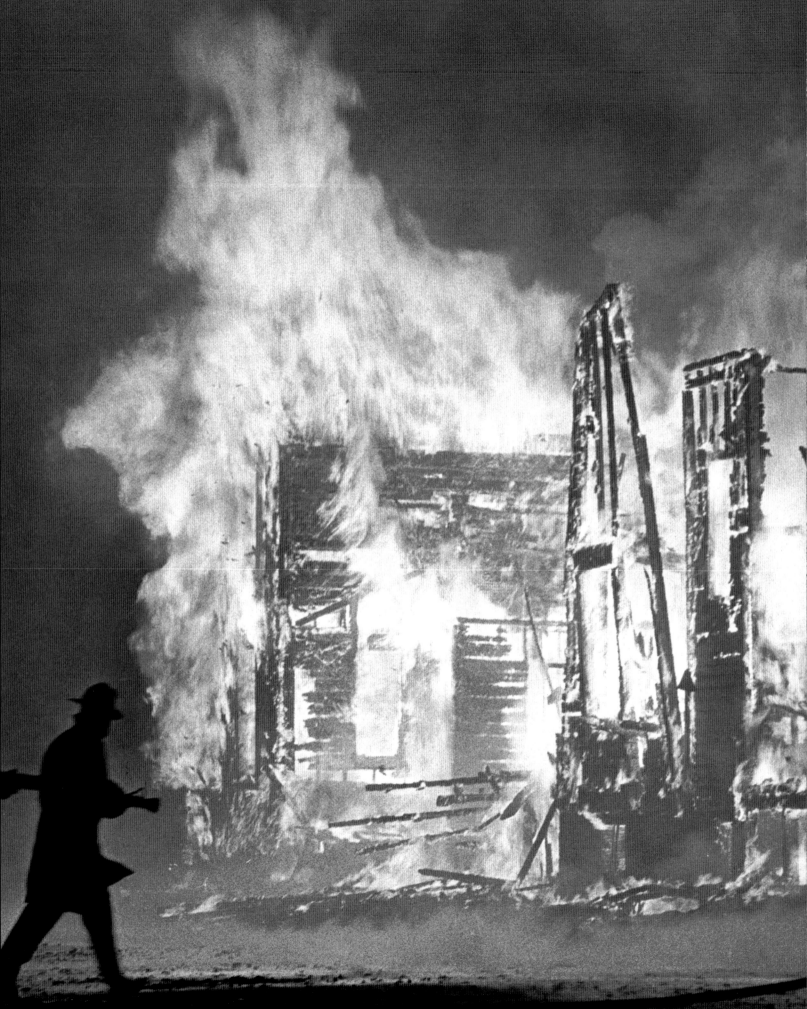

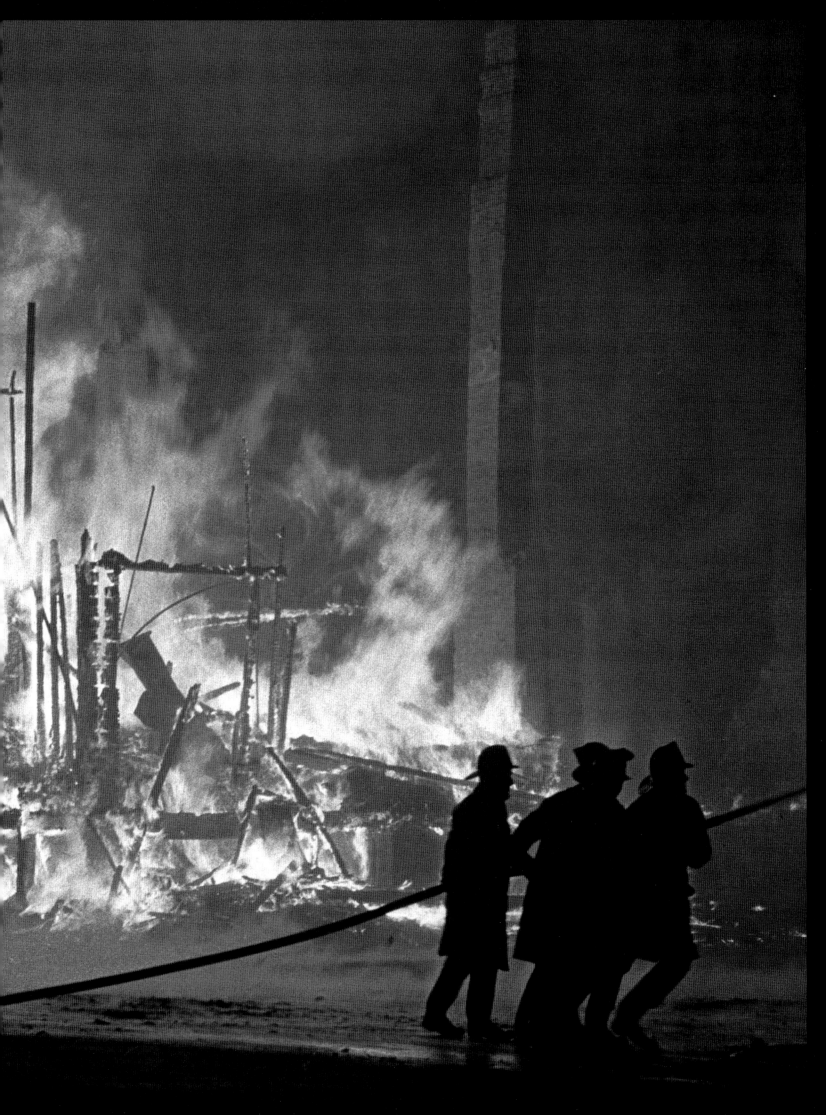

FIREMEN WERE HELPLESS FACING THIS INFERNO IN DETROIT'S RIOT AREA IN JULY 1967. NEARLY 200 FIRES WERE REPORTED IN THE CITY. AT LEAST TWO FIREHOUSES WERE BESIEGED BY SNIPERS.

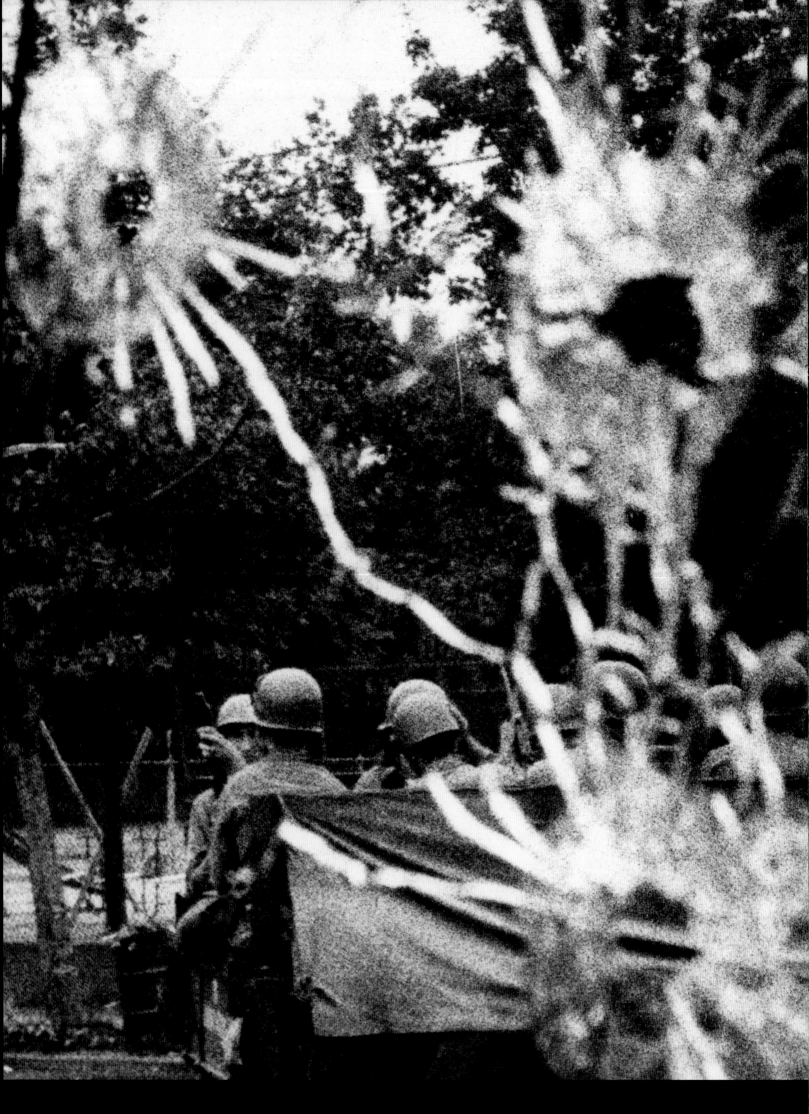

RIOT SCENE THROUGH A BULLET-SHATTERED WINDSHIELD.

1968
CRISIS POINT

It has been three years since Adams first went to Vietnam in 1965. Now, in 1968, things were different. In 1965 there were 25,000 American troops in Vietnam; when Adams left Vietnam the second time in June 1966, American troops numbered some 400,000. When he returned in 1968 American troop strength had escalated to some 500,000.

When Adams left Vietnam in 1966 there was a polite relationship between the media and the military. That relationship had deteriorated substantially by the time Adams returned. A series of media stories reported the difficulties of the war, the possibility that the war could not be won, and there were instances where military accounts of engagements did not match eyewitness accounts of correspondents. Media and military had become wary of each other.

The deterioration would reach a point that prompted Richard Nixon to say:

This is the first war in our history during which our media were more friendly to our enemies than to our allies.

He did not know it, there in the Saigon customs shed, but in just a few weeks he would make a photo that would become the signature picture of his career, a picture that would haunt him for life.

Sights and sounds in Saigon told Adams that preparations were underway for Tet, the Vietnamese New Year celebration to begin on January 30. Brilliantly colored decorations trimmed shop fronts, vendor stalls with holiday trinkets crowded the sidewalks and the promise of celebration created a festive atmosphere. Firecrackers and fireworks were common. No western holiday compares to the seven-day-long Tet. It is a combination of Christmas, New Year's, and Fourth of July. Most shops and all government offices close for several days. Families visit families, homes are decorated in bright colors, gifts are exchanged, debts are cleared up. Celebration is the mood of the weeklong festivities.

Each year the warring parties of Vietnam unofficially put down their weapons for several days to observe the season. North Vietnam announced that they would again observe a truce during the early Tet period. Plans were afoot, however, that would make the 1968 Tet an historical turning point in Vietnam's post—World War II history.

For some weeks prior to Tet, American intelligence reports cited major Vietcong and North Vietnamese Army troop movements in the sector near the North Vietnamese border and along the borders with Cambodia and Laos. Truck traffic on the Ho Chi Minh trail increased by an order of magnitude. These reports led the American and South Vietnamese military to expect major attacks soon after Tet. The attacks, it turned out, were seriously underestimated in scope and timing.

North Vietnamese leadership conceived a massive multi-pronged assault of combined North Vietnamese Army regulars and the Vietcong. Some units would attack in the north, others across the Cambodian and Laotian borders in central Vietnam, and a major assault would strike Saigon itself. The plan called for infiltrators to slip into the capital and into other cities with revelers from the countryside arriving for the Tet holiday. In Saigon the silent invaders took refuge in the crowded streets and back alleys of Cholon, the Chinese section of the city, over a period of weeks.

The attack was coordinated to begin on all fronts on the eve of the holiday with the expectation that massive military action would inspire

a national uprising and the overthrow of the central government.

Artillery strikes against the U.S. Marine base at the besieged Khe Sanh started about ten days before Tet, creating a consensus in intelligence circles that the Marine base camp would be a major target. Early fighting also broke out in Nha Trang. Adams, unaware that Saigon would soon be a target, went to Nha Trang two days before the start of Tet, writing:

Nha Trang sucked. Nothing was happening. It was quiet. But I heard that a major battle was shaping up.

Soon after, Tet Eve partying subsided, and as Saigon slumbered in the early morning hours of January 31, a suicide squad of nineteen Vietcong soldiers attacked the U.S. Embassy. Using rockets, they blasted a hole in the embassy wall, killed several Marine guards, and entered the embassy grounds. Other Marines took up the fight and a gun battle blazed into the morning hours. The Marines held off the attackers, killing most of them by the time U.S. Airborne reinforcements arrived by helicopter, landing on the embassy roof and finishing off the remaining attackers. No embassy personnel were hurt and the embassy building was never entered by the attackers. Simultaneously, in Cholon Vietcong infiltrators—some said as many as 4,000—confronted Vietnamese and American troops in violent urban warfare.

IT WAS VERY QUIET ... WHEN THERE IS NO MOVEMENT, YOU KNOW THAT SOMETHING IS UP.

Adams hurried back to Saigon where a full-scale battle for the city was being fought. Major military installations were under fire, as was the radio station, presidential palace and other locations. Firefights in Cholon pitted national police, South Vietnamese military and American troops against Vietcong in a street-by-street, house-by-house conflict. Major fighting in Saigon would continue for ten days; it would take a month to clean out the full Vietcong presence with much of Cholon destroyed in the process. Fighting broke out across the country with enemy units operating in some forty important provincial capitals and other cities. The Vietcong units in the cities were eliminated quickly but damage was extensive and casualties were high. Only in Hue did the enemy hold out for weeks before Vietcong and North Vietnamese Army regulars were dislodged. The Tet holiday attacks became known as the Tet Offensive.

On the morning of February 1, Adams, newly arrived from Nha Trang, checked into the AP bureau, where Vietnamese staff pho-

tographers were out riding the streets on motor scooters and bicycles making pictures.

In a taped interview that was part of an oral history about AP photography Eddie recalled:

The Associated Press office was in an old German embassy building. Next to AP was the NBC office... we didn't really share the office, but were right next door...we would tip each other off a lot on stories because NBC was no competition to us...and the NBC correspondents had a better chance of getting on the air if AP carried a story. We would hear about something...or they would hear about something... there was a lot of this, back and forth. We'd ask each other, "You want a ride?" "This was normal routine.

That morning Tuckner, poked his head in and says, "Hey, there's a little battle taking place in Cholon. Anybody want to come along?" I said, "Sure. I'll go.'"So we [Adams, Tuckner and NBC camerman Vo Su] *got in the car and we went*

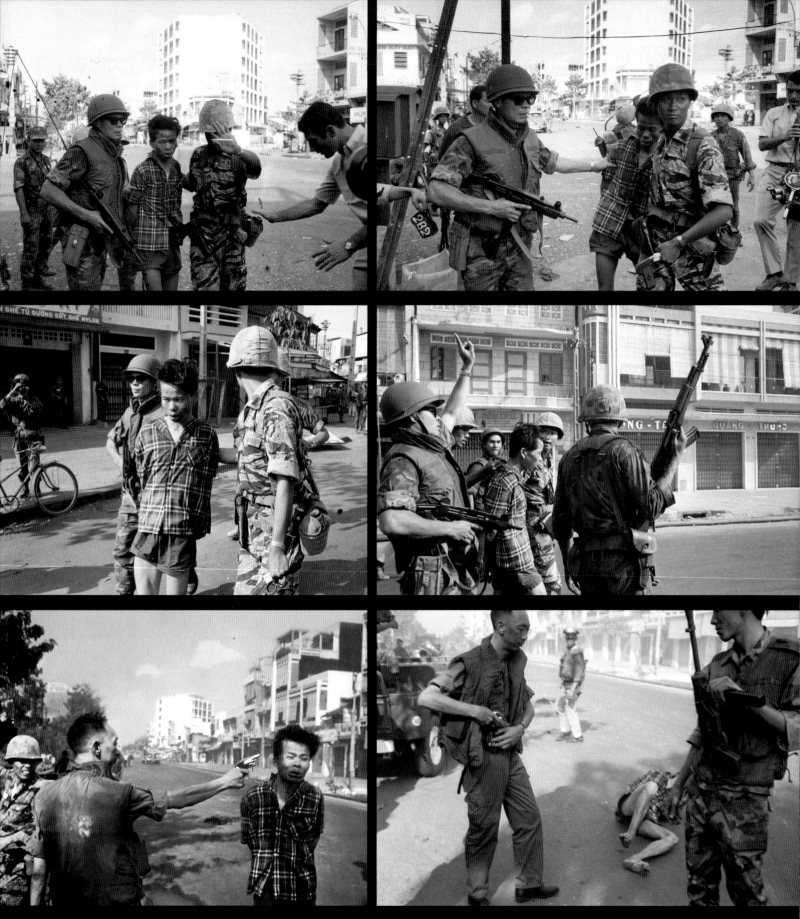

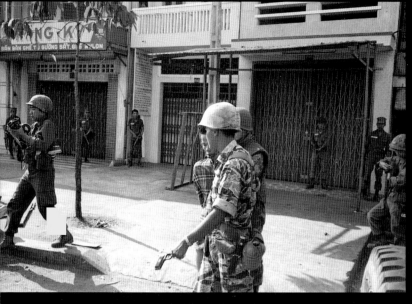
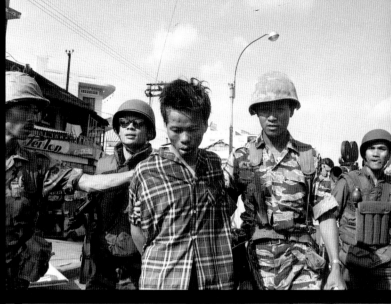
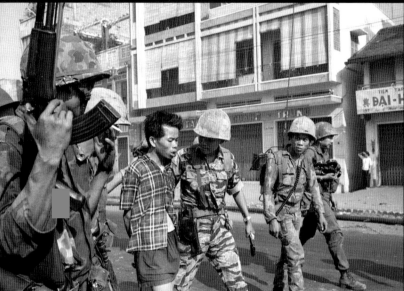
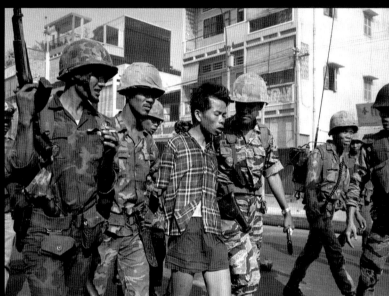
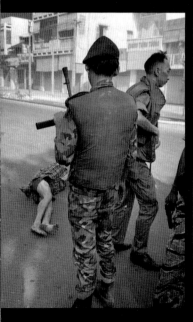
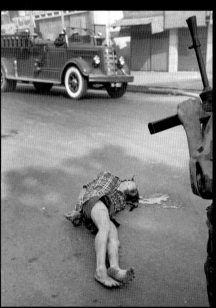
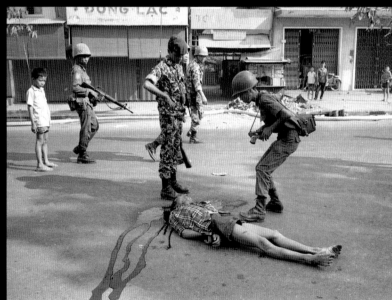

THE MOMENT THAT SOUTH VIETNAMESE NATIONAL POLICE CHIEF BRIG. GEN. NGUYEN NGOC LOAN EXECUTES A VIETCONG OFFICER WITH A SINGLE PISTOL SHOT IN THE HEAD IS PICTURED BY ASSOCIATED PRESS PHOTOGRAPHER EDDIE ADAMS IN SAIGON FEB.1. THE VIETCONG OFFICER GRIMACES AT THE IMPACT OF THE FATAL BULLET. CARRYING A PISTOL AND WEARING CIVILIAN CLOTHES, THE VIETCONG GUERRILLA WAS CAPTURED NEAR AN QUANG PAGODA, IDENTIFIED AS AN OFFICER AND TAKEN TO THE POLICE CHIEF.

ANY PHOTOGRAPHER...WHEN COPS OR ANYBODY GRABS A PRISONER, YOU JUST FOLLOW THEM. I MEAN, IT'S A PICTURE.

to Cholon. We got within a couple of blocks of the area, and it was very quiet and there was no movement. When there's no movement, you know that something is up. And so we parked the car and we walked a couple of more blocks up and took a turn. Then we could see sniping going on...and what it was...it was a mini battle of South Vietnamese soldiers and police... and behind a pagoda called the An Quang pagoda there was some Vietcong...there was only a handful of Vietcong behind the walls of this pagoda... and they were shooting at each other... the VC and the army.

So we went there and it was really nothing, it was a nothing story. So we spent about fifteen minutes there, and we decided to head back. We got maybe thirty yards up from the pagoda and we saw Vietnamese troops pulling this guy out of a building. He was on the ground floor, and they took him by the hand...they pulled him on the street.

To backtrack a minute...any photographer, any news photographer, when cops or anybody grabs a prisoner in New York...you just follow them. I mean, it's a picture. They call it a perp [perpetrator] walk. You follow them until the prisoner is loaded into a wagon and driven away.

That's exactly what we did. It was the NBC crew and myself. I think there might have been a military photographer there, too...I don't really know. We saw them grab this guy and they started walking him down the street, and they just kept walking maybe a hundred yards to the corner. And I have a sequence of pictures. I do not know who this guy is...and they stop for a minute...and to my left....I was about five feet away from the prisoner...and to my left came this guy. I have no idea from where. I had a 35mm lens and a single-frame camera, and he went over and I saw him go for his pistol.

Well, when somebody goes for their pistol... they normally threaten the prisoner...I've taken pictures like that, somebody threatening somebody...You're going to do this or I'm going shoot you. And nothing ever happens. So I saw him go for his pistol. As soon as he raised his pistol I took one frame. And that was the instant when he shot him. I had no idea that he was going to do that.

I saw the VC fall to the ground and I turned my head because I didn't want to photograph what I'd seen...maybe a three-or four-foot spout of blood just shoot up like a water fountain... and I didn't want to photograph that. I thought there was no reason to. I waited, and I said..." Somebody tell me when it's done." I took more frames of just a body laying there.

And right after this happened this guy who did the shooting comes walking up to me, he puts his pistol in his holster, and walks right by, five feet away, and he said, 'He killed many of my men and many of your people.' And he just kept walking...and that's all he said.

It was about noon when the picture was made and Adams and the NBC crew headed back to their offices. Vo Su's film had to be shipped out of Vietnam to either Hong Kong or Tokyo for processing and transmission to New York for broadcast. Adams's pictures were processed in the AP office as soon as he walked through the door.

I think I got a picture of somebody shooting somebody, Adams remembers saying as he turned in the film. Others recall him as more excited, saying the pictures were pretty good. Horst Faas was in the office editing film. He had been recently wounded in both legs and was doing editing chores as he recovered well enough to go back into the field.

I saw the film, he said, and I knew we had a great newsphoto.

Adams left the office for lunch but returned as prints from edited film came out of the darkroom, were captioned and taken to the building where they were transmitted to the world.

The life of many pictures would end there, or soon after they were printed in newspapers. Not so this photo...not so the story of the man who shot the VC...and not so Adams's role as the photographer. The photo was published widely and generated immediate reaction worldwide. It appeared on television, in magazines, and was made into huge placards that were carried by anti-war demonstrators. Reaction was predictable. The hawks complained that the media should get on the team, and the doves and the anti-war demonstrators held up the picture as an example of the brutality of the people allied with the U.S. The photo was destined to become the most talked-about picture of the war and a controversial icon of historic proportions.

Adams tells more of the story:

We found out later that he (the shooter) was the National Chief of Police for South Vietnam. His name was Nguyen Ngoc Loan and he was a Lt. Colonel. After the picture was taken we got word from New York about what was happening in the States with the photo, about the demonstrations, and everybody wanted to know, "Who was this guy?" New York wanted a story on him...and I volunteered to do it. Everybody in the AP office said, "No, we'll get someone else." I said, "No. I want to do it." And they finally said okay.

So every day for the next two weeks I went knocking on the door of his office to see him. And everybody knew I wanted to get that story. Finally, after two weeks a colonel brings me into Loan's office. He is now a general, just recently promoted. General Loan is sitting in his chair behind his desk...and he got up from his desk and he came over to me....and I have never mentioned the photograph to him once.

I said "I'd like to follow you around for about a week or a few days...and see what you do, and do a story." He got up from the desk and he stuck his head right next to mine...we were eye-to-eye, and we almost touched noses, and he said, "I know the Vietnamese who took that

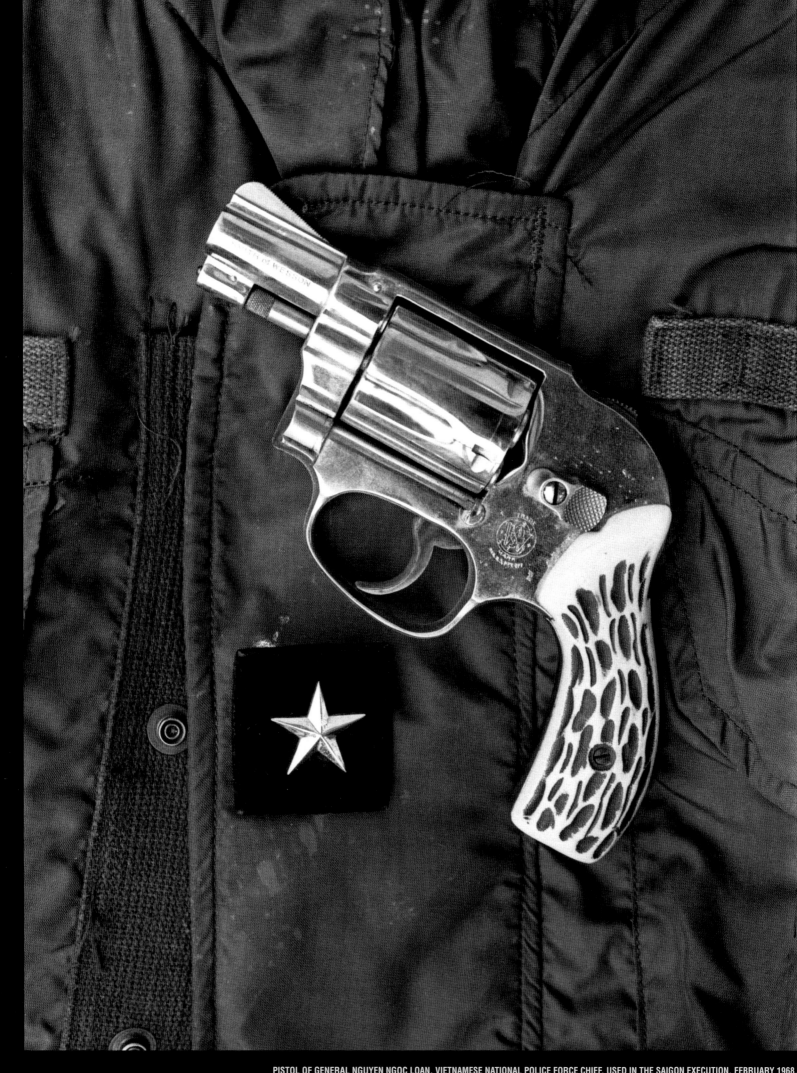

PISTOL OF GENERAL NGUYEN NGOC LOAN, VIETNAMESE NATIONAL POLICE FORCE CHIEF, USED IN THE SAIGON EXECUTION, FEBRUARY 1968.

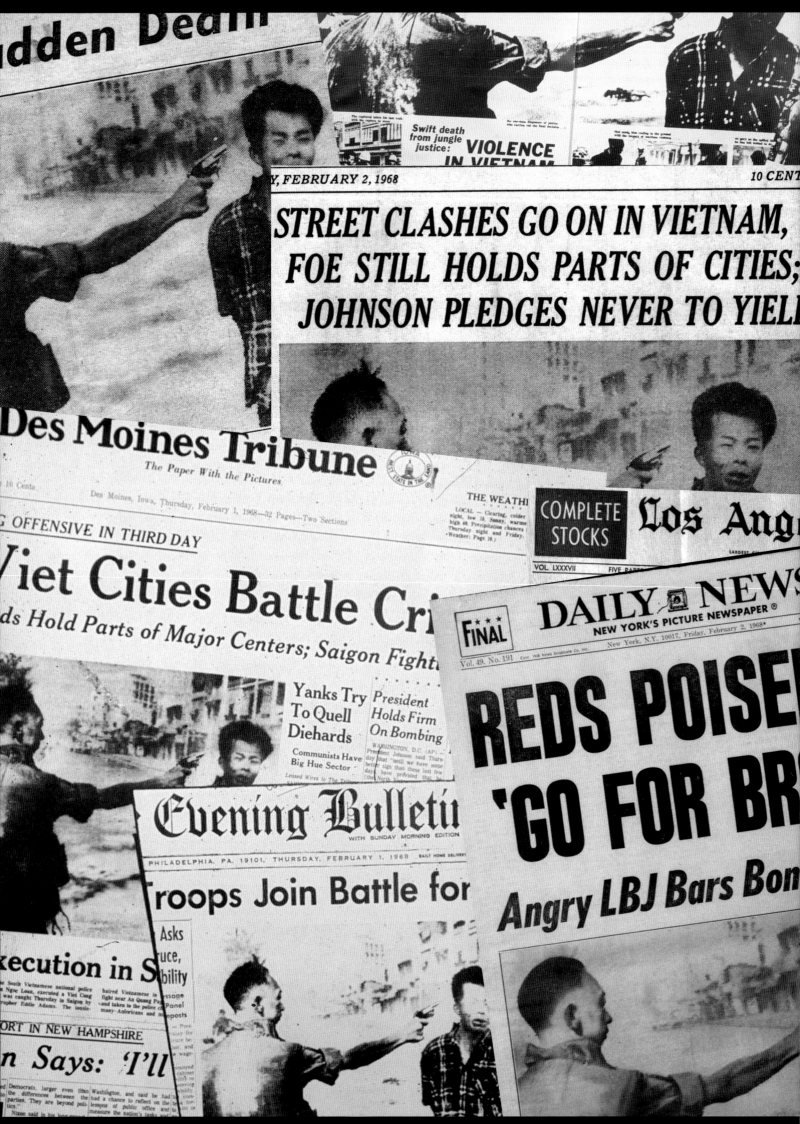

dden Death

Swift death
from jungle
justice: **VIOLENCE
IN VIETNAM**

...Y, FEBRUARY 2, 1968 10 CENT...

STREET CLASHES GO ON IN VIETNAM,
FOE STILL HOLDS PARTS OF CITIES;
JOHNSON PLEDGES NEVER TO YIEL...

Des Moines Tribune
The Paper With the Pictures

10 Cents Des Moines, Iowa, Thursday, February 1, 1968—32 Pages—Two Sections

THE WEATH...

**COMPLETE
STOCKS**

Los Ang...

VOL. LXXXVII FIVE PART...

...G OFFENSIVE IN THIRD DAY

Viet Cities Battle Cri...
...ds Hold Parts of Major Centers; Saigon Fight...

Yanks Try To Quell Diehards	President Holds Firm On Bombing
Communists Have Big Hue Sector -	WASHINGTON, D.C. (AP)—President Johnson said Thurs day that "until we have some better sign than these last few day... have provided that ... the North Vietnam...

Leased Wires to The Trib...

FINAL ★★★ **DAILY ● NEWS**
NEW YORK'S PICTURE NEWSPAPER ®
Vol. 49, No. 191 Copr. 1968 News Syndicate Co. Inc. New York, N.Y. 10017, Friday, February 2, 1968

REDS POISE...
'GO FOR BR...
Angry LBJ Bars Bom...

Evening Bulletin
WITH SUNDAY MORNING EDITION
PHILADELPHIA, PA. 19101, THURSDAY, FEBRUARY 1, 1968 DAILY HOME DELIVERY

...roops Join Battle for...

Asks
...uce,
...bility

...xecution in S...
...South Vietnam's national police
...Ngoc Loan, executed a Viet Cong
...was caught Thursday in Saigon by
...pher Eddie Adams. The insu...

...ORT IN NEW HAMPSHIRE

...n Says: 'I'll

Democrats, larger even than...
...the differences between the
...parties. They are beyond poli...
Nixon said in his k...

photograph. "And then he went back to his desk and sat down. And I could never understand what he meant by that until later, which I did find out. He wasn't blaming me for the picture. He said later on several occasions that if I wasn't there, somebody else would have done it. He told me, "You were doing your job and I was doing mine.""

In his office that day he scared the hell out of me…it was nose to nose…he was looking me right in the eye...and then he sat down and he says, "You know, after the picture appeared my wife scolded me. She told me that I should have taken the film from the photographer. She thinks that's all I have to worry about…taking film from photographers. She has no idea…"

Adams recalls his own reaction to the picture, his immediate feelings and the mindset he developed over time:

When I took the picture, I absolutely thought very little about it, and said, "I think I got this guy shooting somebody." Then I went to lunch. I had no idea what we had. When I saw the picture I wasn't impressed. And I'm still not impressed because, again, you can look at it a lot of different ways…it was not a great work of art in terms of photography. Number one, it's the wrong time of day, the light wasn't right. It's a news picture. The composition was terrible. But on the other hand, it was a moment that, I guess, was very important. I still don't understand to this day why it was so important. I've heard so many different versions of what this picture did…like it helped end the war in Vietnam. I don't understand it. I really don't understand a lot of it.

But two people's lives were destroyed that day. The general's life was destroyed, as well as the life of the Vietcong. I don't want to destroy anybody's life. That's not my job. It really isn't. Loan was condemned. One thing that's interesting and it really bothered me… when Vietnam was going down the tubes, the United States would not fly the general out of Vietnam. They said, "We have nothing to do with you." General Loan was killing our so-called 'bad guys,' but the U.S. government kind of disowned him…and he eventually flew out with the Vietnamese Air Force into Guam and had another friend of his, a counterpart in the CIA, help finance the rest of the trip to bring him to the United States, where he eventually opened up a pizza shop.

He was first in his class in the French Air Force Academy…. He went to the U.S. Command Staff college, where he was also first…. His sister was a professor at Harvard in Pharmacology…his brother is also in medicine… He's a very smart man, a very intelligent man and was very well-loved in Vietnam.

Over the years questions about the picture came up frequently but Adams usually tried to avoid discussing it. When he did grant an interview, and when the subject of the photo came up, as it inevitably did, his mood changed and his tone was confrontational. One incident in Amsterdam particularly infuriated him. During an interview at the time he was awarded the World Press Photo's major award, a member of the audience asked him why he didn't try to stop Loan from shooting the man. What a stupid question, Adams recalled. People have no idea of what war is like, and what happens.

In the AP interview in the context of telling the story of the picture, he offered the following: Pictures don't tell the whole story. When you look at a photograph, you're looking at 1/500th of a second and it's a moment. It doesn't tell you why that happened. It doesn't tell you much. You don't see all sides of it. But pictures are very important because people believe photos.

What happens with a photograph…you can have Norman Mailer, David Halberstam, write the greatest story in the world...and it could be factual, right down to every word. And somebody, the public, will look at it and read the story and there'll be that little bit of doubt about whether that really did happen. You'll say, "Well, yeah, maybe. Yeah, well, you know…I'm not very sure.'"

But if there's a photograph right with that story, that's the eyewitness…that'll confirm a personal belief in a story. And the picture can be a lie. But that person will look at that, and it's real, and it becomes a real thing. So pictures are a lot more important than a lot of people think…

You know they say, The written word is bullshit. The picture is what does it!

During the decades that followed that day of Tet 1968, Adams continued to say that pictures—and that picture—can lie. He told the story of Loan, how his aide was murdered the morning of the execution and how his aide's wife and children were knifed to death at the same time by the Vietcong. Adams would ask those he encountered, How would you react under those circumstances?

In fact, on that day another dramatic picture was transmitted on the AP wires. It showed a South Vietnamese Army officer carrying the body of his young daughter through a doorway. The child was assassinated by Vietcong fighters who had targeted government officials and families in the early Tet fighting. Several newspapers played the two pictures—Adams's photo and the child photo—together, providing some dimension to the story.

In one sense the picture was a lie because it helped create perceptions in the United States that the Tet Offensive was another example of the failure of the American effort in Vietnam. American officials in Vietnam and in Washington said for months that the war was turning in favor of the U.S. Then came Tet. That the VC and the North could mount an operation the size of the Tet assault was startling and seemed to contradict earlier statements of success by officials. However, it was quickly known that the Tet Offensive was a military disaster for North Vietnam and the Vietcong. It did not inspire a national uprising as was predicted. North Vietnamese Army and Vietcong casualties were devastating and their military was seriously crippled. The execution picture did not end the war, as some claimed; the war continued for another seven years. The Tet Offensive, however, was perceived in the U.S. as an enemy victory and the execution picture became an emblem of that victory. That perception of victory turned many minds in the U.S. against the war.

The picture, however, offered a greater, mighty truth: it captured war's horror, not just the horror of Vietnam, but of all wars. The picture showed—and continues to demonstrate—in explicit terms the brutality that war creates. It reminds the thoughtful viewer of the greater violence that proceeded and followed that single act.

Whatever the impact of the picture on the world, the effect on Eddie Adams remained a deep guilt, a guilt that haunted him to his final days. He established a bond with Loan and did followup stories on him in the months after the shooting and before Loan was wounded in the spring of 1968.

In 1993 Adams renewed his relationship with the general-turned-pizza-shop operator, then sixty-three years old. While in Virginia doing a story about female Marines, Adams learned that the restaurant Loan operated was nearby. He decided to visit the general.

I hadn't seen Loan in a number of years. So I went into the shopping mall where the restaurant was located in Springfield, Virginia…and there's this small, little, very tiny restaurant, and it's a pizza shop more than anything else…pizza and spaghetti and coffee, this sort of thing. So I walked through the door, and right behind the coffee machine, peering, staring right at me, was General Loan. And his first reaction… he just said, "Oh, you don't know the problems you've caused me." And I said, "I know, General, I know," and I said, "You know, General, you haven't changed a bit…you look just the same." He said, "Well, you sure have, you've gotten a lot older." So I guess he thought it was a little dig at me. We went on…we talked for quite a few hours, and he went on to tell me of his problems getting out of Vietnam, and getting to the States…and how the U.S. would not fly him. He told me about his job hunt, how he couldn't get a job anywhere…"I was over- qualified so then I had to learn how to make pizza."

People figured out who he was and I asked several, "If you were the general at that time, and your people were being killed all around you, how do you know that you wouldn't have pulled that trigger? "During our visit he said the shooting was something that happened—he wanted to forget it. But I remember going into the restaurant's bathroom and reading graffiti on the wall. Someone had written,"We know who you are, you fucker."

That was because of me…and I don't like ruining people's lives with my pictures.

Loan died in 1998 of cancer.

The man in the checkered shirt executed by Loan was later identified. His real name was said to be Nguyen Van Lam but his Vietcong alias was Bay Lap. There were other identifications, too, conceived to obscure backgrounds in the murky world of the Vietcong. Some said he was Vietcong military and wore the newly purchased checkered shirt in an effort to slip out of Saigon as the tide turned against the VC. Another story said he was a political officer in the Vietcong. He was captured carrying a pistol which, in some of the pictures made by Adams, is held in the right hand of a South Vietnamese soldier.

Horst Faas, during a visit to Vietnam on the twenty-fifth anniversary of the war's conclusion, met Lam's widow, who lived quietly in a Saigon suburb. She confirmed to Faas that her husband had indeed been a member of the National Liberation Front (formal name of the Vietcong) who left home one day to prepare for the Tet Offensive and never returned. She said that she would continue to mourn him until his body was found.

For more than a year between the shutter click and the awarding of the Pulitzer Prize, the picture was the subject of considerable discussion. Commentators of all political persuasions offered a multitude of opinions about the photo's influence. One fact none could deny, and all had to accept: the picture was in the mind of everyone who gave the Vietnam war the slightest thought.

The Pulitzer entry submitted by the AP consisted of twenty of Adams's pictures, the execution sequence only a few in a portfolio of work that included, in addition to photos from Vietnam, pictures from other stories covered in 1968. It was the Loan photo, however, that captured the attention of the judges and for all practical purposes was the photo for which he was honored.

The Pulitzer is the last of many awards made each spring for photography of the previous calendar year. The Adams photo swept all the competitions: the prestigious World Press Photo award in Holland, the Long Island University George Polk Memorial Award, the Overseas Press Club Award, the Sigma Delta Chi professional journalist's fraternity award, the National Press Photographer's Award, and the Associated Press Managing Editor's Award. Colleagues felt he was certain to take the Pulitzer, too, but he shrugged off their predictions. (And Pulitzer Prizes are known to resist the trend.)

On May 5, 1969, Adams and his family were in their Bogota, New Jersey home catching up on household chores, picking up kids from school, and generally acting like any other suburban family. Just across the Hudson River the Pulitzer presentations were underway at Columbia University. Hours dragged by as award after award was announced. Late in the afternoon Adams was on a ladder spreading a net over a cherry tree to protect the fruit from birds when the phone rang. AP photographer Bob Schutz, covering the award presentations, was on the line.

Eddie, you won it, Schutz shouted over the phone. *No kidding,* Adams replied. *I really won…that's great.* He gave directions to Schutz to come to his home and make a celebration picture for the wire. He hung up and turned to his family, *I won. How about that.*

It was done. Adams entered the elite ranks of Pulitzer winners for a photograph that not only transcended the awards of a single year but was destined to become one of the icons of contemporary history.

PICTURES ARE MORE IMPORTANT THAN PEOPLE THINK. YOU KNOW WHAT THEY SAY, THE WRITTEN WORD IS BULLSHIT. THE PICTURE DOES IT.

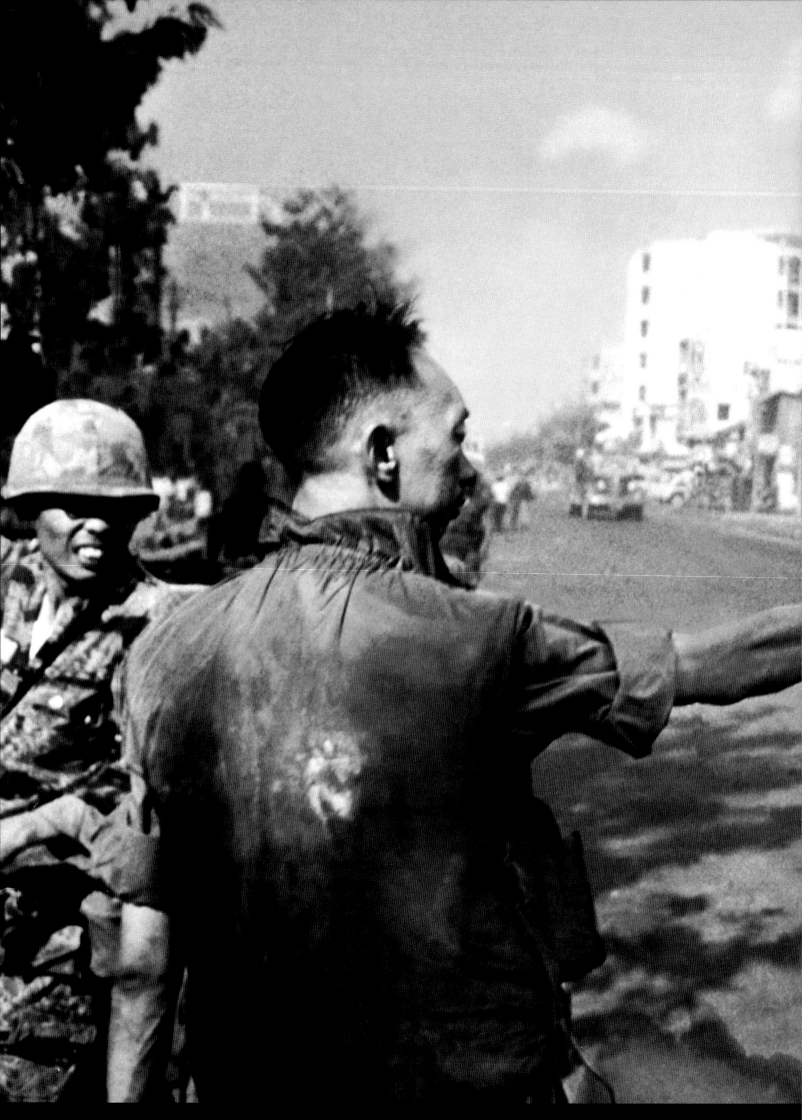

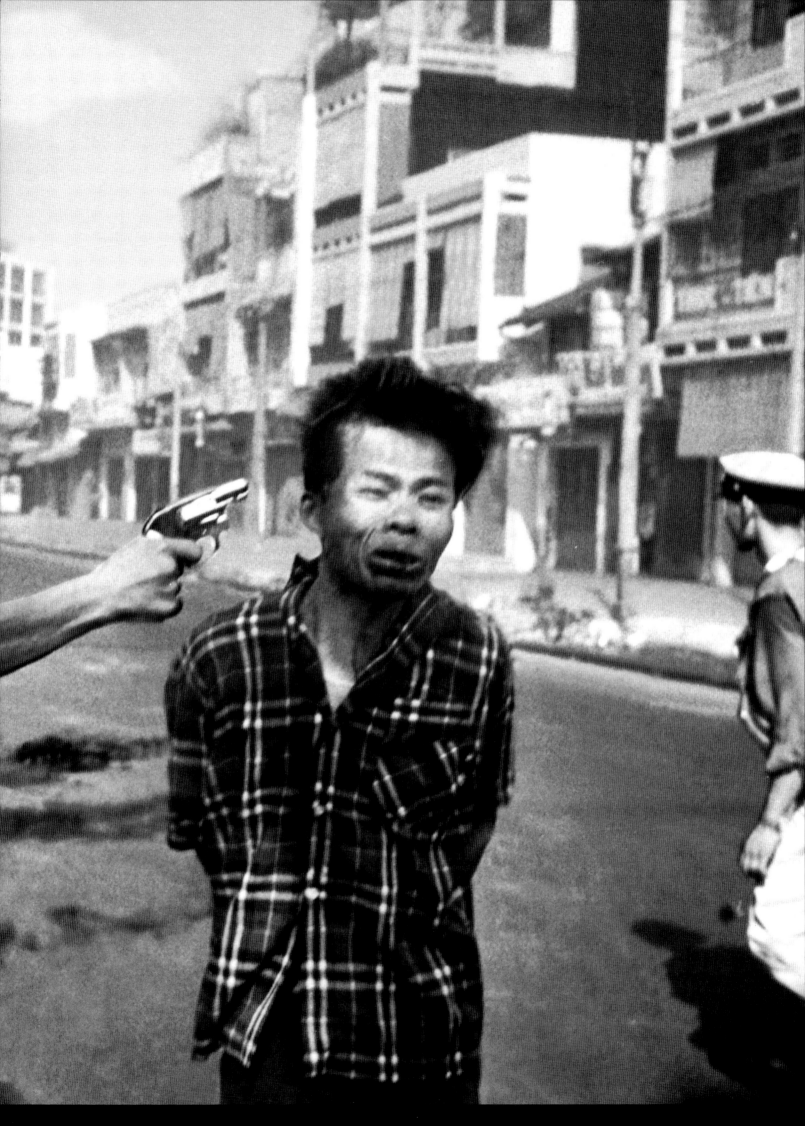

TET OFFENSIVE AND MINI-TET

Photos of a Vietcong executed on a Saigon street captivated attention outside Vietnam but in country major battles continued through spring 1968, many in provincial capitals. Casualty rates soared higher than ever, many of the dead and wounded civilians caught in the crossfire of sudden urban clashes that devastated whole neighborhoods. Tens of thousands of refugees were on the move. Saigon itself was the scene of constant outbursts of urban guerilla warfare of the most personal kind. Assassination was commonplace. Cholon was virtually destroyed in the battle.

Staff photographers and correspondents, stringers and freelancers roamed the streets seeking the clashes between the two sides. Hundreds of rolls of film passed through the AP photo darkroom and editing desk. Many pictures were sent by radiophoto signal to the outside world. Air shipment of Tet print and negative packages were delayed for the first few days; messengers could not move through the city and flights into and out of Saigon were limited.

Adams worked the Saigon streets shooting pictures of a war scenario far different from the rice paddies, jungles and villages near Danang. He followed tanks that blasted their way into Vietcong emplacements in the neighborhoods and in governmental installations that VC occupied for a short time. Children peeked from doors as

soldiers moved through city avenues firing automatic weapons at targets seen and unseen. Residents of neighborhoods under fire fled the chaos carrying bundles of personal belongings, rushing past monster vehicles firing into real or possible enemy positions. Every doorway in the cramped alley-like corridors of Cholon's crowded Chinese section held the possibility of death. Many patrols through the city took Adams across wooden fences, between houses and down dim passageways as the government forces rooted out the enemy. The slightest suspicion of a Vietcong presence prompted heavy fire from the searchers.

At one point Adams and Peter Arnett reported that bodies of people executed by the Vietcong were piled in three separate sections of the quarter. They were blindfolded and many had their hands tied behind their backs. They were killed apparently because they worked for the central government. No count was ever made of the many isolated executions; bodies were buried in mass graves.

Adams reported that some VC operated openly in the city. In one instance several Vietcong were eating soup at a sidewalk vendor. South Vietnamese Rangers spotted them and they were arrested. Adams learned from one of the Ranger officers that the restaurant was their base of operations.

By the end of the first week after the initial Tet attack, the fighting ebbed. Just after midnight Saturday in Saigon, Ed White sat down to write his daily war roundup aimed at Sunday morning papers in the U.S. *Intelligence reports indicated the enemy might launch another series of intensive attacks across South Vietnam within the next few days. Saigon itself appeared relatively quiet shortly after Saturday midnight. There were the usual flares lighting up the sky over the capital, and the rumble of artillery could be...* The sentence was not completed.

A horrendous blast rocked Saigon just before 1 a.m. and literally blew open the door of the AP bureau. The second wave of Tet, later known as "mini-Tet" had started.

Adams, bedded down in a room on the floor below the AP office, ran up within minutes after the first blast. But, because of a "shoot to kill" curfew in effect, he was unable to seek the trouble spots before daybreak. At dawn he raced to Tan San Nhut airport, one of the major targets in Saigon.

Scores of towns, cities, airports and other installations were hit anew by Communist mortar and rocket bombardments and, in some cases, followed up by ground attacks. The second wave was as widespread as the January 30-31 attacks but was not as intense and was not sustained. The enemy was weakening.

15-YEAR OLD NGUYEN VAN TU SERVES AS A "MASCOT" FOR A MARINE UNIT OPERATING IN THE WESTERN PART OF SAIGON. HE HAD EARLIER HELPED THE UNIT IN DISCOVERING VIETCONG ARMS CACHES IN THE AREA HE RESIDES. HE IS NOT ARMED BUT HELPS WITH THE COOKING, CARRYING THE WOUNDED, AND RUNNING DOWN TO THE CORNER STORE TO BUY A BEER. SAIGON, MAY 1965

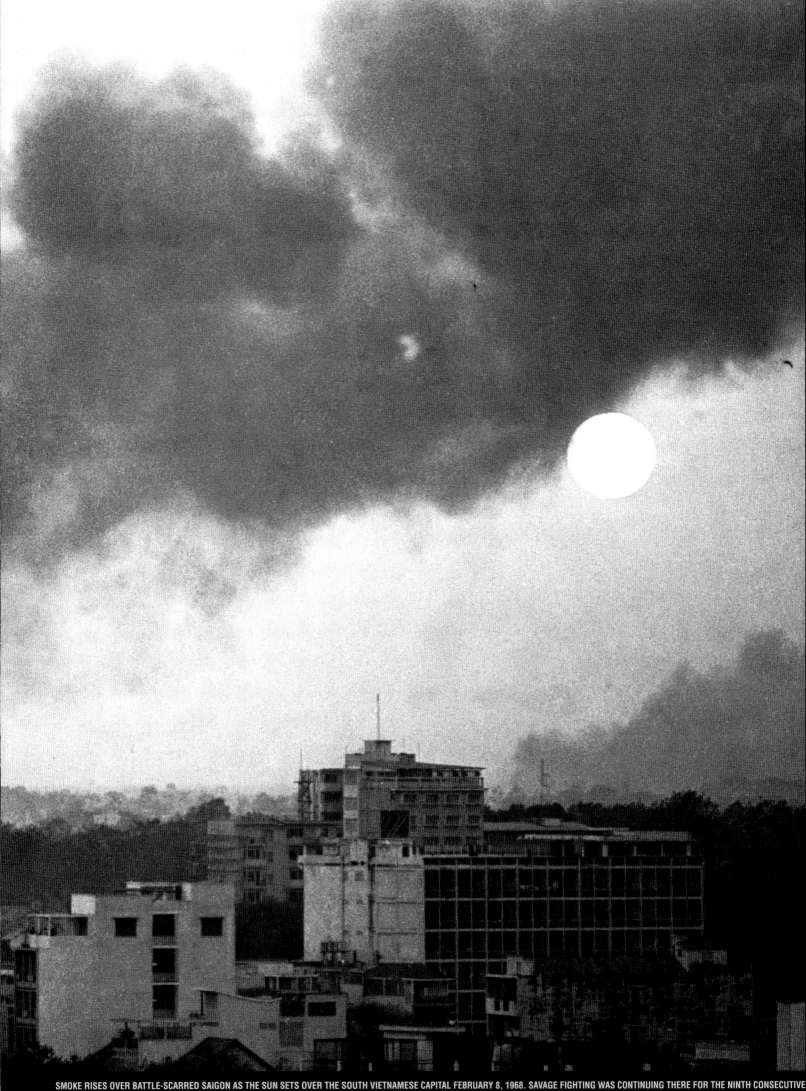

SMOKE RISES OVER BATTLE-SCARRED SAIGON AS THE SUN SETS OVER THE SOUTH VIETNAMESE CAPITAL FEBRUARY 8, 1968. SAVAGE FIGHTING WAS CONTINUING THERE FOR THE NINTH CONSECUTIVE DAY WITH VIETCONG GUERILLAS PITTED AGAINST COMBINED SOUTH VIETNAMESE AND U.S. FORCES.

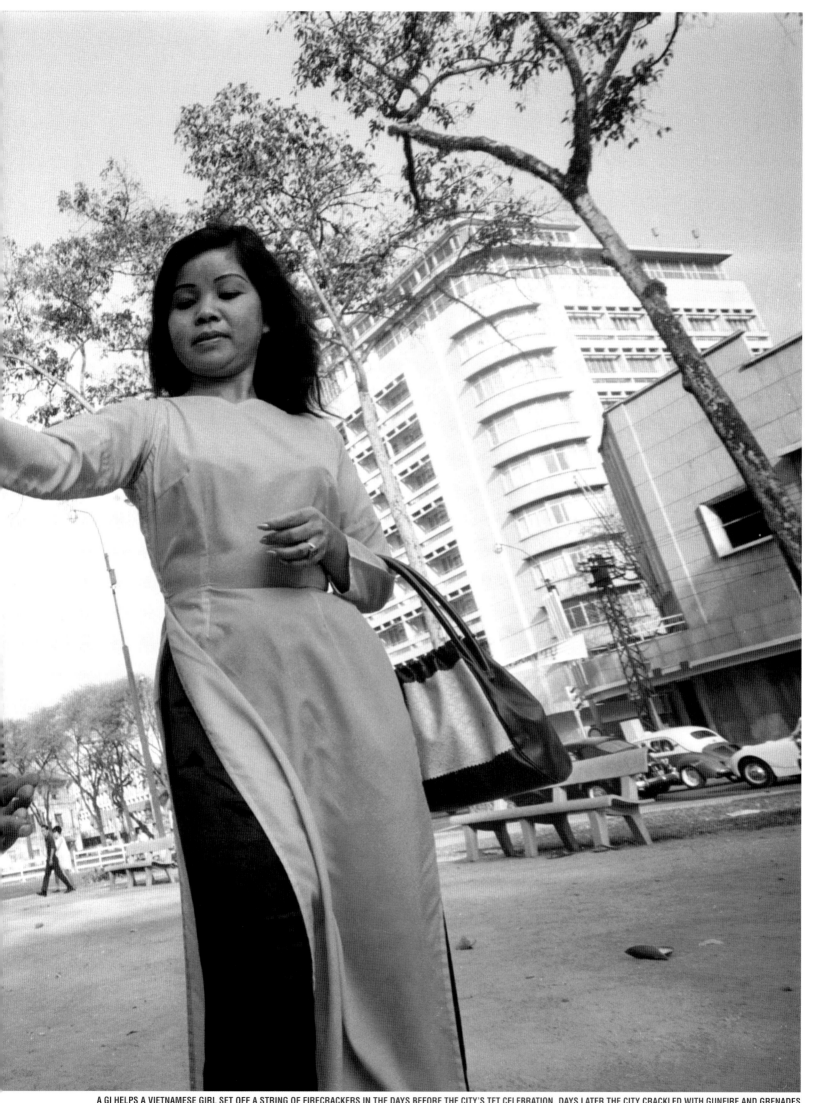

A GI HELPS A VIETNAMESE GIRL SET OFF A STRING OF FIRECRACKERS IN THE DAYS BEFORE THE CITY'S TET CELEBRATION. DAYS LATER THE CITY CRACKLED WITH GUNFIRE AND GRENADES AS VIETCONG AND NORTH VITENAMESE LAUNCHED THE TET OFFENSIVE.

ABOVE: MONSOON, SAIGON MAY 30, 1968

OPPOSITE: WAITING OUT THE MONSOON.

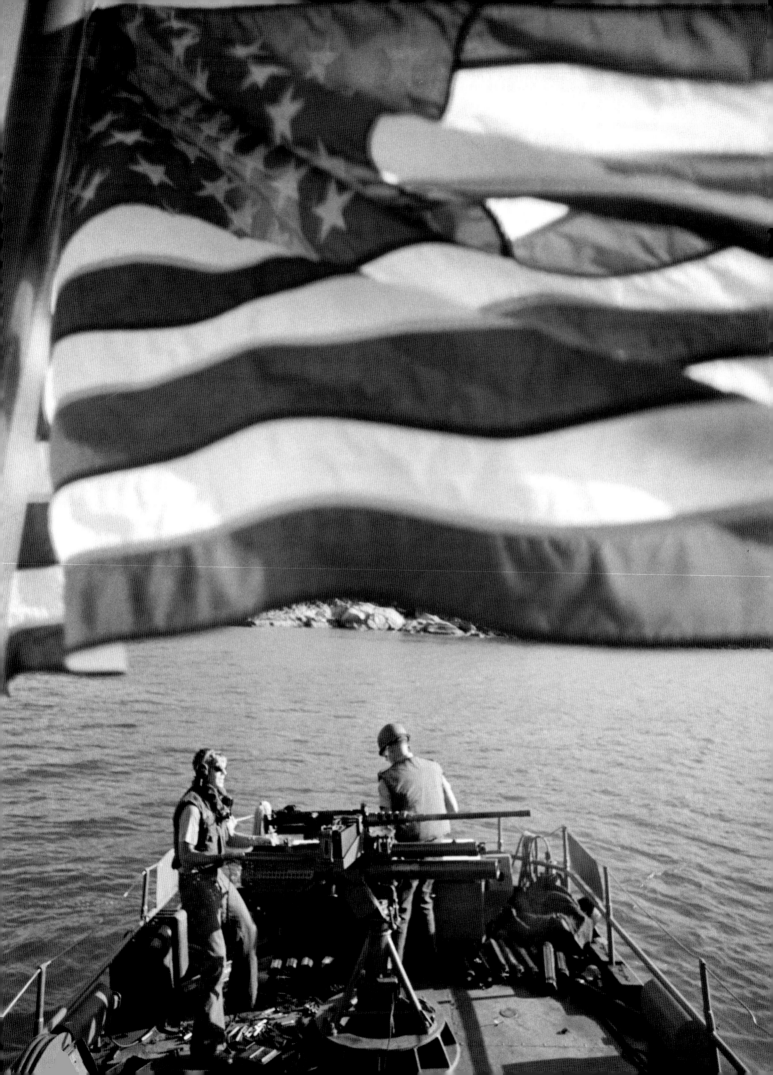

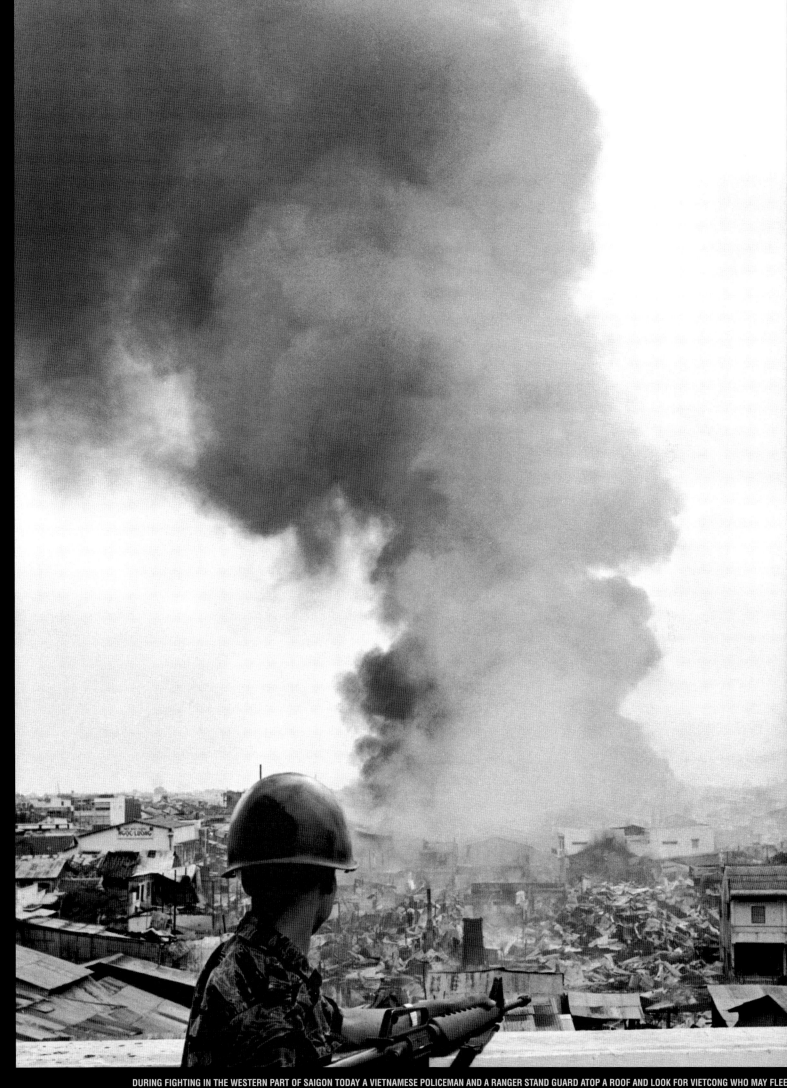

DURING FIGHTING IN THE WESTERN PART OF SAIGON TODAY A VIETNAMESE POLICEMAN AND A RANGER STAND GUARD ATOP A ROOF AND LOOK FOR VIETCONG WHO MAY FLEE
FROM THE AREA. CLOUDS OF SMOKE IN THE DISTANCE RISE FROM BURNING THATCH AND TIN HOMES IN A POOR AREA OF SAIGON. MAY 7, 1968.

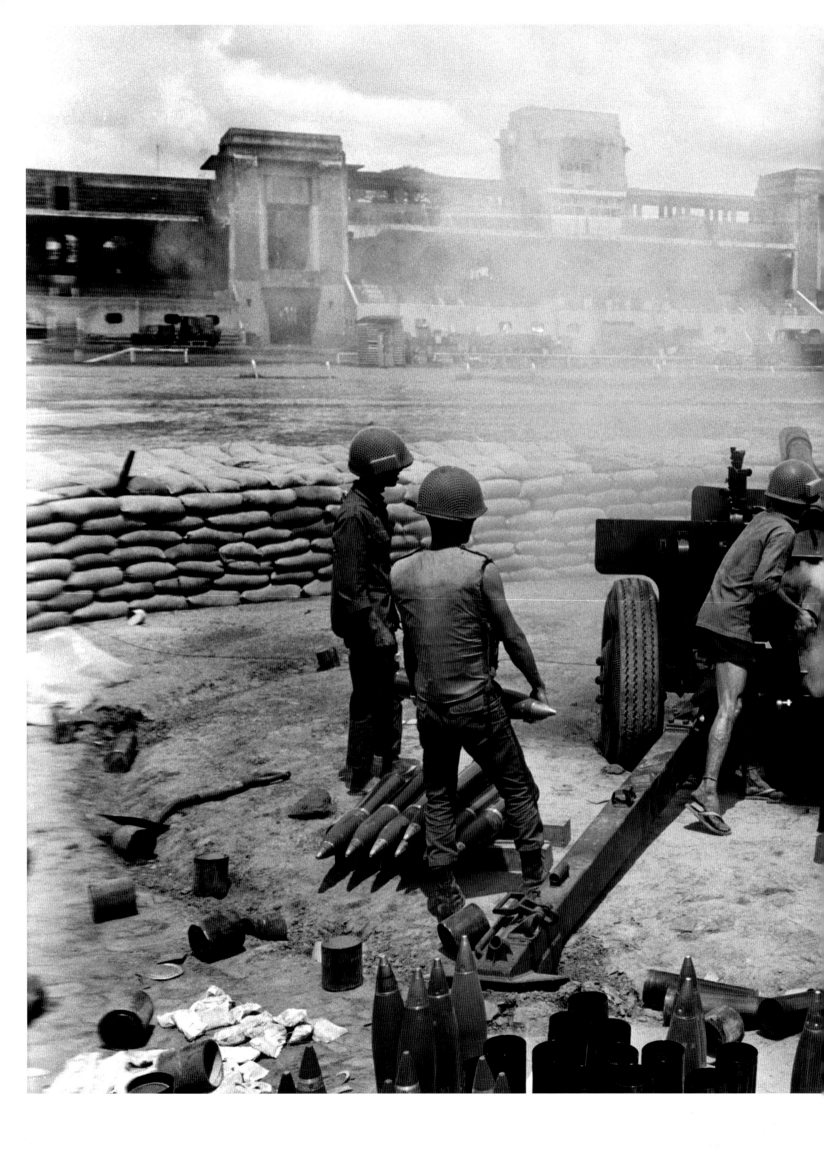

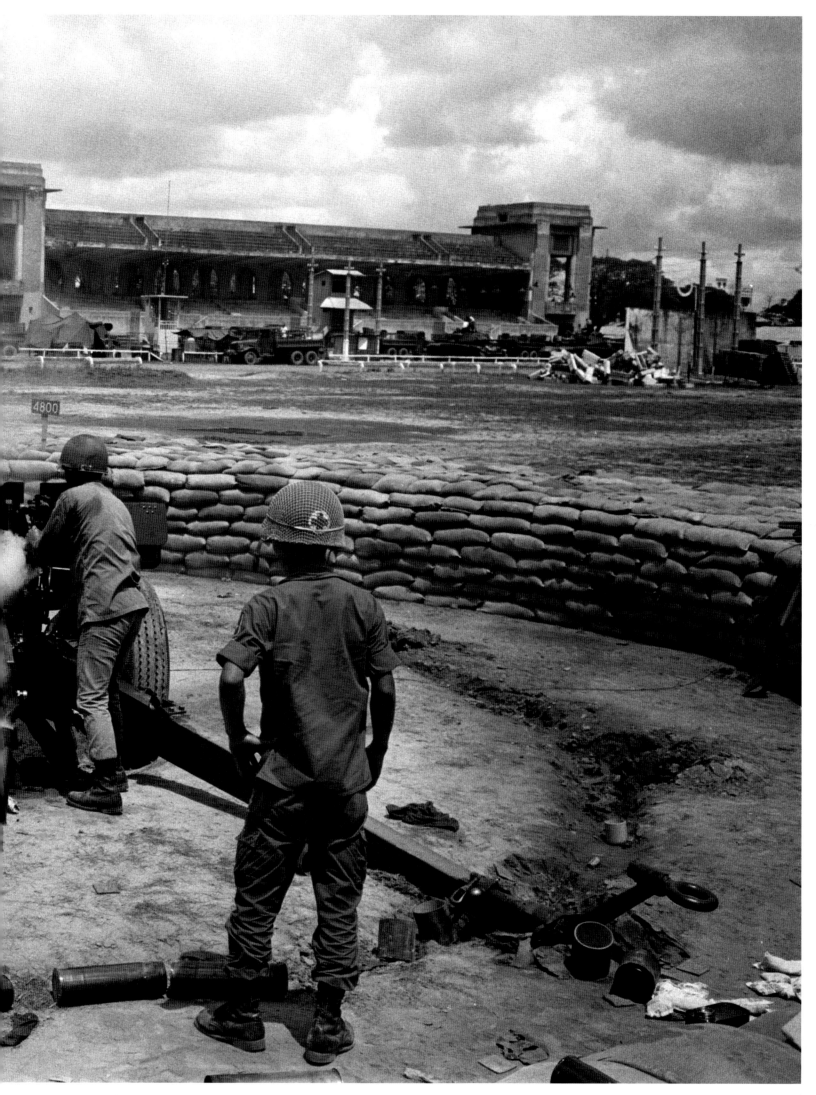

THE PHU THO RACETRACK IN WESTERN SAIGON SERVES AS A FIRE SUPPORT BASE IN AND AROUND THE CITY OF SAIGON. HERE VIETNAMESE ARTILLERYMEN PREPARE TO RELOAD A 105 MM GUN AFTER FIRING A ROUND INTO A NEARBY AREA. THE ARTILLERY WAS SET UP DURING THE TET OFFENSIVE TO SUPPORT TROOPS ENGAGED IN MOP-UP OPERATIONS THROUGHOUT THE CITY. MAY 6, 1968.

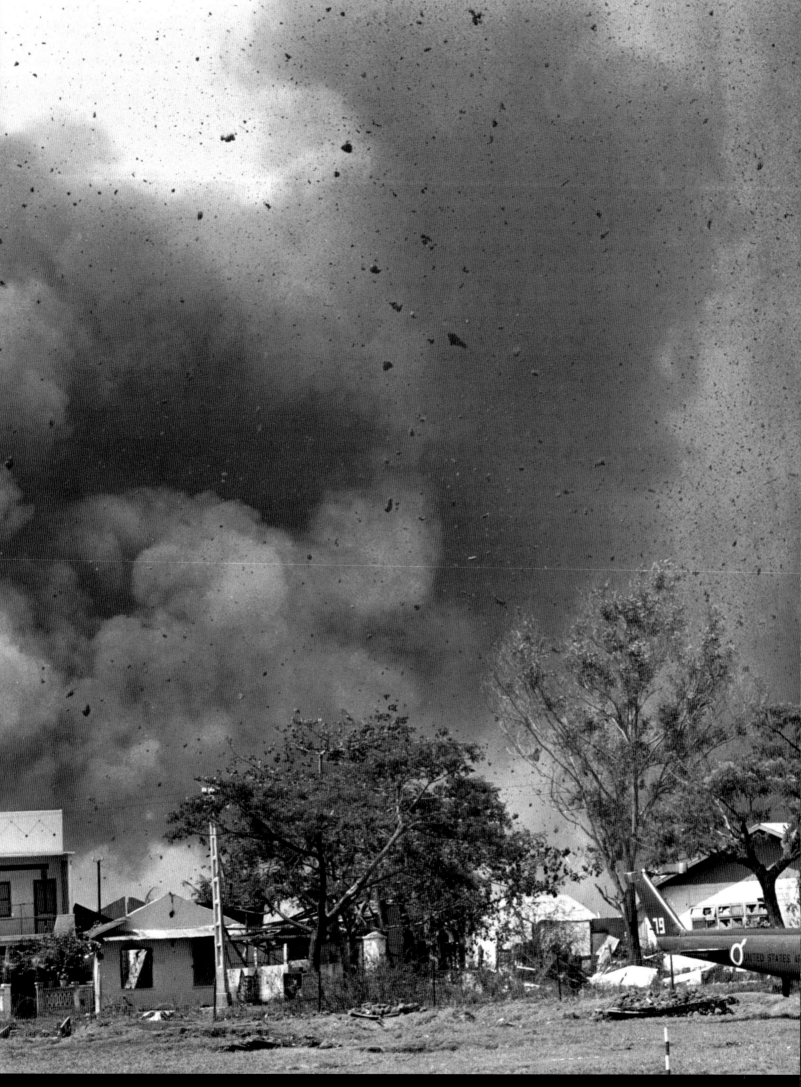

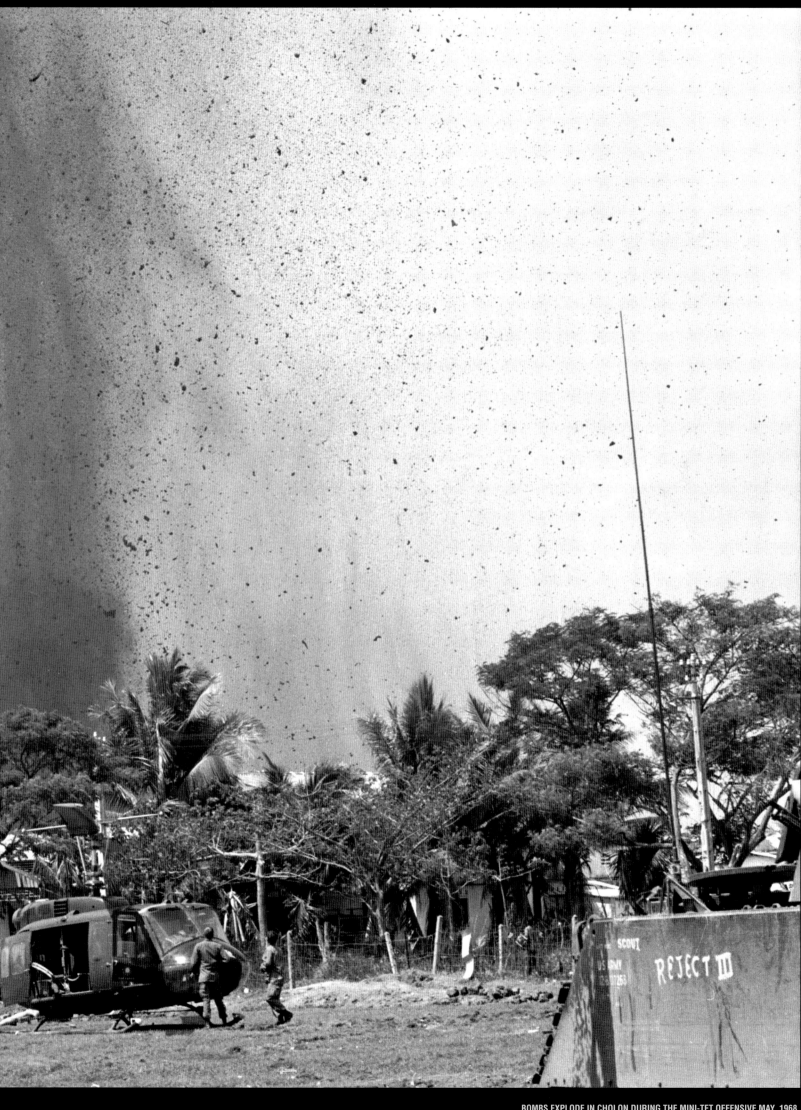

BOMBS EXPLODE IN CHOLON DURING THE MINI-TET OFFENSIVE MAY, 1968.

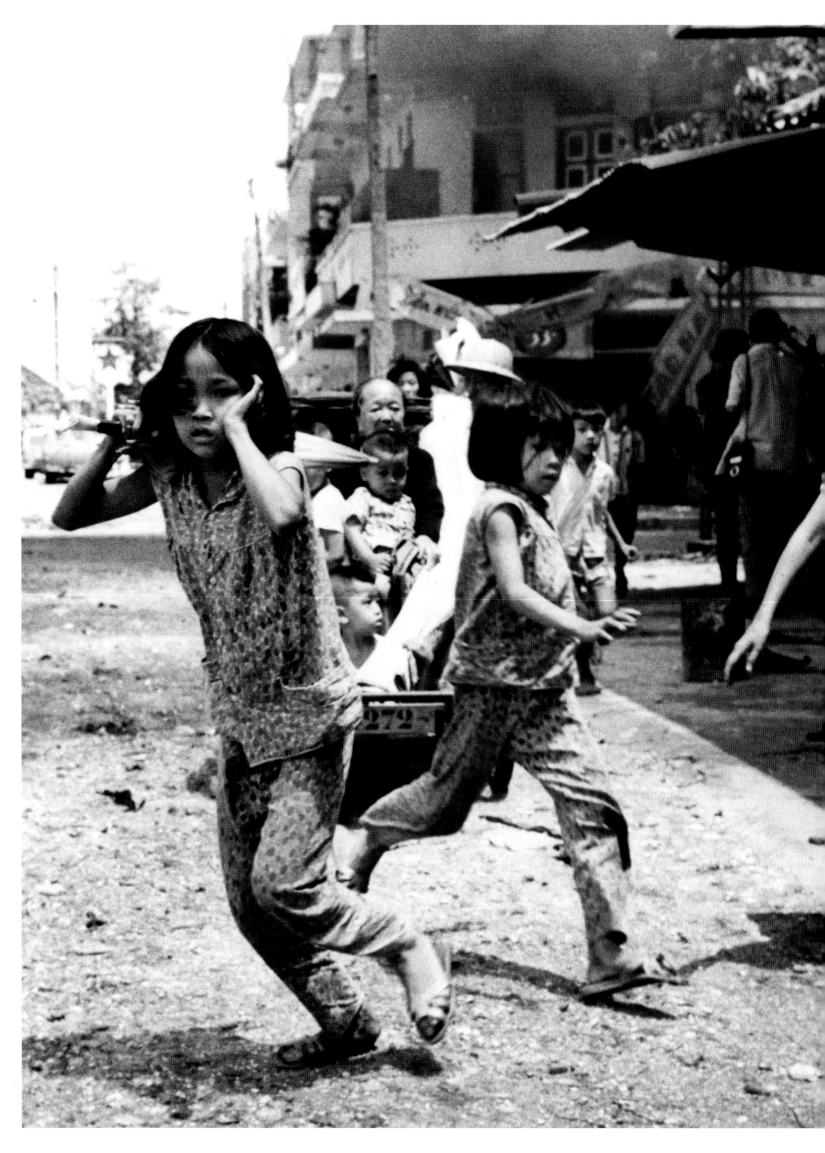

RESIDENTS RUSH TO LEAVE A THREATENED SECTION OF
CHOLON, THE CHINESE QUARTER OF SAIGON. VIETCONG
UNITS MOVED INTO THE AREA BY PASSING VIETNAMESE
MARINES FIGHTING TO THE WEST AND FIRED ON GOVERN-
MENT TROOPS. REACTING INSTINCTIVELY, RESIDENTS
PICKED UP THEIR PERSONAL BELONGINGS, ABANDONED
THEIR HOMES, AND FLED. JUNE 1, 1968.

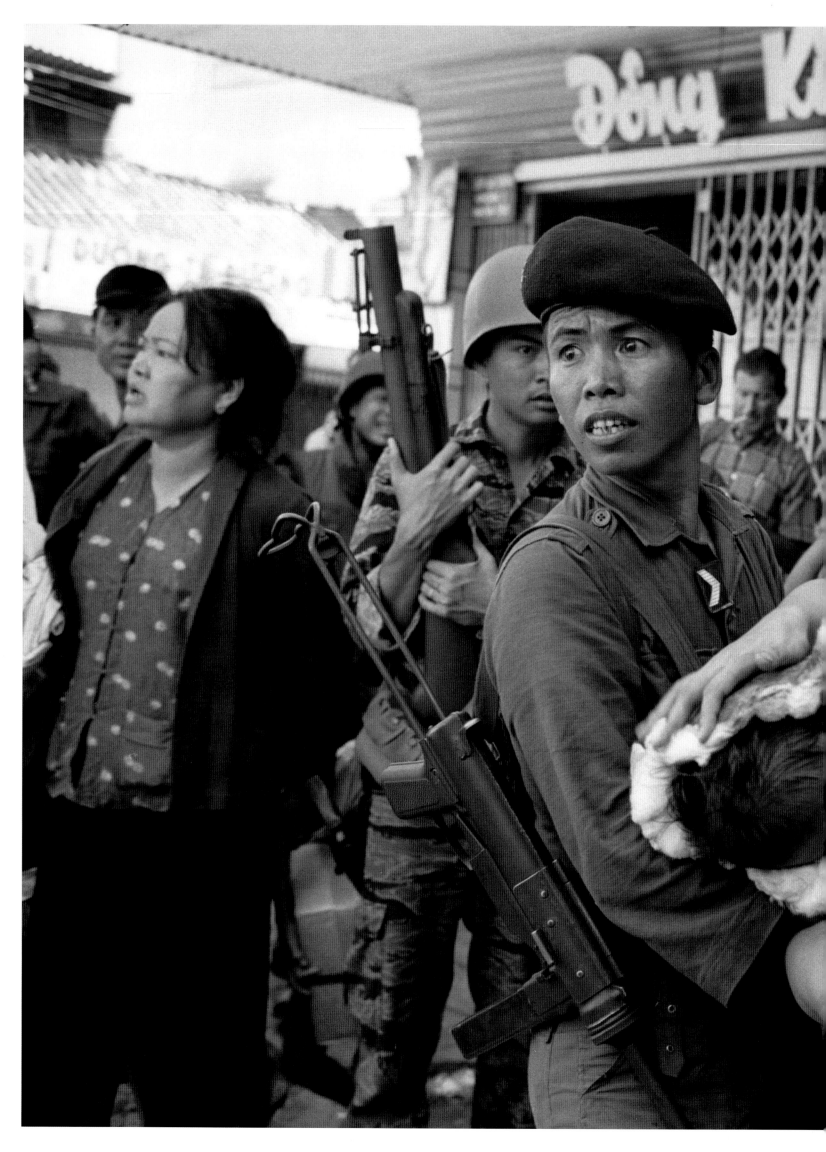

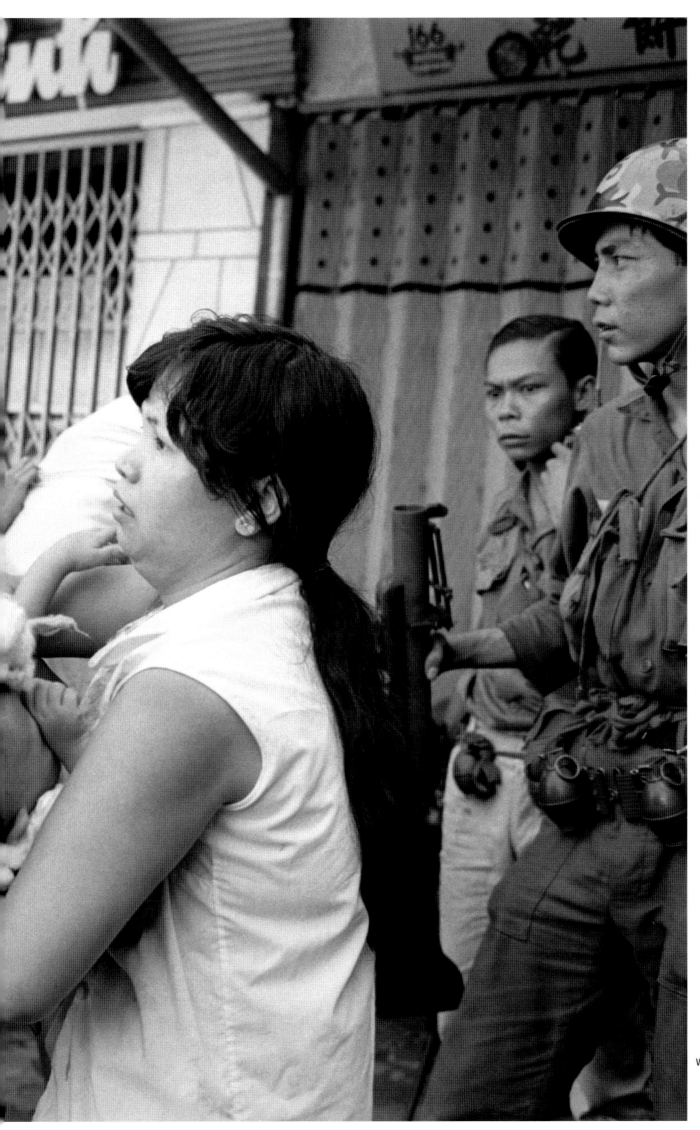

VIETNAMESE TROOPS ASSIST
RESIDENTS OF CHOLON TO
FLEE ATTACKING VIETCONG
FORCES, MAY 31, 1968.

169

THE CAMERA IS LIKE A SHIELD AND I WILL GO INTO SITUATIONS UNARMED. I'VE NEVER CARRIED A WEAPON, I FEEL THAT THE CAMERA'S GOING TO PROTECT ME, YOU KNOW, AND I THINK THAT'S A PART OF SURVIVAL TOO.

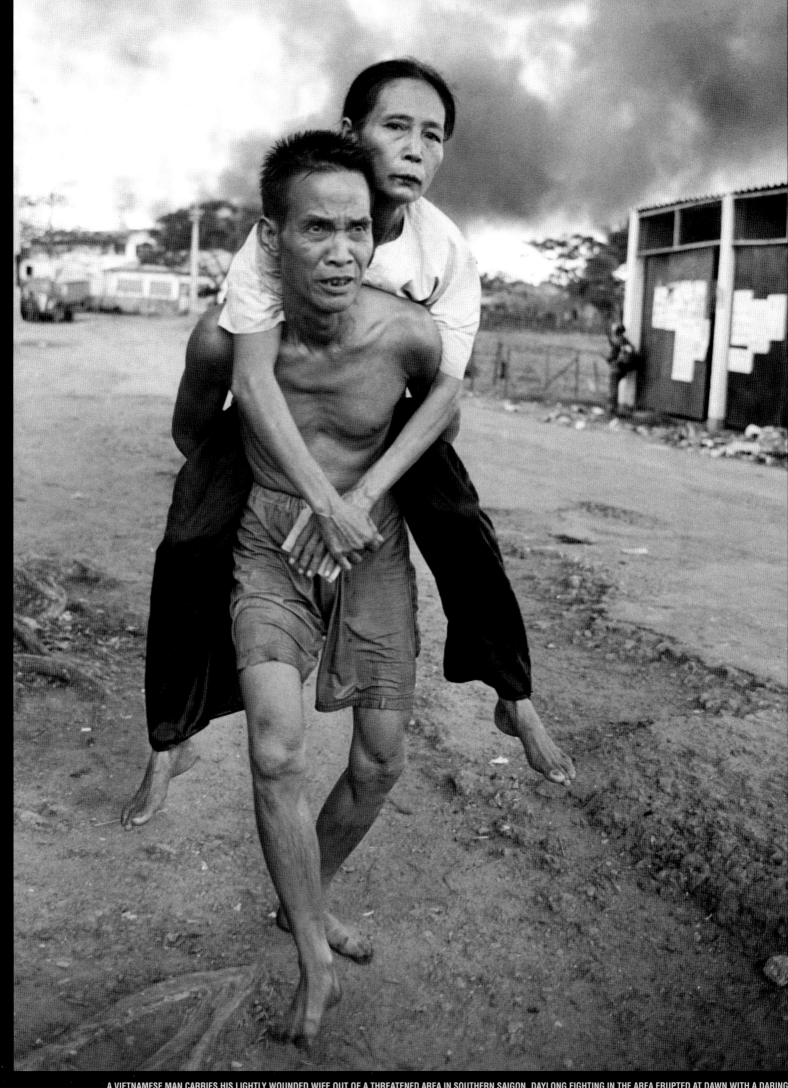

A VIETNAMESE MAN CARRIES HIS LIGHTLY WOUNDED WIFE OUT OF A THREATENED AREA IN SOUTHERN SAIGON. DAYLONG FIGHTING IN THE AREA ERUPTED AT DAWN WITH A DARING VIETCONG ATTACK ON A POLICE STATION. AS THEY DID DURING THE TET OFFENSIVE, RESIDENTS ABANDONED THEIR HOMES ESCAPING TO SAFER PARTS OF THE CITY. SAIGON, MAY 8, 1968.

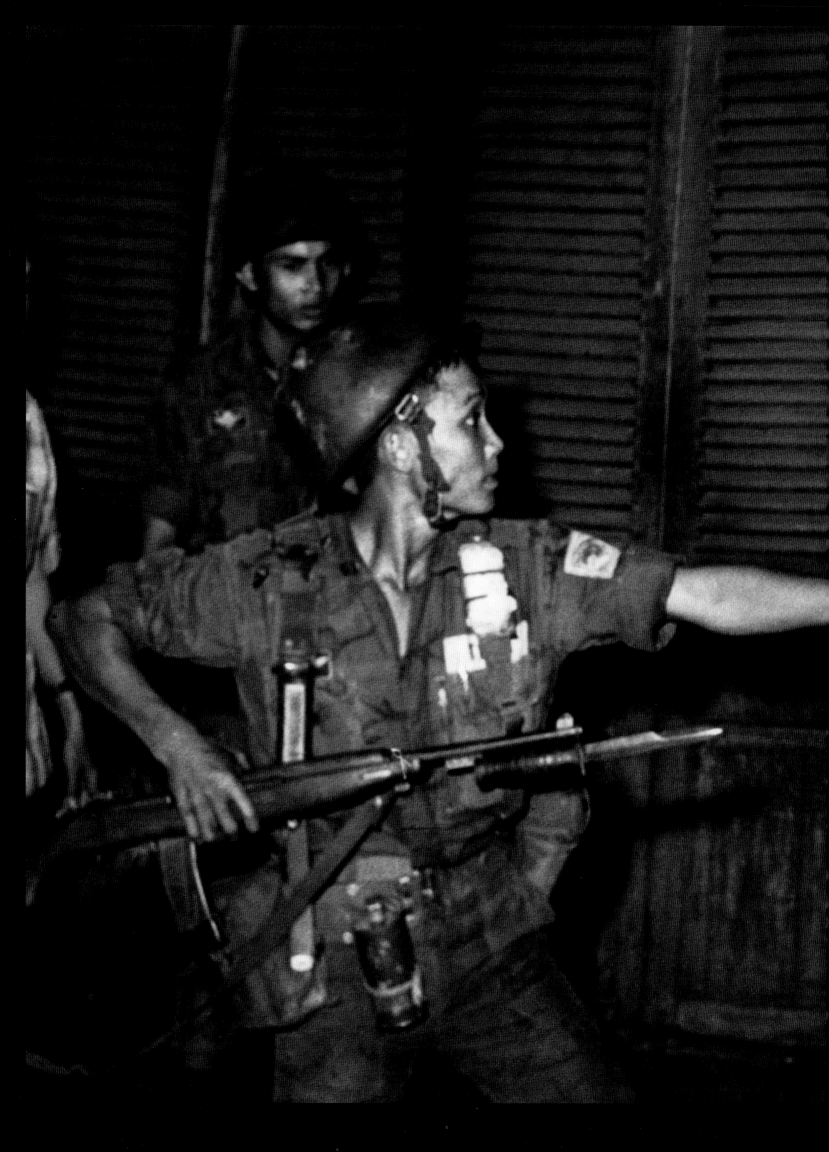

VIETNAMESE TROOPS BREAK UP A DEMONSTRATION IN SAIGON.

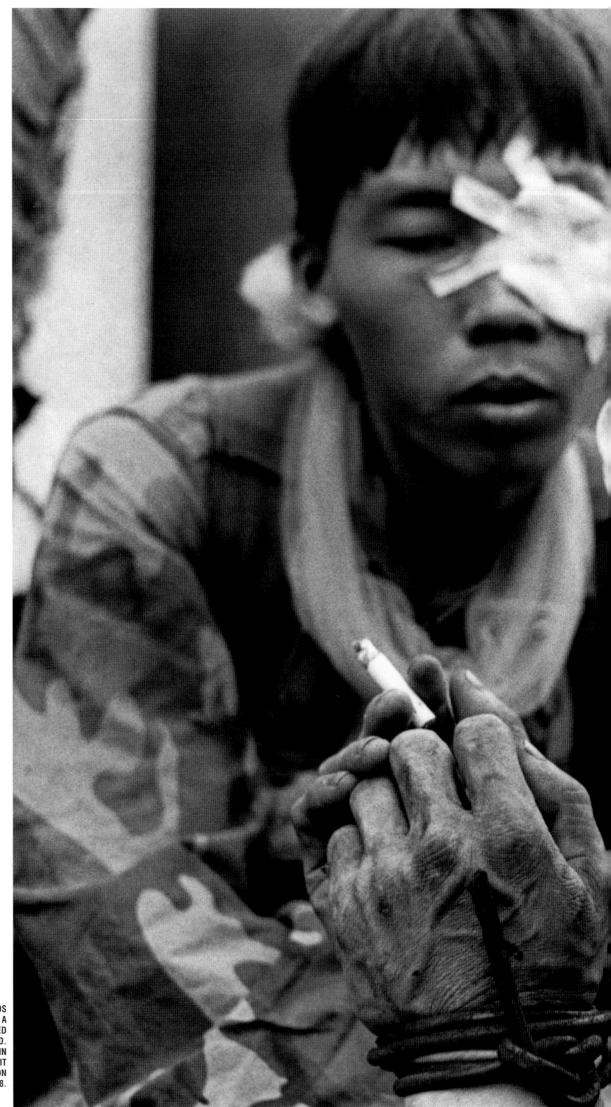

A WOUNDED VIETCONG PRISONER WHOSE HANDS
HAVE BEEN TIED WITH ELECTRIC WIRE SMOKES A
CIGARETTE AND WAITS WITH OTHER WOUNDED
GOVERNMENT SOLDIERS TO BE EVACUATED.
THE MAN WAS WOUNDED DURING FIGHTING IN
WESTERN SAIGON. THE VIETCONG AND HIS UNIT
HAD MOVED INTO THE AREA AND OPENED FIRE ON
GOVERNMENT TROOPS. MAY 31,1968.

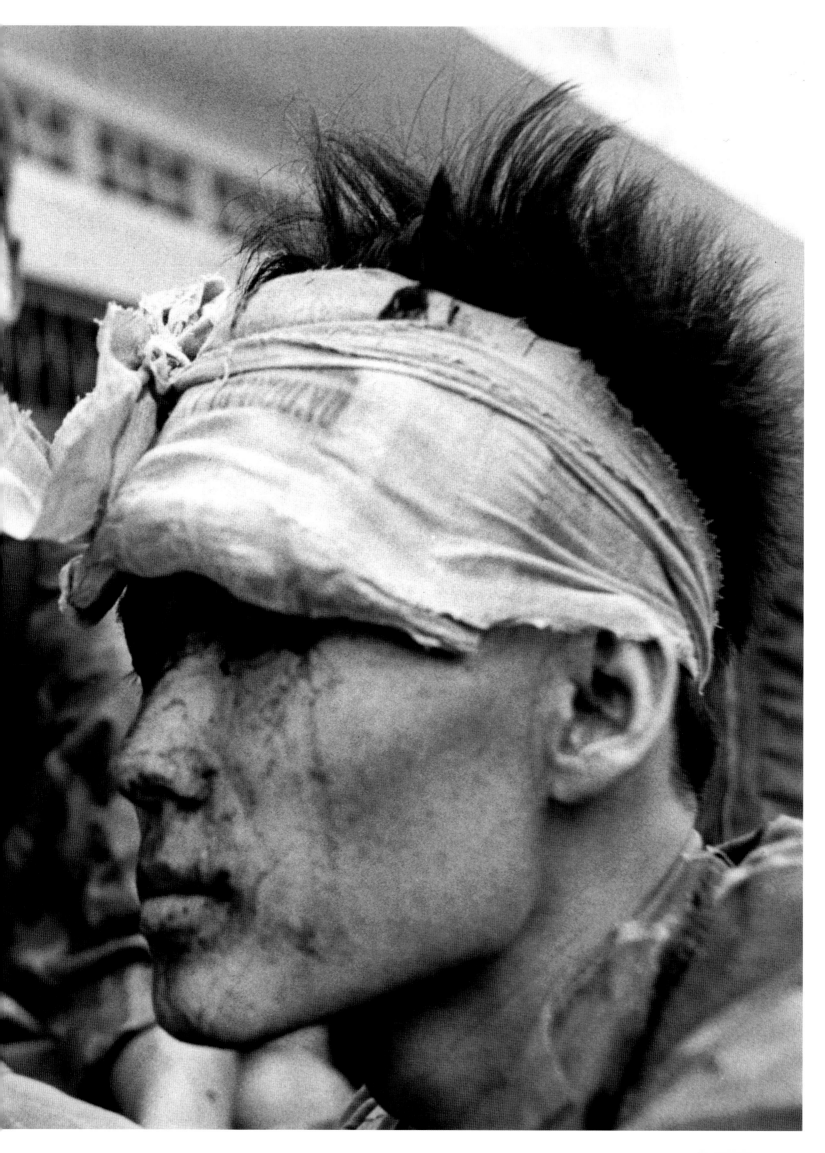

PICTURES DO LIE; PICTURES DON'T TELL THE WHOLE STORY. YOU'RE LOOKING AT 1/500TH OF A SECOND—IT'S A MOMENT. IT DOESN'T TELL YOU WHY... YOU DON'T SEE ALL SIDES. BUT PICTURES ARE IMPORTANT BECAUSE PEOPLE BELIEVE IN THEM.

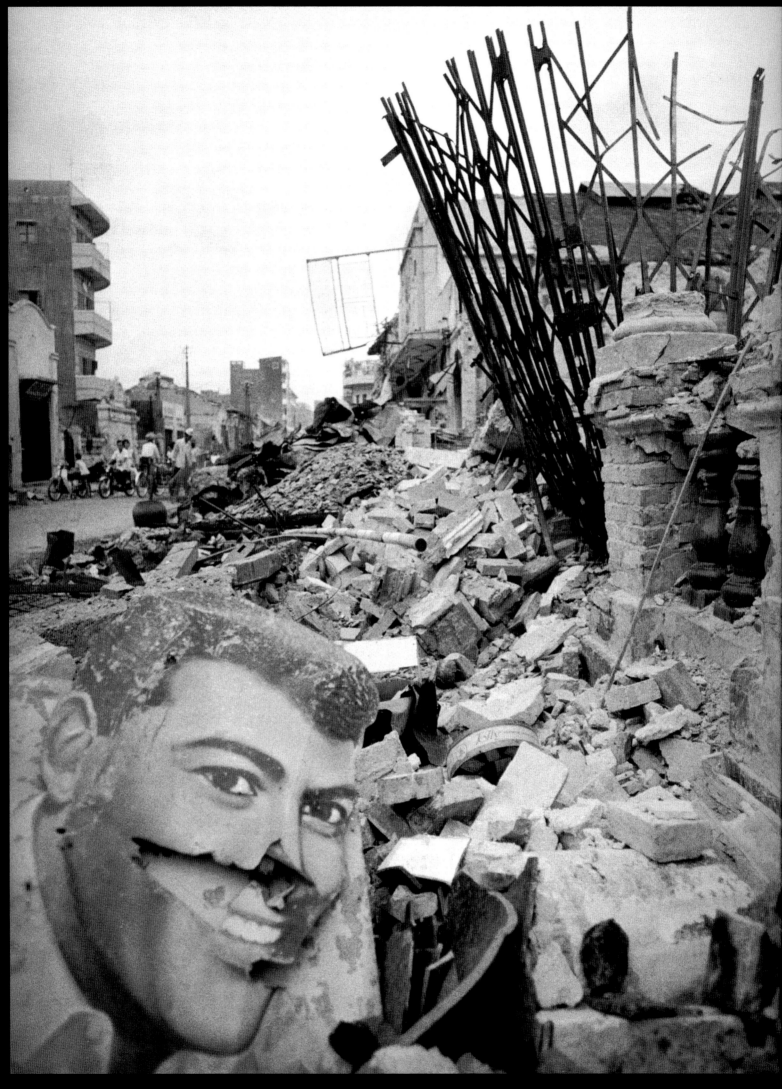

POSTER OF MAN SPORTING A NEAT CREWCUT, AD OF A CHINESE BARBERSHOP, THOUGH CUT AND BRUISED FROM BULLETS AND SCHRAPNEL OF MONTH-LONG BATTLE IN CHOLON STILL GRINS FROM THE
DEBRIS. PEOPLE ARE NOW PERMITTED TO RETURN TO THEIR SHOPS AND HOMES AFTER MOST DIEHARD SNIPERS WERE BLASTED FROM THEIR HIDING PLACES OR SURRENDERED. JUNE 14, 1968.

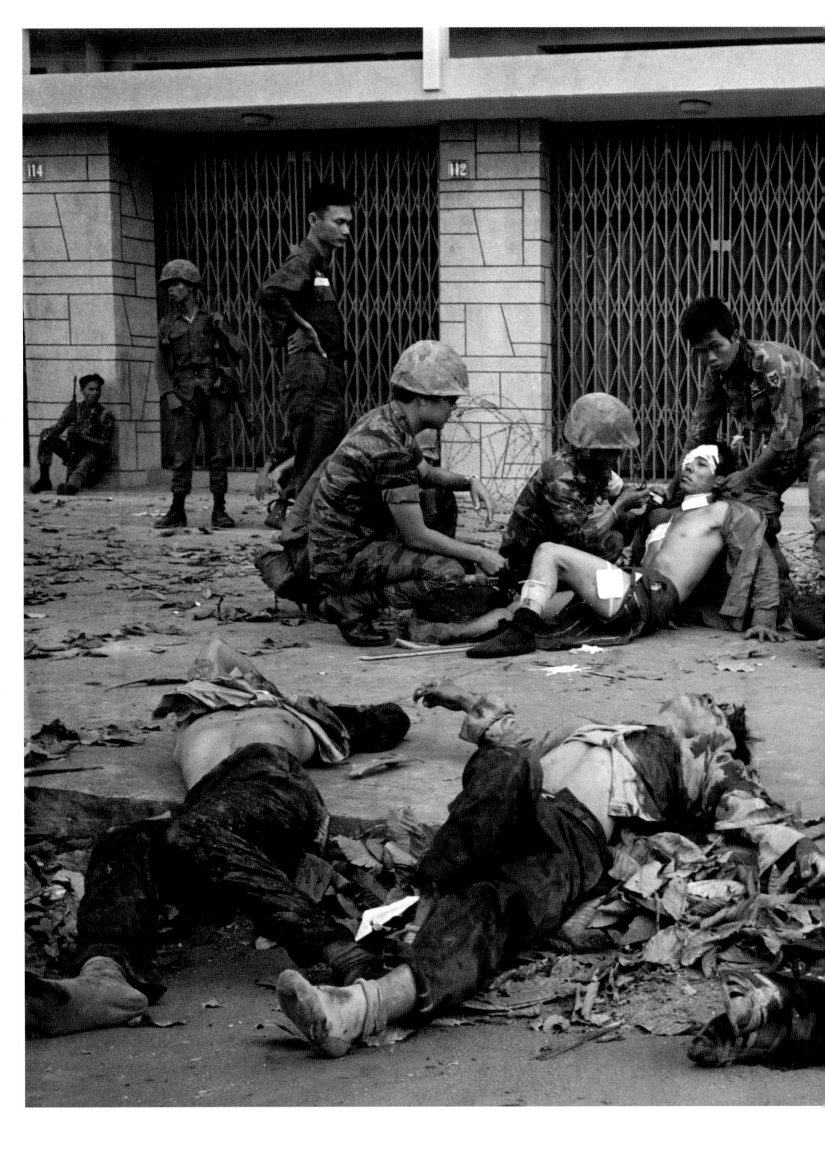

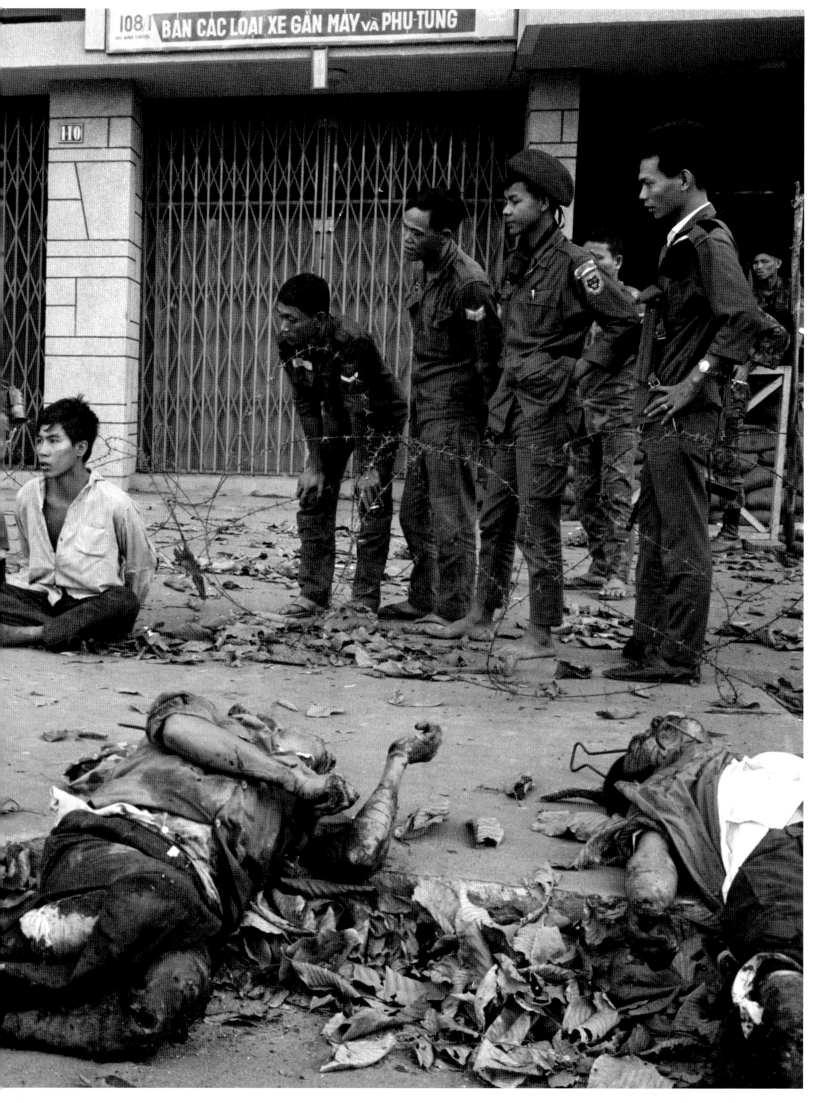

THE WOUNDED AND THE DEAD IN A SAIGON STREET DURING THE TET OFFENSIVE.

LONG AND BITTER STRUGGLE

From February until late June the AP staff was on the go, Adams included. When fighting eased in Saigon he went to Khe Sanh or Hue or into the Mekong Delta area. U.S. Marines and South Vietnamese troops fought a bitter encounter around the ancient structure in Hue known as the Citadel. At Khe Sanh, Marines were besieged in a situation sometimes compared to Dien Bien Phu, the 1954 battle that spelled the end of French colonialism in Vietnam. Great portions of villages in the delta were wiped out.

Marines of Khe Sanh, unlike the French, would outlast the North Vietnamese and Vietcong troops in the nearby jungles and mountains, but it was a long and bitter struggle. As one Marine wag inscribed, misspelling included, on a wooden plaque outside a bunker: CAUTION: Khe Sanh Is Hazardous To Your Hellth.

The first time I went to Khe Sanh I went in the way most correspondents go in....Nine times out of ten you fly in on a resupply plane, or an ammo plane....My first time I went in on an ammo plane which was loaded with rockets and grenades and all sorts of ammunition. Coming into Khe Sanh you head for a landing strip....As we started going down a little low, coming in for a landing, a machine gun opened up, and this Vietcong or a North Vietnamese based right there fired on every plane going in.

And the holes started popping through the tail end. The crew chief right next to me was hit on our way in. Every other plane got hit going in.

The planes never stopped moving after touchdown...they just keep on the runway and make a turnaround and you jumped out....The ammo was thrown out while the plane was still moving to take off again and get out of there...if it stayed on the ground for just a couple of minutes it could've been hit and blown up.

Usually Adams would stay at Khe Sanh for a few days, make pictures, then fly back to Danang, mostly on medical evacuation fights. Life in Khe Sanh was lived mostly in bunkers fortified by layers of sandbags. There was even danger from friendly fire; napalm strikes against enemy positions landed within a hundred yards of the base's barbed-wire perimeter.

All the times I'd been there I spent most of my time underground with the troops in the bunkers because they offer the best protection... We'd go above ground....you'd be out for only a few minutes and incoming would start and you head right back down below.

Most of the correspondents stayed with a bunker, it was a spooky place....I'd been on about 150 operations in Vietnam, and this was probably the spookiest place. I'd rather go on an

operation any time where I know that I could hit the ground. At Khe Sanh there wasn't any one place where there was concentrated action and another place where it was safer....except maybe the air strip when the planes came in, that was all action...all the other places were unsafe at any time...it was a bad scene.

One time I almost got left behind outside the perimeter of the base. I thought a helicopter was going into a battle area in the hills around Khe Sanh along with reinforcement troops, so I jumped aboard the chopper. When we set down there were four wounded Marines waiting....and a couple of guys with German shepherds.... I jumped out of the chopper and photographed the loading...and suddenly the helicopter lifted off and I was standing there all alone and no reinforcements in sight....I shouted at them and waved and they came back to pick me up and take me back to Khe Sanh.

Hue, at one time Vietnam's imperial capital, was a different kind of battleground. The major structure in the city was the Citadel, a huge picturesque complex built with great boulders walls. In the first Tet assault the Vietcong and North Vietnamese regulars captured most of Hue but were eventually driven back into the Citadel, whose nooks and crannies, towers and passageways made for excellent fortification. Fighting continued in Hue for weeks.

Adams visited Hue briefly and produced a story and pictures that captured the contrast of war Vietnam-style, a war in which people maintained, through sheer endurance, a semblance of normal life despite the war's intrusion.

For the people of Hue there are many hardships in the wake of the devastation left by a month of fighting during the Vietcong offensive. Simply crossing a bridge is one of them. For the young and old, it is extremely difficult to get across the 500-yard long bridge that was blown up and split in half by the Vietcong. Old men grimace and hug the railing as they climb one steep-angled span dropped by the Vietcong mines. It is hard, tiring work.

The bridge is a vital one. It is the only way to get across the Perfume River from the south side to the north side of the city, where the central market place is located. There is much business to be transacted in the market place. Food is bought and sold. People have fallen into deep crevices while attempting to jump over splits in the structure. Pedestrian traffic is heavy. Many are women carrying heavy loads of bricks to rebuild their destroyed homes, or vegetables to sell at the market place.

The only happy people are the children. Each day they run down the center of the bridge into the water where they spend the afternoon swimming. In the background the guns of war echo off the nearby stone walls of the Citadel.

In the Mekong Delta Adams photographed My Tho, a city that was half destroyed. Nearby Delta communities suffered worse—great areas of destruction, hundreds of civilians dead, tens of thousands homeless.

Sporadic outbursts of fighting continued in the countryside and in Saigon, culminating in the so-called mini-Tet of late spring, undertaken (it was said) to give North Vietnamese a stronger hand at peace talks in Paris. Once again heavy fighting battered Cholon and other sections of Saigon; once again the streets were battlefields. It was like a movie seen a second time: Tanks in the streets, military firing into houses, rocket attacks, house-to-house fighting…Cholon residents fleeing homes still battered and under repair from previous firefights and now being battered yet again.

Adams was in the middle of it. Pictures showed panicked refugees with their ubiquitous bundles of personal belongings rushing down streets as towering columns of smoke from rocket and artillery explosions rose in the background. Soldiers moved in the opposite direction on foot and in their roaring steel vehicles to meet the Vietcong head-on. At one point, it was reported, some 50,000 refugees from the suburban battle grounds were jammed into central Saigon.

Simultaneously, North Vietnamese attacked across the border hundreds of miles to the north in an effort to seize control of the strategic Cu Viet River. Names of towns like Dong Ha, site of a major U.S. Marine command center, and Dai Do, a nearby village taken over by the North Vietnamese, turned up in headlines and in the captions of Adams's photos. Hand-to-hand combat was not unusual as opposing forces battled for control of the river. In one instance Marines ran short of ammunition and resorted to picking up weapons of fallen North Vietnamese to use against attackers.

Tramping through the paddies was tricky for photographers and Marines. The countryside looked peaceful and typically rural. Normally farmers would work in the paddies cultivating rice and sweet potatoes and living in nearby huts.

But the North Vietnamese wanted access to the river and easily swept aside the local militia defenders at Dai Do, built bunkers and waited for the Marines. North Vietnamese shooters were invisible until the shooting started. Then it was into the mud and behind the dikes of the fields for protection. Later, when Dai Do was overcome, the bodies of twenty Marines were discovered. Dai Do was destroyed.

As Doug Robinson of the *Los Angeles Times* put it: *It was not much of a village even when the buildings were standing. Now there is nothing but rubble and the smell of death and destruction. In the last three days Dai Do has received more attention than ever before in its history. It has changed hands three times.*

Marine and South Vietnamese dead and wounded were carried out over the same rice paddies they walked through to reach Dai Do. The wounded and the dead waited side by side on the banks of the Cu Viet River for evacuation, as did Adams with his pictures of the fight.

The debilitating life—switching from urban warfare to war in the paddies—gradually took its toll on Adams. Exhausted by full time encounters with war for six months, he opted to return home.

Adams continued his superior photography for AP until 1972 when he left to join *Time* magazine for several years. The small format of the news magazine and its limited use of pictures frustrated him. His marriage faltered and finally ended in divorce from his wife, Anne. He became a freelancer, and held down a special assignment at *Parade* magazine where he shot hundreds of covers for much of the remaining years of his career, along with other assignments.

In 1988 he married Alyssa Adkins, a designer whom worked with him to build two projects, one of them a large, fully equipped photo studio in Manhattan. Their second project—the creation of Barnstorm: The Eddie Adams Workshop—would be his final legacy.

But before that there would be another visit to Asia and a story he believed to be his most worthwhile coverage of the Vietnam saga.

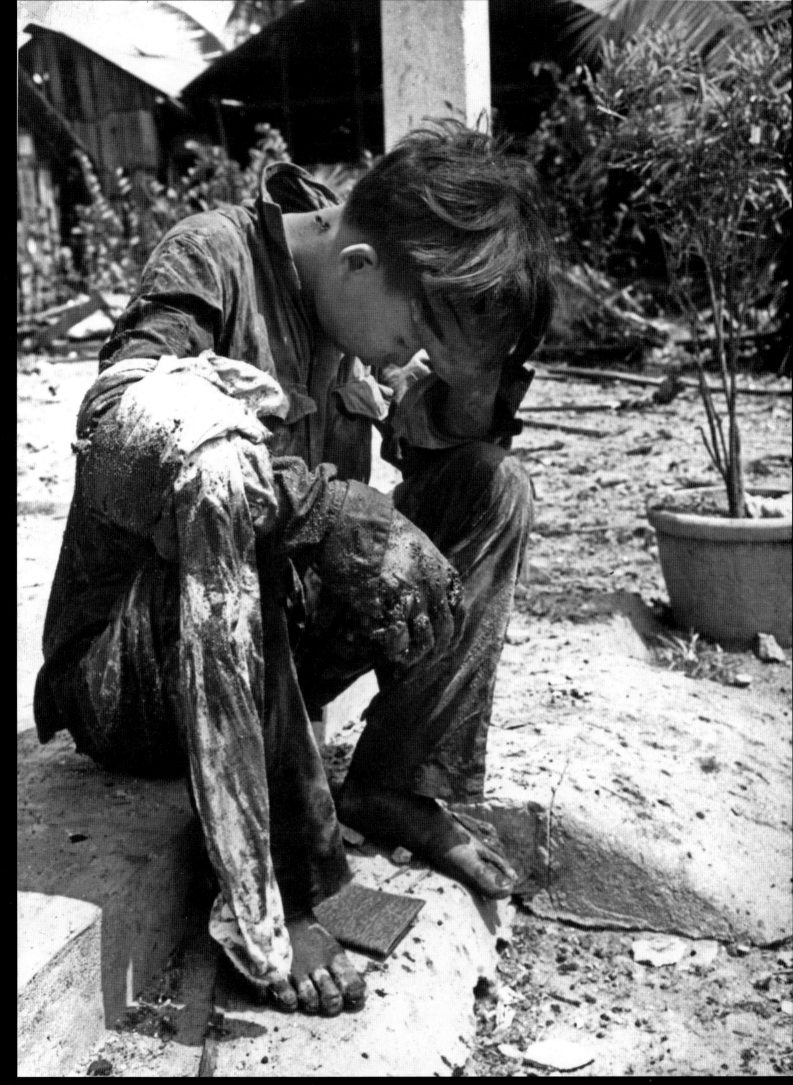

CAPTURED. A WOUNDED VIETCONG GUERRILLA SITS ON A STEP IN NORTHEASTERN SUBURB OF SAIGON FEB.18, WEARY AFTER HIS CAPTURE BY SOUTH VIETNAMESE MARINES, HE WAS CAUGHT HIDING UNDER A BED WHERE HE HAD FLED FROM MARINES. HE WAS WITH A UNIT THAT HAD MARCHED SIX DAYS' TIME FROM ZONE D, ABOUT 50 MILES NORTHEAST OF SAIGON, TO THE CAPITAL FOR AN ATTACK.

MARINES RUN TO BOARD A HELICOPTER AT KHE SANH, 1968.

TWO NORTH VIETNAMESE TROOPS, THEIR HEADS HOODED
WITH SANDBAGS AND HANDS TIED BEHIND THEIR BACKS,
ARE LED INTO KHE SANH BY U.S. MARINES. THEY WERE
CAPTURED ON THE BASE'S PERIMETER. THE CAPTIVES
WERE EVACUATED FOR INTERROGATION.

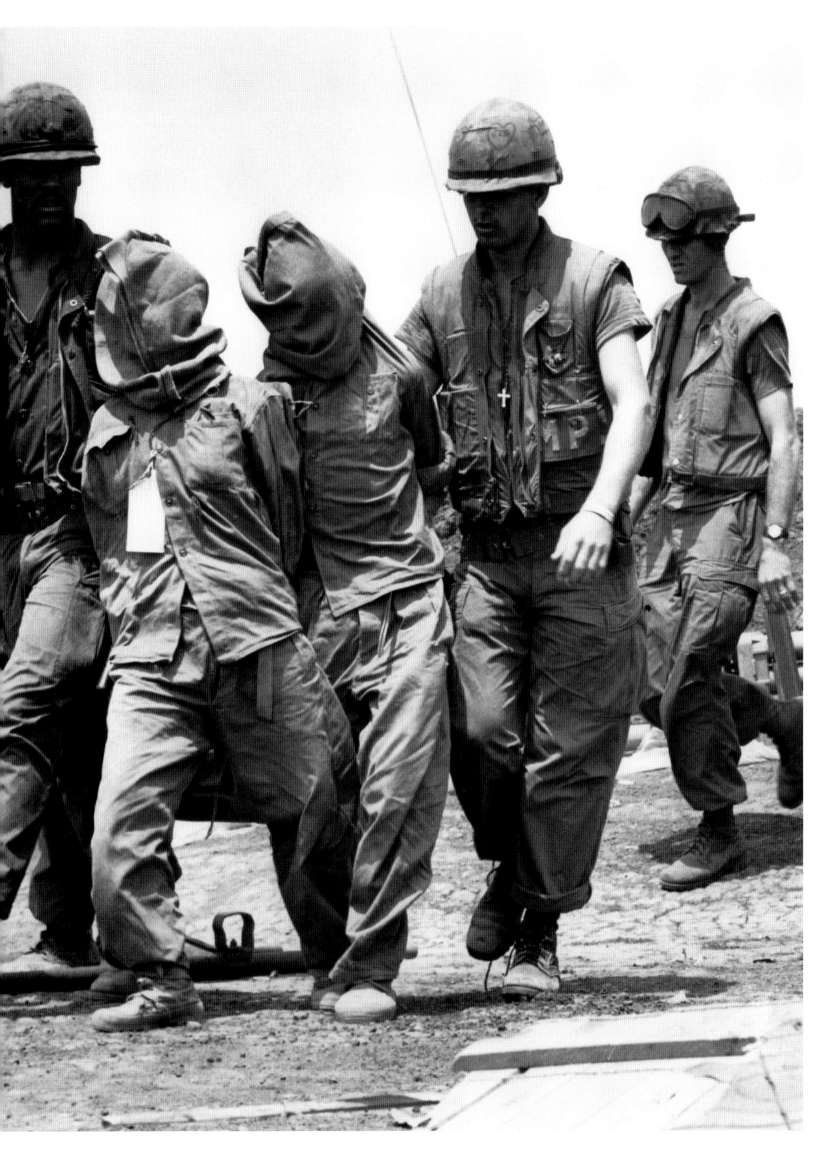

CAVALRY TROOPERS MOVE OFF TOWARDS THE A SHAU VALLEY FROM A LANDING ZONE ON THE FRINGE OF THE VALLEY. THE CAVALRYMEN ARE TAKING PART IN OPERATION "DELAWARE" WHICH WILL TAKE THEM INTO THE VALLEY, THE MAJOR ENEMY SUPPLY BASE IN SOUTH VIET-NAM. THE ENEMY USE SMALL JUNGLE TRAILS TO FERRY THEIR MEN, EQUIPMENT INTO THE AREA. AMERICAN TROOPS HAVE NOT ENTERED THE VALLEY FOR TWO AND A HALF YEARS. THE VALLEY IS SITUATED 25 MILES WEST OF HUE AND 375 MILES NORTH OF SAIGON. APRIL 1968.

RESIDENTS OF HUE MAKE THEIR WAY CAREFULLY ACROSS A BOMBED BRIDGE IN THE CENTRAL CITY.

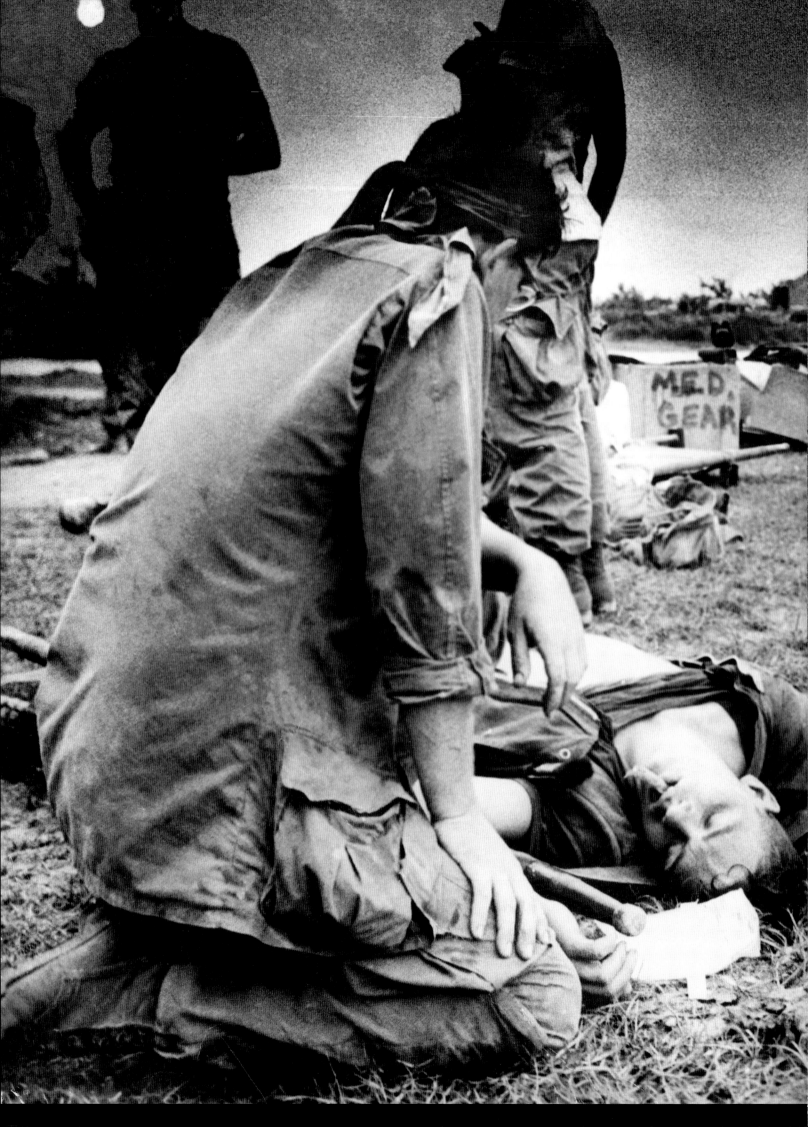

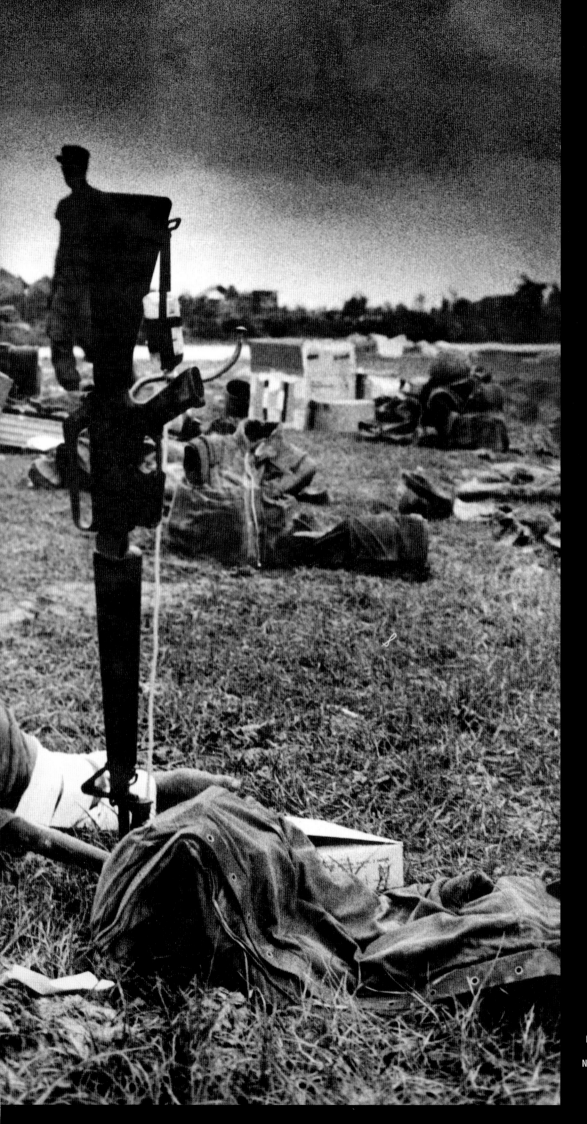

MEDICS TREAT WOUNDED AT CU VIET RIVER WHERE MANY
WERE WOUNDED OVERCOMING ENTRENCHED NORTH VIET-
NAMESE FORCES. FIGHTING TOOK PLACE AT DAI DO, THREE
MILES FROM THE RIVER, MAY 7, 1968.

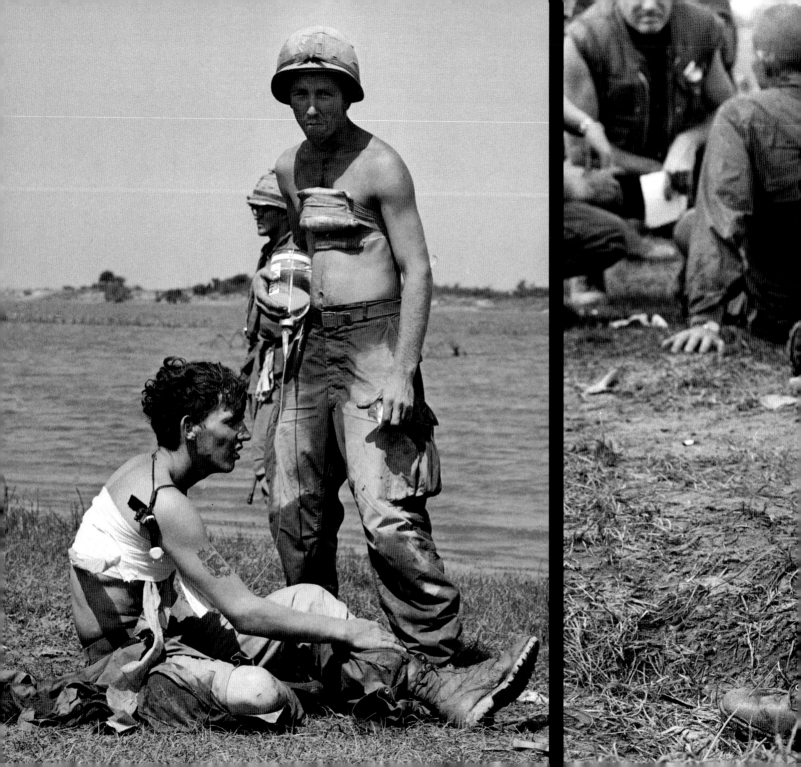

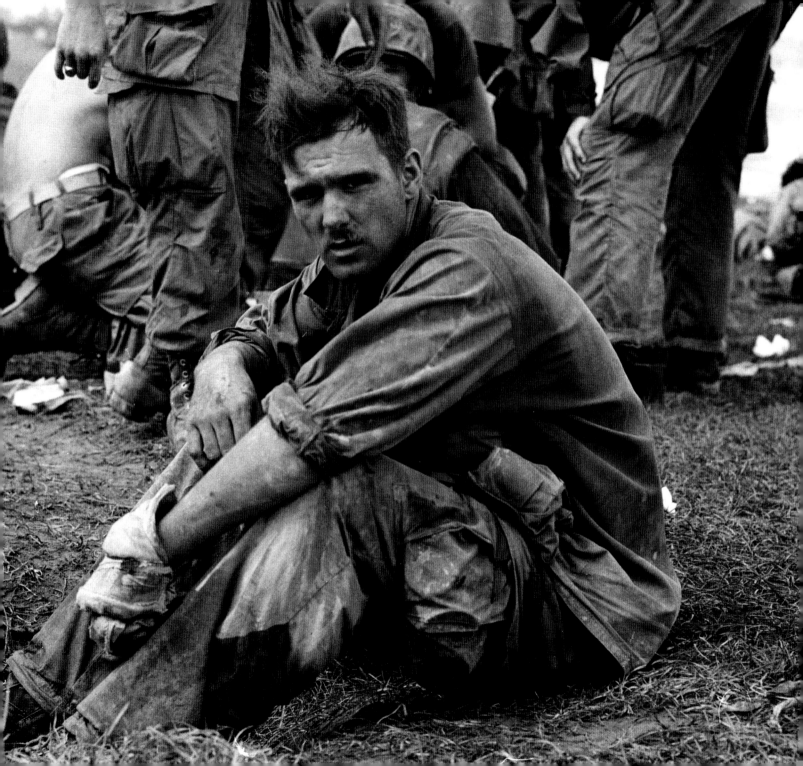

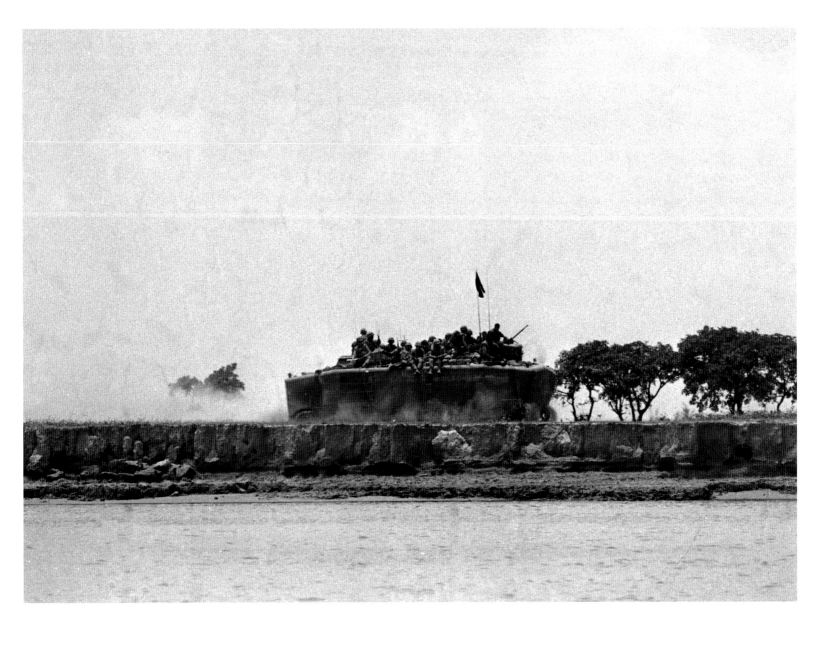

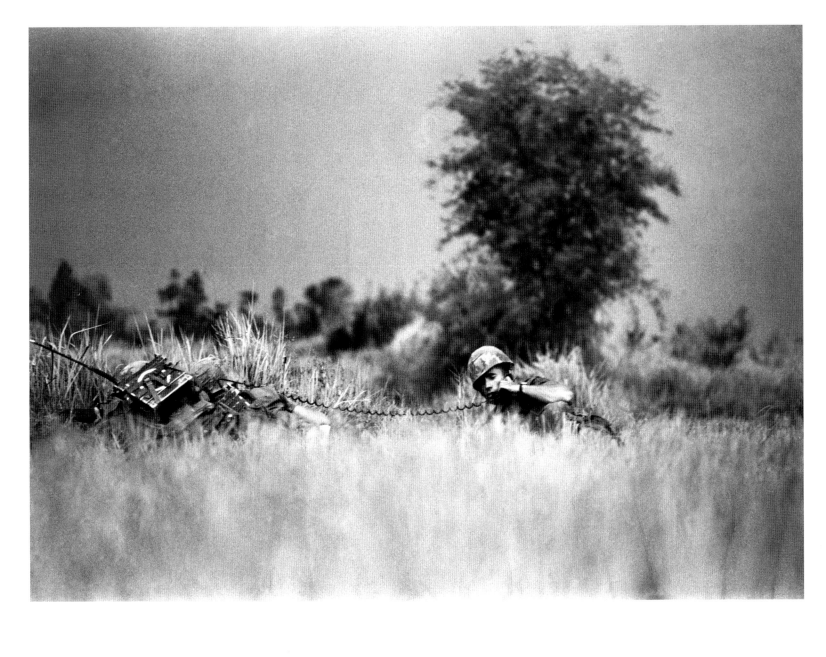

ABOVE: U.S. MARINE CAPT. CHARLES ROBB DIRECTS
MOVEMENTS OF HIS COMPANY VIA RADIO AS HE AND HIS RADIO
OPERATOR LIE NEXT TO A DIKE IN A RICE PADDY AS VIETCONG SNIPERS
OPEN FIRE. ROBB WAS LEADING HIS COMPANY THROUGH RICE PADDIES
SOUTH OF DANANG IN SOUTH VIETNAM. ROBB'S WIFE, LYNDA BYRD
JOHNSON, DAUGHTER OF PRESIDENT JOHNSON, IS EXPECTING A CHILD
IN LATE OCTOBER. SOUTH OF DANANG, VIETNAM, MAY 18, 1968.

OPPOSITE: U.S. MARINES PILED ONTO THE TOP OF AN AMPHIBIOUS
VEHICLE SLOWLY MOVING TOWARD POSITIONS OF A BATTALION IN HEAVY
CONTACT WITH AN ESTIMATED 2000 NORTH VIETNAMESE REGULARS AT
DAI DO, NEAR DONG HA ON THE DMZ. THE NVA WAS ATTEMPTING TO INTER-
DICT THE CUA VIET RIVER, FOREGROUND, WHICH SERVES AS A
VITAL RESUPPLY LINK TO A GROUP OF BASES ALONG THE DMZ.
THE BATTALION SUFFERED HEAVY CASUALTIES IN TWO ATTEMPTS TO
STORM ENEMY-HELD VILLAGE. DAI DO, MAY 5, 1968.

MARINE MEDICS AND HELPERS EVACUATE THE
WOUNDED AT AN EVACUATION POINT ALONG THE CU
VIET RIVER. THE MARINES WERE WOUNDED DURING
SEVERAL CHARGES AGAINST A NORTH VIETNAMESE
HELD VILLAGE NEAR THE DMZ, MAY 5, 1968.

1977
THE BOAT OF NO SMILES

The years pass. The decade of the '60s inevitably becomes the decade of the '70s. Stories are covered. Saigon falls to the North Vietnamese in 1975. Wars are fought elsewhere. Adams shoots news and picture stories for the AP. His fame is assured. Despite his protests the Saigon execution photo is the signature picture of his career. It will be that way always.

But the old feelings haunt Adams. *That which sustains us also consumes us.* There must be better opportunities for great pictures, he believed, and he left the AP to join *Time* magazine for a few years. That didn't work out and he rejoined AP.

Adams noted a story in *The New York Times* about refugees from Vietnam. The thought of Vietnam triggered memories—and Adams followed up. He was a Special Correspondent for AP, the only photographer to ever carry a title usually reserved for highly valued writers.

He suggested that he and Arnett, now working in New York, go to Southeast Asia and try to find the refugees fleeing the Communist world of Vietnam.

You just want Arnett to do the digging, the hard work, he was told. And he responds, truthfully. *Yes, I just want to shoot pictures.*

Go, he was told, *but go alone.* He did.

In his Associated Press oral history interview, Adams recalled the multiple frustrations that he encountered from all quarters in setting up the refugee story.

I asked about going over there and trying to find these people and getting on a boat escaping from Vietnam. And I was told to go. So I started calling all AP bureaus all over the world to try to find out about these people. The story was kind of pooh-poohed by most of those I talked to.

I called everybody from Australia to the Philippines to Indonesia…all the places in Southeast Asia…and everybody said they're all fishing boats, and you can't tell the refugees from the fishermen.

Adams wasn't certain how to go about getting the story but his experience and what he learned in his telephoning told him to go to Thailand as a start.

I felt I would go to the Thai Marine Police, and ask if I could get on a patrol boat with them. Thailand—and none of the other countries— would accept them. What they would do is let them come to shore, put a rope on them and pull them back out to sea. Nobody wanted them.

I went to the Thai Marine Police and I met with them several times. At one meeting they said a boat had just pulled in and they would tow it back out to sea. I remember running and

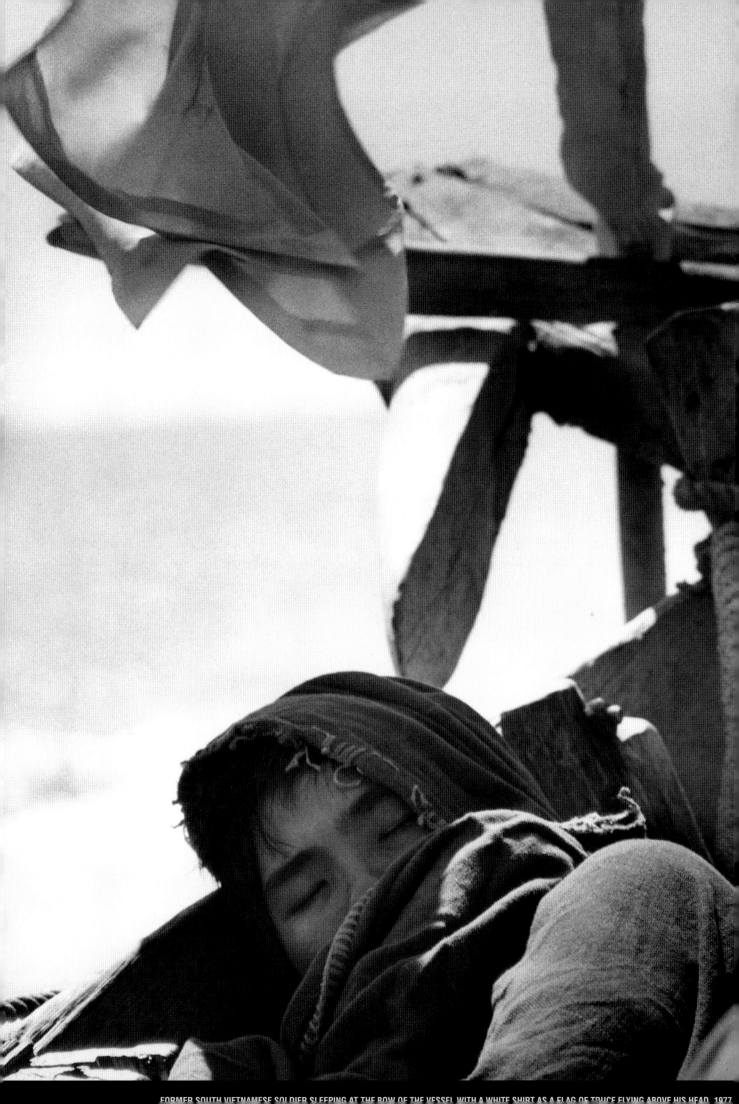

FORMER SOUTH VIETNAMESE SOLDIER SLEEPING AT THE BOW OF THE VESSEL WITH A WHITE SHIRT AS A FLAG OF TRUCE FLYING ABOVE HIS HEAD, 1977

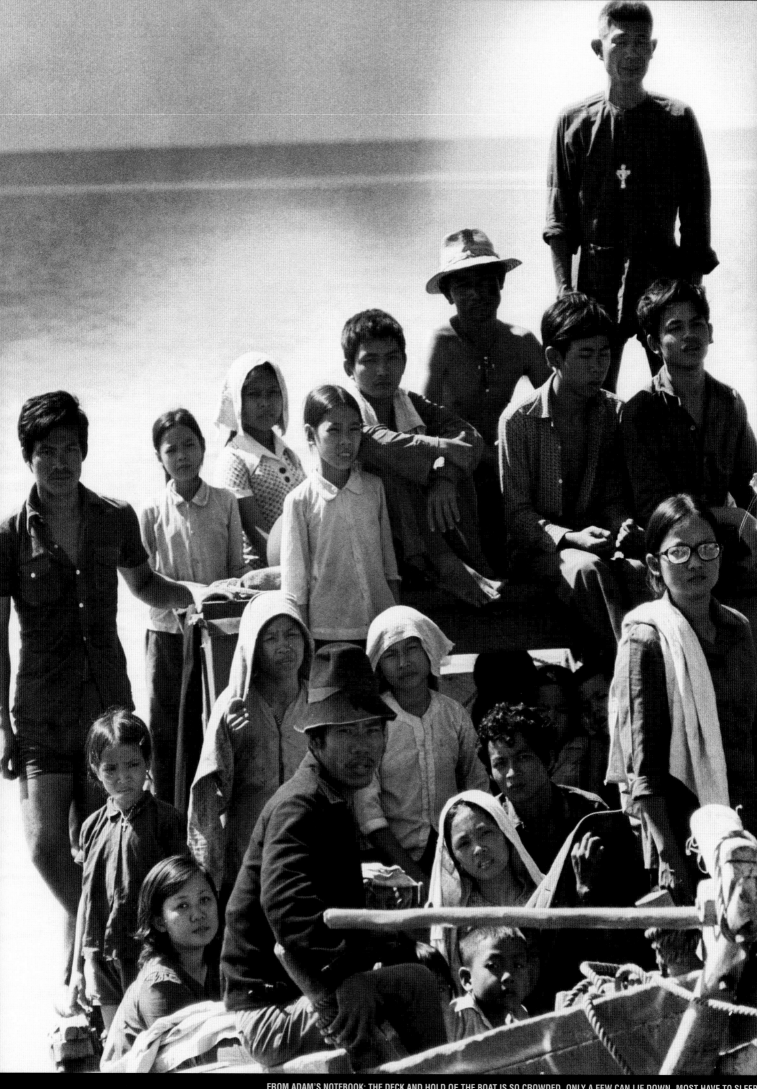

FROM ADAM'S NOTEBOOK: THE DECK AND HOLD OF THE BOAT IS SO CROWDED, ONLY A FEW CAN LIE DOWN. MOST HAVE TO SLEEP
SITTING UPRIGHT. THERE WERE NO SMILING FACES ABOARD THE FISHING VESSEL WITH NO NAME, 1977

running to get to the area, and here was this boat...a thirty-foot fishing boat with fifty people on board. And they were at sea for about five days, and they had just landed. They were there for about thirty minutes and they were getting ready to tie the ropes on, so I ran up to them and I said, "Wait, wait." They had no fuel or anything, so I bought $100 worth of gasoline and rice and asked the Vietnamese—some of them spoke very good English—could I go with them. They said okay, they'd accept me. So I bought the food and fuel and they towed us back out to sea.

And we were out there and I'm wondering what the hell am I doing here. At that time Thai pirates were blowing up everybody and robbing them and drowning people and the first thing I could think of was, "Where do I take a pee?"

There's fifty people...men, women, children... they're sitting on the deck because there is no room. And the Vietnamese had one umbrella on board and the sun was beating down, and they're holding it over my head.

The Thai police left...all of sudden we're floating, and I have no idea where we're going or what we're doing...and I'm wondering again what I'm doing there.

The Vietnamese, of course, were happy to have me. They believed that when they landed at another Thai port—if they landed—with an American on board their chances of being accepted were better.

Late in the day, just before sunset, another Thai Marine Police boat came by, with a loud speaker and someone speaking in English. Who's on board but Mangkorn, the AP photographer from Bangkok.

The loudspeaker said, "You are coming off that boat," and the police boat came along side and ordered me once again, "You are coming off that boat."

I had mixed feelings about getting off. I really wanted to get off, but I didn't want to get off because I felt I really didn't have all my story.

But the Thai meant business, so off I went.

So I wrote a small story...and the reason it was called "The Boat of No Smiles" is because I'd probably been, at that time, in almost every refugee camp in the world at one point or another and a lot of wars. No matter when you aim the camera at children...I don't care if there's fifteen bodies stacked up...the children will smile. And this was the first time in my life that nobody smiled, not even the children, and I'm three feet away...I'm right next to them and I was aiming that camera...and so I called it the Boat of No Smiles.

Adams's story read, in part:
Khlong Lai, Thailand (AP) - "I will die, I will die, I will die," screamed the Vietnamese woman aboard the boat of no smiles.

Forty-nine other sick or hungry refugees sat in silence or wept uncontrollably on the deck of the weather beaten thirty-foot fishing boat that had brought them from Phuquoc on the west coast of Vietnam through the dangerous waters off Cambodia.

They thought they had reached freedom on that last day of November when they entered the snug harbor of Khlong Lai, a tiny fishing village within shouting distance of Cambodia.

But Thai Marine Police, armed with M-16 rifles, refused them permission to come ashore and towed the crammed fishing boat three hours back out into the Gulf of Siam.

Naked children were crawling about the small cabin and an infant fed at its mother's breast.

The only other area protected from the punishing sun, the chill night fogs, and the soaking waves, was the hold used for fish. Three people were trying to sleep in it.

The oldest person on board was a woman in her 70s. The youngest was an infant born Nov. 24th in the fish hold. The baby was delivered by her husband, a former medical corpsman in the South Vietnamese army.

The story went on to describe life on the boat—the cramped conditions, the dangers of life on the open sea, the lack of a compass, the lack of food and fuel save that which Adams provided, the fear of returning to Vietnam where they believed they would be executed.

"The sun and stars have guided us," one passenger said, "We don't know how long our luck will hold but this is only the beginning. More and more will escape no matter what it costs."

A white shirt was tied to mast as a sign of truce, Adams wrote, as the ship moved away.

A few hours later the police patrol passed through the area where the fishing boat was last seen but there was no sign of it. U.S. and embassy officials said they had a thirty to fifty percent chance of survival.

The story and pictures were distributed on AP wires and were published worldwide. Prints were entered in Congressional proceedings and made their way to the desk of President Jimmy Carter, who admitted to being touched by the photographs.

There had been discussions in U.S. government circles to do something to help the Vietnamese refugees. The pictures by Adams, it was widely acknowledged, accelerated the process that eventually paved the way for some 200,000 Vietnamese immigrants to be admitted to the U.S.

Of all the work he did in Vietnam, the Boat of No Smiles was what Adams considered to be his most productive, positive picture story.

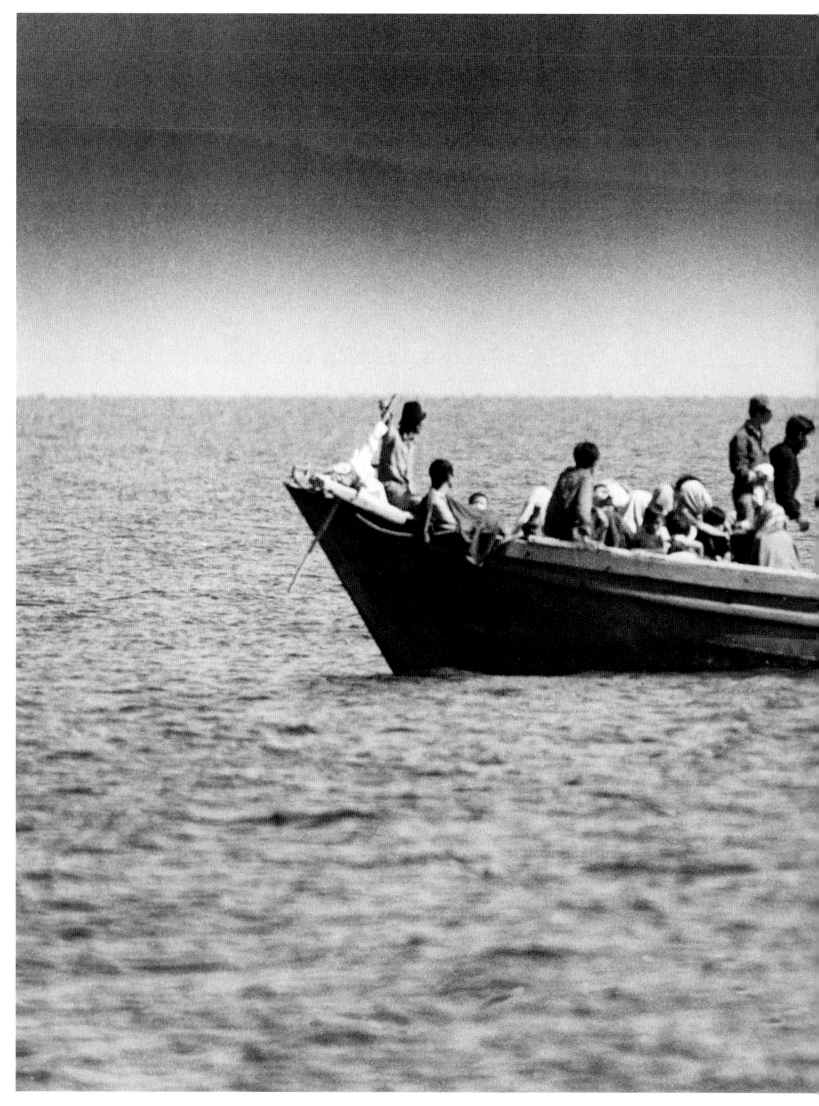

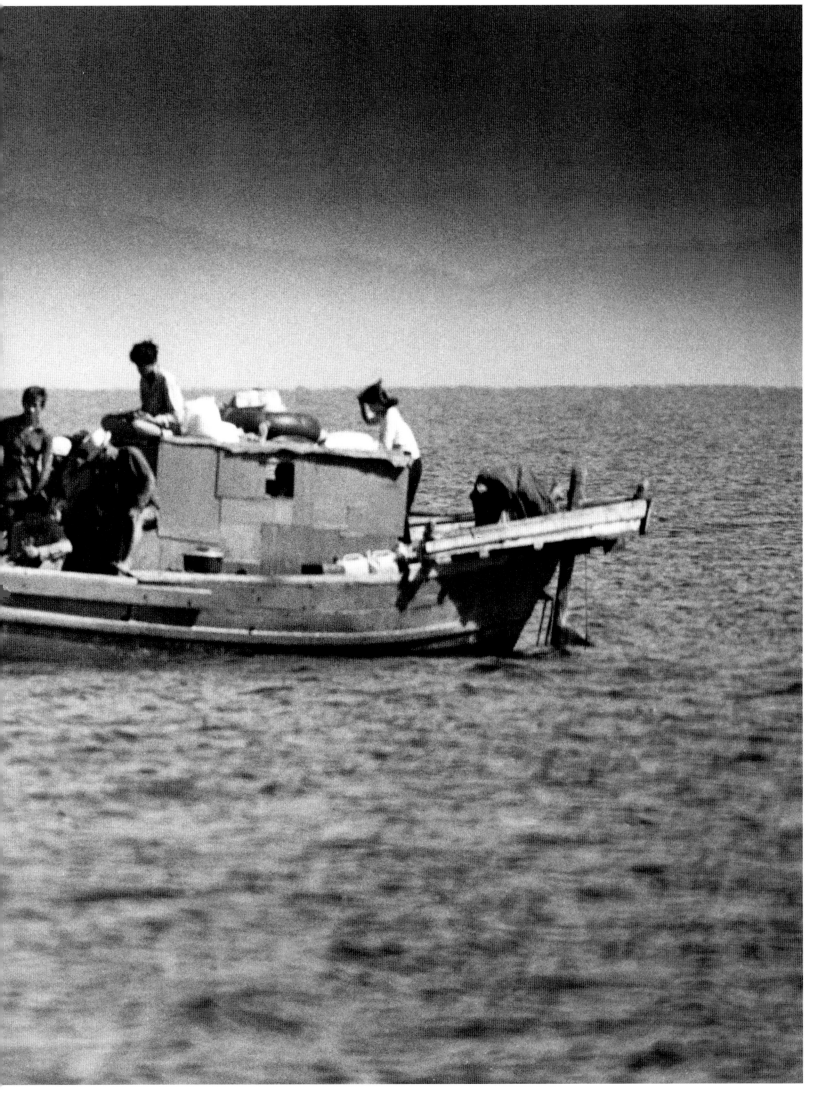

THE BOAT AS IT WAS LAST SEEN FROM THE THAI MARINE POLICE BOAT.

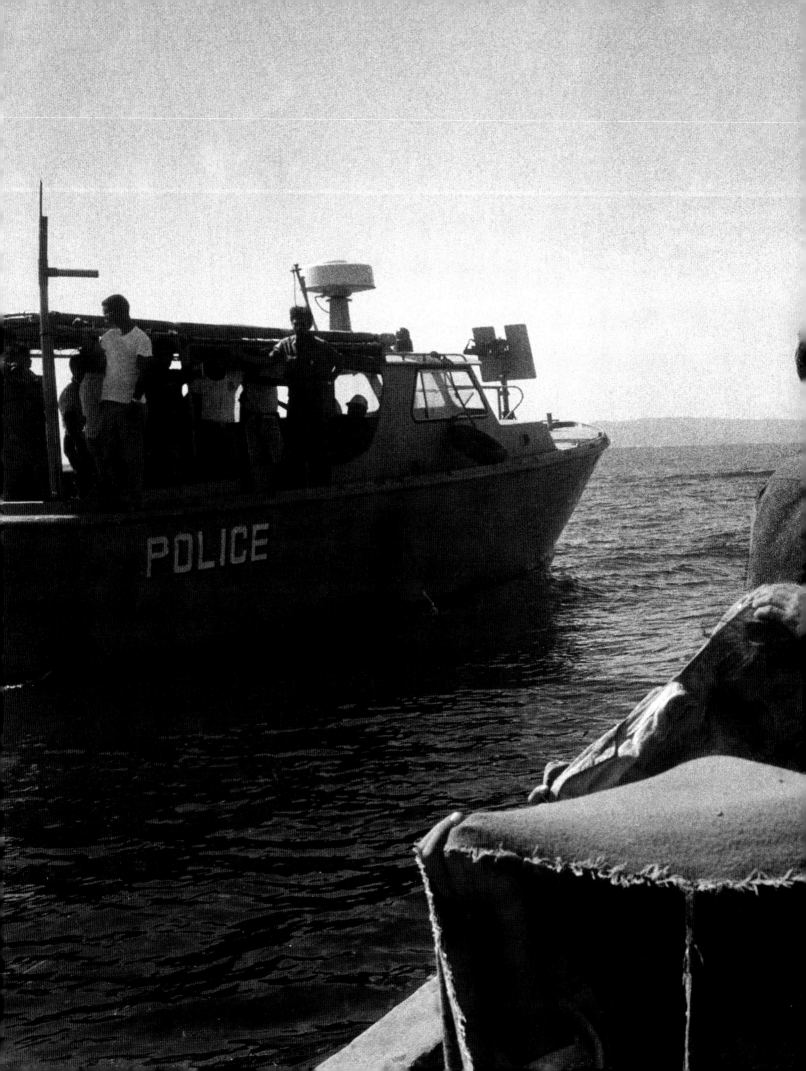

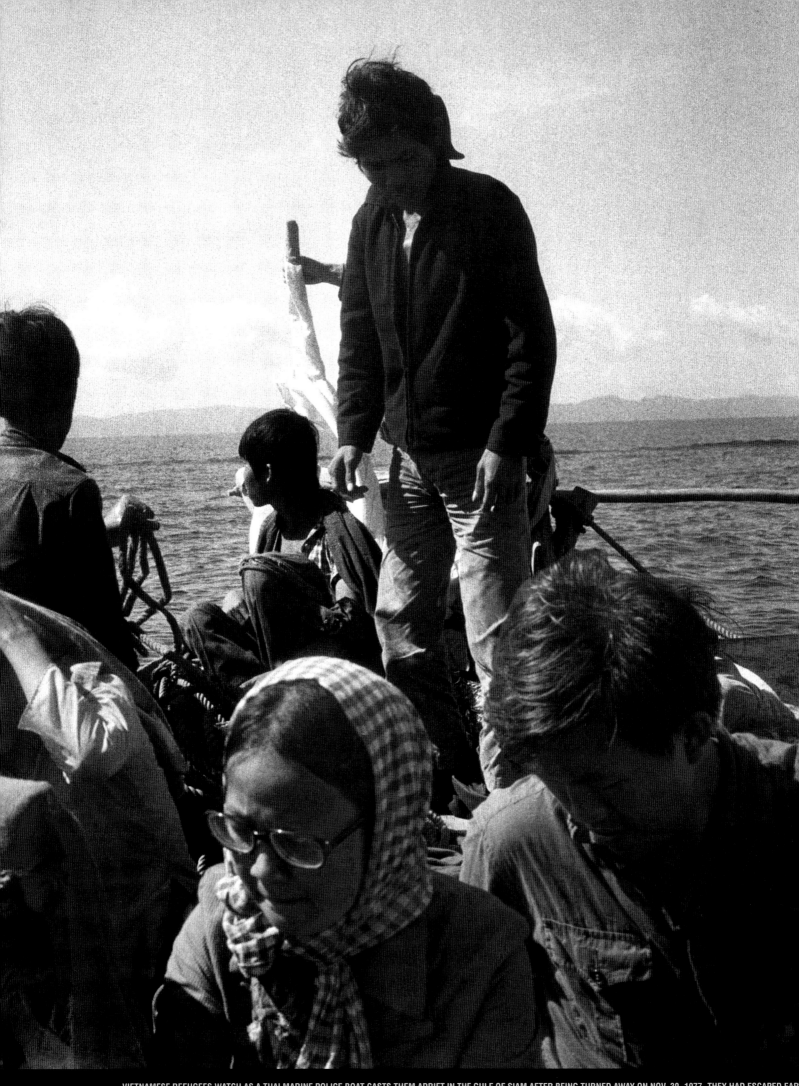

VIETNAMESE REFUGEES WATCH AS A THAI MARINE POLICE BOAT CASTS THEM ADRIFT IN THE GULF OF SIAM AFTER BEING TURNED AWAY ON NOV. 30, 1977. THEY HAD ESCAPED EARLIER IN NOVEMBER FROM VIETNAM TO WHAT THEY THOUGHT WOULD BE FREEDOM, BUT THAI POLICE REFUSED TO ALLOW THEM TO COME ASHORE.

NO MATTER
WHEN YOU AIM
A CAMERA
AT CHILDREN...
I DON'T CARE
IF THERE ARE
FIFTEEN BODIES
STACKED UP...
THE CHILDREN
WILL SMILE.
THIS IS THE
FIRST TIME IN
MY LIFE THAT
NOBODY SMILED,
NOT EVEN THE
CHILDREN.

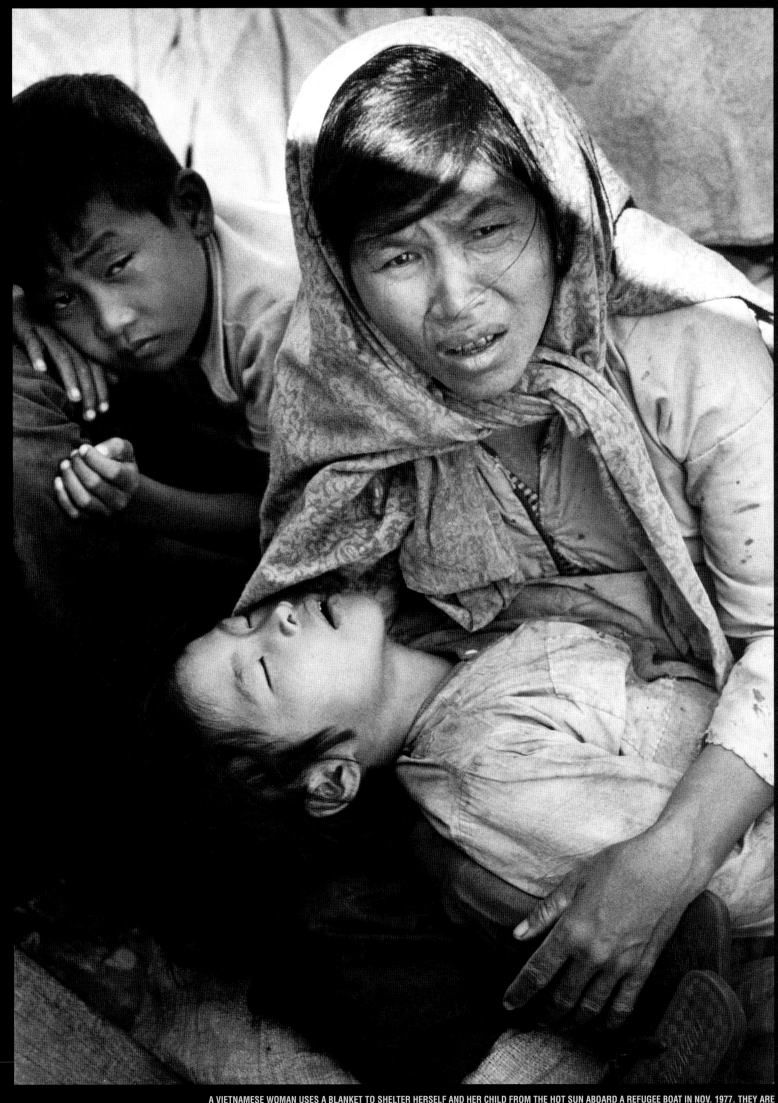

A VIETNAMESE WOMAN USES A BLANKET TO SHELTER HERSELF AND HER CHILD FROM THE HOT SUN ABOARD A REFUGEE BOAT IN NOV. 1977. THEY ARE AMONG 50 REFUGEES ABOARD A 30-FOOT FISHING BOAT IN THE GULF OF SIAM LOOKING FOR FREEDOM IN THAILAND.

AN ELDERLY VIETNAMESE WOMAN
ABOARD A THIRTY-FOOT FISHING
BOAT WITH FORTY-NINE OTHER
REFUGEES SEEKING FREEDOM
IN THAILAND AFTER TRAVELING
THROUGH DANGEROUS WATERS
OFF CAMBODIA, NOV. 30, 1977. THE
REFUGEES WERE REFUSED ENTRY
AT A SMALL FISHING VILLAGE AND
TOWED BACK TO SEA.

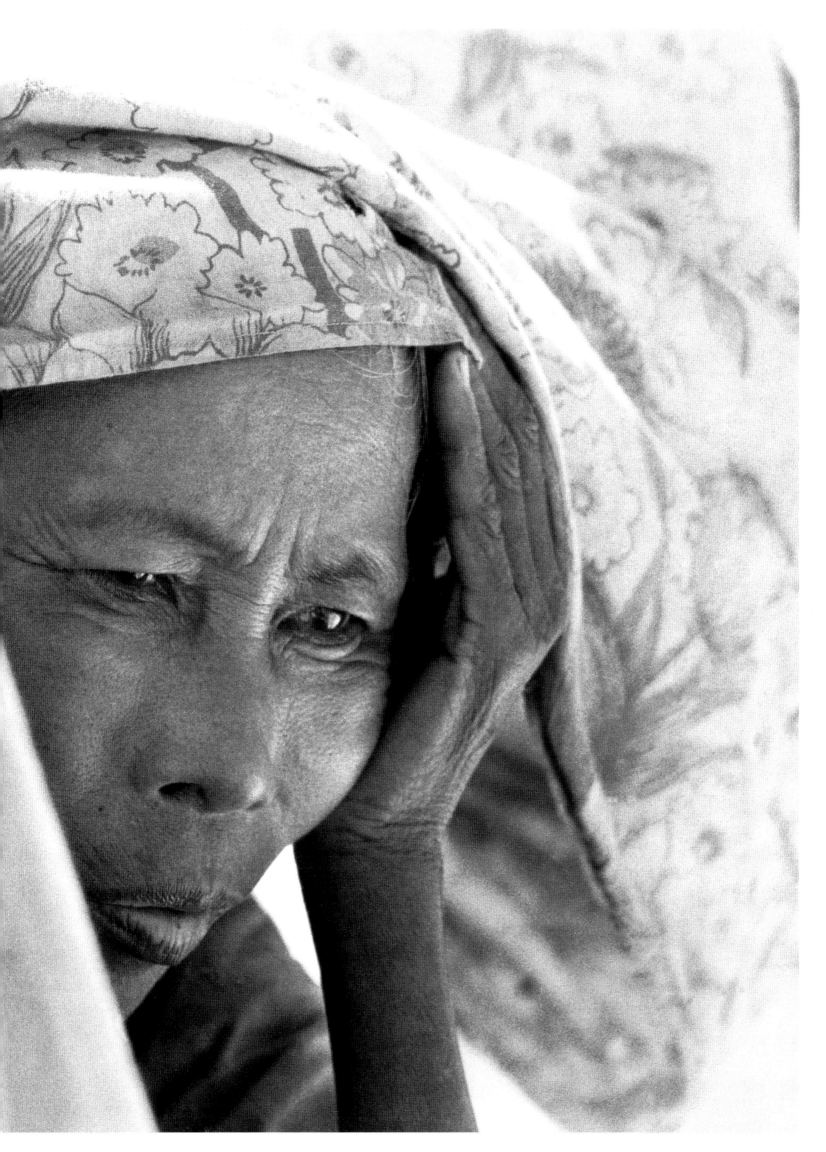

THE BOAT
PEOPLE
PHOTOGRAPHS
WERE PRESENTED
TO CONGRESS AND
THEY AGREED:
"LET 'EM COME TO
AMERICA."
THE PICTURES
CONFIRMED IT.
I FELT GOOD ABOUT
THAT. TO ME—I
THINK THAT'S THE
ONLY THING I DID
IN MY LIFE THAT
WAS GOOD.

SOUTH VIETNAMESE FLAG, 1968.

CONTRIBUTORS

PETER GREGG ARNETT was born November 13, 1934 in Riverton, New Zealand. He is a New Zealand–American journalist and author who has worked for *National Geographic* magazine and various television networks, most notably CNN. He is perhaps best-known for his wartime coverage of the Vietnam War and the Gulf War. In 1966 Arnett was awarded the Pulitzer Prize in International Reporting for his work in Vietnam, where he was present from 1962 to 1975 as a reporter for the Associated Press. Arnett wrote *Live from the Battlefield: From Vietnam to Baghdad, 35 Years in the World's War Zones* in 1994 and in March 1997, he was able to interview Osama bin Laden. The Journalism School at the Southern Institute of Technology is named after him.

THOMAS JOHN BROKAW was born February 6, 1940 in Webster, South Dakota. An American television journalist and author, Brokaw is best known as the former NBC News anchorman and managing editor of the program *NBC Nightly News with Tom Brokaw*, which became the most watched cable or broadcast news program in the United States during his tenure. In addition to his work on the *Nightly News*, Brokaw has hosted, written, and moderated special programs for NBC, and he continues to work at NBC as a Special Correspondent. Brokaw has written for periodicals and authored several books. He currently serves on the boards of trustees of the University of South Dakota, the Norton Simon Museum, the American Museum of Natural History and the International Rescue Committee and on the Howard University School of Communications Board of Visitors. Brokaw has been the recipient of numerous awards and honors for journalism throughout his distinguished career.

HAL BUELL is a veteran photo editor who spent more than forty years with Associated Press, twenty-five of them as head of the AP's worldwide photo service. He has worked on assignment for AP in more than thirty-five countries, organizing and managing picture news coverage of national and international events that run the range from national political conventions to Olympic Games. He was in charge of the AP's worldwide staff of some 300 photo personnel. Buell is the author of *Moments: The Pulitzer Prize–Winning Photographs,* and *Uncommon Valor, Common Virtue,* the story of the Iwo Jima flag picture. He edited *World War Two,* which includes 2,000 pictures of WWII, plus *Vietnam: The 10,000 Day War,* which includes 2,200 pictures, and picture and word anthologies on Normandy and Vietnam. Buell has appeared as a photo commentator on NBC, ABC, CBS, PBS, CBC, NPR and was a team member that produced Emmy-nominated documentaries on photography for the History Channel. He has lectured on photo ethics internationally and is a trustee of George Eastman House, the world's largest photo museum. Buell has judged numerous photo competitions, including the Pulitzer Prize and World Press Photo. He has produced several photo exhibitions and has been a photo consultant for PRNewswire. Buell is a graduate (bachelor's and master's degrees) of Medill School of Journalism, Northwestern University, Evanston, Illinois. He is a native of Chicago and has lived in New York most of his professional life.

TOM CURLEY is the president and CEO of The Associated Press since 2003, and the 12th person to lead the AP since its founding in 1848. Under Curley's leadership, the AP modernized from a wire service to an interactive global news network, developing multimedia databases for all AP content, along with an international strategy to drive new and international business. Previously president and publisher of *USA Today,* the nation's largest-selling daily newspaper, Curley has served as senior vice president of the newspaper's owner, Gannett Co., Inc.His journalistic career started early: at the age of fifteen, Curley covered high school basketball for his Pennsylvania hometown *Easton Express.* He joined Gannett's *Rochester Times-Union* (New York) in 1972 as night city/suburban editor, became director of information for Gannett in 1976. He became editor of Gannett's *Norwich Bulletin* in 1982 and publisher of *The Courier-News* in Bridgewater, New Jersey, in 1983 before returning to *USA Today* in 1985.

GEORGE ESPER is an American journalist who has been with the Associated Press since 1958. Esper is well-known for his war coverage, reporting from the Vietnam War for ten years and the first Gulf War in 1991, as well as on U.S. peace missions in Somalia and Bosnia. He is one of a handful of AP reporters to earn the title of AP Special Correspondent. In addition to his war coverage, Esper reported on many major stories in the U.S. including the great Midwest floods, Hurricane Andrew, and the bombing of the federal building in Oklahoma City. After retiring from the AP in 2000, Esper took a position in the WVU P.I. Reed School of Journalism. He teaches writing and reporting, and journalism history. Esper received an honorary doctorate degree from WVU in 2000. Other honors include the President's Award from The Press Club of Western Pennsylvania "in recognition of outstanding career achievement and contributions to Western Pennsylvania journalism."

DAVID HALBERSTAM (1934-2007) was a Pulitzer Prize-winning journalist who in the early 1960s covered the nascent American war in South Vietnam for The *New York Times.* His reporting, for which he received a Pulitzer in 1964, spoke about a corrupt South Vietnamese government, no match for Communist guerrillas and their North Vietnamese allies. His dispatches infuriated policy makers in Washington, but reflected reality. Eight years later, he chronicled what went wrong in Vietnam in a book whose title entered the language: "The Best and the Brightest." Halberstam went on to write more than twenty books, on topics as varied as America's military failings in Vietnam, the deaths of firefighters at the World Trade Center and the high-pressure world of professional basketball.

KERRY KENNEDY started working in the field of human rights in 1981 when she investigated abuses committed by U.S. immigration officials against refugees from El Salvador. Since then, her life has been devoted to the fight for equal justice, to the promotion and protection of basic rights, and to the preservation of the rule of law. She is the author, with Eddie Adams, of *Speak Truth to Power*, profiles of fifty human rights defenders around the world and co-directs that organization with Nan Richardson. She has led forty human rights delegations to twenty-seven countries. Kennedy is on the Board of Directors of the Robert F. Kennedy Memorial, a non-profit organization that addresses the problems of social justice. She established the RFK Center for Human Rights to ensure the protection of rights codified under the U.N. Declaration of Human Rights. Kennedy has led delegations to, and negotiated with, government officials from all over the world and has worked on diverse human rights issues such as child labor, disappearances, indigenous land rights, judicial independence, freedom of expression, ethnic violence, impunity, the environment, and women's rights. Kennedy has appeared on ABC, NBC, CBS, and CNN, among others, and her commentaries and articles have been widely published.

DAVID HUME KENNERLY born in 1947, is an American photojournalist. Kennerly began his photography career in Roseburg, Oregon, where he published his first picture in his high school newspaper at the age of fifteen. He later worked for the *Oregon Journal* and eventually with United Press International, which took him to Vietnam. In 1972 he won the Pulitzer Prize in Feature Photography for his work during the Vietnam War. After the returning to the United States, Kennerly worked as a photographer for *Time* magazine, and eventually became the White House Photographer for President Gerald Ford. Kennerly continues to work, shooting for *LIFE, Newsweek, George,* and *Good Morning America.* He has photographed more than thirty-five covers for *Time* and *Newsweek* and covered assignments in over 130 countries. On March 16, 2006, Kennerly was named an NBC News Contributing Editor. He provides special still-photo essays for NBC and its affiliates and is the author of six books.

MORLEY SAFER is a reporter and correspondent for CBS News. Born in Toronto, Ontario, Canada, Safer began his career in journalism as a reporter for various newspapers, eventually joining the Canadian Broadcasting Corporation. In 1964, Safer joined CBS News and opened their bureau in Saigon in 1965. That year he followed a group of United States Marines to the village of Cam Ne for what was described as a "search and destroy" mission. When the Marines arrived, they gave orders in English to the inhabitants—by all accounts harmless civilians—to evacuate the village. When the homes were cleared, the Marines burned their thatched roofs with flamethrowers and Zippo lighters. Safer's report on this event was broadcast on CBS News on August 5 and was among the first reports to paint a bleak picture of the Vietnam War. President Lyndon Baines Johnson angrily called CBS's president accusing Safer of having "shat on the American flag." Certain that Safer was a communist, Johnson also ordered a security check; upon being told that Safer 'wasn't a communist, just a Canadian," he responded "Well, I knew he wasn't an American." He joined the CBS News program *60 Minutes*, where he was a correspondent for over thirty-five years. Safer authored the bestselling book, *Flashbacks: On Returning to Vietnam* in 1990.

BOB LLOYD SCHIEFFER, born February 25, 1937, is an award-winning American journalist. He has been a correspondent for the CBS News since 1969 and served as anchor on the Saturday edition of *CBS Evening News* for twenty-three years. Schieffer has been CBS's chief Washington correspondent since 1982 and has moderated the Sunday public affairs show *Face the Nation* since 1991. He also acted as the interim weekday anchor of the *CBS Evening News* between March 2005 and August 31, 2006. Schieffer's primary coverage has been on national politics. He is one of only a handful of reporters to have reported from the four major Washington posts: the Pentagon, the White House, Capitol Hill, and the State Department. In 2004 he moderated the third presidential debate between then-governor, President George W. Bush and Senator John Kerry. Schieffer resides in Washington, DC. He his wife have two daughters and twin granddaughters.

TIMELINE: THE VIETNAM WAR

1945

Ho Chi Minh Creates Provisional Government: Following the surrender of Japan to Allied forces, Ho Chi Minh and his People's Congress create the National Liberation Committee of Vietnam to form a provisional government. Japan transfers all power to Ho's Vietminh.
Ho Declares Independence of Vietnam.
British Forces Land in Saigon, Return Authority to French.
First American Dies in Vietnam: Lt. Col. A. Peter Dewey (he had been mistaken for a Frenchman).

1946

French and Vietminh Reach Accord: France recognizes Vietnam as a "free state" within the French Union. French troops replace Chinese in the North.
Negotiations Between French and Vietminh Break Down.
Indochina War Begins: Following months of steadily deteriorating relations, the Democratic Republic of Vietnam attacks the French.

1947

Vietminh Move North of Hanoi.
French Defeated: French General Etienne Valluy fails to wipe out the Vietminh in one stroke.

1949

Elysee Agreement Signed: Bao Dai and President Vincent Auriol of France sign the Elysee Agreement, wherein the French pledge to help build a national anti-Communist army.

1950

Chinese, Soviets Offer Weapons to Vietminh.
US Pledges $15M: The United States sends $15 million in military aid to the French for the war in Indochina, including a military mission and military advisors.

1953

France Grants Laos Full Independence.
Vietminh Forces Push into Laos.

1954

Battle of Dien Bien Phu: 40,000 heavily armed Vietminh lay siege to the French garrison and win, using Chinese artillery to shell the airstrip, cutting off all supplies.
Eisenhower Cites "Domino Theory" of Communist Containment: Commenting on the defeat of the French at Dien Bien Phu, he said: "You have a row of dominoes set up. You knock over the first one, and what will happen to the last one is the certainty that it will go over very quickly."
Geneva Convention Begins: Delegates from nine nations convene in Geneva to negotiate for the end of hostilities in Indochina. The idea of partitioning Vietnam is explored.
Geneva Convention Agreements Announced: Vietminh General Ta Quang Buu and French General Henri Delteil sign the Agreement on the Cessation of Hostilities in Vietnam. As part of the agreement, a provisional demarcation line is drawn at the 17th parallel, which will divide Vietnam until nationwide elections are held in 1956. The United States does not accept the agreement; neither does the government of Bao Dai.

1955

Diem Rejects Geneva Accords, Refuses Elections.
China and Soviet Union Pledge more Support to Hanoi.
Diem Urged to Negotiate: Britain, France, and United States covertly urge Diem to respect Geneva Accords and conduct discussions with the North.
Diem Becomes President of Republic of Vietnam: Diem defeats Bao Dai in rigged election and proclaims himself president.

1956

French Leave Vietnam.
U.S. Train South Vietnamese: The U.S. Military Assistance Advisor Group (MAAG) takes on the French role of training South Vietnamese forces.

1957

Communist Insurgency into South Vietnam: Communist insurgent activity in South Vietnam begins. Guerrillas assassinate more than 400 South Vietnamese officials. Thirty-seven armed companies are organized along the Mekong Delta.
Terrorist Bombings Rock Saigon: Thirteen Americans working for MAAG and U.S. Information Service are wounded in terrorist bombings in Saigon.

1959

Weapons Moving Along Ho Chi Minh Trail: North Vietnam forms Group 559 to begin infiltrating cadres and weapons into South Vietnam via the Ho Chi Minh Trail. The Trail will become a strategic target for future military attacks.
The First Americans to Die in the Vietnam War: Major Dale R. Buis and Master Sergeant Chester M. Ovnand die in a guerrilla attack at Bien Hoa.
Diem Orders Crackdown on Communists, Dissidents.

1960

North Vietnam Imposes Universal Military Conscription.
Kennedy Elected President: John F. Kennedy defeats Richard Nixon.
Diem Survives Coup Attempt.
Vietcong Formed: National Liberation Front for South Vietnam forms in Hanoi. Diem's South Vietnamese government dubs them "Vietcong."

1961

Battle of Kienhoa Province: 400 guerrillas attack, but are defeated by South Vietnamese troops.
Vice President Johnson Tours Saigon: During a tour of Asian countries, Vice President Lyndon Johnson visits Diem in Saigon, calling him "crucial to U.S. objectives" in Vietnam, and "the Churchill of Asia."

1962

U.S. Military Employs Agent Orange: The Air Force begins using a defoliant that comes in metal orange containers to expose roads and trails used by Vietcong forces.
Diem Palace Bombed in Coup Attempt.
Mansfield Voices Doubt on Vietnam Policy: Senate Majority Leader Mike Mansfield reports back to JFK from Saigon his opinion that Diem had wasted the $2 billion America spent there.

1963

Battle of Ap Bac: Vietcong units defeat South Vietnamese Army (ARVN) in Battle of Ap Bac.
President Kennedy Assassinated: How to proceed in Vietnam now Lyndon Johnson's problem.
Buddhists Protest Against Diem: Tensions between Buddhists and the Diem government are further strained as Diem, a Catholic, removes Buddhists from key government positions and replaces them with Catholics. Buddhist monks protest Diem's intolerance for other religions and the measures he takes to silence them. To protest, Buddhist monks start setting themselves on fire in public places.
Diem Overthrown, Murdered: With tacit approval of the United States, operatives within the South Vietnamese military overthrow Diem. He and his brother Nhu are shot and killed in the aftermath.

1964

General Nguyen Khanh Seizes Power: In a bloodless coup, Khanh seizes power in Saigon. South Vietnam junta leader, Major General Duong Van Minh, is placed under house arrest, but is allowed to remain as a figurehead chief-of-state.
Gulf of Tonkin Incident: On August 2, three North Vietnamese PT boats allegedly fire torpedoes at the USS *Maddox*, a destroyer located in the international waters of the Tonkin Gulf, some thirty miles off the coast of North Vietnam. The attack comes after six months of covert U.S. and South Vietnamese naval operations. A second, even more highly disputed attack, is alleged to have taken place on August 4.
Debate on Gulf of Tonkin Resolution: The Gulf of Tonkin Resolution is approved by Congress on August 7 and authorizes President Lyndon Johnson to "take all necessary measures to repel any armed attack against forces of the United States and to prevent further aggression." The resolution passes unanimously in the House, and by a margin of 82-2 in the Senate. The resolution allows Johnson to wage all-out war against North Vietnam without ever securing a formal Declaration of War from Congress.
Vietcong Attack Bien Hoa Air Base.
LBJ Defeats Goldwater: Lyndon Johnson is elected in a landslide over Republican Barry Goldwater of Arizona. During the campaign, Johnson's position on Vietnam appeared to lean toward de-escalation of U.S. involvement, and sharply contrasted the more militant views held by Goldwater.

1965

Operation Rolling Thunder Deployed: Sustained American bombing raids of North Vietnam, dubbed Operation Rolling Thunder, begin in February. The nearly continuous air raids would go on for three years.
Marines Arrive at Danang: The first American combat troops, the 9th Marine Expeditionary Brigade, arrive in Vietnam to defend the U.S. airfield at Danang.
Heavy Fighting at Ia Drang Valley: The first conventional battle of the Vietnam War takes place in Ia Drang Valley. The U.S. 1st Air Cavalry Division employs its newly enhanced technique of aerial reconnaissance to defeat the NVA, although heavy casualties are reported on both sides in the extended battle.
U.S. Troop Levels Top 200,000.
Vietnam "Teach-In" Broadcast to Nation's Universities: The practice of protesting U.S. policy in Vietnam by holding "teach-ins" at colleges and universities becomes widespread. The first "teach-in" (featuring seminars, rallies, and speeches) takes place at the University of Michigan at Ann Arbor in March. In May, a nationally broadcast "teach-in" reaches students and faculty at over 100 campuses.

1966

B-52s Bomb North Vietnam: In an effort to disrupt movement along the Mugia Pass (the main route used by the NVA to send personnel and supplies through Laos and into South Vietnam) American B-52s bomb North Vietnam for the first time.
South Vietnam Troops Take Hue and Danang.
LBJ Meets with South Vietnamese Leaders: Meeting with South Vietnamese Premier Nguyen Cao Ky and his military advisors in Honolulu, Johnson promises to continue helping South Vietnam fend off aggression from the North, but adds that the U.S. will be monitoring South Vietnam's efforts to expand democracy and improve economic conditions for its citizens.
Veterans Stage Anti-War Rally: Veterans from World Wars I and II, along with veterans from the Korean War, stage a protest rally in New York City. Discharge and separation papers are burned in protest of U.S. involvement in Vietnam.
CORE Cites "Burden On Minorities and Poor" in Vietnam: The Congress of Racial Equality (CORE) issues a report claiming that the US military draft places "a heavy discriminatory burden on minority groups and the poor." The group also calls for a withdrawal of all U.S. troops from Vietnam.

1967

Operation Cedar Falls Begins: In a major ground war effort, 16,000 U.S. and 14,000 South Vietnamese troops set out to destroy Vietcong operations and supply sites near Saigon. A massive system of tunnels is discovered in an area called the Iron Triangle, an apparent headquarters for Vietcong.
Bunker Replaces Cabot Lodge as South Vietnam Ambassador.

Martin Luther King Speaks Out Against War: Calling the US "the greatest purveyor of violence in the world," Martin Luther King publicly speaks out against U.S. policy in Vietnam. King encourages draft evasion and suggests a merger between antiwar and civil rights groups.

Dow Recruiters Driven from Wisconsin Campus: University of Wisconsin students demand that corporate recruiters for Dow Chemical—producers of napalm—not be allowed on campus.

McNamara Calls Bombing Ineffective: Secretary of Defense Robert McNamara, appearing before a Senate subcommittee, testifies that U.S. bombing raids against North Vietnam have not achieved their objectives. McNamara maintains that movement of supplies to South Vietnam has not been reduced, and neither the economy nor the morale of the North Vietnamese has been broken.

1968

January

Sihanouk Allows Pursuit of Vietcong into Cambodia.

North Vietnamese Launch Tet Offensive: In a show of military might that catches the U.S. military off guard, North Vietnamese and Vietcong forces sweep down on key cities and provinces in South Vietnam, including its capital, Saigon. Within days, American forces turn back the onslaught and recapture most areas. From a military point of view, Tet is a defeat for the Communists, but turns out to be a political and psychological victory. The U.S. military's assessment of the war is questioned and the "end of tunnel" seems very far off.

February

Battle for Hue: The Battle for Hue wages for twenty-six days as U.S. and South Vietnamese forces try to recapture the site seized by the Communists during the Tet Offensive. Previously a religious retreat in the middle of a war zone, Hue was nearly leveled in a battle (a U.S. and ARVN victory) that left its population homeless. Mass graves containing thousands of bodies executed during the Communist occupation are discovered.

Westmoreland Requests 206,000 More Troops.

My Lai Massacre: On March 16, the angry and frustrated men of Charlie Company, 11th Brigade, American Division entered the village of My Lai. "This is what you've been waiting for—search and destroy—and you've got it," said their superior officers. A short time later the killing began. When news of the atrocities surfaced, it sent shockwaves through the U.S. political establishment, the military's chain of command, and an already divided American public.

March

LBJ Announces He Won't Run: With his popularity plummeting (and dismayed by Senator Eugene McCarthy's strong showing in the New Hampshire primary), President Lyndon Johnson stuns the nation, announcing that he will not be a candidate for re-election.

April

Martin Luther King Slain in Memphis.

May

Paris Peace Talks Begin: Following a lengthy period of debate, North Vietnamese and American negotiators agree to begin talks in Paris on May 10 with W. Averell Harriman representing the United States, and former Foreign Minister Xuan Thuy heading the North Vietnamese delegation.

June

Robert F. Kennedy Assassinated in Los Angeles.

August

Upheaval at Democratic Convention in Chicago: In Chicago, Mayor Richard Daley orders police to crack down on antiwar protests. As the nation watches on television, the area around the convention erupts in violence.

November

Richard Nixon Elected President: Running on a platform of "law and order," Nixon narrowly defeats Hubert Humphrey.

1969

Nixon Begins Secret Bombing of Cambodia: To destroy Communist supply routes and base camps in Cambodia,

Nixon gives the go-ahead to Operation Breakfast. The covert bombing of Cambodia, conducted without the knowledge of Congress or the American public, will continue for fourteen months.

Policy of "Vietnamization" Announced: Secretary of Defense Melvin Laird describes a policy of "Vietnamization" to describe a diminishing role for the U.S. military in Vietnam, shifting the burden of defeating the Communists onto the South Vietnamese Army.

Ho Chi Minh Dies at Age 79.

News of My Lai Massacre Reaches U.S.: Through the reporting of journalist Seymour Hersh, Americans read for the first time of the atrocities committed by Lt. William Calley and his troops in the village of My Lai. The Army had, by publication time, already charged Calley with the crime of murder.

Massive Antiwar Demonstration in DC.

1970

Sihanouk Ousted in Cambodia: Prince Sihanouk's attempt to maintain Cambodia's neutrality while war waged in neighboring Vietnam forced him to strike opportunistic alliances with China, and then the United States. This leads to a coup orchestrated by defense minister Lon Nol.

Kent State Incident: National Guardsmen open fire on a crowd of student antiwar protesters at Ohio's Kent State University, resulting in the death of four students and the wounding of eight others. President Nixon publicly deplores the actions of the Guardsmen, but cautions: "when dissent turns to violence it invites tragedy."

Kissinger and Le Duc Begin Secret Talks.

Number of U.S. Troops Falls to 280,000.

1971

Pentagon Papers Published: A legacy of deception on the part of the military and the executive branch concerning U.S. policy in Vietnam is revealed as *The New York Times* publishes the Pentagon Papers. The Nixon administration appeals to the Supreme Court to halt the publication but The Court decides in favor *The Times* and allows publication of the documents.

Nixon Announces Plans to Visit China: In a move that troubles the North Vietnamese (seen as an effort to create discord between themselves and their Chinese allies), President Nixon announces his intention to visit The People's Republic of China.

Thieu Re-elected in South Vietnam.

1972

Nixon Cuts Troop Levels by 70K: Responding to charges by Democratic presidential candidates that he is not moving fast enough to end U.S. involvement in Vietnam, President Nixon orders troop strength reduced by seventy thousand.

Secret Peace Talks Revealed.

B-52s Bomb Hanoi and Haiphong: To force North Vietnam to make concessions in the ongoing peace talks, the Nixon administration orders heavy bombing of supply dumps and petroleum storage sites in and around Hanoi and Haiphong. The message: that no section of Vietnam is off-limits to bombing raids.

Break-In at Watergate Hotel.

Kissinger Says "Peace Is At Hand": Henry Kissinger and Le Duc Tho reach agreement in principle on several key measures leading to a cease-fire in Vietnam. Kissinger's view that "peace is at hand," is dimmed somewhat by President Thieu's opposition to the agreement.

Nixon Wins Re-election.

1973

Cease-fire Signed in Paris: An agreement that per Nixon, "brings peace with honor in Vietnam and Southeast Asia," is signed in Paris by Henry Kissinger and Le Duc Tho.

End of Draft Announced.

Last American Troops Leave Vietnam.

Senate Armed Services Hearings Begin: Allegations are made that the Nixon administration allowed secret bomb-

ing raids during a time when Cambodia's neutrality was officially recognized. As a result, Congress orders that all bombing in Cambodia cease at midnight, August 14.

Henry Kissinger and Le Duc Tho Win Peace Prize: Kissinger accepts the award, while Tho declines, saying that a true peace does not yet exist in Vietnam.

1974

Thieu Announces Renewal of War.

Report Cites Damage to Vietnam Ecology: A report issued by The National Academy of Science shows use of chemical herbicides during the war caused long-term damage to the ecology of Vietnam. Subsequent inquiries prove the connection between herbicides, particularly Agent Orange, and widespread reports of cancer, skin disease, and other disorders in individuals exposed to them.

Communists Take Mekong Delta Territory.

Nixon Resigns.

Communists Plan Major Offensive: With North Vietnamese forces in the South at their highest levels ever, South Vietnamese leaders gird themselves for a mass offensive.

1975

Communist Forces Capture Phuoc Long Province: The South Vietnamese Army loses twenty planes in a failed effort to defend Phuoc Long, a key province just north of Saigon. North Vietnamese leaders interpret the U.S.'s lack of response as an indication that they could move more aggressively in the South.

Hue Falls to Communists.

Communists Take Aim at Saigon: The North Vietnamese initiate the Ho Chi Minh Campaign—a concerted effort to "liberate" Saigon. Under the command of General Dung, the NVA sets out to capture Saigon by April, in advance of the rainy season.

Ford Calls Vietnam War "Finished": Anticipating the fall of Saigon to Communist forces, U.S. President Gerald Ford, speaking in New Orleans, announces that as far as the U.S. is concerned, the Vietnam War is "finished."

Last Americans evacuated from Saigon.

Jimmy Carter Elected U.S. President.

Carter Issues Pardon to Draft Evaders: In a bold and controversial move, the newly inaugurated President extends a full and unconditional pardon to 10,000 evaders of the Vietnam War draft.

Vietnam Granted Admission to United Nations.

Relations Between Vietnam and China Deteriorate.

Vietnam Invades Cambodia: Determined to overthrow the government of Pol Pot, Vietnam invades Cambodia. Phnom Penh, falls quickly as Pol Pot and his Khmer Rouge followers flee into the jungles.

"Boat People" Flee Vietnam: Swarms of Vietnamese refugees take to the sea in overcrowded and unsafe boats in search of a better life. The ranks of the "boat people" include individuals deemed enemies of the state who have ve been expelled from their homeland.

China Invades, Withdraws from, Vietnam.

U.S. GAO Issues Report on Agent Orange: After years of Defense Department denials, the U.S. General Accounting Office releases a report indicating that thousands of U.S. troops were exposed to the herbicide Agent Orange. Thousands of veterans had demanded a government investigation into the effect of dioxin, a chemical found in Agent Orange, had on the human immune system.

Ronald Reagan Elected U.S. President.

1976-80

Pham Van Dong Heads Socialist Republic of Vietnam: In July of 1976, Vietnam names Pham Van Dong its prime minister. Van Dong and his fellow government leaders, all but one of whom are former North Vietnamese officials, take up residence in the nation's new capital, Hanoi.

BIBLIOGRAPHY

BOOKS OF PHOTOGRAPHY AND FILM

Anderegg, Michael. ed. *Inventing Vietnam: The War in Film and Television.* Philadelphia: Temple University Press, 1991.

Barber, Craig. *Ghosts in the Landscape: Vietnam Revisited.* New York, Umbrage Editions, 2006.

Burrows, Larry. *Vietnam.* London: Jonathan Cape, 2002.

Cook, David A. *Lost Illusions: American Cinema in the Age of Watergate and Vietnam, 1970-1979.* New York: Scribner, 2000.

Daugherty, Leo J. and Gregory Louis Mattson. *Nam: A Photographic History.* New York: Metro Books, 2001.

Dittmar, Linda and Gene Michaud. *From Hanoi to Hollywood: The Vietnam War in American Film.* New Brunswick, N.J.: Rutgers University Press, 1990.

Emering, Edward J. *Vietcong: A Photographic Portrait.* Atglen, Penn.: Schiffer Pub., 1999.

Epstein, Mitch. *Vietnam: A Book of Changes.* New York: DoubleTake/W.W. Norton, 1997.

Horst, Fass, Tim Page and Peter Arnett. *Requiem: By the Photographers Who Died in Vietnam and Indochina.* New York: Random House, 1997.

Griffiths, Philip Jones. *Vietnam Inc.* London: Phaidon Press; New Ed, 2001.

Griffiths, Philip Jones. *Agent Orange: Collateral Damage in Vietnam.* London: Trolley, 2004.

Griffiths, Philip Jones and John Pilger. *Vietnam at Peace.* London: Trolley, 2005.

Page, Tim, Douglas Niven and Christopher Riley. *Another Vietnam: Pictures of the War From the Other Side.* Washington, D.C.: National Geographic, 2002.

Wolins, Jeffrey. *Inconvenient Stories: Portraits and Interviews with Vietnam Veterans.* New York: Umbrage Editions, 2006.

Anderson, Donald. Aftermath: *An Anthology of Post-Vietnam Fiction.* New York: Holt, 1995.

Barker, Mark. *NAM, The Vietnam War in the Words of the Men and Women Who Fought There.* New York: Abacus, 1982

Buckley, William. *Tucker's Last Stand.* New York: Random House, 1990.

Bunting, Josiah. *The Lionheads.* N Y: G. Braziller, 1972.

Buonanno, Chris. *Beyond the Flag.* Tower Books, 1981.

Clayton, Paul. *Carl Melcher Goes to Vietnam.* Thomas Dunne Books, 2004.

Danziger , Jeff. *Rising Like the Tucson.* New York: Doubleday, 1991.

DeMille, Nelson. *Word of Honor.* New York: Warner, 1985.

Ford, Daniel. *Incident at Muc Wa.* Garden City, NY: Doubleday, 1967.

Galli, Richard. *Of Rice and Men: A Novel of Vietnam.* San Francisco: Presidio, 2006.

Grady, Patrick. *Through the Picture Tube.* San Francisco: Robert D. Reed, 2000.

Groom, Winston. *Better Times than These.* New York: Summit, 1978.

Halberstam, David. *One Very Hot Day.* Boston: Houghton Mifflin, 1968.

Heinemann, Larry. *Close Quarters.* New York: Farrar, Straus, and Giroux, 1977.

Janko, James. *Buffalo Boy and Geronimo.* Curbstone, 2006.

Jett, Michael. *Secret Games.* Gardenia Press, 2003.

Kamps, Charles, Jr. *The History of the Vietnam War: An Illustrated History of the War in South East Asia.* Aerospace Publishing Ltd, 1988.

Karlin, Wayne, Larry Rottmann, and Basil T. Pacquet. eds. *Free Fire Zone: Short Stories by Vietnam Veterans.* New York: McGraw-Hill, 1973.

Ninh, Bao. *The Sorrow of War.* Vietnamese original Hanoi, 1991; English translation London: Martin Secker & Warburg, 1993; New York: Pantheon, 1995.

O'Brien, Tim. *If I Die in a Combat Zone, Box Me Up and Ship Me Home.* New York: Broadway Books, 1999.

O'Neill, Susan. *Don't Mean Nothing: Short Stories of Vietnam.* New York: Ballantine, 2001.

Pfarrer, Donald. *The Fearless Man: A Novel of Vietnam.* New York: Random House, 2004.

Roth, Robert. *Sand in the Wind.* Boston: Little, Brown, 1973.

Vick, Edward. *Slingshot.* Bedford: Press/Xlibris, 2002

FOR FURTHER READING

Adair, Dick, foreword by Peter Arnett. *Dick Adair's Saigon: Sketches and Words from the Artist's Journal.* New York and Tokyo: Weatherhill, 1971.

Alperovitz, Gar. *Who We Are.* Boston: Little, Brown, 1969.

Asprey, Robert B. *War in the Shadows: The Guerrilla in History, 2 vols.* Garden City, N.Y.: Doubleday, 1975.

Beidler, Philip D. *Late Thoughts on an Old War: The Legacy of Vietnam.* Athens: University of Georgia Press, 2004.

Bell, J. Bowyer. *Dragonwars: Armed Struggle and the Conventions of Modern War.* New Brunswick, N.J.: Transaction Publishers, 1999.

Borer, Douglas A. *Superpowers Defeated: Vietnam and Afghanistan Compared.* London: Frank Cass, 1999.

Bows, Ray. *Vietnam Military Lore: Legends, Shadows and Heroes.* Hanover, Mass.: Bows and Sons, 1998.

Brown, T. Louise. *War and Aftermath in Vietnam.* New York: Routledge, 1991.

Brown, Weldon A. *Prelude to Disaster: The American Role in Vietnam, 1940-1963.* Port Washington, NY: Kennikat Press, 1975.

Burkett, B. G. and Glenna Whitley. *Stolen Valor: How the Vietnam Generation Was Robbed of its Heroes and its History.* Dallas: Verity Press, 1998.

Chananie, David. *Not Yet at Ease: Photographs of America's Continuing Engagement with the Vietnam War.* Capturelife, 2002.

Chanda, Nayan. *Brother Enemy: The War after the War.* New York: Harcourt Brace Jovanovich, 1986.

Chong, Denise. *The Girl in the Picture: The Story of Kim Phuc, the Photograph, and the Vietnam War.* New York: Viking, 2000

Clifford, Geoffrey (photography) and John Balaban (text). *Vietnam: The Land We Never Knew.* San Francisco: Chronicle Books, 1989.

Croizat, Victor J. *The Development of the Plain of Reeds: Some Politico-Military Implications.* Santa Monica: Rand, 1969.

Daoudal, Yves. *Le dossier Boudarel, ou, Le procès impossible du communisme.* Paris: Editions Remi Perrin, 2001.

Debris, Jean-Pierre and André Menras. *Rescapés des bagnes de Saigon: nous accusons.* Paris: Éditeurs Français Réunis, 1973.

David *Vietnam Revisited: From Covert Action to Invasion to Reconstruction.* Boston: South End Press,

Demariaux Maurice. *Poulo-Condore, archipel du Viêtnam: du bagne historique à la nouvelle zone de dévelopement économique.* Paris: l'Harmattan, 1999.

Franchini, Philippe. *Continental Saigon.* Paris: Métailié, 1995.

Jorgenson, Kregg P. J. *Beaucoup Dinky Dau: Odd, Unusual, and Unique Stories of the Vietnam War.* Seattle: Maxwell James Publishing, 1995.

Jorgenson, Kregg P. J. *Very Crazy, G.I.: Strange but True Stories of the Vietnam War.* New York: Ballantine, 2001.

Kerkvliet, Benedict J. Tria and David G. Marr. eds *Beyond Hanoi: Local Government in Vietnam.* Singapore: ISEAS, 2004.

Larsen, Wendy Wilder and Tran Thi Nga. *Shallow Graves: Two Women and Vietnam.* New York, Random house 1986.

Rokus, Josef W. *The Professionals: History of the Phu Lam, Vietnam U.S. Army Communications Base.* Philadelphia: Xlibris, 2002.

Rothberg, Donald M. "Assuming Nothing: How Mortuary Practices Changed During The Vietnam War," in *The VVA Veteran,* August/September 2001.

Ryan, David and John Dumbrell, eds. *Vietnam in Iraq: Lessons, Legacies and Ghosts.* New York: Routledge, 2006.

Sarkesian, Sam. *Unconventional Conflicts in a New Security Era: Lessons from Malaya and Vietnam.* Westport, Conn.: Greenwood, 1993.

Schwab, Orrin. *A Clash of Cultures: Civil-Military Relations During the Vietnam War.* Westport, Conn.: Praeger, 2006.

Scipione Paul A. *M.A.R.S. Calling Back to "The World": A History of Military Affiliate Radio Systems Operations during the Vietnam War.* Kalamazoo, Center for the Study of the Vietnam War, 1994.

Scott, Peter Dale, Drugs. *Oil, and War: The United States in Afghanistan, Colombia, and Indochina.* Lanham, Md.: Rowman & Littlefield, 2003.

Sheehan, Neil, After the War was Over: Hanoi and Saigon. New York: Random House 1992.

Shrader, Charles R. *Amicicide: The Problem of Friendly Fire in Modern War.* Fort Leavenworth, Kans.: Combat Studies Institute, US Army Command and General Staff College, 1982.

Sledge, Michael. *Soldier Dead: How We Recover, Bury, and Honor Our Military Fallen.* New York: Columbia University Press, 2005.

Sterling, Eleanor Jane, Martha Maud Hurley, and Le Duc Minh. *Vietnam: A Natural History.* New Haven: Yale University Press, 2006.

Taylor, General Maxwell. *Responsibility and Response.* New York: Harper & Row, 1967. New York: Random House, 1986.

Tri, Le Huu. *Prisoner of the Word: A Memoir of the Vietnamese Reeducation Camps.* Black Heron Press, 2001.

Walker, Glenn R., Jr. *The Evolution of Civil-Military Relations in Vietnam.* Master's thesis, Naval Postgraduate School, Monterey, Cal.

Weiner, Milton Gershwin and Marvin B. Schaffer. *Border Security in South Vietnam.* Santa Monica: Rand, 1971.

LEGACIES OF THE WAR

Arnold, Gordon. *The Afterlife of America's War in Vietnam: Changing Visions in Politics and on Screen.* Jefferson, N. C.: McFarland, 2006.

Bates, Milton J. *The Wars We Took to Vietnam: Cultural Conflict and Storytelling.* Berkeley: University of California Press, 1996.

Beattie, Keith. *The Scar that Binds: American Culture and the Vietnam War.* New York: New York University Press, 1998.

Capps, Walter H. *The Unfinished War: Vietnam and the American Conscience.* Boston: Beacon Press, 1982.

Hall, Mitchell K. *Crossroads: American Popular Culture and the Vietnam Generation.* Lanham, Md.: Rowman & Littlefield, 2005.

Huebner, Andrew Jonathan. "The Embattled Americans: A cultural history of soldiers and veterans, 1941--1982." Ph.D. dissertation, History, Brown University, 2004.

Isaacs, Arnold R. *Vietnam Shadows: The War, its Ghosts, and its Legacy.* Baltimore: Johns Hopkins University Press, 1997.

Isserman, Maurice and Michael Kazin. A*merica Divided: The Civil War of the 1960s.* New York: Oxford University Press, 1999.

Jeffords, Susan. *The Remasculinization of America: Gender and the Vietnam War.* Bloomington: Indiana University Press, 1989.

Kinney, Katherine. *Friendly Fire: American Images of the Vietnam War.* New York: Oxford University Press, 2000.

Klatch, Rebecca E. *Generation Divided: The New Left, the New Right, and the 1960s.* Berkeley: University of California Press, 1999.

Lembcke, Jerry. *The Spitting Image: Myth, Memory, and the Legacy of Vietnam.* New York: New York Universiy Press, 1998.

Lewis, Adrian. *The American Culture of War: A History of American Military Force from World War II to Operation Iraqi Freedom.* New York: Routledge, 2006.

Lewis, Lloyd B. *The Tainted War: Culture and Identity in Vietnam War Narratives.* Westport, Conn.: Greenwood, 1985.

Lytle, Mark Hamilton. *America's Uncivil Wars: The Sixties Era from Elvis to the Fall of Richard Nixon.* New York: Oxford University Press, 2006.

Morris, Richard J. and Peter C. Ehrenhaus. eds. *Cultural Legacies of Vietnam: Uses of the Past in the Present.* Norwood, N.J.: Ablex, 1990.

Schulzinger, Robert D. *A Time for Peace: The Legacy of the Vietnam War.* New York: Oxford University Press, 2006.

Spanos, William V. *America's Shadow: An Anatomy of Empire.* Minneapolis: University of Minnesota Press, 1999.

Sturken, Marita. *Tangled Memories: The Vietnam War, the AIDS Epidemic, and the Politics of Remembering.* Berkeley: University of California Press, 1997.

Timberg Robert. "The Vietnam Fault Line." *Naval History,* August 1996.

ECONOMIC ISSUES

Abadie, Maurice. *Les races du Haut-Tonkin de Phong-Tho B Lang-Son.* Paris: Challamel, 1924.

Allen, Douglas and Ngo Vinh Long. *Coming to Terms: Indochina, the United States and the War.* Boulder, Colo.: Westview Press, 1991.

Balaban, John and Nguyen Qui Duc. *Vietnam: A Traveler's Literary Companion.* San Francisco: Whereabouts Press, 1996.

Brown, Frederick Z. *Second Chance: The United States and Indochina in the 1990s.* New York: Council on Foreign Relations Press, 1989.

Campagna, Anthony S. *The Economic Consequences of the Vietnam War.* New York: Praeger, 1991.

Coughlin, Richard. *The Position of Women in Vietnam.* New Haven: Yale University Press, 1955.

Duiker, William J. *The Rise of Nationalism in Vietnam, 1900-41.* Ithaca, N.Y.: Cornell University Press, 1976.

Englemann, Larry. *Tears Before the Rain: An Oral History of the Fall of South Vietnam.* Oxford: Oxford University Press, 1990.

Hickey, Gerald Cannon. *Free in the Forest: Ethnohistory of the Vietnamese Central Highlands, 1954-1976.* New Haven: Yale University Press, 1982.

Mus, Paul. *The Role of the Village in Vietnamese Politics.* Pacific Affairs,1949.

Nguyen Huyen Chau. "Women and Family Planning Policies in Postwar Vietnam," *Postwar Vietnam: Dilemmas in Socialist Development.* Ithaca, N.Y.: Cornell University Southeast Asia Program, 1988.

Nguyen Van Canh. *Vietnam under Communism, 1975-1982.* Stanford: Hoover Institution Press, 1983.

Pham Minh Hac. *Education in Vietnam: Situation, Issues, Policies.* Hanoi: Ministry of Education and Training, ed. 1994.

SarDesai, D. R. *Vietnam: The Struggle for National Identity.* Second Edition. Boulder: Westview Press, 1992.

Shiraishi, Masaya. "State, Village and Vagabonds: Vietnamese Rural Society and the Phan Ba Vanh Rebellion," *Historical and Peasant Consciousness in South East Asia.* Andrew Turton and Shigeharu Tanabe, eds. Osaka: National Museum of Ethnology, 1984.

Tai, Hue-Tam Ho. *Radicalism and the Origins of the Vietnamese Revolution.* Cambridge: Harvard University Press, 1992.

White, Peter T. and David Alan Harvey. "Vietnam: The Hard Road to Peace–Hanoi: The Capital Today," *National Geographic,* 1989.

Young, Stephen B. "Vietnamese Marxism: Transition in Elite Ideology," *Asian Survey,* 1979.

MISCELLAEOUS

Dang Nghiem Van. "An Outline of the Thai of Vietnam," *Vietnamese Studies.* 1972.

Elliott, David W. P., et al. *Vietnam: Essays on History, Culture and Society.* New York: Asia Society. 1985.

Fahey, Stephanie. "Vietnam: 'Pivotal Year'," *Southeast Asian Affairs.* Singapore: Institute of Southeast Asian Studies. 1994.

Hhrlimann, Martin. *Burma, Ceylon, Indo-China.* New York: B. Westermann, Co., Ltd. 1930.

Huynh, Frank C. H. "Vietnam 1991: Still in Transition" in *Southeast Asia Affairs.* Singapore: Institute of Southeast Asian Studies. 1992.

Hunh Sanh Thûng, ed. and tr. *The Heritage of Vietnamese Poetry.* New Haven: Yale University Press, 1979.

Jamieson, Neil Livingstone III. *Vietnam: A Study of Continuity and Change in a Sociocultural System.* Kyoto University Press1981.

Woodside, Alexander. *History, Structure and Revolution in Vietnam.* International Political Science Review. 1989.

Yarr, Linda. *The Indigenization of Christianity in Pre-Colonial Vietnam,* Unpublished paper presented at a Conference on Christianity as an Indigenous Religion in Southeast Asia, sponsored by the Joint American Council of Learned Societies and Social Science Research Council Committee on Southeast Asia, Cebu City, the Philippines. 1986.

Yeager, Jack A. *The Vietnamese Novel in French: A Literary Response to Colonialism.* Hanover, N.H.: University Press of New England. 1987.

Young, Marilyn B. *The Vietnam Wars, 1945-1990.* Boulder Colo.: Westview Press. 1991.

Young, Stephen B. "Vietnamese Marxism: Transition in Elite Ideology." *Asian Survey.* 1979.

ACKNOWLEDGEMENTS

Where to begin? Warm thanks to:

HAL BUELL, Eddie's former AP boss who knew Eddie for a hundred years, wrote the text making both the pictures and Eddie come alive. This book couldn't happen without his knowledge of Eddie, the AP, the Vietnam War, and photography and history in general. **MARIA RAGUSA**, who is first generation Sicilian and Eddie's kindred spirit, was relentless about setting dates to edit and rolled her sleeves up over the light table after work at night. **JULIE MIHALY** for instantly recognizing that there was a book on Vietnam. **MELINDA ANDERSON**, friend of the family and editor, who knows Eddie's work intimately and helped with the book through all its permutations and for introducing **MARIE SUTER** to the project, designer extraordinaire who without knowing Eddie personally conveyed his boldness in her graphics. **TOM CURLEY** from Pennsylvania, as was Eddie, recognized where Eddie came from and why Eddie was who he was. **WALTER ANDERSON**, a good friend of Eddie's, a supportive friend to me and a great sounding board. **NAN RICHARDSON**, who edited the only other book that Eddie did, *Speak Truth to Power*, because I could trust her to give the book "legs," and her staff at **UMBRAGE EDITIONS**, including **TEMPLE SMITH RICHARDSON, UNHA KIM, ASHLEY SINGLEY, KATRIN MACMILLAN. HOLLY HINMAN**, who with the utmost respect organized the materials and cataloged all the negs. **SHAUNA LYON,** former producer of The Eddie Adams Workshop, who helped edit the initial text. **PETE KIEHART & DUSTIN STEFANSIC**, who are intimate with Eddie's work. **CINDY ADKINS, SUSAN COOPER** and **ISAAC HAGY** who produced a documentary on Eddie and inspired this book to move along. **AUGUST ADAMS** who has a very good eye for helping with the tough decisions: "in or out?"

In addition: Adelaide Adams, James Adkins, Lori Adkins, Brian Aho, Vin Alabiso, Scott Allen, Wally Amos, Loretta Anderson, Nancy Andrews, Peter Arnett, Adrienne Aurichio, Mel & Anita Benarde, Grazyna Bergman, Pancho Bernasconi, Jennifer Borg, Jim Brady, Tom Brokaw, Sylvia & Kyle Browne, Jason Burfield, Russell, Bobbie Baker, James & Sarah Burrows, Sheri Calhoun, Fran Carpentier, Joey Castro, Jimmy Colton, Sandy & Irene Colton, Andre Constantini, Mel & Lorraine Conwell, Jim Dietz, Ray DeMoulin, Curt, Kathy & Hope Drogmiller, Jay Drowns, John & Rita Durniak, Jill Enfield, Bill Eppridge, George Esper, Mirjam Evers, John Filo, Steve Fine, Eric Finske, Deirdre Finzer, Maura Foley, Bill Frakes, David Friend, Henry & Marion Froehlich, Sam Garcia, Sarah Garrity, Yonca Gerlach, David Gipson, MaryAnne Golon, David Griffin, David & Jean Halberstam, Dirck Halstead, Pete Hamill, David Hartman, Cliff Hausner, Ed & Claire Hill, Johanna Holka, Bob Houlihan, Marilyn Jacanin, Jack Jacobs, Peter Jennings, Song Hae Jung, Peter & Sharon Kaplan, Shelly Katz, Joan Kearney, Joe & Helen Kellerher, Kerry Kennedy, Tom Kennedy, David Hume Kennerly, Mark Kettnehofen, Zhong Chill Kim, Douglas & Francois Kirkland, Beverly Klemzak, Kristian Kozlowski, Evan Kriss, JP & Eliane Laffont, Vincent Laforet, Yvonne Lai, Melissa LeBoeuf, Nancy Lee, Ryan Liebe, Neil Liefer, Richard LoPinto, Gerd Ludwig, Santiago Lyon, Hank & Peggy Martone, Clay Patrick McBride, Michele McNally, Jim McNay, Sid & Michelle Monroe, Allen Murabayashi, Carl Mydans, Hank Nagashima, Si Newhouse, Al & Gerard Paglione, Gordon Parks, Bill Pekala, Kim Phuc, Richard Pyle, Richard Rabinowitz, Loretta Rae, Tim Rasmussen, Vanessa Reiser, Geoffrey Rittenmyer, Joe Rosenthal, Morley Safer, Bill Samenko, Grover Sanschagrin, Mark Savoia, Ray & Darlene Schimmelfanick, Virginia Sherwood, Manny Steg, Skip Steffner, Michele Stephenson, Brian Storm, Jessica Stuart, Mark Suban, Kelly Tunney, Judy Twersky, Nick Ut, Catherine Vanaria, Lauren Wendle, Walt & Marion Wheeler, John White, Miriam White, Stephen Wilkes, Ira Yoffe, Chuck Zoeller.

On Sources: A Note

Photo captions on pictures from Vietnam were written first in Vietnam and sent to New York with the pictures. Captions may have been edited in New York—shortened, amplified, changed for updated information. Captions in this book are mostly taken directly from the pictures as provided by AP originally. Thus there are references to contemporary time periods such as "last week" or to specific dates when available. The editors believed that captions as close as possible to the original helped maintain the book's authenticity. Captions that are brief were taken from Eddie's handwritten notes on photo envelopes.

In some cases the only copy of a photo was the original picture as transmitted by radiophoto circuit from Saigon to New York. Print quality shows the transmission interference that left streaks and sometimes poor tones in the photo. These pictures are reproduced in the book. The print quality is the same as was delivered to newspapers at the time.

Quotes attributed to Adams are in italics and are his actual quotes. Excerpts from his stories are likewise in italics or are treated in special boxed presentation. Quotes from interviews originate primarily from two sources: a taped interview by historian David Culbert of Louisiana State University and the Vietnam Archive of

Texas Tech University and from a videotaped interview conducted as part of AP's oral history project. Quotes from stories are from newspaper archives and the AP Corporate Archive. Quotes from other sources are credited in the text. The chapter on Eddie Adams: Photographer, except as noted, are mine alone.

Photographs come from AP files.

Finally Adams would want it known that many, perhaps most, of the stories were put together by correspondents in the AP Saigon bureau who debriefed him either in person or by phone. Adams could, and did, write but the speed needed for wire service handling of news frequently required one person to report the story and another to put it on paper and on the wire. The reporter always got the byline.

Hal Buell

Interviews with Peter Arnett, Tom Brokaw, Morley Safer and Bob Schieffer are from the film *An Unlikely Weapon* by Susan Morgan Cooper © 2008. For information about the documentary film on Eddie Adams contact: tel. 001.323.467.9904.

Political cartoon p.149, top: Pat Olihant.